La Vie de Boheme

Henri de Toulouse-Lautrec experienced a life of deformity and disappointment. He left an artistic legacy beyond praise or price. Though his friends were the great personages of his time—Van Gogh, Debussy, Degas, Oscar Wilde, Sarah Bernhardt, Zola, among others—he was perpetually lonely. Though educated and witty, his life was a continual and desperate search for romantic love and happiness.

Four women were important to him: Denise, who first showed Lautrec the futility of his romantic hopes; Marie, a girl of the streets who enslaved him; Myriame, with whom he almost found contentment; his mother, who devoted herself to softening the blows which life continually dealt her sensitive son.

"Color, dram

MOULIN ROUGE

PIERRE LA MURE

▲ PYRAMID BOOKS ● NEW YORK

MOULIN ROUGE

A PYRAMID BOOK
Published by arrangement with Random House, Inc.

First printing, March 1966

Printed in the United States of America

PYRAMID BOOKS are published by Pyramid Publications, Inc.,
444 Madison Avenue, New York, New York 10022, U.S.A.

To you, Dolly,

with my everlasting gratitude and love

Contents

THE CURTAIN

RISES

I

"Please, Maman, don't move! I'm going to do your portrait."

"What, another one! But, Henri, you just did my portrait yesterday." Adèle, Comtesse de Toulouse-Lautrec, rested her embroidery in the lap of her crinoline and smiled down at the little boy crouched before her on the lawn. "I haven't changed since yesterday, have I? I still have the same nose, the same mouth, the same chin . . ."

Her gaze took in the tousle of black curls, the pleading brown eyes almost too big for the small heart-shaped face, the rumpled sailor suit, the pencil slanted in eager readiness over the open sketchbook. Riri, dearest Riri! He was all she had, but he made up for everything—the disappointments, the regrets, the loneliness.

"Why don't you make a sketch of Dun?" she suggested.

"I already have. Twice." He glanced at the Gordon setter dozing under the table, its nose between its paws. "Besides, he's asleep now, and when he sleeps he has no expression. I'd rather paint you anyway. You're prettier."

Gravely she accepted the naive tribute.

"Very well then. But only five minutes, not one minute more." With a graceful gesture she removed her wide-brimmed garden hat, uncovering her smooth auburn hair parted in the middle and curving like folded wings over her ears. "It's almost time for our drive. Joseph will be here any moment. Where shall we go today?"

He made no reply. Already the pencil was racing over the page.

They were alone in the stillness of this luminous September

11

afternoon of 1872, surrounded by the muted companionship
of old and familiar things, isolated from the world and happy.
About them the lawn stretched its green expanse; the sun loafed
in the sky. Birds gossiped on the edges of their nests, dashed
off on errands of their own. Through the yellowing foliage of
the sycamores rose the crenelated silhouette of the medieval
castle, with its angle towers, embattlements and narrow, ogival
windows.

A moment ago "Old Thomas," fat and solemn in his blue
livery, had removed the tea tray with the air of supercilious
hauteur befitting the major-domo of an ancient and princely
house, and marched off, followed by Dominique, a mere
youngster of fifty-eight with only twelve years of service.
A few minutes later "Tante" Armandine, who was nobody's
aunt but a distant relative who had come to the château seven
years ago for a week's visit, had folded her newspaper, emitted
one of her genteel snorts and excused herself "to write a few
letters," which meant she was going to take a nap before
dinner.

Tonight Joseph, the mutton-chopped coachman, would
appear to announce that Madame la Comtesse's carriage was
ready. Today a simple but formal dinner would be served
by elderly liveried *valets de table* in the dim, chilly and too-vast
dining room, hung with mournful tapestries and portraits
of frowning ancestors in armor. After dessert, the young count
would sleepily climb the monumental staircase to his bedroom,
where presently his mother would join him. She would sit
on the edge of his bed, tell him about Jesus and what a good
boy He was, about Joan of Arc, the First Crusade and
how great-great-great-great-great-great-grandpa Raymond IV,
Comte de Toulouse, had led the Christian knights to Jerusalem
and rescued the Saviour's Tomb from the wicked Turks.
A kiss, a last caress. A drowsy "Bonsoir, Maman." The blanket
pulled up, the coverlet tucked in. With a last glance she would
pass into her adjoining bedroom.

One by one the lights would go out of the mullioned
windows. And once again, as it had for centuries, night would
spread its cloak over the castle of the Comtes de Toulouse.

"Where shall we go today?" she asked again. "The old
tilery or Saint Anne's chapel?"

His busy nod signified his approval of either place.

A twinge broke the serene melancholy of her face. Poor
Riri, he didn't suspect this would be their last drive. He
hadn't learned yet that life was an ever-repeated farewell,
and that tomorrow might be unlike today. No longer would

he scramble up in the dogcart; snuggle up to her as she gathered the reins; babble away as they rolled along country roads; tease Joseph, armfolded and impassive on the rear box; ask a thousand questions while gazing about with gleaming, avid eyes. Life's first cruelty. The first thread was breaking in the close-knit weave of their intimacy. In time, others would snap, until one day the fabric would unravel and, like all boys, he would go away. . . .

Her lips quivered with a sigh.

"Don't move!" he chirped. "I'm doing the mouth and that's the hardest—"

Again her eyes scanned the small crouching figure: the knit eyebrows, the lower lip sucked-in in unaware intentness. From whom had he inherited this baffling passion for sketching? It was puzzling, even to her who knew his innermost thoughts, this streak of stubbornness, this craving for affection and approval, this hunger of his little heart that made him interrupt their romps to fling himself in her arms. All the more since he showed so little aptitude for art. Oh, well, it would pass, like his latest decision to be a sea captain. . . .

"Did I ever tell you about the time you wanted to draw an ox for Monseigneur the Archbishop?"

"The fat old man who comes here for dinner?"

"Not 'for' dinner, Henri, 'to' dinner. And—" now she spoke in the "severe" voice he knew so well "—you mustn't speak of Monseigneur as 'the fat old man'."

"But he is, isn't he," He lifted round, uncomprehending eyes at her. "Almost as fat as 'Old Thomas'?"

"Yes. But he is a man of God and a very important person. That's why we kiss his ring and say, 'Yes, Your Grace. No, Your Grace'."

"But . . ."

"Anyway," she hastened on, to avoid further debate, "it was at the christening of your brother Richard . . ."

"Brother? I didn't know I had a brother. Where is he?"

"He went back to Heaven. He lived only a few months."

"Oh . . ." His disappointment was genuine, but brief. "Why did they christen him then?"

"Because everybody must be christened to go to Heaven."

"Am I?"

"Of course."

This seemed to satisfy his curiosity, and he returned to his drawing.

"Then I'll go to Heaven when I die." His voice betrayed no jubilation at the prospect, only assurance.

"Perhaps . . . If you are a good boy and love God with all your heart."

"I can't." His tone was final. "I can't love Him with all my heart because I love you better."

"You mustn't say such things, Henri."

"But I do!" His eyes rested on her with the disarming defiance of children. "I do love you better."

Her arms on her knees, she watched him. He would never give in on this point. But then, perhaps, it was asking too much of a child to love a God Who never hugged you, never tucked you in . . .

"All right. I, too, love you, Henri," she said, feeling he expected her reassurance. "And now, stop interrupting or I'll never be able to tell you about that ox. Well, it happened four years ago, and you were a tiny tot then, barely three years old . . ."

In a low voice, furry with tenderness, she told him about the christening of his brother Richard whom he did not remember at all. After the ceremony the archbishop had led the guests to the sacristy to sign the parish register. It was then that Henri, until now very quiet, had insisted on signing "the big book."

"But, my child," the prelate had remonstrated, "how can you sign your name when you don't even know how to write?"

Henri had retorted haughtily. "I'll draw an ox, then!"

He did not appear very much interested by the anecdote and with a flourish lashed the last pencil strokes.

"There!"

He held out the sketch with a triumphant smile.*

"You see, not even five minutes."

Effusively she pretended to admire the portrait. "Nice! Very nice! You are a real artist." She laid the sketchbook on the garden bench.

"Come and sit next to me, Riri."

At once he was on the alert. No one but Maman ever called him Riri, and then only on rare occasions. It was a secret password between them. It could be the mark of high favor—if he had been exceptionally quiet at Mass, for instance, or counted to a hundred—or the omen of momentous, unpleasant news.

"You are seven now," she began, when he had cuddled against

* Lautrec's astonishing childhood portraits are today in the Albi Museum.

her, "a big boy. You want to be captain of a great big ship, don't you? Sail all over the world and sketch lions and tigers and savages?"

He nodded uneasily, and she drew him closer, as though to soften the blow.

"Then—it's time for you to go to school."

"School?" he echoed, vaguely alarmed. "But I don't want to go to school."

"I know, *mon petit,* but you must. All little boys go to school." Her hand fondled his black curls. "In Paris there is a big school, called Fontanes. All the nice boys go there. They play together and have fun. Oh, so much fun!"

"But I don't want to go to school!"

Tears welled in his eyes. He did not understand exactly what she meant, but obscurely he sensed that his world was crumbling about him: the dogcart drives; the lessons with Maman or "Tante" Armandine; the jaunts on his pony, Tambour, with Joseph at his side; the visits to the stables and the portraits of the grooms; the games of hide-and-seek with Annette in the corridors of the château . . .

"Sshh!" She pressed a fingertip on his lips. "A good boy never says 'I don't want'. And you mustn't cry. A Toulouse-Lautrec never cries."

She wiped his tears, blew his nose, while explaining that a Toulouse-Lautrec never cried or sniveled, but was always smiling and brave like great-great-great-great-great-great-grandpa Raymond, who had led the First Crusade.

"Besides," she added, "Joseph and Annette are coming with us."

"They are?"

That helped a little.

Annette was Maman's old nurse. She was very small, with bright blue eyes and a face full of wrinkles. She had no teeth, and she sucked in her lips so that it looked as if she had no mouth either. From morning till night she scurried through the château's corridors, the wings of her white coif flapping like a bird's. When she spun wool in her room, she let Henri sit on her footstool and sang old Provençal ballads in a high-pitched treble.

Joseph's presence also was reassuring. He had always been about, like "Old Thomas," the sycamores in the garden, the portraits in the dining room. Although he seldom smiled, he was a trusted friend, besides being a wonderful subject for portraits in his cockaded hat, white breeches and blue coachman's coat.

"And that's not all," she went on. "In Paris you'll see . . . Guess." For a second she held back the final enticement. "You will see Papa!"

"Papa!"

Oh, well, this put an entirely different light on things! Papa was wonderful. Whenever he came to the château, lessons were forgotten, schedules went unheeded. Life assumed an ebullient venturesome quality. The old castle itself seemed to stir out of its slumber and resounded with the tramping of his riding boots, the sound of his imperious voice. There were long drives with Papa cracking the whip, telling thrilling stories about horses and hunts and wars.

"Shall we live with him in his château?" Rapture glowed in his eyes.

"In Paris, people don't live in châteaux. They live in hotels or in beautiful apartments with balconies from which they can see what goes on in the street."

"But we shall live with him?" he insisted, warily.

"Yes, at least for a short while. He will take you driving in the Bois de Boulogne, a huge forest with a lake where people skate in winter. For they have snow in winter in Paris. And he will take you to the circus. Real lions and clowns and elephants! Oh, there are so many exciting things in Paris. Carrousels, puppet-shows . . ."

Wide-eyed, lips parted, he listened, forgetting to wipe the tears still trembling at the ends of his lashes.

During the days that followed, things were upset at the château. People rushed about in all directions, like flustered hens. Instead of playing with him, Maman held lengthy conferences with "Old Thomas," Auguste, the head gardener, and Simon, who had charge of the stable. The corridors were filled with open trunks. There were no more riding lessons . . .

Then, a week later, there was the excitement of departure. The *au revoirs*, the pecks on the cheek, the *brouhaha* of the railway station, with the locomotive puffing great billows of steam, like a charger before the battle. Then came the discovery of the train compartment with its springy banquettes, its luggage net, its intriguing windows that slid up and down.

Three shrill squeaks, a clanking of iron wheels, and the station with the people in it started moving backwards.

Soon the Albi countryside was flashing by: trees, rivers, tile-roofed farms he had never seen before.

"Look, Maman! Look!"

Exciting at first, it grew tedious and then boring.

He fell asleep.

The next thing he knew they were speeding through the Paris suburbs, and he was pressing his face against the window.

"Look, Maman! It's raining!"

High, square, ugly houses, grimy and slate-roofed, with laundry swooping from the windows. Smoky factory chimneys. Broken-fenced, weedy little patches of gardens between houses. Heaps of twisted metal rusting in the rain. In the muddy streets, men and women, antlike, bundled in overcoats, scuttled by, heads down. Instead of the blue Albi sky, a pall of dirty clouds. Awfully ugly place, this Paris . . .

At last, with a great sigh of relief, the locomotive came to a stop. Husky men in blue smocks burst into the compartment, seized the valises as if they belonged to them, and lumbered off. Maman drew on her gloves, straightened her bonnet.

On the platform a sea of waiting faces.

And there, towering above the crowd, grinning in his clipped beard, looking very handsome in his shiny top hat, his gold-knobbed cane tucked under his arm, a white carnation in the lapel of his frock coat—Papa!

When he was not entertaining at his hunting lodge, visiting at some friend's château, riding to hounds in England, attending Longchamps or Ascot or the Epsom Derby, shooting grouse with some congenial duke, hunting stag in the Orléans Forest, sipping sherry at the Café de la Paix or Pré Catelan, patting the cheek of some tutued ballerina in the foyer of the Opera or bending to kiss some lady's fingertips, Comte Alphonse de Toulouse-Lautrec could be found resting from his life of strenuous idleness in his suite at the Hôtel Perey, an exclusive residential hotel in the vicinity of Place de la Madeleine, where he lived in bachelor fashion amidst his riding trophies, his guns, his servants, and his beloved falcons, which he kept in a darkened room, especially equipped for its purpose.

Since the arrival of his wife and child he had suffered in silence the disruption of his habits and bravely borne up under the strain. He had taken Henri to the Cirque d'Hiver, driven with him through the Bois. Together they had strolled along the *grands boulevards*, the Tuileries Gardens, and spent a whole afternoon at the Jardin des Plantes gaping at the monkeys, the tigers and the yawning lions.

Tonight the count was going on with his fatherly duties. Clad in a crimson smoking jacket, his long legs sprawled toward the fire, he was impressing on his son what it meant to be born a Toulouse-Lautrec.

"Well, my boy, there they were, His Majesty the King

and your great-granduncle Pons, jogging along through the Fontainebleau Forest after the hunt, recalling the happy times they had had at Versailles when they were young and Marie Antoinette, who was only fifteen at the time, came to play with them. Of course that was before that confounded Revolution and the reign of the canaille . . ."

He turned to pick up the brandy glass at his side.

"Suddenly—" he took a sip and ran a finger over the fringe of his mustache "—suddenly your great-granduncle's horse shied and threw him."

"Oo-oh!"

The cry of sympathy came from Henri, sitting very erect on the edge of the capacious red-leather chair. "Did he die?"

"No, he didn't die."

"Was he hurt?"

"No, he wasn't hurt. Every horseman worth his salt has been thrown a few times. No dishonor in a little spill. I've taken a few myself. It's all in the game, my boy. All in the game. But do you know what your great-granduncle did when he picked himself up?"

"Climb back on his horse?"

The count shook his head. "No. He unbuttoned his breeches and emptied his bladder then and there."

"You mean—he made *pipi?* In front of the King?" gasped Henri.

"By the beard of Saint Joseph, that's exactly what he did! And why? Because your great-granduncle Pons was a very well-brought-up gentleman who always did the proper thing. He knew the rules of Court etiquette, and there is an old rule which says that if you take a spill in the presence of the king, you must empty your bladder at once. At once! Remember that, Henri. So that if His Majesty ever returns to his throne and you happen to be riding with him and your horse shies and throws you, you won't look like a silly bourgeois, and will know what to do."

With a flash of his strong white teeth he grinned at Henri from behind the smoke of his after-dinner Havana and enjoyed the look of worship in the boy's eyes. Nice child, Henri . . . Rather shy and naive, and stuffed with catechism and flummeries of that sort, but then what could you expect from a mother who went to Mass every Sunday and had a prayer stool in her bedroom? Give the boy a few years and then it would be time to take him in hand and make a gentleman of him.

"Yes, Henri, that's the difference between an aristocrat

and a bourgeois. An aristocrat always knows what to do. A bourgeois, on the other hand . . ."

Henri gazed at his father.

Wasn't he wonderful? Could anyone have a more intelligent, more handsome Papa? Even in the streets people turned when he passed, twirling his cane. Everything about him was exciting: living in this hotel with him, being told what to do when you went riding with the king, sitting up like this after dinner, like a grownup, instead of being sent to bed—even if you had to struggle to stay awake . . .

And this room! Nowhere in the whole world was there another such room. Mounted antlers and stags' feet on the oak-paneled walls, silver cups on the mantel, guns neatly racked in glass cabinets, pictures of horses everywhere. It smelled of old leather, tobacco and adventure. When he grew up, he, too, would have a room like this. And he would carry a gold-knobbed cane, smoke a big cigar and drink whatever it was that Papa was drinking.

"And so, after doing what etiquette prescribed, your great-granduncle remounted his horse, and the King and he went on with their conversation about the old days when they were young. Of course the King wasn't King then. He was called Comte d'Artois. Now, do you know why he was called Comte d'Artois?"

He waited an instant, a gleaming smile in his short black beard.

"Of course, you don't. Well, I'm going to tell you. And I want you to listen carefully."

He shifted his bulk and took another sip of brandy.

"In the old, old days France was divided into provinces. There were the provinces of Artois, Champagne, Bourgogne, Aquitaine and others. At the head of each province there was a great lord who was sometimes a count, sometimes a duke. Then the provinces would be known as a country or a duchy. Sometimes the same lord was both a count and a duke. We, for instance, were Counts of Toulouse and Dukes of Aquitaine. This is very important."

He paused to let these explanations penetrate the boy's mind.

"Don't ever, ever forget it. We were Counts of Toulouse *and* Dukes of Aquitaine."

The role of pedagogue was new to the count and he was enjoying it.

"Getting sleepy, Henri?"

"No, Papa."

"Good. And not only were we Counts of Toulouse and Dukes of Aquitaine, but we were Counts of Quercy, Louergue, Albi. We also were Marquises of Narbonne and Gothia, as well as Viscounts of Lautrec. But—" He fixed his piercing eyes on Henri and his voice rose to a solemn rumble. "But above all, my child, you must never forget we are and always will be Comtes de Toulouse!" An odd gentleness came into his eyes. "Today I am the head of our House. Some day it will be your turn. Then it will be your first son's turn, and his son's, and his son's son's . . . And so on, as long as there is France."

He noticed the filmy look in Henri's eyes.

"Well, enough for tonight. You're dead asleep. To bed with you, my boy. And don't forget what I've told you."

The child rose. As he was kissing his father good night, the count held him by the sleeve.

"Getting to be a strapping lad, aren't you?" he smiled. "Joseph tells me you're quite a horseman. Splendid, my boy. By the beard of Saint Joseph, if there's something we Toulouses can do, it's ride a horse! Next summer you will come to Loury and follow the hunt. Never too young to learn about such things. And there's nothing like stag hunting to acquire a good seat on a horse."

During the following week Henri learned more about the House of Toulouse and was taught the nuances of nobiliary genealogy.

"You see, my boy, there are counts and counts. Just as there are wines and wines, horses and horses, and, as you will discover in a few years, women and women."

There were *comtes de petite noblesse*. Insignificant country squires with puny châteaux not over one or two hundred years old. There were *comtes de robe*. Paltry judges, magistrates and small dignitaries of the *ancien régime*. There even were such ridiculous creatures as Napoleon's counts, and, ludicrous beyond description, Papal counts! Of these, nothing could be said except they fooled no one but Chicago heiresses.

"What's Chicago?" Henri inquired.

"A town in America where they kill pigs and marry their daughters to papier-mâché aristocrats. A pity, too, for American girls are devilishly pretty as a rule."

Finally there were the real *comtes* who were, like the Toulouse-Lautrecs, authentic feudal sovereign lords.

"And these, my boy, are an entirely different pair of breeches, as your grandfather used to say."

These were the real *grands seigneurs,* Lords of the Sword.

They ruled over their provinces, administered justice, made laws, held court, exchanged ambassadors and declared war.

"We even declared war on the Pope! And to show him we meant business, we began by hanging his ambassador. By then we were the richest, most important lords in France."

"More important than Monseigneur the Archbishop?"

"Archbishop!"

Count Alphonse's roar of laughter filled the room.

"Why, a Toulouse-Lautrec is worth a dozen archbishops and two or three cardinals thrown in for good measure. By the beard of Saint Joseph, whoever told you an archbishop was an important person?"

"Nobody," said Henri quickly.

When he was not talking about his House, Count Alphonse would show Henri his guns, let him shoulder them to get the feel of them, discourse about hunting or about falconry, a sport which was his consuming passion and on which he was a world authority.

Then, abruptly, he would emerge from his world of medieval lore, falconry and hunting, and turn into a dashing Parisian boulevardier. When he walked, white-spatted and puffing on his cigar, through the hotel's carpeted hallways, chambermaids curtsied to him and flipped admiringly, *"Bonjour, Monsieur le Comte."* If they happened to be young and pretty he would pat their cheeks; if they were old and ugly, he would merely tip his hat and walk on.

Before long, however, the strain of his wife and child's presence began to tell on Count Alphonse. He snapped at servants; at meals he hardly spoke. No more talks about the Toulouses, no more lectures on falconry.

"Your father has many important things on his mind," the countess said to Henri one day. "I'm afraid we are disturbing him."

That afternoon they drove together to an apartment house on Boulevard Malesherbes.

It had a tessellated marble-floored entrance, a red carpet ran up the stairs, and potted palms stood on each floor landing. A bald, redingoted gentleman preceded them to the second floor, where he unlatched a door and stepped aside to let them enter. Henri noticed a spacious corridor that stretched the length of the apartment. Nothing, of course, like the château's wonderful corridors where you could hide all day long, but big enough to play in. A huge crystal chandelier still hung from the ceiling of the empty drawing room.

"Did they forget it, the people who lived here before?" he inquired.

After they had peered into many bare rooms, his mother said, "This is going to be our new home, Henri. Do you think you will like it?"

He said he would, very much.

A few days later furniture was moved in. Things were sent for from the château. With pleasure, Henri observed the reappearance of many familiar objects. In Maman's sitting room went her wing chair, and the Savonnerie carpet on which he had tottered his first steps. Also the rosewood escritoire, the eighteenth-century pastels, and, on the mantel, the little alabaster clock he had known all his life.

At times it seemed he had never left home.

Henri's first day at school was one of discovery and tremulous apprehension.

Father Mantoy, the teacher, began class by reciting the *Spiritus Sanctus*. This done, he made a little speech welcoming the boys to Fontanes, impressing on them how privileged they were to receive a Christian education and enter the wonderful realm of knowledge.

Then without further ado, he stepped down from the platform and started dictating: "The sky is blue . . . Snow is white . . . Blood is red. Our flag is blue, white and red."

Once he stopped to peer over Henri's shoulder. "Very good, my child," he muttered, "very good!"

Still smiling, he resumed his stroll among the desks, his cassock rustling about his ankles, his hands clasped behind his back.

"The sea is blue . . . The trees are green . . ."

During recess Henri found himself alone. As Maman had said, there were boys everywhere. They played and ran and shouted and had fun. But they all seemed to know one another, and apparently had no intention of including him in their games.

Longingly he was watching a leapfrog contest when a blond, freckle-faced boy in knee breeches and Eton collar approached him.

"You're new here?" he began, stopping a few steps from Henri.

"Yes."

"Me, too."

For an instant they eyed each other with the devastating bluntness of children.

"What d'you want to be when you grow up?"

"A sea captain."

"Me, I'm going to be a pirate."

The blond boy took a step forward.

"Would you like to be a pirate, like me?"

"I don't know. What do they do?"

"They have cutlasses between their teeth, and capture boats and kill everybody aboard." As details from stories rushed to his mind, he elaborated: "And then, when they are through, they sail back to their island, bury their treasures in the sand, dance and drink rum."

The whole idea appealed exceedingly to Henri.

"Perhaps we could be on the same boat? What's your name?"

"Maurice. Maurice Joyant. What's yours?"

"Henri de Toulouse-Lautrec."

"That's a long name!"

Both took a step toward each other.

After a silence, Maurice asked, "How old are you?"

"I'll be eight soon."

"Me, I'm almost eight-and-a-half!" A victorious pause. "Where do you come from?"

"Albi."

"Where's that?"

"Far. Very far. It takes almost a day in the train to get there."

"Does it snow there?"

Crestfallen, Henri shook his head. "But sometimes there's snow on the mountains."

"Where I come from, it snows all the time in winter!" said Maurice.

His triumph was complete, yet he remained friendly, his blue eyes smiling in his freckled face. "Want to play?"

"Yes."

"Let's see who runs faster."

That evening, Henri burst into his mother's sitting room and breathlessly told her he had made a new friend and was going to be a pirate.

"We'll capture boats and kill everybody aboard. Then we'll dance, and play the accordion and hide our treasures in the sand."

From then on school was fun. Several other Fontanes boys were also planning to become pirates, and this in itself formed a solid basis for understanding. They included him in their games. Now recesses were all too short. He ran and yelled

until sweat glistened on his face. Even classes weren't so bad. Father Mantoy was pleased.

"Look, Maman! Look!"

That day Father Mantoy, in front of everyone, had pinned the Croix d'Honneur—a beautiful enamel-and-brass replica of the Cross of the Legion of Honor—on his sailor blouse.

She gasped, fondled the cross, declared it was the most beautiful thing she had ever seen. "I am proud of you, Riri," she hugged him, held him a long time in her arms. "Oh, so proud!"

Gradually the château, the dogcart drives, the portraits, even the rides on his pony, Tambour, receded into the past. His life became a serious, well-regulated affair that began every morning with Joseph's knocking on the door.

"Seven o'clock, Monsieur Henri. Time to get up!"

First came a hasty bath. The scramble to the dining room where Annette, white-coifed and grinning, was waiting. The bowl of steaming chocolate. A last mouthful of croissant. A quick kiss. The red-pomponed beret and pelerine snatched from the rack. At last, at a quarter to eight sharp, the race down the red-carpeted stairs, with Joseph in a derby, a black overcoat over his livery, trailing decorously in the distance.

By now Henri and Maurice had become inseparable. During class they slipped notes to each other; during recess they played together. On Sundays they went to Parc Monceau where they raced their hoops and played Indians among the columns of the small Greek temple by the pond.

If it rained they played pirates in the corridors of the apartment, took Joseph prisoner, dragged him to their ship and made him walk the plank. They stabbed the parlor maid, harassed the cook and, firing their wooden pistols, irrupted into Annette's bedroom.

Late one afternoon as they were stretched on the rug in front of the drawing-room fire, their faces still smeared with burnt cork, Maurice said unexpectedly, "What do you say we don't become pirates and become Canadian trappers instead?"

"Trappers?" cried Henri, taken aback by this sudden change in their plans. He liked being a pirate, hoisting the black flag and leaping on the decks of English ships. "What do they do?"

"They ride in virgin forests, hunt bears and fight Indians. We would live in a log cabin by a lake."

Henri mulled the proposition over. No denying it, it did sound attractive, especially the prospect of a lifetime spent with

Maurice. To stress his independence, however, he raised a few objections that Maurice swept aside.

Soon he capitulated.

"All right, we'll become trappers, but only if we live together and don't let anyone come along. We must never separate."

"Never!" echoed Maurice.

"How can we make sure?"

A long, brooding silence.

"There's only one way," declared Maurice at last. "We must become blood brothers. Then we'll be bound to each other unto life and unto death." He had read the expression in some book and liked it. "What d'you say? Do you want to be my blood brother?"

Henri nodded eagerly. "And you?"

"Me, too. But remember it's for life. You can't go back on it. And you can have only *one* blood brother. It means that whenever one of us is in trouble, the other must come to the rescue."

That afternoon, while the March rain streaked the window-panes, they scratched their wrists with a pin and exchanged a drop of blood. Solemnly they clasped hands.

"Now we must repeat the sacred oath," said Maurice. "*A la vie et à la mort!*"

"*A la vie et à la mort!*" repeated Henri with pounding heart. "Let's spit in the fire to make it even more sacred!"

They spat.

"Now we are bound together unto life and unto death," said Henri, smiling happily. "It's just as if we were brothers—real brothers!"

Thus the first Paris winter wore on. On Boulevard Malesherbes the chestnuts grew fuzzy with buds. One day, Henri found the apartment cluttered with trunks, the carpets rolled, pictures covered and slip covers on the furniture.

Before he knew it, school was over.

II

Vacation was almost over. Soon it would be time to return to school. It had been nice to be back once more in the château, make fresh portraits of everybody, resume the games of hide-and-seek in the winding corridors, the visits to the stable, the morning pony rides on Tambour, and of course to write long messy letters to blood-brother Maurice about their Canadian plans. All in all, it had been a very busy and pleasant summer.

Early in September they had gone, Maman, Annette and he, to Celeyran, Maman's home. It was called the Château de Celeyran, though it was only a big square green-shuttered house, barely two hundred years old, standing at the end of a long poplar alley.

As usual Grandpère was waiting in his white linens and panama, a grin like an upturned croissant between his fluffy side whiskers. As soon as the brougham turned into the driveway, he waved his handkerchief and hurried down the steps, his gold chain dancing on his paunch. There was the habitual confusion and excitement of arrival: the groom holding the sweating horses, Joseph running to lower the footboard, kisses, pats on the cheek.

At daybreak next morning, Grandpère tiptoed into his room.

"Up with you, young man! Why, the birds have been up for hours."

He sat down on the edge of the bed.

"Let's have a look at you. Hmmm, pretty good! A little pale perhaps. You haven't been sick this winter, have you?"

"No, Grandpère."

A pleading look came into the old man's eyes. "You *are*

going to grow big and strong, aren't you, Henri? Like your Papa?"

Now what kind of question was that? Of course, he would grow big and strong! Everyone did in time. Maybe not like Papa, but surely as big and strong as Grandpère, who was short and fat.

That day they rode together to the winery. Now and then, Léonce de Celeyran would rein in his horse and stop to chat in patois with his farmers, field hands, and the women gathering grapes in the vineyards. "This is my grandson," he would beam, waving at Henri. "Strapping young rascal, isn't he?"

At the winery bare-legged men and women hopped in enormous vats, like Indians doing a war dance, and Henri made a sketch of them. The following day they rode to the granary; the next to the poultry yards; the next to the dairy and stables. On all sides there were subjects to sketch. Toinon, the old donkey, pulling a cartload of manure,* roosters, strutting about as though on stilts, geese, ducks, sheep, cows . . .

In the evenings the big house echoed with music and laughter. There were enormous banquets, with Grandpère at the head of the table, very elegant in his puce redingote and brocaded vest, heaping food on everyone's plate, talking, laughing, carving, urging his guests to drink his wine, his wonderful Celeyran wine, and at dessert, flushed and a little tipsy, rising to toast slurrily everybody's health.

Henri was still smiling at the memory of those happy days at Celeyran when he heard his mother's footsteps.

She came in, a letter in her hand.

"Papa wants you to come to Loury for the hunt," she said in her low, sad voice.

"Are you going, too?"

She did not reply at once. Already her eyes had lost their Celeyran sparkle.

"Are you?"

She bent down and caressed his cheek. *"No, mon petit. But Joseph . . ."*

"Then I won't go! I won't, I won't, I won't! I don't want to go without you! Why aren't you coming? Why . . ."

Her fingertips hushed his lips.

"Ssshh! A good boy never says 'I won't'. Papa wants you to become a fine horseman like him. You will have a nice

* This Toinon water color, as well as numerous studies of farm workers and animals, are today in the Albi Museum.

hunting outfit with a beautiful pink coat. And remember you must never call it red, but pink. You will follow the hunt, meet nice people. Why, you will have a lot of fun. When you are introduced to a gentleman, don't forget to bow and say, 'It's an honor, Monsieur, to make your acquaintance.' And if a lady wishes to kiss you, you mustn't turn your head aside, as you always do. And you must remember to comb your hair, brush your teeth, and say your prayers."

Her soft voice lulled his protests. Gradually he abandoned himself to the excitement of seeing Papa again, galloping through the forest in a beautiful red—no, pink—coat.

That night he dreamt he was leading the Crusade and hunting stag with great-great-great-great-great-great-grandpa Raymond and a host of pink-coated knights in the forests of Jerusalem.

"Ha, here you are, my boy! Let's have a look at you."

For ten minutes, Henri, in his diminutive hunting outfit, had stood unnoticed on the threshold of the huge oak-beamed room, full of booted, pink-coated gentlemen and ladies in shiny top hats and long riding skirts, talking, laughing and drinking from silver goblets. Now he stood in front of his father, taller and more formidable than ever in his hunting clothes, grinning in his Medici beard, slapping his boots with his crop.

"Turn around. Not bad, not bad! A perfect fit. I had your mother send me one of your suits. But your hair is too long. You must tell your mother to have it cut when you return to Paris. You look like a girl with those curls! You don't want to look like a girl, do you?"

Still chuckling, he took Henri by the hand, led him to a group of guests standing by the fire.

"This, ladies and gentlemen, is my son Henri," he announced with genial formality. "I thought it would do him good to follow the hunt and see how these things are done. Never too young to learn, eh?"

He leaned down and, indicating each guest in turn, proceeded: "This, Henri, is Madame la Vicomtesse de la Tour-Jacquelain . . . This is Madame la Baronne de Vauban . . . This is Monsieur le Comte de Saint-Yves . . . And this is my old friend Monsieur le Duc de Doudeauville. His horse won the Grand Prix last year. And he is president of the Jockey Club, so you'd better be nice to him, or he won't let you in!"

Frantically Henri tried to recall his mother's instructions, but nothing came to his mind. He felt the blood rush to

his face as he bowed awkwardly and mumbled something, his eyes on the toes of his boots.

"A trifle shy, isn't he?" smiled the duke. "But he'll grow out of it, I wager. Boys do, nowadays."

The introductions continued. "This, my boy, is Madame la Duchesse de Rohan . . . This is Monsieur le Marquis de Villeneuve . . . This is Monsieur le Comte de—"

Names, names, names! Long names, difficult to remember . . . Grins, bows, handshakes, pats on the cheek . . . The men weren't so bad; they said a few words, held out their hands and returned to their drinks. But the women! They circled around you, squatted down, raised their veils to kiss you. "Isn't he adorable in his little pink coat? . . . How old are you, *chéri?* . . . What lovely curls! . . . You must come and visit me in Paris this winter." On and on they cackled and cooed and fretted, running their long-nailed fingers through your hair. Dutifully, you replied, *"Oui, Madame . . . Non, Madame . . .* I am eight and a half, Madame—almost nine . . ." And you remembered not to turn your face away when they hugged you and pressed their red, sticky lips against your cheek . . .

During the week at Loury, Henri was very busy. Whenever he could he sneaked off to the stables, fed lumps of sugar to the horses, wheedled the grooms into posing for their portraits. He made sketches of dogs, horses, and ladies posting sidesaddle, their veils fluttering in the wind.*

And of course, he followed the hunt.

He saw the kennelmen pull on the leashes of barking hounds, and grooms hold the bridles of pawing, glossy-coated horses while gentlemen leaned down and cupped their hands to boost the ladies into their saddles. He acquired a smattering of the sport's vernacular and was taught the rigid etiquette of stag hunting. Under Joseph's watchful eye, he followed the hunt as best he could, jumping low hedges and fording shallow streams. He heard the harbourers signal the whereabouts of a "warrantable" stag and watched the tufters harass the animal into the open. He learned when to make his pony stand still and when to gather up the reins and, with a swish of the crop, dash off in hot pursuit. Finally when the stag was broken, he listened to the mournful strains of the hunting horns and watched the ritual of the kill. But when he saw the panting beast crumple to its knees, tears spilling from its eyes, he turned

* Most of the Loury drawings are in the Albi Museum and have become popular through extensive reproduction.

his head aside and decided in the secret of his heart he did not like stag hunting.

He was glad when the time came to say good-bye and return to Paris.

Father Jammes, the next teacher, was very strict and on to all the tricks. No more prompting, cribbing, notes slipped under the desk. He peered dead at you over the rim of his spectacles, and the gray eyes in the round shiny face were sharp and all-seeing.

The grueling schedule was resumed. Joseph's knock in the morning. "Seven o'clock, Monsieur Henri. Time to get up!" The hasty bath, the bowl of steaming chocolate, the beret and pelerine snatched from the rack, the race down the red-carpeted stairs.

Now in the evenings, there was homework to be done by the light of the sitting-room lamp, with Maman in her wing chair reading or sewing by the fire, giving a little help now and then with the solution of some difficult problem. When the little alabaster clock on the mantel tinkled nine, she would say. "Enough for today, *mon petit!* Time to go to sleep." A hug, a tender kiss. And so—drowsily, head full of arithmetic and Latin verbs—to bed.

Of course life wasn't all work. There was still time for marbles and leapfrog contests during recess, and on Sundays Indian wars in Parc Monceau. With Maurice and other Fontanes schoolmates, he smoked calumets at the foot of Cornu's marble group "L'Abandonnée," pitched his tent amidst the shrubbery and hopped around imaginary fires. Placid, beribboned *nounous* and elderly messieurs reading their newspapers were startled by whooping, grimacing Iroquois in short pants and Eton collars.

Thus, the second Paris winter rolled by, happy and laborious as the first.

Henri was nine. He had become a real Parisian schoolboy, accustomed to the hubbub of the boulevards, the clanking of trolley bells, the unending flow of carriages and the sight of gendarmes quarreling with *cochers*. Occasionally he visited his father in his hotel suite.

"Why don't you and Papa live together?" he asked his mother one day.

"Because Papa is a very busy man," she replied hastily. "Now, tell me what you did at school today . . ."

Gradually the apartment on Boulevard Malesherbes became

home. The fashionable church of la Madeleine, with its plume-hatted beadle and its gold-plated collection salver, replaced the ancient and mellow Albi Cathedral as the place you drove to each Sunday to call on God. His mother made a few new acquaintances among the ladies of the neighborhood. Now and then, upon his return from school, he would find her entertaining in the drawing room. Madame Proust, the wife of the celebrated doctor, who lived only a few doors away, came quite often with her two boys, Marcel and Robert. Sometimes the doctor himself dropped in for a visit. Henri thought him exceptionally intelligent, for the physician never failed to compliment him on his Croix d'Honneur.

That year he made his First Communion, and in preparation for this momentous event he was submitted to intensive religious instruction. Before bed he glibly recited the Commandments and various Acts of Faith, Hope, Charity and Contrition, and developed an intimate relationship with the Holy Ghost, the Trinity, Virgin Mary, the angels and archangels as well as the swarms of saints, martyrs, virgins, hermits and holy men who, after miserable lives on earth, were now enjoying glorious leisure in Heaven.

As for God Himself, Henri clung to some secret—very secret—reservations about Him. Of course He was very powerful. The catechism and the Bible were full of His deeds and tremendous accomplishments. Yet, when put to specific test, God's performance fell considerably short of its promise. A number of times he had respectfully requested a few simple miracles, and each time God had failed to hear or been too busy to oblige.

Finally he reached the conclusion that God was very generous and powerful, but extremely chary of His gifts and His power. He was rather like Uncle Odon, who was reputed to be fabulously rich, yet somehow never sent you anything except a postcard for Christmas.

Once again, it was spring. On Boulevard Malesherbes chestnut buds opened like avid little hands. The count expressed the wish to take his son to the Concours Hippique, Paris' fashionable horse show. Accordingly, after Mass the following Sunday the countess drove Henri to the hotel, instructing him on the way to watch his manners, refrain from asking questions and not speak unless spoken to.

"In short, I want you to be a good boy," she said, smoothing the wrinkles in the white sailor suit.

The carriage had come to a halt in front of the door. With her soft white hands she straightened his wide-brimmed straw hat, and the Croix d'Honneur on his blouse.

He gave her a quick kiss, and leapt out of the carriage. At the door he turned to blow her a kiss and wave to Joseph. Then he disappeared into the hotel lobby.

When he was ushered into his father's room, the count was adjusting his tie in front of the pier glass.

"Gorgeous day, isn't it?" he grinned at Henri in the mirror. "I see your mother has had your hair cut at last. Good!"

He slipped a white carnation in his silk lapel, took the gold-knobbed cane from the hand of his valet, and with a little tap to his topper, started toward the door.

"Next year we'll ride to the Bois instead of driving like a pair of decrepit old women," he declared, as their carriage bore them swiftly along the Champs Elysées. "A gentleman's place is on the back of his horse, not behind."

Eagerly Henri gazed about him. On either side broughams, victorias, landaus and fashionable Kellner cabs streamed by in an unbroken flow. The gleaming hoofs of prancing satin-coated horses pelted the wood-bricked pavement like a steady rain. Harnesses flashed in the April sunlight. Ladies' parasols and flowered hats made bright patches of color against the footmen's somber liveries.

"I see you're wearing the Croix d'Honneur," the count observed. "Splendid, my boy, splendid! Your mother informs me you are at the head of your class." He chuckled indulgently. "But you're not going to turn into a bookworm, I hope. Books are all right in their proper place. Like painting, music—such things are meant for women. There are more important things in life."

From time to time he interrupted himself to raise his hat to some acquaintance, and a lifetime of mundane *savoir-faire* went into each greeting. To the Duc and Duchesse de Rohan, an unhesitatingly, courtly salutation, reminiscent of the *ancien régime;* to the banker's daughter, recently married into the aristocracy, a correct, faintly condescending bow; to Sophie Croisette, the actress, showing off her new pair of hackneys, an amused nod and meaningful lift of the eyebrows.

"By the way, have you started taking fencing lessons? No? Now fencing, my boy, is much more important than algebra or Cicero's speeches. Gives you the right to tell people what you think of them. And what about dancing? We must do something about that, too. Great careers have been built on expert dancing."

As the victoria rounded the Arc de Triomphe, he leaned forward and tapped the coachman's back with the knob of his cane.

"To Pré Catelan, François!"

Settling back in his seat, he turned again to Henri with a smile. "I don't suppose you have ever been to Pré Catelan?"

His grin broadened, and his white teeth flashed in the sunlight.

"No. I guess you haven't. Your mother wouldn't approve of it. Too frivolous for her tastes, I fancy."

Clusters of ladies in bright spring ensembles and whiskered messieurs in top hats stood about on the lawn or sat at white-iron tables under striped umbrellas, sipping apéritifs or ordering lunch as Henri and his father made their way into the restaurant's glass-enclosed veranda.

"A sherry," the count said to the waiter, while removing his gloves, "and for the young gentleman, a pink grenadine."

Excitedly Henri gazed about the crowded room.

From behind a screen of potted palms came the languid strains of a *valse lente*. Sunlight filtered through the arched windows in blond vaporous shafts, bringing a sparkle to the rims of the glasses and kindling colored fires in the ladies' jewels. Despite its size, the rotunda had the intimate atmosphere of an aristocratic salon. Men waved to each other or walked to one another's tables for short visits; ladies held out their hands, laughed prettily, nodded to acquaintances.

"See the white-bearded gentleman near the window?" whispered the count, leaning forward across the table. "That's Victor Hugo. A senator. *Un républicain, naturellement!* Everybody is a *républicain* these days. He writes too, I believe. Politics and literature! Poor France, she is dying from them!"

He rose and strode to a nearby table. Henri watched him lean down to kiss a lady's fingertips, exchange a few laughing remarks with her escort. Then, as abruptly as he had left, he returned.

"Do you see that gentleman with the square beard and monocle," he resumed, taking a sip of sherry, "the one talking to the very pretty lady? He is King Leopold of Belgium."

"A king!" gulped Henri, turning around to stare at the elderly gentleman.

"Don't stare! It's rude to stare at people! Besides, he's here incognito."

The count swung around as a hand touched his shoulder.

"Ah, *bonjour*, Doudeauville! Remember my son, Henri? I introduced him to you at Loury. I'm giving him a taste of

Paris life before taking him to the Concours Hippique this afternoon."

Henri scrambled to his feet and plunged into a deep bow.

The duke smiled at him, patted his cheek, said a few words to the count and casually strolled away.

A moment later another gentleman stopped at their table. Quick! The jump, the bow. "It's an honor, monsieur, to make . . ." Then it was Papa's turn to rise. This time he visited some people at the far end of the room. A few minutes later he was back.

"Do you see the lady wearing the long white gloves? That's Sarah Bernhardt, my boy. She is with her latest—hrrff!—her cousin! . . ."

Apparently this was how things were done. You sipped your sherry. Friends came to visit you. You walked to some-one's table, kissed some lady's fingertips, exchanged a few pleasantries, returned to your place. You took another sip of sherry. More friends tapped you on the shoulder . . .

"And now let's go to the Club and have lunch," announced the count, glancing at his watch. "You must be famished."

The Jockey Club's dining room smelled faintly of wax, old wood and Havana tobacco. Ancient and whisper-voiced stewards, gibbous from years of bowing, wandered between the tables like liveried ghosts. After dessert the count ordered his usual Napoleon brandy.

"And now, my boy," he remarked expansively, after draining the enormous tulip-shaped glass, "I just have time to change my clothes, and we'll be on our way to the Concours."

The Palais de l'Industrie, an immense and gaudy relic of the Exposition Universelle of 1855, stood on the Champs Elysées. To justify the preservation of this gigantic hodgepodge of statues, plaster cornices and colonnades, the authorities put it to various uses. Here was held the famous Salon de Peinture et Sculpture des Artistes Français, the *Salon,* as it was called, a great mundane event and the dream of thousands of artists. Here, also, took place cattle shows, charity bazaars, patriotic rallies, and the very exclusive, very fashionable Con-cours Hippique.

"Watch especially the jumpers," the count instructed Henri, as they entered the glass-domed auditorium, transformed for the occasion into an arena, and made their way to the section reserved for Jockey Club members.

"Riders are made, my boy, but jumpers are born. Watch

how they crouch forward when they take their mounts over the hurdles."

They took their places in the box, and he adjusted his binoculars.

"That's the secret. You must help your horse, almost lift him over the jump. Once I made a wager I could jump my mare, Juno, over a fiacre, and by the beard of Saint Joseph, I did!"

He stopped abruptly as he focused his lenses on a lady sitting alone in a box across the ring.

"Stay here," he said rising, "while I visit some friends."

He leaned forward and called to a short, potbellied old man who was sitting in the front row of the loge, busily sketching on a pad.

"Monsieur Princeteau! Would you mind keeping an eye . . ."

As the man did not turn, the count raised his voice to a bellow.

"Eh, Monsieur Princeteau! Would you . . ." He shrugged irritably. "Oh, what's the use! He's deaf as a post. Go sit with him, Henri. But don't try to talk to him. He's mute as well as deaf. You can watch him sketch. He does excellent paintings of horses. That's why we let him sit in the Club's box. I'll join you after the show."

Monsieur Princeteau welcomed Henri at his side with the eager smile of people who are not used to having their company sought. He thumbed through his sketchbook and showed Henri his pencil studies of horses. Soon the two were like old friends, deep in a conversation of nods, grins and gestures.

For Henri it was a memorable afternoon, what with the band playing martial tunes, beautiful horses jumping, caracoling, cantering, racking, and everyone applauding whenever the judges handed out silver cups and ribbons. At his side the old artist went on sketching, unaware of the noise around him.

After a while he pulled a small pad from his pocket.

"Do you like to draw?" he wrote.

Henri read the question and replied with an emphatic nod.

Whereupon Princeteau smilingly held out his sketchbook. Henri began to draw a pair of trotting hackneys under the eyes of the deaf-mute artist, who watched with an indulgent interest that soon changed to surprise, then downright stupefaction. For a few seconds he stared incredulously at the boy.

With a hand trembling with excitement he snatched the pad from his pocket and scribbled hurriedly, "You draw extremely well!" He underlined the word "extremely."

This was the first thing Henri told his mother that evening as he rushed into her sitting room, panting from the race up the stairs, his eyes still wide with excitement of the day.

"Maman, Maman!" he gasped, forgetting to kiss her. "I met an old man—a real artist, who said I draw extremely well! That is—he didn't say it because he can't talk. But he wrote it on his little pad. He's deaf too . . ."

"Goodness, what a *méli-mélo!*" she smiled, drawing him to her.

Tenderly she stroked his hair, listened to the quick beating of his heart beneath his white sailor blouse.

"First catch your breath, *mon petit*, and give me a kiss. You ran up the stairs, didn't you? Now tell me about this old man who cannot talk. And begin at the beginning—from the moment I left you at Papa's hotel this morning."

In a gush he told her the wonders of the day.

"And then we went to Pré Catelan where there was a king incognito!" he prattled importantly. "He was with a lady . . ."

"Do you know what incognito means?"

Just like Maman to ask embarrassing questions! Dejectedly he shook his head.

"It means that someone is not using his name or title because he's ashamed of what he is doing and the company he's keeping."

"But the lady was pretty!"

"Never mind!" she retorted, cutting short a perilous discussion. "What else did you do?"

He told her about lunch at the Jockey Club, the thrills of the Concours, his meeting with the old deaf-mute artist.

"Then he snatched his little pad from his vest pocket and wrote 'You draw extremely well!'" As his mother did not appear sufficiently impressed, he added, "It's true, Maman, it's true! He even underlined '*extremely*'!"

"How kind of him!" she said calmly. "And then what did you do?"

Well after the show they had gone to Rumpelmayer's. He had eaten two big *babas au rhum* and one chocolate eclair. Then back to the hotel where Papa had changed a third time. Into a dress suit, this time. He looked very handsome. They had dined at Larue's.

"Papa ordered pheasant and a bottle of Château-Lafite. He said I must learn to order the right wines. It's very important. Oh, another thing, Maman! I must take fencing and dancing lessons. Papa said they're more important than Cicero's speeches. And books are only for women."

Just like Alphonse to say such a thing. Why was it that non-intellectual people took such pains to deride knowledge and praise ignorance, as though it were some difficult accomplishment?

Aloud she said, "Of course, fencing and dancing are very important, but a real gentleman—oh, a *real* gentleman knows much more than fencing and dancing! He reads Cicero's speeches, learns his grammar and arithmetic, and becomes a great scholar. Now, give me a big kiss and go to bed."

For an instant she held him close, her cheek pressed against his. Her boy, her Riri! . . . No one was going to spoil him, turn him into a useless, foppish clubman. No one—not even his father!

"And now, off with you!" she smiled, with a pat on his backside. "You've had enough excitement for one day. And don't forget to say your prayers."

Somehow, the following autumn, time was found for fencing and dancing lessons.

Every Saturday afternoon Henri went to Maître Boucicot's gymnasium where he donned a pair of black silk breeches, a tight-fitting plastron and learned one of the accomplishments of the true French gentleman.

Despite his complexion, which was that of an uncooked round of beef, Maître Boucicot was an abstemious man, kindly and modest about everything but his mustache, of which he was inordinately and justifiably vain. It extended thirteen inches, that mustache, from one waxed tip to the other and curved on both sides of his insignificant face like a double scimitar. It gave him an air of illimitable strength and a ferocious yet alluring manliness. Whenever one thought of Maître Boucicot, one could think of nothing but his mustache. It dominated his personality. When he raised his foil in salute, swelled his chest in a long wheezy draught and thundered, "En garrrrrde!" Maître Boucicot was a sight to behold.

On the other hand, Mademoiselle Alouette, directress of the Académie de Danse pour Jeunes Messieurs et Demoiselles, was all frailty and spinsterly grace. God had made her plain,

and smallpox had done the rest. But her voice was pure honey, and she had a way of smiling without showing her carious teeth that was regarded as the quintessence of refinement.

Twice a week in the evening Henri drove to Mademoiselle Alouette's, usually accompanied by his mother. Awkwardly he stepped back and forth, bowed, smiled woodenly at beribboned little girls in starched dresses, while in the background a piano clanked, and Mademoiselle Alouette, an ectoplasm in mauve satin, clapped her hands and called the steps.

By Christmas Henri could stumble through the polka, the schottische and the lancers. His mother decided that the holidays would be an appropriate time to discharge numerous social obligations with a little *réception-dansante*. Guest lists were compiled, amended, added to. It was astonishing to find how many people one knew. Engraved invitations were sent. A four-piece orchestra was engaged. The count, in an expansive mood, promised to attend and lend his two men and his cook to help with the service.

By three o'clock the drawing room was already crowded. At four, guests were still arriving and overflowing into the sitting room, transformed for the occasion into a salon-buffet.

Madame Proust arrived in a state of great agitation, apologizing profusely for her husband's absence. These doctors were so unreliable! Always called out at the most inopportune times!

Henri greeted his schoolmates as they and their families were ushered into the drawing room. They said a few polite words, gazed at one another self-consciously, embarrasssed by the presence of their parents, uncomfortable in their stiff Sunday clothes.

At last the orchestra launched into the lancers. Flushed and unsmiling, the boys rushed to their appointed partners, bowed stiffly and slipped on their white cotton gloves. Under their parents' benevolent gaze, the steps learned at Mademoiselle Alouette's were gravely executed. Decorous applause marked the end of the ordeal. Like a flock of birds the youngsters flew out of the room to the butler's pantry where ice cream, *petits fours* and pink grenadine were awaiting them.

By five o'clock Indian wars were breaking out in the corridor. Forgotten, the little girls leaned against the walls enviously watching their brothers and cousins scalp one another. At six-thirty it was all over.

"Did you enjoy it, Henri?" his mother asked later that evening.

"Oh, Maman, it was wonderful! Let's have one every Christmas."

"I think that's an excellent idea," she smiled.

Next morning he could not get out of bed.

III

"A headache, eh? A mean, nasty headache?"

The doctor chortled in his square gray beard. Well, they were going to take care of that headache. Make it go . . . pftt! The fever, too, they were going to make it go . . . pftt! Just like that . . .

Under the countess' eyes he was diligently going through his routine, earning his fee, displaying his bedside manner for rich little children. While talking, he took Henri's pulse, pressed his cold ear against his chest.

"Like a Comanche with his ear to the ground listening to distant hoofbeats," Henri thought drowsily.

At last the physician snapped shut his black leather bag and turned to the countess. It was nothing, nothing serious. Yet some small symptoms puzzled him. Would it be all right if he brought in a colleague for consultation that afternoon?

"No reason for alarm, Madame la Comtesse, but one can't be too careful, can one? Children are such delicate, complex little organisms."

The colleague also had a square gray beard. He, too, jested while he took Henri's pulse, peered down his throat, examined his tongue and pressed his ear against his chest. At the end of his examination the colleague also looked puzzled.

After a brief whispered conference, the two physicians addressed the countess.

"Your child, Madame, is anemic. Anemia, especially when combined with rapid growth, produces sometimes unexplainable phenomena. However, there is nothing to worry about. The waters of Amélie-les-Bains are positively infallible in cases of anemia." They bowed, whirled around, exchanged many *Après-vous* at the door, and finally departed.

"Frankly, I don't know what it is," Doctor Proust confessed that evening, "and I'll be hanged if anyone else does."

He sat on the edge of the bed fondling his beard pensively, a frown between his eyebrows. He had just learned of Henri's illness and had dropped in for a friendly visit on his way home. Being such a famous doctor, he could afford to tell the truth.

"I don't like that fever," he muttered to himself, "I can't understand it." With great tenderness he slipped Henri's hand back under the blanket. "Try to sleep, *mon petit*. Sleep is still the best medicine."

With a smile that was half-sigh, he stood up and turned to the countess.

"Take him to Amélie-les-Bains," he shrugged. "Take him by all means. Perhaps they are right, perhaps it is anemia. The waters may help. They certainly can't do any harm."

During the week that followed burly men in blue smocks trampled through the apartment and tiptoed into Henri's room. They rolled carpets, covered furniture, took down curtains and pictures, carted away trunks. Papa came, the white carnation in its usual place, a pearl in his ascot. "Hurry and get well, my boy. And don't forget you're coming to Loury in the fall." Awkwardly he held out a thin leather-bound book. "I brought you this little falconry manual. I'm sure it will interest you. You'll be able to read it during your convalescence." Father Superior called, smiled at Henri, gave him a blessed medal and, in the name of Fontanes, wished him a speedy recovery.

And, of course, blood-brother Maurice came, accompanied by his mother.

"You won't forget about Canada, will you?" he whispered, the moment they were alone.

Feebly Henri shook his head on the pillow. They clasped hands and repeated the sacred oath while blinking back their tears. With difficulty Henri raised himself on his elbow and spat on the floor, for spitting made the oath unbreakable. Maurice promised to write every week. When his mother came to fetch him, he burst into loud sobs and clung to the bedpost. She had to drag him out of the room.

The Grand Hôtel d'Amélie-les-Bains was almost empty when they arrived. From his bed Henri could see the white-capped Pyrenees frozen in an eternal storm. An indescribable sadness hung over the famous spa, as though every patient who had ever come there had left behind him his quota of

pain and regrets. Once he felt strong enough to dine with his mother in the gold-and-plush dining room, where the few guests made a brave attempt at gaiety. After dinner some even tried to dance. But they were ill, gravely ill, or they would not have been there in the dead of winter. Soon they straggled back to their tables, while the orchestra went on playing to dancing ghosts.

New doctors examined Henri. Like their Paris colleagues they made jovial remarks, patted his cheek, took his temperature and looked puzzled. Behind closed doors they held lengthy conferences with his mother, from which she emerged white-lipped, her face drawn.

Then suddenly he was well.

Perfectly well. Normal. The fever had disappeared—pftt! The buzzing in his head—pftt! A mysterious recovery as baffling as the illness itself. The doctors reappeared, grinning effusively. All along they had known the Amélie waters would cure him. *Miraculeuses*, Madame! That's what they were, those waters, *miraculeuses!*

The countess decided that the warm Riviera sun would hasten his convalescence. Already they talked of returning to Paris after Easter.

"I'll work twice as hard and catch up with my class," Henri promised.

He wrote a long exuberant letter to Maurice.

They arrived in Nice shortly after the carnival. Confetti still flecked the sidewalks, and colored serpentines hung from the branches of the plane trees on the Avenue de la Gare. The winter season was at its height with at least three Russian grand dukes in town, a sprinkling of toothy lords and American *milliardaires*, all more or less incognito. In the garden of the Grand Hôtel de Cimiez the mimosas were in blossom, and their fragrance filled Henri's room.

It was wonderful to be well again, awake refreshed, run barefooted into Maman's adjoining room, clamber up on her bed and tell her how well he felt, how hungry he was and what a beautiful day it was for a drive on the Promenade des Anglais.

The breakfast on the loggia of their suite was another delight, with Maman in her white satin peignoir, looking young and happy again. Splashes of sunlight on the red-tiled floor, birds chirping in the trees below. And in the distance the Baie des Anges sparkling between the fronds of the palm trees, as if a bushel of diamonds had been strewn on a blue carpet.

At ten came the newly engaged tutor. He was nice, and

looked very hungry. One day he had lunched with them and
had almost devoured his plate.

In the afternoon the drive with Maman on the Promenade
des Anglais was another treat. Victorias, landaus, tilburies,
dogcarts passed them, driven by elegant ladies who cracked
their whips, clucked their tongues, while in the rear, liveried
footmen sat with their arms folded, impassive, like top-hatted
idols. Back in the hotel, they made wonderful subjects for
water colors.*

Abruptly the fever returned. So did the buzzing in his head.
Without warning. For no reason . . . No more rushing into
Maman's room in the morning, no more breakfasts on the
loggia, no more drives on the Promenade des Anglais.

A new doctor came. This one did not joke, but he looked baf-
fled, as the other had. He, too, asked to bring in a colleague
for consultation. They mumbled a long time between them-
selves, nodded to each other, stroked their beards. A pro-
nounced organic debility was their verdict. Extreme anemia
with recurrent fever. Nothing serious of course, yet something
to watch. They advised the waters again. This time the Barèges
waters.

And so Henri and his mother went to Barèges. Here the
same thing took place. Shortly after arrival his condition im-
proved. He was able to stroll in the hotel garden, sit with
his mother in the Jardin Public, where every afternoon the
municipal band gave a concert. Then, again, without warning,
the same vague symptoms reappeared. Back to bed . . . No
hope now of returning to Fontanes and catching up with
his class.

"The Plombières waters, Madame la Comtesse, are positively
miraculous," the doctors said, "Ha, Madame, the Plombières
waters!"

They journeyed to Plombières. Then it was Evian. A few
months later, Guyon. Then, back to Nice. Then, once again,
Amélie-les-Bains. Someone suggested Lamalou-les-Bains, and
that also was tried. Then, Guyon a second time—Barèges
a second time—Amélie a third time. As hope flickered, they
visited little-known, out-of-the-way spas, still hoping for a
cure. Everywhere the strange illness followed the same pattern.
Brief recoveries followed by ever-lengthening relapses.

Soon Henri was confined to his bed most of the time.

Life became an aimless, desolate wandering in quest of

* These early water colors have been extensively reproduced and
are among Lautrec's most popular works.

health, a succession of similar hotel rooms, solicitous hotel managers and puzzled physicians.

The months stretched into a year.

Then another year.

Like a ship vanishing into the horizon, Fontanes receded into the past. Boulevard Malesherbes, the red-carpeted stairs, Parc Monceau, the Indian wars, the *réception-dansante* became shadowy memories. The only realities were the bed, the fever, the thermometer, the doctors, the bedstand cluttered with medicine bottles and the constant buzzing in his ears. And, of course, Maman! Maman, white-faced and weary-eyed, always at his bedside, smiling, watching, praying . . .

For more than a year Maurice went on writing every week. Passionately he clung to the Canadian project and signed his letters "Your fellow-trapper and blood brother unto life and death!" Gradually his letters became rarer. Finally, they stopped. What was there to write about any more?

At last the day came when there were no more spas to visit, no more miraculous waters to try, no more doctors to consult. Two years after their departure from Paris, they returned home—to the château.

The battlements, the angle towers, the musty smells, the enormous crested fireplaces, the library with the somber breast-plated Toulouse-Lautrecs frowning down from their gold frames—they all were as they always had been. Everybody looked the same, except "Tante" Armandine who had bought a new russet wig and looked ten years younger. There were butterflies in the garden, the winding corridors invited games, and Tambour still waited in his stall.

But now he was too weak to ride, play hide-and-seek or chase butterflies. Too weak even to sketch; the pencil weighed a ton. When he walked from his room to the terrace, Joseph or Maman had to support him under the armpits.

In June, however, he felt so much better that they drove in high spirits to Celeyran. During the journey he chatted with Annette and made her sing her Provençal ballads. On the front seat Joseph cracked his whip joyously. Spring was in full sway. Through the window the passing meadows looked as though they had been freshly painted green.

As usual Grandpère was waiting on the perron. The moment the brougham entered the driveway, he waved his handkerchief and hurried down the stairs, as in the old days. But poor Grandpère, how changed he was! Old and thin, his cheeks sagging, his brocaded vest twice too large for him. He tried to smile

his welcome, but when he started to speak his lips quivered, his voice cracked, and for a second or two it looked as though he were going to break down and cry.

Early next morning he came as usual into Henri's room and sat down on the edge of the bed.

"How are you this morning, *mon petit?*" he whispered huskily. "Did you sleep well? How do you feel?"

There he was again with his questions! "I feel fine, Grand-père. Do you think we could drive to the winery this morning?"

"I should say we can! We can do anything we please. And you can bring your sketchbook along."

A little of the old waggishness rang in his voice, and for a few minutes he went on talking cheerfully, blusteringly in loud whispers.

Suddenly he leaned forward and grasped Henri's hand.

"You are going to be all right, aren't you, *mon petit?* You *are* going to get well? Aren't you?"

The words came out in halting gasps. Great unabashed tears tumbled out of his red-rimmed eyes and trickled down the sides of his nose.

"Please, *mon petit*, please!" His voice broke, and his last "please" was a sob.

With a desperate effort he clamped shut his mouth and remained silent, gazing blurrily at the boy through his tears, his broad chest heaving with stifled grief.

No, he would never get well . . . Look at that peaked face, those puny wrists, those enormous eyes burning with fever! He should never have been born, this beautiful child. He was too noble, too inbred. The family doctor had been blunt. "Léonce, I beg of you, don't let Adèle marry Count Alphonse. They are first cousins." But the lure of a Comte de Toulouse for a grandson, a boy who could affix a number to his Christian name, like the kings, had been too strong. . . .

"Please, Grandpère, don't cry. I feel fine. Really I do!"

The frail voice brought the old man out of his thoughts.

"Of course you do!" He forced a smile. "You're going to be all right. In no time you'll be back on that pony of yours, and we'll go riding again."

Hastily he bent down to kiss his grandchild and fled from the room.

The visit to Celeyran was cut short. Henri had not improved. If anything, he appeared to grow worse. On the journey back to the château, he cuddled against his mother in a state of drowsiness between wakefulness and sleep. Now and then he opened his eyes, smiled filmily at her, pointed to the cherry

trees in bloom along the roadside. On the opposite seat Annette had fallen asleep, her coifed head bobbing up and down with the swaying of the carriage.

Toward the end of the day the sky turned a pallid green. In the distance the dark-gray Albi hills looked like crouching elephants.

Three days later, disaster struck.

The library of the château . . . The countess choosing a book from the shelves . . . Unwatched for an instant, Henri leaves his chair, takes a few unaided steps in her direction . . . A stumble, an insignificant stumble on the highly waxed floor . . . The dry, wooden snap of a breaking twig . . . To his surprise he cannot get up . . .

"The leg is broken, Madame la Comtesse," declared the doctor, a short while later, as he wrapped the splint. "In a month it will be as good as new."

A month later the fracture had not knit.

"You see, Madame la Comtesse, it's one of those compound fractures that call for specialists. At Barèges, they have specialists. And, of course, the hot sulfurous waters are most efficacious. Nothing like them to build up resistance, and that's what the boy needs. He is weak, Madame, very weak. That is why the leg has not healed."

Once again they traveled to Barèges, and ironically the doctor's prediction proved true. The fracture knit. Two months after his arrival Henri could get out of bed, hop about the room on crutches. Soon he was able to go out for short walks.

Then—

Sunday afternoon . . . The Jardin Public with its prim begonia beds . . . In the kiosk, the municipal band puffing the "Sambre-et-Meuse". . . Humming gendarmes, thumbs in their belts, strolling amidst the crowd. The rubber tips of Henri's crutches leave round embossed prints in the sand of the neatly raked paths . . . A pebble, a small pebble, no bigger than a pea . . . The crutches, suddenly unmanageable, teeter wildly . . .

"MAMAN—"

The headlong plunge . . .

This time both legs were broken.

Now, pain never left him. Day and night it pulsated, throbbed, rose and fell, thrummed inside him in a groundswell which, at times, rose to hurricanes of suffering that convulsed his face and glazed his eyes. He had a name for these crises; he called them *"attaques."*

They lasted a minute or so and began with an uncontrollable

trembling of hands and chattering of teeth. Gradually the pain swelled, tore every tendon and ligament in his legs and thighs, arched his spine, buffeted his brain, inflated his skull until it seemed about to burst. By degrees it spiraled to a needle-sharp summit of excruciation where his whole body sublimated into pure, unadulterated agony that choked his screams into a gurgling rattle and rolled his eyes backward in their sockets. For a few seconds he lay unconscious, mouth contorted, nails dug deep into his mother's palms. Then, in clawing, electric tremors, the pain receded. Life returned to his eyes, air rushed into his lungs, his fingers relaxed. Blurrily he smiled at his mother as she bent over him to wipe the spittle drooling from the corners of his lips. The *attaque* was over.

Pain settled back to a dull throb which now, by contrast, seemed almost negligible. During the lull, he could see his mother looking at him with helpless anguish. Sometimes they exchanged a few words; sometimes she kissed him, ran her fingers over his brow.

Then the trembling would start again, his breath would quicken once more . . .

Doctors reappeared, but they grinned no longer. They brought with them the smell of chloroform and held gleaming scalpels in their hands. And they hurt—hurt until his hair stood on end, and his screams stopped people in the hotel garden below. At last he had no strength left to scream and sank into a merciful coma. Only his lips continued to move in a monotonous whimper. "Maman! . . . Maman! . . . Maman! . . ."

After four operations, the specialists informed the Countess that the lack of calcium and other minerals in Henri's bones defeated their efforts. "His bones need strengthening . . . the Royan waters, Madame, are most helpful in cases of this nature . . ."

The dolorous wanderings began once again. Royan . . . Châtel-Guyon . . . Mont Dore . . . Plombières again . . . Barèges again . . . Evian again . . .

But now Henri's legs were imprisoned in plaster casts. Travel had become a laborious procedure, a series of transfers from stretcher to stretcher that started with his being lifted out of bed by white-clad male nurses, carried down the hotel's service stairs to a waiting ambulance, driven to the station, hoisted in a train compartment; then, many hours later, in some similar station, being transferred to another ambulance, driven to another hotel, carried to another room, lifted into another bed—only to find pain, the same old pain awaiting him.

Doctors advised this; doctors advised that. A famous surgeon declared that all previous surgery had been bungled and insisted on breaking the bones afresh and performing another operation which brought Henri new agonies and proved equally futile. For three months a renowned specialist applied a new, wondrous treatment called electrotherapy; another guaranteed results from massage. Henri was carried into pools of hot sulfurous waters, and his legs and thighs were rubbed by professional masseurs who, hardened as they were, turned their heads aside not to see the torment in the boy's eyes. One specialist prescribed one thing; another something else . . . Everything was tried and everything failed.

Gradually the doctors came less and less often. When they did come, they made a confused murmur of words and looked grave and knowing, which was their way of admitting defeat.

In time pain itself seemed to tire of its excesses and settled into a dull, throbbing ache that for Henri became part of life itself. He grew accustomed to the companionship of pain, as one living near the sea gets accustomed to the pounding of the surf—angrier one day, gentler the next, but always there. Occasionally the *attaques* returned, but they became rarer as the months dragged by.

In this fashion a year passed.

Finally the realization of incurability forced itself upon Henri and his mother. Like a black-veiled figure, Hopelessness dwelt in the room, lived with them. They sensed Her presence, saw Her shadow across the bed, avoided each other's eyes not to read their thoughts. He told himself he would never leave his bed, never walk again. In retrospect the crutches he had used at Barèges appeared like fabulous vehicles of an intoxicating, unattainable freedom. His legs would remain in plaster casts forever. He would spend his life in bed, drawing mental pictures on the ceiling, learning to guess the hour by the changing patch of sky in the window. When he still happened to think about Fontanes, Commencement Day, Maurice, the Indian wars, they were shadowy, unreal memories woven of the substance of dreams. The outside world had vanished. Only Maman remained. Maman! . . . Her face was the last thing he saw when sleep came to him, the first thing when he awoke. Remote, in silent despairing prayer . . .

He was now fourteen. Suffering had brought a waxy pallor to his cheeks, burnished the bridge of his small, straight nose, but had left untouched the smoothness of his skin. All growth had stopped since they had left Paris almost five years ago. He still looked the Fontanes schoolboy he then had been.

At times his mother gazed at his puny chest, his frail wrists, his thin arms, and wondered whether he might not remain a child forever.

It was in Nice that the miracle occurred. Once again they were staying at the Grand Hôtel de Cimiez where he had spent his first convalescence. From his bed he could smell the familiar scent of mimosas rising from the garden below.

"Maman! Maman! My legs didn't hurt last night!" he cried one morning as she entered the room. "And they don't hurt now. And—" he stopped, made shy by the enormity of the forthcoming news "—and I don't have any fever this morning."

"No fever!" She knew he had become expert at guessing his temperature, but she no longer dared to hope. "How do you know? You are not a doctor."

"You'll see," he grinned.

She tried to hide her emotion when she read the thermometer. He was right; he had no fever. The first feverless morning in more than two years! Sternly she reined in her pounding heart.

"We must wait until tonight," she said with all the calm at her command. "What would you like for breakfast, *mon petit?*"

That evening he had no fever. The next morning his eyes were clear, his face cool, and he was smiling when she came in.

"A marked improvement," declared the doctor cautiously a few days later, tapping his gold pince-nez in his palm to hide his bewilderment.

The following week the healing was progressing "remarkably well, remarkably well, indeed!" For the first time the fractures seemed to knit. By the end of the month he was talking about removing the casts.

Still they did not dare to believe, did not dare to express their hopes. They merely looked at each other, smiling, sharing in their hearts their wonderful secret.

The day came when the doctor removed the plaster casts and pronounced the cure complete. Of course the legs, broken in so many places, would never be strong, but Henri would walk. He staked his reputation on that. He would walk. On crutches at first. Then, later on, who could tell? Why, he might walk normally, as well as anyone. At worst, he might have to use a cane.

"Yes, Madame la Comtesse, a most miraculous cure," repeated the physician, picking up his bag and preparing

to leave. "Meanwhile there is nothing for the boy to do but eat and sleep all he can, and let the mysterious alchemy of youth do its work and bring back health and vigor to his exhausted constitution. I shouldn't be at all surprised if before long he started to grow again."

After the doctor had gone, Henri and his mother sobbed in each other's arms, muttering incoherently, clutching each other, listening to the mad pounding of their hearts.

Now the days passed swiftly. His mother read aloud to him. They played checkers with the board spread on the bed, frowning and fretting over each move, laughing like children. She propped him against the pillows, brought his sketching paraphernalia and posed for innumerable portraits. Tenderly she coaxed him into eating a little more chicken, one more slice of bread, one more spoonful of custard.

Sometimes in the afternoons to while away the hours, she reminisced about her childhood, about the years she had spent at the Sacred Heart Convent at Narbonne. One day she told him about her friendship with Angélique. "We were inseparable, but shortly after leaving the convent she married a Navy officer. I haven't heard from her for many years. . . ."

As for Henri, he was living in a dream. His legs were free and alive again! He could sketch; he could move; he was going to walk! No one, no one really could understand what this meant. It was beyond expression, something to be gloated over in silence. No one could understand the ecstasy of wiggling your toes, bending your legs, feeling the blood course through your limbs . . . Like a colt rolling in clover, he tossed and turned in bed for the sheer delight of it. But most wonderful of all was to see Maman happy and smiling again, so happy that at times she lowered her lids, as though no one had the right to know such happiness.

As the doctor had predicted, he started to grow again. But his growth was limited to the upper half of his body. His chest expanded, his shoulders broadened, while his legs remained unchanged—the frail, undeveloped limbs of a child, hairless and purple-scarred.

Like a mask removed by an invisible hand, childhood vanished from his face. His voice lost its boyish treble. His finely chiseled nose burgeoned into a shapeless protuberance of flesh, flanked by cavernous nostrils. His lips swelled and turned scarlet, like a tumescence of internal tissue. His eyesight failed and strong lenses were prescribed. The pince-nez with its silk cordon became a part of him; the last thing he removed

at night, the first thing he groped for in the morning. Black fuzz sprouted on his face, arms and chest. Less than a year ago he had looked like a child; now he looked like a man. In her haste, Nature had skipped adolescence.

With unbelieving horror his mother watched him turn into a freak, half man and half child. To her frantic pleas doctors replied that some obscure glandular disease caused this unbalanced, one-sided growth. In the end they shook their heads, mumbled their regrets. Science, they declared, was powerless.

For the first time her courage failed her. She became panic-stricken. She had resigned herself to a bedridden invalid, even a crippled child. But not to a grotesque, shortsighted dwarf, ludicrous and pathetic.

At night, after he had fallen asleep, she would bend over him, biting her lips to fight back the tears, scan the unfamiliar, hairy face for some trace of the lovely child he had been. Could this be her son, her Riri, who had romped with her on the lawn of the château, rushed into her arms after school? What had he done to deserve this?

She wrote to the count, and he came at once. His face was ashen when he entered Henri's room. For a moment he stood in the doorway unable to speak.

"Papa!" Henri cried from his bed. "I'm going to walk! The doctor says I'm going to walk! Look! No casts!"

He flung back the sheets.

The count did not hear. Who was this stranger? This bearded repulsive midget, grinning at him from behind his absurd pince-nez? Not his son, surely! His son, his only son, the last of his line!

"I'm not in pain any more. And the doctor says . . ."

Still dazed the count took a few steps toward the bed. For a moment he stared at Henri with wide, uncomprehending eyes.

"My poor, poor child!" he groaned at last.

Then he whirled on his heels and stalked out of the room.

A few seconds later the entrance door slammed.

"Why did Papa run away?" he asked his mother, as she rushed into the room.

"You know how Papa is always in a hurry." She busied herself with the pillow. "He'll be back soon."

He sensed that she was deceiving him, and when, a few days later, she mentioned that the count had been suddenly called back to Paris, he merely said, "Papa is a very busy man, isn't he?"

One morning he asked her point-blank, "Do you think my legs will start growing soon?"

"Your—your legs? Of course they will—in time. They've been so long in casts that the muscles will require several months. Perhaps a year or two . . ."

He noticed her uneasiness, and thereafter refrained from asking questions.

Before long he was permitted to get up and sun himself on the loggia. In the distance the Baie des Anges glittered through the palm fronds as it had six years ago. Again he heard the chirping of birds and the creaking of the early cicadas. Below, the garden was the scene of great animation, for Queen Victoria was sojourning in the hotel. Occasionally he would spy her dumpy figure, swathed in mourning veils, as she climbed into her carriage for her daily drive.

"The doctor says in two or three weeks you will be strong enough to walk, and that we may go driving," his mother said one day. "You'll need some new clothes."

A tailor was summoned and carefully briefed. When he entered the room he did not betray his surprise by so much as a lifted eyebrow. With a face creased in smiles he went about his business and took Henri's measurements as though he were called every day to make suits for bearded youngsters with athletic shoulders and stunted legs.

Soon Henri and his mother went driving through the hilly surroundings of Nice. They jogged along the Grande Corniche, wandered through the fragrant, sun-dappled lanes of Cap Ferrat.

To Henri it was like being born again. Behind his pince-nez his eyes blinked with excitement.

"Look, Maman, look!" he cried at every new sight.

Sometimes his happiness would choke him. Tears would well in his eyes. He would seize her hand, hold it or press it against his cheek.

Once they pushed as far as Menton, and from there they could see the rococo dome of the San Remo Cathedral in the haze of the Italian Riviera coastline.

"Let's go there some day, you and I," he said. "Let's go to Italy."

On their return they remained silent, their fingers knit under the laprobe. As they skirted Beaulieu they heard the Angelus. In the twilight the black cypresses stood against the opal sea like hooded praying figures.

They began to talk about returning home. Neither of them

wanted to go back to the château. Too many memories awaited them there.

One morning she entered his room and sat down on the edge of his bed. For a moment she gazed at him, her hands folded in her lap. He thought he had never, even in the days of the *attaques*, seen her look so spent, pale and utterly sad. Her glossy titian hair had turned a drab brown. There were shadows of sleeplessness under her eyes, lines of grief at the corners of her mouth.

"Riri," she murmured at last, "the doctors say you are well. They have done all they can. If you wish we can return to Paris . . ."

Her breath caught in her throat. Like a broken flower, she crumpled on the bed and buried her face in the coverlet. He could see only the white nape of her neck and her back shaking with muffled sobs.

THE HUNGRY

HEART

IV

"I am proud of you, Henri."

"Are you—are you really, Maman?"

"Yes, Riri, very proud." Tenderly she looked at him across the fireplace. He hadn't changed; he always would be hungry for approval—the little boy who used to rush in after school to show her his Croix d'Honneur. "Frankly, I didn't believe you'd be able to make up for so much lost time."

"I knew you did; that's why I worked so hard," he said with an impish grin. "Of course you know it's for you I took that silly degree. Personally I didn't care a sou whether I ever was a bachelor or not."

Shortly after their return to Paris, sixteen months ago, he had embarked upon the preposterous venture. A tutor, Monsieur Tetard, had been engaged, a sandy-haired young savant, literally dripping Sorbonne diplomas. Books had piled up on the sitting-room table. A movable shelf had been hinged to the arms of the wheelchair to accommodate the bulky Latin dictionary. For months the very air had throbbed with hexameters, history dates and algebraic functions. Now it was all over; that day Henri had won his bachelor's degree.

"Come and sit here—" she smiled, motioning him to her footstool "—as you used to do when you were a little boy."

Grief clouded her face as she watched him lift himself from the armchair and with the help of his short rubber-tipped cane take a few tottering steps toward her.

"Monsieur Tetard assures me you could try for a master's degree," she said, bending forward when he had come to squat at her feet. "Wouldn't you like to? Books are a great comfort, perhaps the greatest."

Yes, books had been a comfort and a blessing. They had

helped him forget his loneliness, his bitter disappointment
at learning that blood brother Maurice had left Paris with
his family, and that doctors had been wrong about his legs.
Oh, yes, the wheelchair had been discarded. He could stand
up, even take a few shuffling steps with the help of his cane.
But that was about all, and by now he knew it never would
be any better. He knew that his legs would never grow, never
heal sufficiently for him to walk normally, and their aching
would never cease. He never spoke about it, but she knew
he knew; she had read it in his eyes. Books had helped him for-
get; perhaps they would also help him live . . .

"Books are faithful friends," she went on, "and a source
of lasting happiness."

Hesitantly she unfolded the plans she had come to cherish
in these last months: a studious, sheltered existence in the
noble companionship of books. She stopped abruptly as
she saw him shake his head.

"No, Maman," he said, "I don't want to try for a master's
degree. Books are all right, but I'd die of boredom if I had to
spend my life doing nothing but read."

"Perhaps you could write?"

"About what? You must live before you can write." He
read the disappointment on her face. "I'm sorry, Maman,"
he murmured wistfully.

"Then what are you going to do, *mon petit?*" she asked
after a pause. "How are you going to spend your time?"

"I don't know." He turned his head and gazed at the fire.
"I'll have to think about it."

Absently she went on stroking his hair. He was hungry
for life as he was for love. He wanted to live and didn't suspect
how cruel life would be to him.

"Henri," she asked with sudden gravity, "do you still say
your prayers?"

His jaw set into a hard line. "No, Maman." He waited
for her reproof, but she did not speak, and he went on. "I
haven't prayed since that day in Nice, remember—the day
you wept. That day I decided it was better to admit there
was no God than to go on finding explanations and excuses
for a God Who chastises those He loves and punishes those
He doesn't love, Who makes the innocent pay for the guilty
and Who made you cry."

Slowly he raised his head and looked up at her. "Please,
try to understand, Maman. I couldn't go on praying to a
God I could neither understand nor forgive nor respect nor
love."

Desolately she returned his gaze. Poor Riri! Crippled, ugly, in constant pain and without friends, he had lost the solace of prayer, the one thing that could have made his lot endurable. Perhaps beyond a certain point, youth could no longer forgive . . .

"I understand," she said in a toneless voice. "It is sometimes difficult to believe in God's mercy, but you will find it still more difficult to live without God."

That year they spent the summer at the Château de Malromé, which she had recently purchased. The brooding grandeur of the Albi castle had always been oppressive to her; since Henri's accident it had become unbearable. Malromé held no memories for them. A turreted seventeenth-century mansion, nestled among old trees, it was located in the Gironde province, not far from Bordeaux, in a region of vineyards and rolling hills that reminded her of her native Celeyran.

Henri loved Malromé, its peaceful walled-in garden with its high wrought-iron gate, its gravel driveway, its colorful dahlia beds. He strolled to the stables, fed carrots to the horses and chatted with the groom. He sat on the ledge of the lily pond and thoughtfully watched the stately convolutions of goldfish in the dark emerald waters. After lunch he dozed in the ratan chaise-longue on the small terrace at the back of the house where they took most of their meals. He teased "Tante" Armandine, who had come from Albi to spend a few days with them and stayed all summer. He argued with Doctor Mouré, the local physician, who occasionally came to dinner, and he drove to the rectory to play checkers with Abbé Soulac, curé of Saint André de Bois, the nearby village, and grew to love this simple and kindly country priest. He took afternoon drives with his mother in the blue victoria along peaceful, dusty roads, with Joseph, once again in his coachman's regalia, on the front seat.

The evening before their return to Paris he was sitting on the terrace with his mother, listening to the monotonous screaking of cicadas, enjoying the cool night breeze.

Suddenly he turned to her. "Maman," he said shyly, "I would like to become an artist."

A gasp escaped her. "An artist!"

The word rang in her mind with disreputable connotations. Except for a few respectable academicians, artists were disheveled, immoral bohemians who lived squalid and objectionable lives in Montmartre garrets, drinking absinthe and painting nude women. They gravitated at the outer fringe of society,

like actors, writers, musicians. Some talented shopkeeper's son might conceivably choose to become an artist, but not a young man of rank and wealth. Certainly not a Toulouse-Lautrec . . .

"An artist!" she repeated. "But, Henri . . ."

"I know what you're going to say," he interrupted, guessing her objections. "But I haven't much choice. What can I do, Maman, frankly what can I do? On the other hand, I've always liked drawing. Remember the portraits I used to do at the château? And the ox I wanted to draw for Monseigneur the Archbishop? Of course," he went on hurriedly, "the first thing I must find out is whether I have any talent or not. I thought that perhaps Monsieur Princeteau—you remember the old artist I met at the Concours Hippique—might be willing to give me a few drawing lessons . . ."

Pensively she gazed into the autumn night. A few drawing lessons wouldn't do any harm. They would make him forget his loneliness, and keep him busy. And that was the important thing—keep him busy, keep him busy . . .

From the start a deep and tender relationship established itself between the elderly deaf-mute and the seventeen-year-old cripple. They understood each other through a language of nods, frowns, smiles and, in emergencies, a note scribbled on the little pad.

Although not a great artist himself, Princeteau was quick to recognize his pupil's phenomenal gifts and was genuinely dismayed by them. Why, the boy had all Impressionism in him! He was all color, directness, originality! That was bad. People didn't want bright, original paintings; they wanted dark, glossy, minutious pictures like his own. For his own good the lad must be curbed, made to paint correctly, successfully. First, no more colors. Black, nothing but black . . .

One morning Henri found a plaster cast of a prancing horse on the table, a clean sheet of Ingres paper tacked on his drawing board and an assortment of finely pointed charcoal sticks. Cheerfully he sat down at his easel, dashed off a sketch which he showed to his master who nodded approvingly, moved the cast a few degrees and returned to his work without so much as a smile. By the end of the afternoon the floor was littered with charcoal sketches of the prancing stallion, and a grumbling flashing-eyed Henri was executing his twenty-eighth drawing.

Thereafter he found a new plaster cast every morning, a fresh stock of drawing paper and charcoal.

"Monsieur Princeteau," he would occasionally remonstrate with appropriate gestures of distress, "are you *ever* going to let me paint?"

Princeteau would shake his head and Henri would return to his drawing board, interrupting himself to dart furious glances at his master who pretended not to notice them.

"Horses! Horses! Horses!" he wailed at dinner. "Do you know, Maman, how many times he made me draw the same miserable horse today? Thirty-seven times! I could draw horses in my sleep! I, who wanted to become a portrait painter!"

She sympathized, secretly hoping he would tire and give up.

But he did not, and doggedly returned to the studio every day. And there one morning he noticed a blank canvas propped up on his easel. On a small table nearby lay a brand-new paint-box. A note was tacked on its lid. "From René Princeteau to his beloved and talented pupil."

"Oh, thank you, Monsieur Princeteau!" His gratitude gushed out in great soulful looks and eloquent waving of hands. "I just don't know how to thank you."

Already he was unscrewing tubes, squeezing shiny ribbons of paint on the brand-new palette.

"That's odd!" he remarked with a frown, leaning down to examine the neat row of tubes. "There doesn't seem to be any yellow . . . And no green! And no blue!! And no RED!!!"

His voice rose with each exclamation. Eyes blazing he faced his benefactor of a moment ago.

"MONSIEUR PRINCETEAU!"

Leaning on his cane he bent down to read the labels.

"Listen to this! Tobacco brown! Mummy brown! Chestnut brown! Vandyke brown! Mahogany red! Burnt umber! Sienna! Ocher! Terre verte! And of course, black! Ivory black, lamp black! Enough black to paint a locomotive!"

With the pathos of a lawyer addressing a jury he looked at his teacher. "How do you expect me to paint with mummy brown and lamp black? Monsieur Princeteau, how could you do such a thing?"

Out came the little pad.

"Bright colors are dangerous," wrote the old artist. "They should be used sparingly. Rembrandt could make dimness look very luminous. Learn to do the same."

"But, I am not Rembrandt!" protested Henri, after a glance at the note. "I don't want to paint like Rembrandt! Rembrandt's an old . . ."

Princeteau was already returning to his easel. With a sigh Henri squeezed some Vandyke on his palette and started to paint.

A few happy weeks followed.

Time passed swiftly in the warm, quiet studio while the winter rains lashed at the windows. Mummy brown, Vandyke and terre verte might not be the most thrilling colors in the world, but you could get some fun out of them. Like playing a piano in the low registers, but still better than not playing at all . . .

Now and then he would hobble to his master's easel and with dramatic gestures and imploring glances ask for a speck of bright color. "Please, Monsieur Princeteau, please give me a little yellow! I need it. Come and see." Unconvinced, the artist would rise, examine the canvas, return to his paintbox, select a tube and cautiously squeeze a microscopic blob of chrome yellow on Henri's palette.

Out would come the little pad again.

"Yellow is the most dangerous of all colors. Should be used only with the most extreme circumspection—like cymbals in music."

An affectionate smile would spread over the old man's round, clean-shaven face as Henri perused the note. For a second or two the net of wrinkles would fan out of the corner of his eyes. Then with a shake of the head he would return to his easel.

Shortly before Christmas, Princeteau fell gravely ill. From his bed he wrote to the countess he was leaving Paris. As for Henri, he was ready to begin his academic training as a portraitist and should enroll in some well-known *atelier*, such as Professor Bonnat's, for instance.

"Wouldn't you rather take lessons at home?" she suggested, after waiting for Henri to read the letter. "We could transform one of the rooms into a studio."

"But, Maman," he protested heatedly, "it wouldn't be the same thing. Think of the advantages of studying under a man like Bonnat, one of the greatest portrait painters in the world!"

"Yes, but have you thought you might find yourself out of place in an *atelier*, especially arriving like this in mid-term?"

"How am I ever going to become a portraitist if I don't join an *atelier*? I can't go on working from plaster casts all my life. And then," he added in lowered voice, "perhaps I could make some friends at the *atelier*."

The longing in his voice brought the sting of tears to her

eyes, but she forced herself to go on. "You might," she said dubiously, "but it's a great risk to run. Young people are clannish as a rule and resent intruders. Besides you are very shy with strangers and people often mistake shyness for snobbishness. Another thing. These young men will probably be in their early twenties while you aren't even eighteen. You may not understand them, and they may not even try to understand you." Her voice trailed off in pleading urgency.

"I know what you are thinking." His enormous brown eyes rested upon her with the intense sadness that often came into them. "I too am afraid. But I can't stay home and hide forever, can I?"

His hands behind his back, Professor Léon Bonnat was making his weekly tour of inspection, strolling among the easels, stopping now and then to glance at a student's canvas.

"Portraiture," he discoursed, addressing the class as he went along, "is not only the highest expression of art, but also, financially speaking, the most rewarding. To become a successful portrait painter you must remember these basic rules. If your sitter is a man of action—a general, an industrialist, a statesman—you must paint him standing up and frowning, two fingers in his waistcoat, like Napoleon. If he is a thinker—a scientist, a writer or a prince of the Church—then you paint him seated, chin in hand, a thoughtful look on his face. I refer you to my portrait of Cardinal Lavigerie."

Trembling with fear Henri sat hunched on his low folding stool, applying hesitant brushstrokes, blinking at the model on the stand, taking measurements with his thumb. What would Bonnat say this time? Would he rant and sneer and hold him in ridicule to the class, as he always did?

"But in all cases," pursued the academician as he meandered through the room, "the technique is the same. First you quadrate your figure, make a careful preliminary sketch and then fill your primary shadows with raw umber. Raw umber, do you hear?" he repeated with sudden violence. "Nothing else. Let the Impressionists and those pranksters of Independents put blue or purple in their primary shadows. *You* will use raw umber!"

At last he reached Henri's easel and interrupted his lecture to squint at his canvas, all the while nervously fondling his goatee. An expectant silence fell over the *atelier*. The weekly diversion was about to begin.

"Do you by any chance call this a painting?" he began with silky irony. "If you do I must warn you that you are mistaken."

Then, in an explosive snort of anger, "Do you know what I call it? *Une cochonnerie!*"

He barked the words at Henri amid the guffawing hilarity of the students. "Why do you persist in coming here?" he went on as the laughter subsided. "Do you really believe you'll ever be an artist? How many times must I tell you that all your pictorial instincts are wrong, that you have no talent whatever, not a shred of it. That you have no eye for beauty but only for ugliness, that you will never be able to paint and would confer upon us a great favor by staying home and sparing me the ordeal of looking at your grotesque daubs!"

He went on scratching his chin as if about to continue, then with a shrug he walked away. A moment later he took his top hat from the rack, slipped on his overcoat and departed.

"Five-minute recess," chanted the studio *massier*, clapping his hands.

On the stand the model came to life and wrapped a soiled peignoir around her shoulders. She produced a newspaper which she proceeded to read while picking her teeth with a match. The students rested their palettes on their paintboxes and gathered around their easels in small whispering groups.

Henri went on painting, blinking the tears from his eyes. There was no use going on, being ridiculed each week, laughed at by a roomful of strapping, hostile art students. Maman had warned him they wouldn't even try to understand him, and as usual she had been right. They had rejected his timid advances, made it painfully clear they didn't want him. Why—why did they dislike him so? Because he was a cripple? No, not that. What they resented was his youth, his expensive clothes, the fact he was driven to the *atelier* every morning by a liveried coachman. To them he was an amateur, one of those rich mama's boys who toyed with art to pass the time. If they only knew! Well, they didn't, and it was senseless to go on. Better give up. Perhaps he would go after that master's degree after all, as Maman hoped. . . .

"Don't let the old bastard get you down!"

The booming voice behind him startled him out of his thoughts. He turned on his stool. A towering young man in a shabby frockcoat, checkered trousers and flowing bow tie was grinning down at him. Henri had noticed him among the students because of his great height, his loud Midi drawl and the crinkly beard that spread like black foam over most of his face.

"Let him yell, let him rant," went on the husky Meridional. "You paid the fees, didn't you? Well, then, what do you

care? He can't kick you out and you can spit in his eye. By the way, my name's Rachou—Henri Rachou. How about lunch together at Agostina's. Later if you want, I'll show you my studio. Nothing much, but it's got a wonderful view of the Montmartre Cemetery. Ever been to Montmartre?"

Agostina's restaurant was at its noisiest when Henri and his companion made their way to a small corner table. Hirsute Montmartre artists in black corduroy suits and enormous felts slanted forward over their risotto and shouted at one another, brandishing their crumpled napkins through the stuffy garlic-scented air. Like a bountiful Juno, a handsome liquid-eyed brunette circulated among the tables, followed by her two faithful wolfhounds, oblivious of the pandemonium about her, carrying plates of steaming minestrone, jesting, arguing, laughing her fruity laugh.

"That's Agostina," whispered Rachou, pointing the stem of his pipe in her direction. "She used to be a model."

At thirty-nine Agostina Segattori was a Montmartre legend. At sixteen she had arrived in Paris from her native Sicily, barefooted, penniless and ravishingly beautiful. Six months later she was the most sought-after artist's model in the capital. Venerable academicians fought for her services and her favors. Sculptors gulped at the perfection of her pelvis and hammered their chisels with renewed fervor. For two decades her stimulating bosom and classical profile had been a feature of the annual Salon, while her luscious shape had gone to grace countless public squares in the guise of Diana, Democracy or the Spirit of the Marseillaise. Of a romantic disposition she had left much of herself in the studios where she posed and had comforted with her caresses legions of artists through the despondent hours of their careers. When three years ago she had opened her restaurant, a swarm of grateful painters had offered their services in memory of their brief romances. Since she couldn't oblige them all she had asked each one to decorate one of the tambourines which hung in orderly rows on the walls and gave the place its name. The number of these tokens testified to Agostina's generous nature.

Henri watched her lean down solicitously over one of her patrons, a russet-bearded sculptor, and plead in a loud whisper, "I beg of you, Roberto, don't eat the risotto. I put the garlic in it and you know how the garlic gives you the nightmares. Eat some pepperoni instead. They make the blood fierce, and tonight you'll surprise your wife and make her happy, eh?"

She accompanied her remarks with an affectionate nudge; then, still laughing, she turned toward the two students.

"Ah, *bambini*—" all students, whatever their age or size were *bambini* to Agostina "—you have the hunger, *hein?* The big appetite? Well, first I give you the minestrone. Then a *meravigliosissimo* risotto. A risotto like you've never seen. It is like music. Like a caress to the belly."

Agostina's patrons were used to her lyricism. It was as natural to her as the wave in her blue-black hair.

"And then, I give you . . ."

"Anything, anything you want," agreed Rachou, who was ravenous. "You always do anyway."

During lunch he spoke little, shoveling down his food in large crunching mouthfuls. But Henri was too excited to eat. This was a wonderful place. He had never been in such an exciting restaurant. Those strange smells, and such a noise, and all those artists waving their arms, yelling at one another across the room, arguing about something.

For a moment he watched a stocky kindly-eyed old man who was puffing at a charred curved pipe and conversing with a blond-bearded young man of great delicacy of features.

"The old one with the big white beard—that's Pissarro," said Rachou, his mouth full. "He is an Impressionist. The other one is Théo van Gogh. He runs an art shop on Boulevard Montmartre." Noticing Henri's almost untouched plate, he boomed on threateningly, *"Merde alors,* eat your risotto, or Agostina'll be mad at you!" Their lunch over, the two students walked the short distance to rue Ganneron where Rachou had his studio.

"Isn't that a view!" intoned Rachou, pushing the door open and sweeping an arm over a panorama of tombstones, mausoleums and statues of weeping angels. "Like living in the statuary section of the Louvre, isn't it? And you'd never believe the effect it has on the girls. Especially the crematorium. Scares them to death and makes them passionate." He pointed to a derelict couch under a pseudo-oriental coverlet. "That's why I put the bed there, where they can see it."

With an absent stretch of his long simian arm he removed a mandolin hanging from a nail on the wall, and launched into a popular Montmartre ballad entitled "Ah, Que Tu Fais Bien l'Amour!"

Gradually Henri took the habit of lunching with Rachou and spending the afternoon in his studio. There he painted, joined in the refrains of *atelier* songs, watched the funeral

processions that streamed under the window at all hours, and clinked glasses with hearse drivers, gravediggers and crematorium technicians who came to the studio to pose for their portraits, enjoy a bottle of *vin ordinaire* and share in a few much-needed laughs.

"You know," Rachou observed one day, peering intently at Henri, "there's really nothing wrong with you. Of course, you're practically an infant," he added looking condescendingly at his companion from the height of his twenty-two years, "but you aren't really stupid. And you can draw! Even if that bastard of Bonnat says you can't."

To Henri such compliments were like a healing balm. His gratitude overflowed for this Rabelaisian colossus who had befriended him. "Oh, Rachou, I wish I could tell you . . ."

"Shut up!"

The thundering retort was intended to teach the youngster that expressions of feeling were frowned upon among students. Friendship must be cloaked in coarseness and feed on invective.

"The trouble with you," he went on, ignoring Henri's dismayed expression, "is that you are too shy, too polite and too damn clean. Why, look at your nails! *Merde alors*, a little dirt never hurt anybody. And another thing. You should say *'merde,'* and *'nom de Dieu,'* and 'I spit in your eye' now and then, like everybody. Then people wouldn't think you're queer."

During the following weeks Rachou initiated Henri into the lingo, mannerisms and deportment of authentic art students.

"Now, suppose you and I were having an argument," he proposed suddenly on a gentle, cloudy March afternoon. "Let's say about Rubens. And I say, 'Rubens is the greatest painter who ever lived.' What would you say?"

"I'd say I didn't know."

Henri's reply distressed Rachou. For a few seconds he stared at his friend, shaking his head. "No, no, no!" he said at last, as if addressing a backward child. "You should say, 'Rubens? *Merde alors*, your Rubens I spit in his eye. He is a pierced bladder, I wipe my *derrière* with your Rubens!' See? Then everybody would understand what you're trying to say." His small piggish eyes were gentle as he looked down at his protégé.

Henri sensed that in his devious way his mentor was grooming him for his debut in the student world. He was right. Late one afternoon Rachou said casually, "Let's go to La Nouvelle. I want you to meet a few friends of mine."

La Nouvelle turned out to be the Café de la Nouvelle

Athènes, a smoke-filled artists' rendezvous on Place Pigalle;
the friends, three Bonnat art students—François Gauzi, Louis
Anquetin and René Grenier—who, like Rachou, lived in
Montmartre. Obviously they had consented to meet "the rich
amateur" only to please Rachou, who enjoyed an enormous
popularity. They greeted Henri with frigid reserve. After a
curt nod they ignored him altogether and went on discoursing
among themselves. Henri, in turn, sipped his beer and remained
unobtrusively silent.

Oddly, it was this quality of reticence that eventually broke
down their prejudices against him. Inveterate talkers as they
were, they longed for an audience—any audience. In Henri
they discovered a sympathetic listener to the accounts of
their amatory exploits and their troubles which were invariably
of a financial nature.

Gauzi was the first to enlist Henri's good offices. Less than
a month after their meeting at La Nouvelle, he approached
Henri at the *atelier* during a five-minute recess.

"Guess what happened last night?" he began with the air
of a man who has just lived through a memorable experience.

He was gaunt, sallow-cheeked, naive, vain about his looks,
which were nonexistent, and modest about his talent which
was real. He had a passion for bright waistcoats on which
he squandered an already inadequate allowance, and firmly
believed that women could not resist hypnotic commands
and scented beards. For this reason he practiced magnetic
glances in his mirror and drenched his straggly beard in
lilac water.

"I was on my way home," he proceeded, encouraged by
the look in Henri's eyes, "and I happened to stop in a little
bistro at the corner. And there guess what I saw?"

A young woman of breathtaking loveliness, alone and
in tears. He had gone to sit at her side and inquire as to the
cause of her distress. Between sobs she had confided to him
that her landlady had locked her out of her room for non-
payment of rent. Gauzi had been understanding, warmly sym-
pathetic. The hypnotic glances he fired at her as well as the
fragrance of his beard, which he pushed close to her face, had
created a bond of mutual attraction. They had left the bistro
together and somehow found themselves in Gauzi's room, where
their budding friendship had ripened almost instantly into
blazing love. During an unforgettable *nuit d' amour*, Babette
—that was her name—had revealed herself a *femme parfaite*,
a woman of infinite understanding, torrential passion and
exquisite depravity.

It would have been perfect but for one thing: Babette had come into Gauzi's life at a most inconvenient time.

"You see, just two days ago I bought this waistcoat." He pointed to the superb lemon waistcoat he wore. "And so . . ."

Henri understood. Discreetly he reached for a twenty-franc gold piece which Gauzi accepted with a mixture of reluctance and alacrity.

A week later it was Anquetin's turn to look to Henri for comfort.

"I've lost her!" he moaned disconsolately. "Such a wonderful girl!" Unlike Gauzi, who grew bitter, Anquetin idealized his mistresses the moment he lost them. "I should never have taken her to the Louvre!"

Anquetin was handsome in a blond disheveled way. Midinettes would glance back at the gesticulating yellow-bearded young man in the battered top hat. He failed with women because of his illusions about them. Their ignorance and stupidity appalled him. He tried to improve the minds of his mistresses, as some men try to improve the morals of theirs —and with the same results. He would turn intellectual on them when the occasion called for silence and dispatch. Or he would drag them to the Louvre and expose them to the uplifting ambience of great art when they would have preferred to play simple games at home.

"Yes, I lost her in the room of the Flemish Primitives," sighed Anquetin. "I'll never go to that damn museum again."

By the time he finished unburdening himself to Henri, he was feeling considerably better. A week later he was earnestly improving the intellect of a young laundress he had met in a dance hall.

René Grenier was the last to overcome his prejudices against Henri. Yet his reserve changed gradually into a prudent cordiality and soon into genuine comradeship. He took Henri to his two-room apartment on rue Fontaine.

"You see that window," he said, pointing across the courtyard. "That's Degas' studio. Sometimes you can see him read his paper or smoke a cigarette."

Henri felt he had been accepted. He had friends; he was happy.

One morning in June Professor Bonnat arrived at the *atelier*, his triangular face wreathed in smiles. The pressure of personal work, he announced, forced him to disband the class.

"But don't be alarmed," he reassured the jubilant students. "I've prevailed upon my eminent colleague at the Académie,

Professor Fernand Cormon, to make room in his *atelier* next October for those among you who wish to pursue their studies."

The class dismissed, the boys exploded with joy.

At the corner of Place Clichy, François Gauzi climbed a lamppost and blew kisses at every passing woman, while Rachou, his hands clasped behind his head, performed a *danse du ventre* to an accompaniment of oriental music provided by Louis Anquetin on his harmonica. René Grenier was passing the hat around when two whiskered gendarmes interrupted the performance on the grounds that it was obscene and injurious to public morals.

"Besides, you're blocking the traffic," said one of them twirling his mustache, *"Nom de Dieu,* what would happen if everybody started doing the *danse du ventre* in the street?"

It all ended amicably after voluble explanations, assurances of patriotism, much hand-waving and an invitation to a glass of wine.

After a riotous lunch at Agostina's, the students repaired to La Nouvelle, which was almost deserted at this early hour. Flushed, hoarse from shouting and in an advanced stage of intoxication from too much Chianti, they kissed Thérèse, the cross-eyed cashier, who had not been kissed since she was a baby, and straggled to their usual table where they sat in silence, not knowing what to do next.

It was then that Rachou suggested they go to a brothel.

"Nom de Dieu de nom de Dieu! We've got to celebrate," he roared, banging his fist on the marble-topped table. "Listen, I know a place not far from here where there's a lot of pretty girls. Pretty as pictures and with nothing on. What d'you say we go and have a little fun." Piously he added, "We don't have to go to bed with them. We can just have a drink."

"S'wonderful idea!" hiccuped Henri. "Let's go!"

"Well, I suppose it's all right," said Grenier. "But how much will it cost?"

"Yes, how much?" chorused Gauzi and Anquetin.

Although they were forever talking about girls and boasting of their conquests, they felt an obscure repugnance for brothel women and the red-plush salons where they plied their trade.

"Who cares about money on a day like this? I'll pay for the drinks!" bellowed Rachou, who always became extravagant when he was drunk.

This ended the argument. Noisily they trouped out of the café, piled into a fiacre.

"Cocher," cried Rachou. "To Le Perroquet Gris, rue Steinkerque."

V

The following October Henri enrolled in Professor
Cormon's class and began his second year as an art student.

Every morning he left his mother's apartment, drove to
Montmartre where the *atelier* was located, carefully climbed
out at the street corner so that his fellow students wouldn't
see him alighting from the landau or jibe at Joseph in his
cockaded hat and blue livery. Pushing himself with his short
rubber-tipped cane he would shuffle toward the frock-coated,
gesticulating students who loitered on the sidewalk, arguing
among themselves and smoking their pipes.

He would exchange a few remarks with Rachou or some
other friend and, on the stroke of nine, laboriously hoist
himself up the four flights of stairs to the studio. Panting,
he would enter the large nondescript room cluttered with
easels and already warmed up by a purring cast-iron stove. He
would hang his derby and overcoat on the rack, shuffle among
the easels toward his folding canvas stool by the model's plat-
form; then, after laying his cane at his feet, he would proceed
to load his palette while inspecting the Venus or Diana or
Leda standing on his easel, or whatever other goddess might
happen to be the week's subject.

Soon the hubbub of voices would dwindle in the room.
Schlumberger, a walrus-mustached ex-sergeant who was the
studio's *massier*, would motion to the model to disrobe and
assume the pose. And for the next three hours Henri would
be one of the thirty-odd students who squinted at the model,
tugged their beards, tilted their heads, took measurements
with their thumbs, flourished their brushes and went through
all the motions and grimaces of artistic creation.

Once a week, Professor Fernand Cormon, member of

71

the Académie des Beaux Arts, member of the jury of admission to the Salon, member of the Advisory Council of the National Museums, honorary member of numerous foreign academies, officer of the Legion of Honor, painter of vast murals for banks and municipal buildings, portraitist of dowagers and *femmes du monde,* author of innumerable and highly successful nudes, harem scenes and other *peintures de boudoir,* would visit the *atelier* and inspect his pupils' work. At the door he would graciously hand his silk hat, silver-knobbed cane and yellow gloves to Schlumberger, who also helped him out of his opulent fur-lined overcoat. Thus divested the academician would emerge, considerably reduced in height and bulk—a liverish, stoop-shouldered, skeletal, middle-aged man, dressed in a modish cutaway, spats and ascot tie.

With the tread of a cautious stork he would pick his way among the easels and begin talking in an urbane well-modulated voice, fluttering his fleshless manicured hands, stopping now and then to add a few deft brushstrokes to a pupil's canvas or make some technical remark in a tone of indulgent and faintly contemptuous bonhomie.

In the course of these weekly lectures Henri learned that prettiness was the keystone of art and the artist's mission in life to paint pretty pictures. He learned that pigment should be delicately applied to the canvas and carefully "licked" with the brush, that backgrounds should invariably be black or dark brown and the composition of a painting inexorably triangular.

But mostly he learned about the portraiture of women. "A woman's portrait!" Cormon would explain with a convolution of his spidery hands "Ah, *mes amis,* what tact, what skill, what insight it requires!" Since as a rule only mature ladies could afford to have their portraits painted, it also required much chivalry on the part of the artist and often downright charity. Fortunately most women did not know how they looked and entertained the greatest illusions of their appearance. While keenly objective about their best friends' age and approaching decrepitude, they sincerely believed that by some special dispensation they themselves looked ten—more often fifteen—years younger than they were.

"Therefore," Cormon would admonish with a ribald little chuckle, "all you have to do is discover your sitter's illusions about herself and capture them on canvas."

To this end you straightened the nose, rosebudded the mouth, widened the eyes, freshened the complexion, elongated the neck, rounded the shoulders, slendered the arms, uplifted

the bosom, narrowed the waist and omitted all wrinkles, warts, moles or blemishes of any description. You paid enormous attention to such things as brooches, rings, stomachers and diamond bracelets; imbued the picture with an air of supreme elegance, opulence and refinement; and your sitter declared herself delighted by the striking likeness you had achieved. Then you were well on your way to artistic and financial success. "Don't ever be afraid to flatter a woman too much," Cormon would conclude. "It simply cannot be done."

For all his apparent bonhomie, his "Ah, *mes amis!*" and his fluttering hands, Professor Cormon was subject to sudden and explosive angers. The feeblest attempt at originality, the slightest infraction of the rules of academic painting would send this amiable discursive skeleton into fits of sputtering, shrill-voiced rages. "You may have forgotten that I am a member of the jury of admission to the Salon, but I shan't let you forget it. I shall see that your *envoi* is barred from the Salon. This will teach you the proper respect for art and the teaching of your masters." Usually the guilty student would drop out of the *atelier* and, since the Salon was closed to him, renounce an artistic career.

Henri, well aware that his pictorial instincts were "wrong," exercised constant vigilance over them. Doggedly he filled his primary shadows with raw amber, licked every brushstroke. His diligence was so patent that even Cormon would notice it and occasionally reward him with a friendly pat on the shoulder, "Courage, Lautrec," he would say. "You have no natural talent, but you are full of good will. You obey my instructions and work hard. Courage! In time you may learn to paint reasonably well. And who knows? Some day you may actually exhibit at the Salon."

With such thrilling words he would pass to the next student, leaving Henri hunched on his stool, almost choking from happiness.

The class over, he lunched with his friends at Agostina's amidst the pandemonium of the place, the prattle of his fellow students and the heated discussions in progress at the nearby tables. He listened to innumerable imprecations against art dealers, critics and academicians hurled by vociferous members of the newly founded Société des Artistes Indépendants.

There he saw Georges Seurat, the pointillist, a placid young man with the face of a whiskered cherub and the physique of a grenadier, dreamily smoking his pipe over his demitasse; Renoir, the ascetic-looking painter of opulent

nudes; Claude Monet, square-headed, square-fingered, looking like the prosperous Norman country squire he was. Once he spied Cézanne, on one of his rare trips from Aix-en-Provence, lunching alone, churlish and suspicious.

And there one memorable day he and his friends were invited by Camille Pissarro, the snowbearded Impressionist, to have coffee with him and Degas, with whom he was lunching that day.

"So, you are art students, *hein?*" crackled the painter of ballet girls. "All promising artists, I am sure. Anxious to bestow upon the world the fruits of their genius."

Henri was too excited to notice or even hear the sarcasm of these remarks. Recently he had acquainted himself with Degas' work and conceived for the artist an admiration bordering on idolatry. Adoringly he gazed across the table at the pale, gray-bearded face seamed with crisscrossing lines of bitterness. Degas! He was having coffee with Degas!

For an instant the painter fidgeted with his cigarette, then in his clipped voice he blurted out, "Can't you see you haven't a chance? What sort of reward can art offer you? Fame? In the entire history of art there are about sixty great names. Since our century has already produced Géricault, Daumier, Manet, Ingres and Delacroix, your chances of immortality are about nil. Money? Art is the most cruel . . ."

"Please, Edgar," intervened Pissarro, "don't speak like this. You're discouraging these young men."

"I wish I could! They'd be grateful to me for the rest of their lives." He returned to the students. "Art is the most cruel of all professions. I can think of about fifty artists who earn as much as moderately successful veterinarians. The others—" he pointed a gnarled finger at them "—they starve. They too were promising artists once. Every house painter in Paris was once a promising artist . . ."

He was warming up to his subject when he was interrupted by Agostina. "Signor Degas," she said, giving him her most fetching smile.

"What do you want?" he barked over his shoulder.

"Could you use a new model? My cousin she's just arrived from Palermo—a beautiful *ragazza*."

"I don't care whether she is a pretty or not. Is she a Protestant?"

"A *protestante!*" exclaimed Agostina, taken aback. "*Madonna mia*, nobody is *protestante* in Palermo!"

"Another thing. What kind of *derrière* has she got, your cousin? Pear-shapped or apple-shaped?"

"Derrière!" gasped Agostina, disconcerted by these questions. "My cousin has a nice *derrière*, same as everybody."

"That's where you're wrong. *Derrières* are extremely individual. If your cousin has an apple-shaped *derrière*, I don't want to see her. But if she has a pear-shaped *derrière*, send her to my studio in the morning. Now leave us alone. I want to speak to these young men."

He spun back to Henri and his companions. "You too will starve." He sneered with acrid relish. "You will tramp the streets with holes in the soles of your shoes, freeze in your studios in winter, tremble at the sight of the landlord, when you could have been happy, respectable bank clerks, policemen or mail carriers."

"Please, Edgar," wailed Pissarro. "You are breaking their confidence, their faith in life."

"No danger," Degas snorted back. "Look at those fatuous faces, their truculent self-esteem. They all think they are Michelangelo. No, I won't discourage them. But life will."

He rose, took his derby from the rack. "I wish you all a good day," he said with a curt nod, and walked away, followed by Pissarro, who waved his arms in helpless apology.

"Don't pay any attention . . . It's his digestion. He's always like that after lunch . . ."

"Cheerful old bastard, Degas, isn't he?" commented Rachou, who was the first to regain his composure.

This appeared to summarize adequately the students' reaction to the interview. With a mixture of resentment and defiance, they got to their feet and shambled out of the restaurant.

As in the previous year Henri spent his afternoons in Rachou's studio, painting, singing, perfecting himself in the style and manners of an authentic Montmartre art student. Later in the afternoon he accompanied the burly Meridional to La Nouvelle, where they joined their friends.

He was now one of the boys—almost. He had received their confidences, loaned them money, paid for countless rounds of beer. He played cards with them, took some timid part in their arguments about art, smoked his first cigarettes, risked his first *"nom de Dieu"* and "I spit in your eye," and listened to their everlasting debates on *l'amour* and women—especially women.

On this last subject their loquaciousness became unquenchable. At first he had wondered whether they would some day get tired of talking about girls; now he knew they never would. Apparently the subject was myriad-faced, limitless.

The women they had had. The women they had almost had. The women they could have had. The qualities they demanded of women. The things women had taught them and the things they had taught women. The physiology of women and its practical use in *l'amour*. The art of pulverizing women's defenses and unleashing their hidden libido. How to deal with virgins. How to make women look at you with concupiscence, forget all maidenly reserve, moan and writhe with ecstasy. The cost of women. The dangers of women. Most of all, how to get women . . .

It could become quite boring, Henri thought privately. He had seen their women, and he couldn't understand what his friends could possibly see in them. Skinny, beady-eyed laundresses met in some dance hall, models who had slept in every Montmartre studio, midinettes on the brink of prostitution. Most of them weren't pretty; some not even clean. They wore homemade dresses, rabbit necklets; they sucked their soups and used cheap and violent perfumes. Yet, according to his friends, they were wonderful. They had secret charms and concealed abysms of indescribable voluptuousness. It was all rather puzzling. Personally he saw nothing in these girls, nor in any other girls for that matter.

He kept his thoughts to himself, content to enjoy the excitement of the café, the clatter of saucers, the singsong of white-aproned waiters. Think of it! Only a few years ago he was lying in bed, his legs in casts, resigned never to walk again. And now look at him! Nineteen and a popular art student, sipping beer, discoursing about Michelangelo or the Italian Primitives, listening to smutty talk about women!

It was so thrilling that it made it hard, very hard, to say good-bye at six o'clock, and drive home to the oppressive quiet of Maman's sitting room. Now if only he could persuade her to let him have a room in Montmartre . . .

"Sorry to be late again," he said one evening, as he hobbled into the dining room. "It took me forty minutes to drive down from Montmartre. The traffic was terrible."

"If you left earlier you would arrive in time for dinner. After all, your art class ends at noon, doesn't it?"

The entrance of the waitress relieved the embarrassment of the moment. Diligently he ladled some soup into his plate.

"And those fiacres are so cold," he went on, when they were alone. "One of these days I'm surely going to catch pneumonia."

She watched from across the table. Pneumonia, indeed! Oh, the thoughtless cruelty of youngsters! How readily they

used the most unfair weapons to gain their own ends! He wanted a room in Montmartre. He had been wanting it for a long time. He had resisted as much as he could, but youth wanted youth. He wanted to be with his friends, go wherever they went, feel free, grown-up. What boy didn't feel the same at his age? He wasn't selfish or callous—merely young.

"You wish to live in Montmartre, don't you?" she said quietly.

Her directness unsaddled him. He had mapped a circuitous campaign of attrition and there she was, forcing him in the open.

"Montmartre?" he echoed with feigned surprise. "I hadn't thought of it, but since you mention it, yes, it would be more convenient. For my work, you understand. I would be near the atelier, and . . ."

". . . and you could spend more time in cafés with your friends," she prompted with a rueful smile. Thank God, he had never learned to lie well! "And you could go out with them in the evening."

No use trying to be clever with Maman. She could see through you with those calm eyes of hers. "Yes, Maman, I'd like to live in Montmartre," he admitted without further pretense.

"I don't object to your living there, but I don't want you to live alone. You might fall, hurt your legs and find yourself unable to call for help."

He had anticipated her objections. "It just happens that Grenier has a two-room apartment. I told you about Grenier, didn't I? He is twenty-three and very serious. Only the other day he was asking if I knew someone who would help him share the rent."

" 'Asked me,' did you say?"

His ears turned scarlet. "Well, not exactly," he confessed. "I asked him."

A melancholy smile passed over her face. "You should never try to lie, Henri. You have no talent for it. You can tell your friend that it's all right."

The ease of his victory confounded him. Perhaps he should also ask for a studio of his own? No. She wouldn't give in easily on that point. She didn't want him to be alone. He would have to wait another year, until he started work on his Salon picture. Then she would have to give in. "Do you mean I can have a room and live in Montmartre?" he asked, still incredulous of his good fortune.

She nodded. "Yes, Henri. You can live in Montmartre."

"Thank you, Maman!" The words gushed out of him. Impulsively he rose from his chair and kissed her. "Oh, thank you! I knew you'd understand. One of the windows of the apartment opens on the courtyard, just across from Monsieur Degas' studio. Imagine being able to look into Degas' studio!"

"And who is Monsieur Degas?" she asked, unimpressed.

"Degas! Why, Maman, he's about the greatest painter alive, that's all. You should see his ballet girls, his nudes, his laundresses. Last week Rachou and I went to his exhibition at Durand-Ruel's . . ."

She did not listen. He was leaving . . . Life was taking him away. Babbling with confidence and illusions about himself, he was starting on his journey. Her hopes to keep him close to her, shield him from the world had come to naught. How lonely it would be without him in this big apartment . . .

That evening after he had gone to bed, she slipped into his room. Holding the lamp high she scanned his pitiful face. Slowly her eyes ran over the outline of his body under the blankets. How small, how very small he was! Not much bigger than the skipping, prancing schoolboy he had been. How quietly he slept! Even the occasional twinge of pain that crossed his face didn't break the peace of his slumber. No, the storm hadn't come yet. He hadn't yet been soiled by the bawdiness of Montmartre, the café talk, the sight of nude models. But time was running short. Soon his heart would awake, his senses make their demands. He would grope for feminine companionship, love. Then the truth about himself would explode in his face. And then, what would he do, O God, what would he do?

"Get up, Grenier! Time to get up!"

A sleepy whine came from the adjoining room. *"Merde alors,* do you have to shout? What time is it?"

"Time to get up! Almost eight." Much splashing of water in the tin basin mingled with joyous aquatic little grunts. "We'll be late at Cormon's! Get up."

"Go to hell, and stop playing the seal in that basin! I don't know why I rented you that room!"

It was the same every morning, and it too was part of the Montmartre rapture, the daily enchantment at awakening in this small room with its narrow brass bed, its white-pine wardrobe and dilapidated washbasin; at being free, adult, and liberated from Annette's solicitude, Joseph's watchfulness and Maman's knowing eyes.

He too now lived in Montmartre in an old decrepit house,

like Rachou and the others; he no longer was a mama's boy, an amateur. This time he *really* was one of the boys. He breakfasted with Grenier in a bistro and walked with him to the *atelier*. No longer did he need to stop the landau at the street corner to avoid the jibes of his fellow students; no longer did he need to tear away from the café discussions and drive to the stifling quiet of the Boulevard Malesherbes apartment. Life had become wonderful. He could spend his evenings with his friends, go with them to those thrilling, malodorous *cafés chantants*. Or that exciting Cirque Fernando, where you ate oranges from Spain while watching acrobats and trapeze artists and tutued bareback riders, trained poodles and clowns. Or Le Mirliton, a dank basement acrid with pipe smoke and the stench of stale beer, where you could make all the noise you wanted, join in the chorus of patriotic songs and listen to Aristide Bruant.

But best of all he now could go to L'Ely.

L'Elysée-Montmartre, "L'Ely" as everyone called it, was an old and shabby dance hall, cheap, noisy and gay. Like the fountain on Place Pigalle where artists' models gathered, and the derelict windmills that still stretched out their motionless vanes, it had always been there—a relic of olden times when Montmartre was a distant and rustic hamlet and a haven for the cutthroats, ruffians and prostitutes of the capital who appreciated its isolation and absence of police.

For more than a century, L'Ely had been a strictly local institution, depending solely on the district for patronage and having no truck with the outside world. Successive generations of Montmartre grisettes had come there to dance, frolic and drink *vin chaud,* the hot sugared wine that was served in chipped bowls by shirtsleeved waiters. Their laughter and the rustle of their hooped skirts still echoed faintly under the ancient beamed ceiling. Enlaced initials and stabbed hearts in the oak of the tables had grown smooth and black with age and told of long-ago idylls. The place was full of ghosts, but they were friendly, forgiving ghosts.

To the young laundresses, seamstresses, models, and midinettes who frequented the establishment, L'Ely was more than a place of amusement; it was the enchanted palace of romance and music, where for a few sous they could forget the squalor of their lives and dance away the confused yearnings of their hearts. They felt at home there, and sincerely believed they could indulge in whatever deviltry they chose on the grounds that what they did at L'Ely was strictly *en famille* and nobody's business. Père la Pudeur, a timorous pink-skulled

old man had the impossible duty of maintaining a semblance
of propriety—be it ever so slight—in the place.

At L'Ely Henri drank *vin chaud,* made furtive little sketches,
and watched his friends cavort about the dance floor, waving
to them whenever he caught their eyes to show them that he,
too, was having a good time. Occasionally Père la Pudeur
stopped at his table and, while sipping his hot wine, told
him his troubles. "These Montmartre girls, monsieur, they
have the morals of alley cats! Because their mothers and
grandmothers have come here and made love under the tables,
they think they own the place and can do anything they want.
The things that go on in the corners and in the lavatories,
I tell you, monsieur, they make your hair stand up on your
head! And it's getting worse. Since that *cochon* of a Dufour—"
he would point an accusing finger in the direction of the
orchestra conductor "—has written his miserable cancan,
things have gone entirely out of hand. The girls go crazy when
they hear the music. Their little brains go pftt! . . . Do you
know what they do? They sneak out to the lavatories and take
off their bloomers; that's what they do. And so when they
kick—and you know how high some of them can kick—well,
you see everything they've got. Horrible! Believe me, a whole
regiment of angels with flaming swords couldn't keep order
in this place!"

At L'Ely Henri met La Goulue who often danced with
Rachou and performed with him the extraordinary routines
the husky Meridional improvised on the dance floor. She
was a blonde, eighteen-year-old laundress. Broad-faced and
stocky, she wore her hair twisted into a high chignon that
stuck up like an enormous thumb on the top of her head.
Her conversation consisted mostly of bursts of laughter,
rowdy gestures and salacious remarks delivered in a loud
and simon-pure Montmartre gutter slang. But as a cancan
dancer, La Goulue had no equal. She possessed a unique sense
of rhythm, and innate obscenity of motion that set her apart
from the other *cancanières.* To Henri she was fascinating,
the prototype of these Montmartre laundresses, who after
ten hours of backbreaking toil at the tubs, paid their hard-
earned money to come to L'Ely and engage in several additional
hours of prancing, hopping and gamboling, only to end the
evening with the cancan, the most strenuous, exhausting form
of dancing ever invented.

Between dances Henri's friends returned to their table.
Mopping their faces, they sat down, lit their pipes, gulped
their hot wine, talked, flirted, kissed their partners who let

out ticklish spurts of laughter and uttered feeble and insincere protests. Knees brushed knees, and hands wandered under the table. There were half-hearted reprimands, "Don't do that, chéri. Not here . . ." At the opening bars of the next number they flocked back to the dance floor, soon to lose themselves into the whirling crowd.

Alone, Henri killed time by watching the dancers as they passed by his table. In the flickering half-light provided by inadequate gasoliers, the ancient dance hall assumed an amber-hued dimness through which enlaced couples appeared, whirled by and vanished like figures in a dream. The men—mostly young apaches, petty thieves and apprentice pimps—danced with great rigidity and the impassiveness which was the fashion of the moment, their cigarettes slanting down from their thin lips, proud of their jerseys, their spitcurls, their caps set at a rakish angle on their pomaded hair. But the girls pressed themselves against their partners and clung to them, their eyes closed, their lips parted, abandoning themselves to the rapture of their moving embrace.

It was also at L'Ely that Henri met and struck an acquaintance with a fabulously tall and thin middle-aged man. He measured almost eight feet from the crown of his top hat to the tip of his patent-leather shoes. His name was Jean Renaudin, but people knew him in Montmartre by the nickname of Valentin-the-Boneless. He was a well-to-do bachelor, a soft-spoken, kindly recluse who had the misfortune to look startlingly like a corpse. His consuming passion was dancing. Shortly before midnight he would leave his home, hurry through dark and deserted streets and come to L'Ely, where he danced the cancan—generally with La Goulue—and swiftly disappear.

For Henri the hours passed without ennui. To him it was thrilling just to be there in that crowded and noisy dance hall, watch the dancers, sketch, sip his wine and laugh at his friends' jokes. Promptly on the stroke of midnight there was a crash of cymbals, followed by a long rolling of drums. The cancan!

Instantly, from every table spectators rushed to the dance floor and circled around each pair of performers who stood, facing each other, tense, holding their breaths: the girls gripping their skirts; the men holding their hands raised ready to clap. The orchestra burst into a furious galop, and instantly, like wound-up toys, the dancers jerked into motion. The girls skipped, pranced, rustled and tossed up their petticoats, while the men stepped back and forth, clapped their hands, slapped their thighs, squatted, rose, contorted themselves in obscene

or eccentric poses and spurred their partners with yells of encouragement. Eyes flashing, hair undone, La Goulue was a human whirlwind; she flung her skirts above her head, kicked her black-stockinged legs and twisted her body as though she wanted to shake off her blouse. Sweat streaked her face; her breasts pointed rigid under her clinging blouse; muscles bulged in the whiteness of her thighs. On the bunting-draped platform Dufour was convulsively goading his men into more and more noise, more and more speed. A collective madness took possession of the dancers, spectators and musicians alike and descended upon the old dance floor which seemed to rock on its foundations. The air crackled with the clapping of hands, the clicking of heels, the yells of the male partners, and lewd remarks of the spectators, the mounting fracas of brass.

Faster and faster the dancers went on with their gyrations and pirouettes until they became leaping, twirling symbols of unleashed motion and lust. The men flapped their sides with their elbows, knocked their knees, shut and spread open their thighs in accordionlike gestures, while the girls, hysterical, disheveled, their mouths twisted, their eyes closed or glassily open, skipped and hopped on one foot, holding the other by the ankle over their heads in a vertical split that exposed their most intimate parts; and at last, in a final explosion of cymbals, plunged to the floor as if slit up in the middle by a knife, their legs spread, their bodies limp, their heads bowed, like broken marionettes.

At the *atelier* Henri "licked" with devotion, kept in check his "wrong" pictorial instincts and dutifully laughed at Cormon's sallies. He often drove to Boulevard Malesherbes and told his mother about his artistic progress, the small incidents of his life, and how, on his last tour of inspection, Cormon had complimented him for the nice handling of chromatic balance in a Reclining Venus. He told her about his trips to galleries with Rachou, and how at Boussod and Valadon's he had met Théo Van Gogh, the manager, a nice Dutchman with a red pointed beard. He tried to make her share his enthusiasm for Degas and his growing love of Montmartre. He described the charm of the crooked, winding alleys, the early-morning animation of rue Fontaine when he and Grenier went to the bistro for their breakfast, the saggy old houses, the sudsy-armed laundresses, the street vendors, the acrobats in soiled pink tights who laid their little carpets on the sidewalk . . . But these things were difficult to put into words. Montmartre was a state of mind and a way of life. Maman

didn't understand. They were living worlds apart, a few minutes away.

He listened to more of his friends' confidences and discreetly helped them through emergencies. Gauzi discovered another *femme parfaite* who left him three weeks later, pinning a farewell note to the pillow of their *lit d'amour*. For a month he went about bitterly denouncing love, accusing the whole female sex of perfidy and swearing off women. Anquetin lost another mistress to the Louvre—this time in the Room of the Italian Primitives, and Grenier had a brief and violent affair with a neighborhood lorette. Henri slept soundly despite the squeaks of mattress and confused noises that came from the adjoining room.

Rachou lured several unsuspecting midinettes to his studio with gratifying results. In the everlasting pursuit of *l'amour* he had developed an individual strategy of lightning warfare. His weapon was surprise; his bait, sympathy; his hunting field, the street. Hat in hand, an innocuous grin on his hairy face, he would approach his prey. "Pardon, mademoiselle. As a rule I don't speak to young ladies in the street but I simply couldn't restrain myself. You see I am an artist, about to start on my *envoi* to the Salon—a madonna—and when I saw your exquisite profile, the irresistible loveliness of your face . . ." Nine times out of ten it worked. The girl consented to pose for the hypothetical madonna and followed Rachou to his studio. There the aphrodisiac panorama of the cemetery, the mandolin and the bottle of calvados under the bed were waiting. These ephemeral romances sufficed for his needs and kept him in high spirits.

Shortly after mid-term a new student enrolled at Cormon's and joined the small group of Henri's friends. Paul Lucas was extraordinarily handsome, lazy and level-headed, except for sudden and unaccountable impulses. On an impulse he had decided to become an artist and come to Paris from his native Normandy, leaving behind his well-to-do and distracted family. His artistic aspirations had died when he was still in the train and he had enrolled in the *atelier* merely to justify his presence in Montmartre to his father, a pious country banker who mailed him each month a starvation allowance along with his malediction.

Toward women Lucas experienced similar impulses, which to his chagrin were invariably crowned with rapid and complete success. In no time his dingy room on rue des Abbesses had grown fragrant with the combined perfume of various midinettes, lorettes and young laundresses who visited there. The

ease of these conquests filled him with dismay, for his interest in women was purely sportive and lasted just as long as the difficulties he encountered in their pursuit. He never was happier than when the object of his affections remained out of reach. Victory brought him weariness. His impulse withered with the laurels of triumph.

Thus the winter dragged to an end. The icy February winds were succeeded by the usual March deluges that turned the Seine into a muddy torrent. In the streets and on the roofs the last patches of snow melted and, like sluggish watery snakes, crawled down the drains. April came, bringing a new softness to the air, a pale green fuzziness to the chestnuts along the Boulevard Clichy, white billowy clouds, and teasing showers that sent people scurrying for shelter under the awnings of cafés.

And then it was spring. Little blades of grass sprouted between the cobbles of the Montmartre streets. Laundresses sang at their tubs, and gendarmes strolled, their thumbs in their belts, benign smiles under their handlebar mustaches. For Henri, Montmartre was never so lovely as in the spring. He felt ebulliently happy, hummed to himself and watched Degas from the window of his little room. In the lengthening twilight he loitered with his friends at the terrace of La Nouvelle, sipping his beer, prattling about art, banging his fist and saying "*merde*" and "*nom de Dieu*," like the accomplished art student he now was.

And so, in an atmosphere of unclouded delight his second *atelier* year came to an end.

Malromé seemed very quiet after the excitement of Montmartre. Of course it was nice being with Maman again, teasing "Tante" Armandine again, taking afternoon drives in the blue victoria and playing checkers with Abbé Soulac. But nothing like the lunches at Agostina's, the arguments at La Nouvelle and the bowls of *vin chaud* at L'Ely.

One evening toward the end of September, he said to his mother, "Next year is going to be my last at Cormon's and I'm going to have to do my *envoi* to the Salon. I'm going to need a studio of my own, Maman."

She didn't protest and kept her eyes lowered on her knitting. "I understand," she said. "When we return to Paris you may look for a studio."

VI

Twenty-one rue Caulaincourt was a four-story house
with green shutters and gracious iron balconies. Over it hung
the mournful air of noble experiments which not only have
failed, but should never have been attempted.

Built shortly after the Franco-Prussian war by a certain
Monsieur Levallier, a well-meaning Parisian capitalist, it was
to be the first unit of a vast housing project intended to provide
dignified and pleasant apartments to fastidious and respectable
families of means. At first the tenants had been delighted
with the Montmartre country-fresh air, the houses' luxurious
appointments, a gas jet on every landing, a toilet on every
floor, two apartments with private bathrooms—as well as
the refinement and graciousness of its concierge, Madame
Micheline Loubet.

It wasn't long, however, before they discovered the malignant
quality of Montmartre's moral atmosphere. At night they
had to fight their way through swarms of streetwalkers who
brazenly slipped their arms through theirs, promised them rare
and violent pleasures their wives couldn't possibly provide.
Some of these gentlemen reached home; others didn't. Bitter
family quarrels ensued. Wiping her eyes with the corner
of her apron, Madame Loubet saw them depart one by one—
sometimes in groups.

For several months the house had stood empty. Monsieur
Levallier's heirs—the capitalist had mercifully died before
the collapse of the venture—had instructed Madame Loubet
to lower the moral requirements of tenancy to such a point
that anyone, anyone at all willing to pay rent, would be accept-
able. Thus, when a few days later a Montmartre hooplala in

a feather boa and net stockings had hipped her way into her lodge and inquired about the second-floor rear, Madame Loubet had no choice but to take her dirty money.

Then an artist, a redheaded giant of a man, had moved in on the fourth floor. At once he had gone to work. First he had knocked down the partition between the two front rooms, merging them into an enormous studio. He had swept the debris onto the landing and left it there. Then he had opened a large window in the wall. People in the street were hit by bits of flying masonry. When they shook their fists at the artist, he spat down at them. Madame Loubet had had to intervene. Several times she knocked on the door. When finally it was opened she had a full-length, unrestricted view of the sweating artist, entirely naked, hammer in hand and plaster in his beard. *"Magnifique, n'est-ce pas?"* he roared. "Now I can paint! Now I have a studio!" He had begun to saw large holes in the door, for better ventilation, when he was forcibly removed by the gendarmes.

Since then Monsieur Levallier's house had been occupied by a motley, disreputable, strictly Montmartre tenancy. Paint had vanished from its walls. Then flakes dropped from the ceilings. Cockroaches overran the corridors. With a sigh Madame Loubet had discarded her trim alpaca dress and her whalebone corset. She had learned to close her eyes and take tenants as they came, expecting the worst and usually getting it. She spent her days in her lodge, reading the newspaper, nursing the geranium plant which she set on her window sill at the first sniff of spring, conversing at length with Mimi, a yellow alley cat that was her sole friend and confidante. She had grown fat and saggy-jowled, and lived her blameless and lonely life amidst the ambient sinfulness of Montmartre.

On this dawn of October, 1885, she stood by her kitchen window, sipping her *café au lait* and watching another dismal and rainy day emerge from the womb of the expiring night. And such an ugly sickly-looking baby she thought it was that, so far as she was concerned, it could go straight back where it came from.

"What a place this Montmartre!" she sighed with a shake of her pendulous jowls. "What a place!"

For a while she remained motionless, her cup in mid-air, gazing at the rain-streaked windowpanes—a tubby moon-faced woman in a voluminous brown skirt and maroon shawl, her gray hair twisted in an egg-sized chignon on the top of her head, and in her eyes the longing, bewildered look of country people who have been forced to live in the city.

Outside rain drummed monotonously against the slate mansard roofs, trickled down the front of the dilapidated houses in forlorn, grimy tears, dripped from eaves, gurgled from drainpipes and crawled between the shiny cobblestones, where it collected here and there in watery jagged-edged mirrors. In Montmartre rain had a dreariness all its own, more pungent than anywhere else in Paris. It was liquid desolation, wretchedness turned to water.

She raised her cup to suck a last drop of coffee, and with a final resentful glance waddled to an overstuffed chair by the window, where she spent most of her time and from where she could see what went on in the street. With a grunt she plumped herself down, tucked her skirt around her knees, fussed with the cushion at her back, snatched her steel-rimmed spectacles from the table at her side and with a sort of restrained violence rustled the newspaper open.

Like all Parisian concierges she was an avid and discriminating newspaper reader. This morning she swept rapidly over an earthquake in Japan, a massacre in India, a revolution in Peru, another Balkan war, and went on to more interesting things. She read the first paragraph of an article about that Grande Exposition Universelle they were going to have in '89, four years hence, and for which they were going to build a tremendous iron tower right in the middle of Paris.

Iron tower, indeed! With an impatient shrug she turned the page and launched into the *mondanités*. Usually they brought her visions of palatial drawing rooms or palm-filled conservatories in which incredibly refined *femmes du monde* in trailing taffeta gowns and elbow-length gloves waltzed rapturously or simply meandered in exquisite idleness.

But this morning the *mondanités* had no flavor. She crumpled the paper on her knees and from her apron pocket pulled her rosary. As her lips began muttering the *ave marias,* her thoughts drifted despondently, then expired. Her head drooped, her chin came to rest on her maroon woolen shawl. She fell asleep.

When she awoke, the rain had stopped. Beads of water still dripped from the eaves, but there were great patches of blue in the sky. She was about to resume her prayer when she heard the rumble of an approaching carriage. Parting the curtains she peered out into the street and and saw a blackbearded gentleman in a derby and overcoat climb down from the fiacre with the help of a short rubber-tipped cane.

"Look, Mimi, a midget," she gasped, staring at the approaching visitor. She rose to open the door of her lodge. "Yes, monsieur," she said noncommittally.

Politely the stranger removed his flat-brimmed derby and she noticed his hair was short and neatly combed to one side.

"Would it be convenient to show me the studio apartment advertised on the sign outside?" he said.

"Certainly, monsieur." There he was, all four feet of him, polite as they came, looking up smilingly at her from behind his pince-nez. "But it's on the fourth floor," she added regretfully, glancing down at his legs. "And the steps are pretty steep."

"They do look steep, don't they?" he replied, glancing at the stairs at the end of the hallway. "May I see it just the same?"

She flung him a dubious glance, clutched her skirt in her two hands and began climbing. He followed her, gripping the banister with one hand, pushing himself up with his cane, doggedly forcing his legs to lift the disproportionate weight of his upper body.

He was panting when they reached the fourth floor. Beads of perspiration glistened on his cheeks.

"You are right!" he gasped, trying to smile. "They *are* steep!" From his pocket he pulled a handkerchief and dabbed his face. "Like climbing the Alps, isn't it?" he grinned.

He had beautiful teeth, she observed, and unusually large brown eyes, curiously boyish. For the first time he looked very young, despite his beard.

"Is monsieur an artist?" she asked, suspiciously.

"No. Not yet. Only an art student." His thick scarlet lips remained parted in a smile. "I've just begun my third year at Professor Cormon's *atelier* and I'm about to start work on my Salon picture. That's why I need a studio."

She looked down at him undecidedly. *Mon Dieu,* another artist in the house! Still, perhaps he'd be different? He looked so young and small, and he was so polite. And he had such nice eyes. Perhaps he wouldn't make any trouble.

She turned the key and pushed the door open.

"O-o-o-o-o-oh!" He uttered the exclamation in a long exhalation of delight. "A real studio!"

For a few seconds he stood on the threshold, open-mouthed, admiring the enormous empty room, with its pale-gray walls, its potbellied stove in the center, its huge, ceiling-high window.

Eagerly he hobbled across the room and gazed at the panorama of jagged roofs and chimney pots.

"What a beautiful view!" he said over his shoulder. "On clear days one must be able to see Notre Dame."

He turned and glanced at a flight of straight narrow stairs that led to an iron-railed balcony. "May I look upstairs?"

"The bedroom's on the left," she directed, as he levered himself up the stairs.

From below she watched him peer casually into the small wallpapered room, heard him say, "Nice, very nice!"

He pushed open another door and let out a cry of surprise. "*Mon Dieu,* a bath!"

"Yes, monsieur. This house was built for nice, rich people. Not the riffraff they've got here in Montmartre! But I must tell you the toilet doesn't work. The artist used to throw plaster in it. Imagine doing a thing like that! But there is a nice toilet at the end of the corridor and you can use it until I get this one fixed. The bathtub doesn't work either, but if monsieur likes to take baths," her tone implied that nice people did not, "I could have it fixed, too."

"No hurry, no hurry," he replied airily, as he descended the balcony stairs. "I won't be living here anyway. I'll just come here to work. I share an apartment on rue Fontaine with a friend."

Instantly her suspicions returned. Two apartments indeed! Nobody had two apartments . . .

The journey downward was silent and laborious. Anxiously she watched him negotiate each stair with the help of his short cane. Surely one of these days he would stumble and break his neck . . .

"I'll take it," he said, as soon as they reached the lodge.

"Are you sure you want it?" she asked, unable to conceal her apprehensions. "Those steps are pretty steep."

"Oh, it's all right," he said with a casual wave. "I am used to stairs. The *atelier* is also on the fourth floor and the stairs are almost as bad as those. It's good exercise. How much is the rent?"

"For a year?"

He nodded.

"Four hundred and twenty francs," she said, bracing herself for the usual protest and bout of haggling.

"That's all right. When can I move in?"

Her shock at his immediate acceptance was such that she shooed Mimi off the chair and motioned him to sit down.

"Any time. But first I must write your name down in my book." She started rummaging for her ledger. When she found it, she sat down at the table, adjusted her spectacles and turned to him.

"Now, first your name," she said briskly, holding her pen slanted over the page. "It's for the police, you understand. They want to know everything."

"Naturally. Toulouse. Henri de Toulouse . . ."

"I didn't ask where you were born. I just want your name."

"I understand. But Toulouse is my name."

She laid down her pen. "Toulouse isn't a name, monsieur. It's a town." Her voice was patient but edgy. "People don't go about calling themselves Paris or Marseilles, do they? Well, then, give me your name." She picked up the pen and waited.

"I told you—Toulouse," he protested. "I can't help it if . . ."

"I see Monsieur likes to make fun," she said through tight lips. "I don't care if Monsieur calls himself Napoleon or Jeanne d'Arc, but the police won't like it." Her fingers tightened on the pen. "Now give me your name, where you were born, what year—everything."

Slowly he began dictating, "Henri Marie Raymond de Toulouse-Lautrec-Monfa. Born in Albi, November 24, 1864 . . ."

That day, as usual, Madame Loubet prepared and ate her solitary lunch, conversed with Mimi, swept the stairs, reminded several tenants of their rents, stepped on cockroaches, and toward the end of the afternoon lit the kerosene lamp and returned to her overstuffed chair to read the newspaper.

It was then that for the second time that day she heard the sound of an approaching carriage. Again she parted the window and squinted down the darkening street. Her eyes rounded in wonder. Why, this was no ordinary fiacre! Fiacre *cochers* didn't wear cockaded hats, white breeches and boots. Why, this was a private landau! Now who in the world . . .

With excitement she watched the closed carriage stop before the house and the liveried coachman climb down from his seat to open the door.

A slender gray-haired lady stepped out, said a few words to the coachman, glanced up inquisitively at the house and walked into the hallway.

"Yes, madame?" said Madame Loubet courteously, recognizing a lady when she saw one. "*A votre service*, madame."

"May I have a word with you?" said the visitor in a low voice.

In one glance Madame Loubet took in the pale, distinguished face behind the black tracery of the veil; the simple black dress, the short sable cape; the muff, also of sable. She waved the stranger to her armchair, insisted on tucking the cushion at her back. Then she sat down and waited, her hands on her lap.

"My son told me he rented an apartment this morning . . ."

"Your son!" Madame Loubet let out a gasp. "You mean—the midget . . ." The words were out before she could clamp her hand over her mouth. "Forgive me, madame," she mumbled. "I didn't mean . . ."

The lady's lips had blanched, for a moment her face closed in an expression of absolute sorrow. "Yes," she said at last, "he is my son. He broke his legs when he was a child . . ."

In the lamplit stillness of the lodge she spoke about Henri. The mysterious illness, the broken legs, the useless operations, the *attaques*. Now and then Madame Loubet let out a moan of sympathy. Social barriers between them had vanished.

"That's why I came to see you," the visitor concluded. "Please, watch over him, won't you? If anything happens, if he hurts his legs, please let me know at once."

"Don't worry, madame," said Madame Loubet, now crying freely and blowing her nose into her vast handkerchief. "I'll keep an eye on him, like he was my own son. I'll see that the studio is always nice and warm when he comes, and he puts his overcoat on when it's cold and everything. And I won't tell him you came. I know how they are at that age."

As she was escorting Henri's mother through the hallway, she asked, "Before you go, would you mind telling me his real name? He said it was Toulouse, but I know he was joking. We had words about it."

"It is Toulouse. His father is Comte Alphonse de Toulouse-Lautrec."

"A count! Then—he, too, is a count?"

"Yes," said the visitor wearily. "But he doesn't use his title. Anyway these things mean so little."

For a moment they stood side by side in the doorway.

"Thank you, Madame Loubet," said the countess, holding out her hand.

Madame Loubet watched the landau disappear down the street. Night had come. Here and there windows glowed yellow in the misty darkness. Far away a train leaving the Gare du Nord howled like a wounded beast. The sadness of great cities hung over Paris.

A few days later the population of rue Caulaincourt was startled by the sight of an unusual funeral procession.

The hearse, drawn by a scrawny and panting mare, was piled high with wicker furniture, three easels, a drawing-table, a tall ladder, and a heap of miscellaneous objects, among which a life-size plaster cast of Venus de Milo that jutted out of the coach like a corpse struggling back to life. On the driver's

seat a whorly-bearded young giant cracked his whip and sang an *atelier* song, interrupting himself now and then to remove his long-stemmed pipe and exchange Montmartre jocularities with the laundresses and puffy-eyed bawds at the windows.

Behind the carriage came four untidy and gesticulating young men in shabby frock coats and flapping lavallière ties whom Madame Loubet recognized unhesitantly from her lodge window as *artistes-peintres*. She spied her new tenant puffing in their wake, hurrying as best he could.

When they reached the house the students gathered around the carriage and began unfastening the ropes that held the furniture, while Henri shuffled into the lodge.

"Bonjour, Madame Loubet," he gasped, removing his derby and trying to catch his breath. "I couldn't get professional movers, and my friends offered to help. Don't worry, we'll be very quiet and careful."

A moment later the house was resounding with tramping feet, *atelier* songs and profanity. Indian-file, the young men staggered up the stairs, carrying furniture on their backs, scraping walls, bumping against the banister, calling to one another between floors and creating an astonishing amount of noise and confusion.

In the studio, Henri, shirt-sleeved and perspiring, was limping agitatedly about the huge room, directing the proceedings and offering his eager but futile services.

"Eh, Lautrec," asked Lucas from the doorway, a bundle of canvases under each arm. "Where do you want this junk?"

"Anywhere . . . There, in the corner. Be careful. One of them isn't dry yet."

Lucas dumped the paintings and turned to examine the room.

"That's what I call a studio! If only my old skinflint of a father would let me have one like that!"

"You can come and work with me if you like."

The mere suggestion of work was distasteful to Lucas, who hurried out of the room just as Rachou staggered in, bent double under a heavy drawing-table.

"Merde alors!" he grumbled, easing the table to the floor and straightening himself up. "Did you have to pick a studio on the fourth floor? Why didn't you move on top of the Colonne Vendôme while you were at it, or do you just enjoy climbing stairs?"

Still blowing out his cheeks he trudged to the couch that had already been set under the window and sat down. For a moment he looked about, his powerful hands cupped over

his knees. "Fine place," he nodded approvingly. "North light and everything."

"You really like it?" Henri came to sit next to him. He would have liked to take his friend's hand but remembered that student etiquette forbade any emotional display. "Thanks for getting the hearse."

Rachou dismissed the matter with a shrug, proceeded with his inspection of the room and struggled to his feet with a groan. "I'd better be moving. Still plenty of stuff to bring up."

As he was crossing the doorway a clamor of quarreling voices arose from the stairs. Henri hastened to the landing. "Please don't make such a racket!" he shouted, leaning his head over the railing.

"That foetus of a Gauzi insulted a girl I used to know," Anquetin shouted from two floors below. "He said she was an old hag."

"All I said," Gauzi replied from behind an easel he was carrying, "is that all concierges are old hags and his girl friend was a concierge."

"Yes, she was," Anquetin tried to explain, "but she was beautiful. I used to go down to her lodge when her husband was out delivering coal." He rested the three-paneled screen he was hoisting up the stairs and leaned over the banister for a glimpse of his antagonist below. "Come up here," he challenged, "come up here if you dare and I'll show you if Emilie was an old hag. You, wall-eyed baboon, you've never slept with a girl like her. You should've seen her breasts! They were —they were like marble!"

Gauzi's snort resounded throughout the building. Only a week before he had found another farewell note, this time pinned at the tail of his freshly laundered shirt, and he was in a somber, misogynistic mood. "Your Emilie, she was like the rest of them! An old crone with a wrinkled belly and breasts down to her navel!"

"Down to her knees!" cried Lucas.

"She sat on them!" offered Grenier from under a wicker armchair he was bringing up on his head.

"She stepped on them!" boomed Rachou, descending the stairs.

Now they were all laughing, filling the stairway with their rollicking Gallic mirth. In the corridor doors opened. Tenants peered out, joined in the hilarity.

"For God's sake, shut up!" pleaded Henri from the top floor. "Madame Loubet might hear you."

She did and her heart went out to him for trying to spare her womanly feelings. Artists were indeed an uncouth and noisy lot, but *he* was different . . .

Gauzi and Anquetin were still arguing when they reached the studio.

"I tell you Emilie was really beautiful," said Anquetin, in an effort at conciliation. "And so passionate! You've no idea the things she made me do." He propped the screen against the wall and wiped the sweat from his forehead with his sleeve. "For instance . . ."

"I know," sneered Gauzi. "She squirmed and wiggled her buttocks, dug her nails in your back and bit you in the neck and said you were killing her. Talk, *mon vieux*, just talk. Women are frigid. They can't help it. Physiologically they're built like fish."

Slowly the moving was coming to an end. One after another the boys shambled into the studio, dumped their loads, sprawled on the floor or slumped on the couch, puffing, staring vacantly at nothing.

"This is the last thing," panted Rachou, clutching the plaster cast of the Venus de Milo in his arms. "She weighs a ton, that woman. But, *mes amis,* what a *derrière,* what a gluteus maximus! I've been studying it while I was carrying her up, and let me tell you . . ."

"I want to thank you all," began Henri, "for helping . . ."

"I'm thirsty!" broke in Grenier.

"The hearse is downstairs," offered Rachou. "I can drop you at La Nouvelle on my way back to the cemetery."

The suggestion was accepted with alacrity. The young men got to their feet, shoved their hats on their heads.

"You go ahead," said Henri. "I'll join you later."

Their clumping footsteps resounded in the stairway. Then the sound of their voices faded out. The topsy-turvy room was silent. Henri sat down on the edge of the couch, smilingly ran his eyes over the canvases hanging dizzily on the walls, the chairs piled on top of one another, the easels, the ladder, the Venus de Milo in the corner.

His studio! At last he had a studio of his own . . . He was going to be happy here. He could feel it. This was the starting point of his career. Even when he became a famous portraitist, he would never forget this huge room with its potbellied stove, its big window, the balcony with its bedroom and bath. . . .

Still smiling, he rose from the couch, put on his derby

and overcoat, gave a last happy glance at the room, and hobbled out, gently shutting the door behind him.

He noticed that the gas jets on the landings had been lit. Nice woman, Madame Loubet. Thoughtful of her to turn on the lights, so that he wouldn't break his neck down those stairs. Yes, he was going to be very happy here. . . .

La Nouvelle was crowded and stifling with smoke when Henri pushed open the door and made his way to his friends' usual table at the end of the room. His arrival failed to interrupt the debate in progress between Gauzi and Anquetin. The two were still glaring at each other over their beer, spitting insults and blowing smoke from their long-stemmed pipes into each other's faces.

Henri sat down on the leather banquette next to Rachou, polished the glasses of his pince-nez, ordered a beer and glanced about the room. It was *l'heure de l'apéritif,* sacred to artists. White-aproned waiters rushed between the tables, their round trays balanced perilously on their fingertips. Outside, on Place Pigalle, the evening traffic made a roar like angry surf that crashed into the café whenever the door was opened, drowning for an instant the conversations and the clatter of saucers against the marble-topped tables. Here and there other art students argued about art and women, raked their fingers through their hair, while others played cards in cagy silence, holding their hands close to their chests, gambling for the evening's drinks. Middle-aged bohemians in paint-spattered trousers and black capes rested from the day's labor by reading the newspaper over their absinthe, or they huddled in small groups to denounce the cruelty of art dealers, the heartlessness of critics and the abysmal stupidity of the public which declined to buy their beautiful paintings.

By six o'clock Henri's friends had copiously insulted one another, expressed their views on Veronese or Goya or Delacroix and the science of making women your slaves and bringing out the worst in them. They had drunk several rounds of beer, smoked a great deal of acrid tobacco and were beginning to feel a little tired.

It was then that Lucas announced he had a rendezvous with Julie. "She works at Le Chapeau Fleuri, one of those chichi modistes where a hat costs fifty francs. She's very pretty, but she won't give in. I tried to kiss her and you know what she did? She slapped me." His sporting instinct was aroused. The possibility of defeat brightened his eyes. "I've got a

tremendous impulse for that girl," he added, pushing back his chair.

"Poor girl!" sighed Grenier. "If you treat her like the others, she'd better jump in the Seine right now."

Calmly Lucas paid the waiter and pocketed the change. "What do you want me to do? Fall in love? Women are fun only if you don't fall in love with them. If you do, you're cooked. They turn nasty and start looking around for someone to abuse them. It's their nature. They like being frustrated in love. If they have an unhappy affair, they think and talk about it all their lives. If you're nice to them, they forget you in a week." With a casual wave he bade them good-night. "See you tomorrow at Cormon's."

There was a silence. Lucas' departure had broken the spell.

"Disgusting the way women throw themselves at him," remarked Gauzi enviously.

Someone suggested going to Agostina's, then to L'Ely. The suggestion was considered for a moment and finally discarded.

"Not tonight," said Rachou. "I'm tired. That damn Venus de Milo weighed a ton."

Grenier left, followed a moment later by Gauzi and Anquetin, who departed together. For another hour Henri and Rachou remained alone at the table in comfortable silence.

"How about going and getting something to eat?" proposed Rachou suddenly, knocking his pipe on the edge of the table. "I'm hungry."

It was past dinnertime when they reached the restaurant. Le Tambourin was deserted except for an elderly goateed gentleman who was munching an apple while reading a newspaper propped against a bottle of Chianti and a blonde sharp-faced streetwalker who was wolfing down her soup. A pleasant stuffiness mingled with the aroma of cooking. From behind the portiere came the muted clatter of dishwashing and the sound of a woman's voice humming an Italian *ritornella*.

The two students had just taken their seats when the song broke off and Agostina rushed to them. *"Madonna mia!* Why are you so late? I said to myself, 'Perhaps the *bambini* have found a better place than Agostina's.' "

She was angling for compliments and they assured her that nothing could lure them away from her cooking. Modestly she conceded that Le Tambourin might not be the finest restaurant in the world, but it was immeasurably superior to those chichi Parisian restaurants they made so much fuss about.

"Do you know where they have the best cooking in the world! Palermo! The meals they give you there! For one lira you can eat and drink like a pig. Such wine, such spaghetti! Fit for an angel. Ah, Palermo!" Her lyricism grew as memories dimmed her beautiful eyes. "The sun shines all the time in Palermo. And the sky is blue—like the Madonna's mantle. And the air is like perfume. . . ."

The praises of Palermo having been fully sung, she went to the kitchen, returning almost at once with two soup plates of minestrone.

Leisurely the two friends ate their dinner. After a while the apple-munching gentleman left, his newspaper tucked under his arm. At her table the lorette was now smoking a cigarette, gazing unseeingly at her reflection in the plate-glass window. From his seat, Henri watched the slow motions of her hand, the indolent pucker of her lips, the delicate flaring of her nostrils as smoke streamed through them. Gaslight softened her features and flecked her hair with gold.

"Have you chosen a subject for your *envoi?*" Rachou asked suddenly.

"At first I thought of something Biblical. You know, 'Abraham Sacrificing His Son' or 'Moses Striking the Rock'. But they're too difficult."

"You're right," nodded Rachou. "Too many accessories."

"What would you think of Icarus? You know, the one who escaped from the Labyrinth and tried to fly with wax wings. He'd make a good triangular composition. I'd show him on a rock, his wings spread, about to spring up."

"I don't know," said Rachou undecidedly. "Nobody's ever heard of him. Why don't you do a Venus or a Diana? They're always good. All you do is go to the Louvre, copy a Boucher, change a few accessories and you're in."

For a while they discussed the various subjects acceptable as Salon pictures.

"How about a good Crucifixion?" suggested Rachou, when the Venus had been rejected. "They're also very good. And the Louvre is full of Crucifixions," he added helpfully.

At great length they discussed *le sujet religieux*. The Jury hesitated to refuse a Crucifixion, a Pietà, a Mary Magdalen drying the Saviour's feet with her hair, a Saint Sebastian offering his epicene chest to the cruel arrows.

"I have it!" cried Rachou, banging his fist with inspiration. "A good cavalry charge! That, *mon vieux*, is absolutely fool-proof. You go to the Luxembourg, copy one of the Detailles,

change two or three uniforms and you're in. You may even get a bronze medal," he wound up enticingly.

The *sujet patriotique* came in for serious discussion. Technical difficulties and the vast number of accessories required argued against it. With genuine disappointment Rachou conceded that a life-sized stuffed horse might prove somewhat embarrassing in one's studio.

"Of course," he offered as a last alternative, "there's always *le sujet de famille*."

"I know. Little Girl Crying over her Broken Doll or Little Boy Stealing Jam," said Henri with veiled irony.

Rachou did not like his tone. *"Merde alors,* what's wrong with Little Boy Stealing Jam?"

"Nothing. There's nothing wrong with mud pies either or wetting your bed, but you should outgrow them some time, don't you think?"

"All right." Rachou gave up. "If that's the way you feel, then Icarus is your best bet. It's dignified and classical. But be sure you 'lick' him well. You know how Cormon feels about 'licking.'" He noticed Henri was not listening. "What are you looking at?"

Henri nodded in the direction of the lorette, lost in thought at her table. "Interesting face, don't you think?" he whispered. "Notice the green shadows on her neck?"

As though she guessed she was being talked about, the streetwalker crushed her cigarette in her plate, fluffed her boa, placed the price of her meal on the table and sauntered out.

"What's the matter with you?" Rachou looked at Henri with an ominous frown.

"Nothing. I just said she had an interesting face. That's all. She'd make a good subject. Some faces are like walls, others are transparent like windowpanes. You see through them. Forget it. You were speaking about 'licking' Icarus . . ."

"One of these days you're going to get in trouble," said Rachou. His voice was stern, his eyes unsmiling. "Why in hell would you want to paint this tart? Because she has green shadows on her neck and a face like a windowpane?"

"I didn't say that, I said . . ."

"Shut up, and let me talk! All right, suppose you paint that girl, what you'll do with it? Sell it? To whom? Show it? Where? Who will want a portrait of a Montmartre whore?"

"Nobody probably, but just the same she'd be more interesting to paint than your damn cavalry charge or Boy Stealing Jam. Or even Icarus, for that matter. Haven't you ever painted

just for the pleasure of painting, just because you wanted to say something? When I was a child I was forever making portraits of my mother, pestering everybody to pose."

"And now?" Rachou spoke with dangerous calm, like a lawyer luring a witness into a trap. "Now you don't like painting any more, is that it?"

"No, I don't! I hate it. I'm sick of those idiotic Venuses and Dianas we do at the *atelier*. I'm sick of putting raw umber in primary shadow. Why should composition always be triangular? And that damn licking? Who said you should lick every brushstroke? Who decided it? Is it one of those 'Go to Mass or go to hell' propositions? Why can't I paint what I want, make shadows blue or green, if I see them blue or green? Why can't I . . ."

"Because you can't!" Rachou's voice was like a thunderclap. "You paint what Cormon wants you to paint and how he wants you to paint, or you'll never make the Salon. And if you don't make the Salon, you know what it means? You might as well say good-bye to being an artist."

"You're right," nodded Henri. "I don't know what came over me. Don't worry. I'll lick my Icarus, and get into that damn Salon if it's the last thing I do."

The jingle of the doorbell made them turn their heads. Two men entered the restaurant.

Henri recognized Théo Van Gogh, manager of the Boussod and Valadon Gallery. "But who's the other?" he asked in a whisper.

Rachou shrugged. "Some tramp he's buying a meal for, I guess."

Théo's companion was broad-shouldered and slovenly dressed in paint-spattered velveteen trousers and a shabby blue jersey that clung to his powerful chest. He wore no hat and his unkempt hair fell in black oily ringlets over his ears. At the door he tossed his cigarette on the floor, ran his opaque bulging eyes over the room in a gesture of surly challenge, and, with the peculiar swagger of sailors, slouched his way to the table.

Théo Van Gogh recognized the two students, hastily excused himself and walked toward them. "Just the two men I wanted to see. May I sit down?" He pulled back a chair and called over his shoulder. "Order what you want, Paul. I've already had my dinner."

"Who's he?" asked Rachou.

Théo leaned forward across the table and lowered his voice. "Paul Gauguin. Used to be a stockbroker, but gave it up to be an artist."

"What a damn fool!" sighed Rachou with conviction.

Théo shook his head. "He is not the only one. My brother has got it in his head he wants to become an artist. He's done a little of everything and stuck to nothing. For a while he thought he wanted to be a preacher, and lived among the Belgian miners. That didn't last either."

"How old is your brother?" inquired Henri innocently. At once he regretted his question, for Théo's face flushed with embarrassment.

"Thirty-three! Much too old to start studying art. Anyway I don't know whether he'll stick to it or not." He paused and slowly ran his slender hand over his wavy red hair. "Still he's my brother and I want to help him all I can. He wrote to me he's coming to Paris after the Christmas holidays and I've enrolled him at Cormon's for the mid-year term."

His voice became urgent, almost pleading. "Please be nice to him. Don't play the usual *atelier* pranks on him. He is very high-strung and touchy. Don't make fun of him, of his accent and his age."

"What's his name?"

"Vincent. Vincent Van Gogh. You'll recognize him easily. He has a red beard, like mine," he added with a smile. "And he is a wonderful person once you get to know him."

The next day Henri drove to Père Tanguy's shop on rue Clauzel to buy a stock of paint and order the canvas for his *envoi* to the Salon.

Rue Clauzel was without a doubt the worst possible location for an art store. Unfrequented during the day, this Montmartre alley enjoyed a period of activity in the dead of the night when it became a refuge for the thugs and prostitutes of the neighborhood who appreciated its total darkness. But Tanguy, a confirmed anarchist, clung to it on the grounds that art was an expression of social consciousness and should be seen in proletarian surroundings. With this conviction he cluttered the little window of his blue store with unframed Cézannes that no one ever saw.

He was sitting behind the counter and drowsily smoking his pipe when Henri entered.

"Ah, Monsieur Toulouse, what a pleasure!" he cried, struggling to his feet to greet one of his rare cash customers. "And how is your precious health these days?" Concern showed on his round stubbly face. "And Monsieur Rachou's? How is his precious health?"

And Messieurs Anquetin, Gauzi and Grenier, how were

their precious healths? And wasn't it most disgusting weather they were having? Business was at a complete standstill. Artists couldn't paint because the light wasn't right. Therefore they didn't buy colors or canvases. Therefore business was at a standstill.

"But never mind," he lowered his voice and cast a quick glance to the door, " when *la revolution* comes, everything will be different. All the good artists—that is those with a real social consciousness—will be supported in luxurious comfort by the state. The others, we'll shoot them."

This brought to his mind an incident which had happened during *la Commune,* those stormy weeks that had followed the collapse of the Second Empire and in which he had played an insignificant part. The story—which Henri had heard several times—took a few minutes. Then Tanguy clapped his hand with brisk efficiency.

"And now, Monsieur Toulouse, what can I do for you?"

"I need six tubes of raw umber and four tubes of Vandyke."

"Six large umber and six large Vandykes," Tanguy flung in a clarion voice, as if addressing a legion of invisible color grinders.

From behind the backroom portiere drifted back a tired woman's voice. "Cash or credit?"

Tanguy couldn't repress a gesture of annoyance. "But, *chérie,* cash naturally. It's for Monsieur Toulouse."

"Thank God!"

That afternoon Henri ordered an enormous fine-grain canvas more than eight feet high and almost as wide. Three days later he started work on his Salon picture, Icarus Trying His Wings.

From then on his days and even his nights were haunted by the ghost of the Flying Athenian. His career, his whole life depended on him. After lunch with his friends at Agostina's he hastened up rue Caulaincourt, pantingly hoisted himself up the four flights to his studio and threw himself into a frenzy of raw umber and careful licking.

The first time Madame Loubet spied him, palette in hand, climbing up and down the ladder on his wobbly legs, she almost fainted and decided he had gone mad.

"Did you really have to make such a big picture?"

Unobtrusively she was insinuating herself into his life. No sooner had he set to work than she would knock on the door, and with an ingratiating smile inquire whether she could give a little glance at the stove. In she would waddle, plunge the poker in the salmon belly of the stove, rattle the coals

and clamp back the lid with much grumbling about the Paris coal which wasn't any good and gave no heat whatsoever. This done she would linger in the room under some pretext or other until he invited her to sit down.

She would accept his suggestion. "But only for a minute," she would insist, plumping herself down in the wicker armchair. Sometimes she would talk to him about Monsieur Levallier, the idealistic, kindly capitalist whose housekeeper she had been, before becoming concierge of his ill-fated building. Sometimes she would read him the newspaper.

Thus the afternoons would pass. Patiently he would hoist himself up and down the ladder, fill his primary shadows with raw umber, "lick" every brushstroke until the paint lay flat and shimmering on the canvas like a satin ribbon. At times, however, the tediousness of the task overwhelmed him. How long would it take to finish that stupid dummy's face with his vacant eyes, its perfect bridgeless nose and girlish carmine lips? And those absurd wax wings? Those bulging muscles? That drumlike chest? Sternly he would recall Rachou's warning, and gritting his teeth he would go on working, dragging his brush, cursing every stroke, every oily shadow, every inch of the smooth butter-colored body.

And sometimes he rebelled. Despite his resolutions he would climb down from the ladder, set a small canvas on an easel and paint a Montmartre scene. A laundress caught walking down rue Caulaincourt, her wicker basket over her arm. A lorette's face glimpsed in the street or in some café. A cancan scene sketched the previous night at L'Ely. Miraculously fatigue would vanish. The old spontaneity would return. So would the acid greens, the slaty blues, the tender mauves. The joy of painting would come back, made more pungent by the reproachful proximity of Icarus.

He was lashing away at a small cancan scene when one afternoon there was a knock on the door and his father strode in. Madame Loubet flung him a terrified glance and hastily withdrew.

"Your mother mentioned you had rented a studio and I came to see what sort of place you had found for yourself." Hands clasped behind his back, the gold-knobbed cane under his arm, he glanced about the room. "Not bad, not bad at all. The house is rather dilapidated, but then I suppose every house in Montmartre is like that."

He walked to the window and stood a moment, legs apart, gazing out. "Fine view. On clear days you must be able to see past Notre Dame." He turned around, swept his eyes

over the room once again. "Yes, you should be able to daub to your heart's content in this place. You always were keen on drawing when you were a child. You may grow to become a good painter of horses—like poor Princeteau."

With pounding heart Henri watched him, struck by the change in his father's appearance. The silk hat, the white carnation, the spats were still there, but a change had come over him, deeper than the passing of years. There was a strange fixity, almost a wildness in the eyes. Strange rumors circulated about him. Poor Papa who had wanted so much a son who could ride with him, hunt stag at Loury with him . . .

"There's a bedroom upstairs, and a bath. Would you like to see them, Papa?"

"What's that?" exclaimed the count, ignoring the suggestion and pointing his cane at the unfinished Icarus.

"My *envoi* to the Salon."

"What on earth is he doing with those ridiculous wings?"

"Daedalus, his father, had made him a pair of wax wings to fly over the sea. But he flew too near the sun, the wax melted and he was drowned. It's an old Greek legend."

"One less idiot in the world!" The count shrugged and turned away from the painting. "Well, I must go now. I'm pleased to see you are comfortable."

As he was about to start toward the door, his eyes fell on the small cancan painting on the easel. He walked to it, bent forward to examine the picture of whirling petticoats and kicking legs. "Your mother would be shocked if she knew the sort of trash you're painting," he remarked, straightening up. "Plain pornography. Tarts have their place, and it's not on canvas."

With a shrug he made for the door. "It doesn't matter. Nothing matters any more."

In the doorway they faced each other for an instant, as if trying to bridge the abyss between them.

The count was the first to turn away. "Well, good-bye, Henri."

"Good-bye, Papa. Thanks for coming to see me."

The count did not reply. From the landing Henri watched his father descend the stairs.

Early in December the joyous Christmas excitement descended upon Paris, bringing a brief smile to winter's grim face. Toys appeared in shop windows. People milled through the slush, their arms laden with packages.

One morning during the usual five-minute recess Lucas approached Henri.

"That girl, Julie . . ."

"The one who works for the chichi modiste?"

"Yes. Well, she won't budge. She says God will punish her if she gives in."

"Why don't you go after someone else? You don't love her anyway."

"That's not the point. It's become a question of self-respect with me. Besides, my impulse is getting stronger and stronger all the time. If I only could give her some little thing for Christmas she might let me kiss her. Now women are funny about kissing. It must work on their ovaries or their Fallopian tubes or whatever they've got, but once they let you kiss them they understand things much better. Just the other day I saw a nice little fur necklet in that second-hand shop on rue Provins . . ."

With a shock Henri discovered that his friends had made plans for Christmas and these did not include him. Lucas was concentrating on Julie, the adamant midinette. Grenier mentioned a rendezvous with a mysterious *jeune fille* about whom he showed himself extremely reticent. Rachou had "sold" his Christmas Eve to an old aunt who gave him a shiny twenty-franc gold piece *after* the Midnight Mass. Anquetin was lost to Jeannette, one of the cancan dancers at L'Ely. Gauzi had ferreted out another of his *femmes parfaites* —an actress, this time.

The sudden dispersion of his friends jolted him and made him realize how precarious was this *atelier* companionship he had come to imagine permanent. A few months and they would leave Cormon's. Their tight little group would scatter. No more joyous lunches at Agostina's, no more debates at La Nouvelle, no more evenings at L'Ely . . .

These disturbing thoughts drifted through his mind on Christmas Eve as he stared pensively at the burning logs in his mother's sitting room. The lamp made an ellipse of yellow light on the ceiling, and on the mantel the little alabaster clock dripped time like a leaking faucet. Outside snow piled up noiselessly on the window sill. Now and then the muffled sound of traffic and Christmas revelry rose from below. Then once again all was stillness and lamplight.

"How's Icarus?" asked his mother, pausing in her knitting. "Are you pleased with it?"

"Coming along beautifully." Sweet Maman, she was trying to show an interest in his artistic career. "The primary shadows

are all done and the face finished. Lot of 'licking' still to do though."

He looked at her as he spoke. Their gradual estrangement hung like a transparent curtain between them. A wave of love swept over him. Poor Maman, how lonely she must be!

"As soon as the Salon opens, we'll be able to leave for Malromé," he said to please her. "And since I'll be through with Cormon's we might spend the autumn there. Even stay until Christmas."

Her eyes were upon him, moist with tenderness. He wanted to make up for his Montmartre room, for the evenings he had spent with his friends when he could have come to visit her. He wanted to show her his love. And being Riri, he wanted to do so in a sumptuous, extravagant, grand-seigneur way, by tossing at her weeks, months of his time—like Alphonse, who left hundred-franc tips in restaurants . . .

"I'm afraid Malromé wouldn't be very cheerful in autumn. It rains a great deal after October."

He insisted, eager to force his sacrifice upon her. Certainly the weather couldn't be worse than in Paris, and it would be pleasant driving to Saint André du Bois for the Midnight Mass.

"We could invite Abbé Soulac to Christmas dinner," he went on. "Please, Maman. Say you'll stay until Christmas."

The coaxing voice brought back the image of the little boy on the lawn of the château pleading with her to pose for her portrait. He hadn't changed. A part of him would always remain childlike.

"We'll see," she nodded with a smile.

For a while they spoke of the studio he would rent next year. Not in Montmartre, of course, but in some quiet, aristocratic district.

"Incidentally," she said, "you will have to have a house-keeper. Have you thought about Madame Loubet? From what you've told me she sounds like a very nice person."

An excellent idea. He would speak to her as soon as Icarus was accepted for the Salon.

His gaze returned to the fire. Idly he watched the tiny blue flames that tiptoed like diminutive dancers across the smoldering logs. What were his friends doing at this moment? Had Lucas finally got his kiss? Had Julie broken down before the little second-hand necklet? It must be nice to have a pretty girl kiss you . . .

Over her knitting his mother watched him. He was troubled,

vaguely afraid. Until now he had been too enthralled with his discovery of life to think about living. But he was coming out of his wide-eyed undemanding rapture. He was emerging out of his belated adolescence and sensual unawareness. He wasn't conscious of it yet, but she sensed it. His eyes had lost their limpidity. The hot blood of the Toulouse-Lautrecs was beginning to stir in his veins.

No, the storm had not come yet, but it was on the way.

VII

The Christmas holidays were over; they had been over three weeks, in fact. Toys had long ago disappeared from shop windows. Who wanted to look at toys after Christmas? Even the serpentine and confetti of Christmas Eve had been swept or washed down the drains by the rains of the last few days. People had forgotten their foolish Noel smiles and sentimental nonsense and gone back to work. Henri had returned to Icarus and his uneventful, laborious and carefree student life.

This morning he sat dutifully at the *atelier*, hunched on his little canvas stool, working hard on his Diana at the Bath, blending fleshtones, watching his anatomy and chromatic balance, gazing now and then at *la grosse* Maria* who stood rigid and naked on the model platform a few feet away.

Everything was as it always was. The stove purred gently away. The room was warm, almost hot, but not unpleasantly so. Schlumberger, the *massier*, was reading his newspaper in a corner while waiting for a five-minute recess. The students stood at their easels, stepped back and forth, bent down to rummage through their boxes and squeeze paint on their palettes. And of course it was raining. The raindrops made a lulling patter on the skylight, like a flock of little lambs rushing by on their tiny hooves. Yes, everything was as it always was; nothing had changed except—except that nothing was as it was and everything had changed. Funny, wasn't it? And why was everything different?

His mind shied away from the question. Impatiently he

* An *atelier* study of *la grosse* Maria by Lautrec hangs today in the Stockholm Museum.

107

leaned back on his stool to inspect his painting. A little more umber in that primary. That left arm wanted a little more licking . . . Would there ever be an end to licking? Why did Cormon insist so much on it? And that damn prettiness of his? After all, he was an intelligent man; surely, he had copied Michelangelo and Greco and Hals and Velasquez and must know that great art, great beauty wasn't pretty? Yet, only yesterday he was still rattling on about the pretty nudes a good artist was supposed to paint. Pretty and saucy, chaste and seductive! "Breasts should titillate the imagination, but nothing more. The pelvis should be virginal while holding its promise of delight. The pubis should be hairless, preferably veiled or hidden by a dainty hand cupped over it, as in Titian's Venus." Did he really believe this rot? He must, for he was getting more and more intolerant. A week ago a student had sneaked a little mauve in his fleshtones, and you would have thought the world had come to an end! "Impressionism! I've told you I won't tolerate impressionism in my class! Perhaps you have forgotten I am a member of the Salon Jury?" The student hadn't come back. What was the use? He knew Cormon would blackball his *envoi*. And he knew that without the Salon he was through as an artist. Well, enough of that. Back to work. Where's that damn raw umber?

He selected a clean brush, softened its bristles in his palm, dipped it in the blob of brown paint on his palette, and for a while devoted himself to his tedious task of applying the pigment in cautious strokes on the canvas.

His mind returned to its musings. He thought of Icarus waiting for him and felt a wave of nausea at the prospect of another afternoon of solid "licking." Would that god-damned Athenian ever be finished?

The violence of his revulsion startled him. What was the matter with him? He had known Icarus would be a bore when he started it, but he also knew that it was the key to the Salon and must be done. Then why this sudden aversion, this display of artistic temperament? What the devil was the matter with him? Even his friends had noticed a change. Something was wrong. He who used to sleep like a log, now turned and tossed and mumbled in his sleep. Grenier had commented about that. And those sudden changes of humor? One minute he walked on air, laughed, talked his head off; the next he wanted to run to Maman, bury his face in her lap and cry. Come on, what was it?

Julie! Like a guilty secret the name whispered itself in some recess of his brain and slowly flooded his consciousness.

That's what was the matter with him. He had tried to hide it from himself and had known it all the time. She hadn't given him a moment of peace since that evening when Lucas had brought her to L'Ely for the first time.

Suddenly she was standing before him, slim, blonde and looking like La Primavera—a Primavera turned midinette, in a frilly little hat, dotted veil and the cheap fur necklet Lucas had given her for Christmas. Whatever her qualms had been, she had silenced them. She certainly didn't want to slap him any more. No, indeed. Her love for that mediocre and handsome Norman betrayed itself in every gesture, every glance, her furtive groping for his hand under the table. It was thrilling —and a little indecent—to watch this clandestine love-making in public; this total and shameless surrender of a decent girl to the demands of her heart and senses. Lucas had been right, kissing did things to women . . .

That evening they had exchanged only a few polite remarks. Twice she had smiled at him across the table. He had watched her sip her *vin chaud* between dances, laugh her pretty laugh, babble away about Le Chapeau Fleuri, how they had nothing but "originals" there, catered solely to the carriage trade and how she had once waited on Madame Sarah Bernhardt. While she spoke he had drawn in her loveliness in swift, covert glances. Stealthily he had run his eyes over her, guessed the young tipped-up breasts under the homemade blouse, the blond fuzz under her armpits, the warm roundness of her thighs. It had been a new and strange sensation, both exquisite and painful—this secret contemplation of a woman, so near and yet as distant and untouchable as a star. It had been then that the change in him had begun.

Later that night, when he was back in his little room, she had returned to him. In a dream, of course, but a dream as real as life could ever be. They were lying on the couch of his studio under the huge window. In the lamplight her body was half amber and half midnight blue. Her nipples had become two wild strawberries, crimson and rigid with desire. Gently he was caressing her, kissing her everywhere at random, trailing his fingers over the warm resilience of her lean belly, the fine-grained texture of her flanks. Abruptly their lips touched, their breaths mingled. In a moan of pleasure her flesh acquiesced, her thighs parted and they were one in the throbbing flow of their clenched bodies.

He had awakened panting, feeling a new and exhausted rapture, a complete well-being he had never experienced and did not know existed. Even his legs had ceased to hurt. He

was not sure whether he was still dreaming or not and lay
motionless in his narrow brass bed, hardly daring to breathe,
too confused to think, too happy to sleep, smiling in the dark-
ness.

It had been like this every night. During the day she
also went with him, invisible to others, but so real to him
that she merely seemed to be the projection of his dream. She
smiled at him from the glossy darkness of Icarus' background,
teased him while Madame Loubet read on, or while his friends
argued and blew smoke into one another's faces. At times
she was playful, almost saucy. At others, almost unbearably
tender. At others still, cruel. He was nothing but a fool. She
didn't love him, never would. Why, she hardly knew him . . .

With a jerk he pulled himself from his thoughts, once more
forced himself to examine his painting. Good, very good . . .
That left arm looked exactly like a stuffed kid glove. Cormon
would love it. And those primary shadows were simply beauti-
ful. Solid brown mud . . .

Irresistibly his thoughts returned to Julie, but with the
infinite versatility of the mind, he looked upon himself this
time with a jocular, almost avuncular detachment. It all
was very simple and natural. Nothing was the matter with
him. He wanted to make love, go to bed with a girl—that's
all. What was astonishing was that he hadn't wanted to before.
Perhaps his long illness had something to do with it . . . As
for Julie, she was obviously a fabrication of his imagination,
like those beautiful women who leaned over poets' shoulders
when they wrote sonnets. She had merely given form to his
vague shapeless yearnings. The thing to do was to get a girl,
a real girl of flesh and bones, and make love to her. Very simple.
Nothing to it. Montmartre was crawling with girls. Easy girls,
eager to love and to be loved, hungry for tenderness and pretty
hats and pretty clothes and dinners in nice restaurants. And
if it came down to that, hungry for money. No problem, no
problem at all . . .

"Five-minute recess."

The *massier's* voice broke through the fabric of Henri's
happy thoughts. With a last flourish of his brush he lay down
his palette, picked up his cane from the floor and shuffled to-
ward a gaunt red-bearded student in a cheap blue-serge suit
who appeared oblivious of the recess and went on painting
with the awkward application of a beginner.

"You are Vincent Van Gogh, aren't you? Your brother
said he was expecting you after the holidays."

"And you, you are Toulouse-Lautrec, are you not?" The new student stopped painting and focused on Henri the two glittering opals of his eyes. "Théo told me about you."

"When did you arrive?"

"Only yesterday, but I've already been to the Louvre!"

He pronounced the name with such ecstatic fervor that Henri could not restrain a smile. Instantly the stranger's face froze and his eyes hardened.

"Why do you laugh, why do you make fun of me? Did I say something wrong?"

"No, no! Please, forgive me." Théo had been right, his brother *was* touchy. "I wasn't laughing at you. I was just thinking you didn't waste much time to visit the old graveyard."

"Graveyard?" Vincent's puzzled frown was followed by a flash of comprehension. "The Louvre a graveyard! That is very funny! Ha-ha-ha! Oh-ho-ho!"

Laughter was spreading through him, sluicing down his weatherbeaten cheeks in rivulets of uncontrollable mirth, bobbing up and down the Adam's apple in his stringy neck, cascading down his shoulders, his chest, his long arms. His hilarity fed on itself, swelling into raucous, wheezing guffaws. "Graveyard! Ha-ha-ha! . . . Oh-ho-ho!" He bent double as if in a paroxysm of pain, and laughter gushed out of him, like water from a squeezed sponge. He was like a man possessed by a laughing demon.

Uneasily Henri watched this torrential, disquieting gaiety. Did all Dutchmen laugh like that? In the *atelier* the students stopped their gossip to witness this explosion of mirth. On the stand *la grosse* Maria, who was buffing her nails on the lapel of her black kimono, was staring at him.

At last laughter rippled out of him in gurgling, diminishing chuckles. "That was really very funny!" he chortled, wiping his eyes. "*Kolosaal!* How do you say in French? *Epastrouillant!*" He risked the colloquialism with the foreigner's relish at displaying his familiarity with the slang of a foreign tongue.

"You speak excellent French," said Henri, hoping his remark would not send the Dutchman into another laughing spasm. "Did you learn it at school?"

"No. I learned it when I was in Paris many years ago, trying to become an art dealer, like Théo. I also taught it in a little school in England for a while. Nothing like teaching a language to learn it yourself."

Blue sparks of laughter reappeared in his eyes, and Henri held his breath. "Of course you're having lunch with us,"

he said quickly. "You absolutely must taste Agostina's cooking. Later we can go to my studio, if you wish."

This time the newcomer did not laugh, but smiled his assent. Henri noticed he had an extraordinarily sensitive smile.

During lunch Vincent was harassed with a thousand questions about Holland, the windmills, the canals, the tulips, the cheese, and the exact pronunciation of his name which to French ears sounded suspiciously like a gargle. Did they have *ateliers* like Cormon's in Holland? Did they have a Salon, and did you have to "lick" and cram your anatomy? A Rembrandt? Had he seen many Rembrandts? Had he seen his house in Amsterdam—or Rotterdam—anyway it was somewhere in Holland? And the girls, how were they? Did they have *élan*? Did they have *savoir-faire*? Or were they like dishes of noodles? Now, here in Montmartre girls resisted you a little at first, but after a while they were grateful for the outrages you inflicted upon them. The greater the outrage, the greater their love. The Dutch girls, were they like that?

The students looked with mixed feelings on this carrot-haired patriarch of thirty-three who had fallen in their midst and was replying to their questions in his formal, guttural French, fixing upon them his hawklike, magnetic blue eyes.

"Surely you must have seen our Mona Lisa at the Louvre?" said Anquetin in his best drawing-room manner. "A masterpiece, isn't it? An incomparable work of art. Only the divine Leonardo could paint like that. It is the greatest painting on earth and—" he flung a challenging glance around the table "—I'll spit in the eye of anyone who says it isn't."

With a gracious smile he returned to Vincent. "Last week I went to the Louvre and had a good look at it. It was so perfect, so noble, so sublime I wanted to go down on my knees in front of it."

"Why didn't you?" interrupted Henri with a reckless grin. "And how do you know it's the greatest painting on earth? And how do you know Leonardo painted it in the first place?"

"How do I know?" Anquetin frowned ominously at Henri. He was very jealous of his title as champion debater of the group. Anyone who challenged him did so at his own risk. He looked at the students with an indulgent chuckle. "That little flyspeck wants to know how I know Leonardo painted Mona Lisa!" Goliath must have chuckled like that when confronted by David.

He fortified himself with a quick draught of *vino rosso*, dabbed his blond mustache with his napkin and crashed his fist on the table. "Well, I tell you, you drooling halfwit!" he

shouted, glaring at Henri across the table. "I tell you how I know Leonardo painted Mona Lisa! I *feel* it, see? I feel it *here*, in my heart!"

"I didn't ask you where you felt it. After all I can feel *here*, in my heart, that you are a jackass, but that doesn't make it so. Or does it?"

The students laughed. Vincent lit his short straight pipe. Anquetin turned red in the face. He had counted on a one-blow knockout.

"That smile!" he exploded in a flash of inspiration. "Even a one-eyed foetus like you must have noticed that trembling, elusive, maddening smile of the eyes. If you say she doesn't smile with her eyes I'll spit in your face!"

"She may smile with her navel for all I care. What I want to know is how in hell do you know she was painted by Leonardo."

There was a short pregnant pause.

"That's easy!" snorted Anquetin in a fresh burst of inspiration. "The technique! Yes, the technique, *mon vieux*. The brushstrokes. Everybody knows Leonardo's brushstrokes." He settled back on his chair waiting for the confusion of his antagonist. "Answer me that one, if you can."

"Now listen," grinned Henri, "and hold on to that amoeba's brain of yours for one minute, if you can. In London they've got a museum. It's called the National Gallery. It's their Louvre, you might say, and in it they have a version of the Madonna of the Rocks, different from the one we have. It's supposed to have been painted by Leonardo with the assistance of one of his pupils . . . Wait. Don't interrupt me," he said, as Anquetin was opening his mouth. "Nobody has ever been able to identify the parts painted by Leonardo and the parts painted by his pupil. The brushstrokes were the same. Perhaps the pupil did it all."

Anquetin had lit his pipe and was now puffing billows of smoke into Henri's face, a recognized method of warfare.

Henri choked and waved the smoke away with his hand. "I'll tell you how you know Leonardo painted Mona Lisa, if you give me a chance."

"All right!" sneered Anquetin, delighted at changing sides. "You tell me!"

"The little brass plate on the frame—that's how!" He grinned at his opponent. "Yes, *mon vieux*. That little brass plate that reads 'Leonardo da Vinci. 1452-1519'. That's how you know. If you found Mona Lisa in a pawn shop, unframed and dusty, you'd think she was just another competent, badly

crackled, heavily varnished Renaissance portrait and you might give five hundred francs for it."

"The things I'd do if I had five hundred francs!" interrupted Rachou with passionate wistfulness.

"But at the Louvre," Henri proceeded, when the students had finished telling one another what they would do if they had five hundred francs, "oh, at the Louvre, it's different! You take off your hat, you tiptoe, you talk in whispers as if you were in church. You read the little brass plates as you go along. Correggio . . . Rembrandt . . . Titian . . . and Rubens . . . Each time you make a mental genuflexion and cross yourself. When you get to Mona Lisa you're groggy with reverence. You don't see an obscure middle-aged Florentine housewife with her hands folded on her stomach and a smirk in the tail of her eyes. You see Leonardo. A legendary, romantic, literary Leonardo wrapped in his beard and his genius. You see Florence, the Ponte Vecchio, the ladies in brocade plucking the lute, the doves, the Medicis—and you want to go down on your knees."

"That's a lie!" thundered Anquetin. "You see genius, that's what you see! Genius, my poor imbecile, is like a diamond. You recognize it at one glance. It hits you between the eyes. You see it plain as day in a Rembrandt, a Titian, a Leonardo! Anyone can see it!"

"Merde alors!" shouted Henri, as Rachou beamed with pride at his pupil's performance. "Then why didn't Mona Lisa's husband see it? He refused the portrait, you know. Damn it to hell, if it's so easy to recognize genius, if it hits you between the eyes, why didn't Lorenzo di Medici see it? Why did he make Leonardo sketch menus and costumes for masked balls instead of letting him paint in peace! And if, as you say, anyone can see genius, why did people laugh at Rembrandt's Nightwatch and let him die a pauper? And Watteau, who had to paint signs? And Teniers, who had to circulate the news of his own death to sell his paintings for a few francs? And Chardin who exchanged a painting for a waistcoat? Why didn't their contemporaries see their genius when we can see it so clearly? And if we are so smart and clairvoyant about old masters, why are we so damn blind about living artists? How do you know Cézanne, for instance, isn't a great genius and will some day be in the Louvre with your divine Leonardo?"

"Who's Cézanne?" asked Vincent.

"Nobody," Gauzi assured him from the end of the table. "Lautrec's just trying to be smart."

Rachou turned patronizingly to Henri. "There may be something in what you say, but you're going too far. After all everybody knows Cézanne can't paint. Even the Impressionists were ashamed of him. They used to hang his paintings in the corner where nobody could see them." He looked with reproachful affection at his protégé, the mama's boy he had molded into a genuine art student. "*Merde alors,* it's not easy to get in the Louvre. When you say Cézanne will some day be in the Louvre you talk like a child. As if you said that some day *you* will be in Louvre!"

The conversation veered back to Vincent. He was given voluble and conflicting advice on where to buy paint on credit, what brand of charcoal fixative to use and where to buy a good second-hand manual of anatomy. The lunch ended in violent and general disagreement, and a furious discussion about the relative merits of triangular composition, chromatic balance, and "pictorial refinement" in the creation of an acceptable *envoi* to the Salon.

Still talking they trouped out of Agostina's and scattered in various directions.

"Rather confusing, isn't it?" said Henri, glancing up at Vincent as they were climbing up rue Caulaincourt.

His companion went on walking, head down, clutching his portfolio under his arm. "I thought if I came to Paris I'd have a chance to learn about art and become an artist," he said at last. "Now I am not so sure. Perhaps Théo was right; perhaps I'm too old."

All laughter had died out of him. He looked so bewildered, so foreign and lost in this Montmartre street that Henri felt sorry for him.

"Don't be discouraged, Vincent. May I call you Vincent? Don't be confused by all this talk about triangular composition and chromatic balance. It isn't really as difficult as it sounds." And since compassion usually expresses itself in deception, he added, "In no time you'll catch up with us."

Haltingly they made their way up the winding street and at last reached the studio, where they found Madame Loubet on the balcony, sweeping plaster rubbish into a dustpan and muttering darkly to herself.

"Those plumbers, monsieur!" she cried, addressing Henri from above. "Look what they did! If I'd known they'd wreck everything I'd never have had that bathtub fixed."

She tossed a curt nod at Vincent, gave a few last vicious

broomsweeps, and clumped down the narrow flight of stairs, broom in one hand and pail in the other.

"Please madame, let me help you," offered Vincent, stretching out his arm to take the pail from her.

The gesture was so spontaneous and gallant that she blinked at him in astonishment. A smile rounded her cheeks. "Nice of you, but I can manage. Now you two have a nice talk and enjoy yourselves." She went out and closed the door behind her.

"You've won Madame Loubet's heart," said Henri, hanging his hat and coat on the rack. "You'll see, in a moment she'll be here with a bowl of *tisane*. Drink it, even if you don't want to, and don't argue. I've tried. It's like trying to argue with a locomotive. Now how about showing me your sketches?"

He walked to a long table and moved the kerosene lamp to make room for Vincent's portfolio.

"Could I first look at your paintings?" said the Dutchman inspecting the unfinished Icarus. "It is beautifully painted. One can see you know anatomy very well. I wish I did."

"Just a list of Latin names to memorize. If you want we'll study together." There was something curiously appealing about this redhaired foreigner. "Please feel free to come here any time you wish. And don't be embarrassed. I used Rachou's studio for two years."

Vincent turned toward Henri, but his eyes passed over him, as if fixed on some inner vision. "Do you know what I'd do if I could paint like you? I would paint the peasants in the fields. I'd try to catch their fatigue, the aching of their backs at the end of day, the way they straighten up in the middle of a furrow to wipe the sweat off their faces with their sleeves. I'd paint the farms, the trees, the flowers, the sün. I'd use yellow, lots of yellow, great big blobs of yellow! Yellow is God's color, for He made the sun yellow!"

The strangeness of this last remark caused Henri to squint wonderingly at him. Was he by any chance a little touched in the head? "God may love yellow, but Cormon loves brown." He smiled. "You'd better stock up on Vandyke and raw umber. I'll take you to Père Tanguy's, where you can get it cheap. What is it?" he asked as Vincent dashed across the room and picked up the little cancan scene. "Oh, that! It's a little picture of the girls dancing the cancan at L'Ely. We'll take you there one evening, perhaps tonight."

"It's beautiful! Beautiful! Beautiful!" cried Vincent. Each successive exclamation rang with growing enthusiasm. "So much better than your big painting! Those girls are alive.

You can see them dance, you can hear the music, feel the crowd, smell the atmosphere of the place. The *joie de vivre!* Why didn't you finish it?"

"Because I didn't have the time. Besides, my father said it was pornographic trash."

"You must finish it," cried Vincent imperiously.

"I shall, one of these days. Don't get so excited. I thought Dutchmen were phlegmatic, but you must be the exception that confirms the rule. But I'm glad you like it. I rather like it myself. I'd be painting things like that all the time if I could."

"Why don't you?"

"Because I want to get in the Salon, and cancan girls don't get you in the Salon. Now, come on. Show me your sketches. The light's beginning to go."

Reluctantly Vincent placed the small painting against the wall, sat down at the table and started untying the tapes of his portfolio. "Please remember I'm only a beginner," he said. "I've never been in an *atelier,* never studied art." He held out a dog-eared sheet of ruled note paper. "This is one of my earliest. A copy of Millet I made from a book illustration."

One by one he handed the sketches across the table.

"These are Rotterdam fishermen . . . This is an old Nuenen weaver . . . This is Sien, a girl I used to know . . . These are Brabant peasants. Potato eaters, we call them."

When he came to the last, light was waning in the studio. "Well, that's the lot. What do you think of them?" Apprehension made his voice tremble. "Do you think I still can become an artist?"

Slowly Henri put down the drawing he held in his hand. For an instant he considered Vincent, staggered by the humility of this freckle-faced man who was staring at him across the table in a fever of suspense. "You mean you don't know? But, Vincent, your sketches are superb! Magnificent! How can you have the slightest doubt about them or about yourself?"

"Do you mean it? Really mean it?" Vincent's voice broke with emotion, as though some inner spring had suddenly uncoiled. "You aren't just being polite? You truly think I can still become an artist?"

"Become? But, Vincent, you *are* an artist!"

Vincent's face winced into a grimace of rapture. "Thank you. Thank you, Henri," he stammered. "You don't know what this means to me. I needed to hear someone say that."

For a while they looked at each other across the table, grinning, not knowing how to put their feelings into words.

"I think we're going to be friends," Vincent said at last, with a slow, hesitant smile.

"I think so, too," Henri nodded. "I'm awfully glad you came to Paris, Vincent. I mean it." He shrugged helplessly at the inadequacy of his words, and rose from his chair. "Let's go to La Nouvelle and have a beer."

There was a discreet knock on the door. Madame Loubet entered, carrying two bowls of steaming *tisane* on a tray.

Henri winked at Vincent. "Didn't I tell you?" he whispered.

Even before mid-winter Henri noticed the change that had come over his friends. They still argued about art and women, spat in one another's eye, puffed on their pipes and boasted of their wickedness, their lecherousness and prodigious virility, but underneath their bombast he felt a new uneasiness, a vague apprehension of the future that betrayed itself in sudden exclamations of regret and gloomy sighs.

"Remember what that old bastard Degas told us last year at Agostina's?" Gauzi remarked one evening. "About artists starving to death, and walking with holes in their shoes. I didn't pay much attention at the time, but it got me thinking . . ."

"Me too," sighed Anquetin to himself. "When I think I could have had that wonderful job in the post office!"

Hesitantly Gauzi pulled an illustrated houseware catalogue from his pocket. "There's tremendous money in catalogue illustration," he said with piteous bravado. His finger rested on the picture of a soup tureen. "You wouldn't believe how much they pay for a little thing like that . . . And then there are window shades. Some people like pictures on their window shades."

They were silent for a moment, united in their thoughts. They had wanted to be artists. Well, soon they would be. And then? How in hell were they going to make a living? Anxiety pierced through the thin veneer of their bohemianism. Their sound instincts of French *petits bourgeois* warned them that life was not a perpetual carousing at L'Ely or beer-drinking at La Nouvelle, that Cormon's tomfoolery of Dianas and Reclining Venuses might get you in the Salon but did not guarantee regular meals.

"In the Temple district," said Anquetin with strained casualness, "there's a man who gives you twenty-five francs for

a Murillo Ascension and twenty-seven for a Nativity. And he takes all you can make."

Rachou announced he had filed an application for a post as an assistant museum curator, second class. "That's the lowest there is," he said with pathetic humility. "But once you're in, you eat."

A few days later Grenier asked Henri abruptly, "Know anything about wallpapers?"

They were having breakfast in their usual bistro on their way to the *atelier*. Outside, rue Fontaine bustled with early-morning animation and resounded with the cries of pushcart vendors, the jovial profanity of wagon drivers. Housewives in slippers and curlpapers haggled with fishwives or inspected heads of lettuce with the air of Hamlet addressing the skull. Old-clothes merchants recognizable by the three hats stacked on their heads caroled their ancient cries; china menders rang their little bells; knife-grinders, a foot in the gutter, bent over their sparkling wheels. Stray dogs wandered through the crowd. Now and then a glazier strolled by, his stock of panes strapped to his back, hopefully looked up for broken windows and yodeled his immemorial *"Viiiiiiiiiiiiiiii-trier!"*

To Henri the scene looked like a Rembrandt etching come to life, and he was about to say so, but already Grenier was going on. "Interesting business, the wallpaper business. Lots of money in it. Very artistic, too. For instance, would you know how to go about designing a good wallpaper?"

"I don't think so," Henri admitted, munching his *croissant*. "It's a craft."

"A craft! *Merde alors,* it's an art!" He leaned forward across the table and lowered his voice. "Remember the young lady I met at Christmas time? Her name is Lili. And she is a real *jeune fille,* not one of those Montmartre girls who sleep with everybody. Very strictly brought up. Well, she's crazy about me, and her father owns a wallpaper plant. He took me through it, and told me how with my artistic training I'd simply be invaluable to him."

Henri watched him over the rim of his cup. Good, sensible Grenier! He too knew that life was not Montmartre horseplay and dancing at L'Ely . . .

"You're absolutely right," he said, when his roommate had finished his confidences. "Marriage is a wonderful thing, they say."

That winter Henri saw much of Vincent. He did a portrait

of him* seated in front of a glass of absinthe; he listened to his self-denunciations, his political harangues and the tumultuous outpourings of a mind inflamed by mysticism, alcohol, disease and awakening genius. He grew used to his pathetic humility, his hesitant smile and disturbing laughter, his volcanic enthusiasms and brooding silences. At L'Ely he watched the former preacher jostle midinettes about the dance floor and engage in awkward flirtations with adolescent laundresses who giggled at his foreign accent, his gaucherie and his orange whiskers. At La Nouvelle he watched him guzzle absinthe, brandish his short pipe and expound his nebulous plans for an artists' colony. "It would be built along the lines of Fourier's phalange. We'd pool our resources. Whenever one of us would sell a painting he would hand the money over . . ."

Alone they argued constantly. Their intimacy and deep understanding fed on their disagreements. The differences of their temperament and upbringing brought about violent clashes which left them hoarse, dagger-eyed and better friends than before.

"Your artists' colony is crazy!" Henri would snort. "Vincent, you've got a flea in the brain. Don't you know artists can't live together? Lock two artists in a room and in a week they'll be slashing each other's throats with their palette knives."

One afternoon Vincent burst into the studio and announced that he had seen the light: he was going to become a pointillist.

"Oh, my God, you, a pointillist!" Henri stopped working on Icarus to laugh over his shoulder at his friend. "Last week you were an impressionist, remember? Like Renoir and Monet."

"This time it's different," said Vincent, with a rapt look in his eyes. "Seurat came to dinner last night, and at dessert he explained his theories. I tell you it's the solution of all artistic problems. And so simple! All you have to do is study optics, the laws of refraction of light, the principle of dominants, the duration of the light-impression on the retina . . ."

". . . and work about a year on a canvas, like Seurat! Do you see yourself applying dots on the same canvas for a year? You, of all people!"

They even argued about politics.

"I can't understand how a fuzzy-brained idealist like you can be so objective in his drawings," Henri would fling in the heat of discussion. "By all rules you should paint syrupy chromos like your hero Millet, but thank God, you don't. Your potato eaters are real. You can tell they have bad teeth,

* This pastel hangs today in the Municipal Museum of Amsterdam.

don't wash often, stink to heaven and are thoroughly miserable."

"Peasants have always been miserable. It was even worse in the old days, when the king stole their crops . . ."

"Where did you read such nonsense?"

"It's true!"

"It's not true!"

"Yes, it is!"

"No, it isn't! *Nom de Dieu,* go the the Louvre and look at the Breughels, the Halses, the Teniers and tell me if their peasants look hungry! Look at their paunches, their fat behinds! And what do they do, your poor starving peasants? They dance under the trees, gorge themselves with food, uncork barrels of wine or cider. And their wives! Plump as quails, their breasts bursting out of their bodices!"

"Then why did they start the Revolution?"

"They didn't. They fought it tooth and nail. It's your damn Republic that starved the peasants by inventing military conscription. A king would never have dared to take a man from his land . . . What are we fighting about anyway? Let's go to La Nouvelle and have a little game of cards. I feel lucky tonight."

Soon after his arrival in Paris, Vincent's chronic restlessness reasserted itself. He could not endure the drudgery of *atelier* routine. Instead he would set up his easel in some dingy Montmartre alley or stay home, at his brother's, and paint still lives of mud-caked shoes or yellow-backed novels. Sometimes, without warning he would vanish for two or three days, only to reappear drenched to the bone, his clothes rumpled, his flaming beard unkempt. "I went to look at the trees," he would announce airily. "I can't breathe in cities. Where did I sleep? Henri, you are a very funny fellow! I don't remember where I slept. Some shack along the Seine. The rain? That is very funny. Don't you know that we Dutchmen laugh at rain? Look, Henri. Look what I did while I was away . . ." Bashfully, apologetically he would lean down, set a canvas against the wall. Something he had dashed off in three hours. A hodgepodge of Pissarro, Delacroix, Seurat, yet intensely personal. All wrong, and yet magnificent.

Or unexpectedly he would charge into the studio, panting from the climb, his portfolio under his arm, on his head a round fur cap that gave him the look of some eccentric Tennessee trapper. "Henri, you've got to teach me anatomy! I simply must know anatomy to be a good artist! Well, how do you like my hat? *Kolosaal, n'est-ce pas?* Very practical. In

winter you can turn down the flaps to keep your ears warm."
He would take a long gulp of rum from the small gourd
dangling from his neck and let out a long happy breath. *"Allons,
au travail!"* And the lesson would begin. "This, Vincent, is
the sternocleido-mastoid . . . This is the latissimus dorsi . . .
The gluteus maximus is the muscle you sit upon . . . The
principal feature of the bones of the head are coronoid,
condyloid, mastoid and zygomatic . . ." Before long Vincent
would hurl his stick of charcoal at the wall. "No use! I'll never
learn those names. I'm too old, too stupid. Let's go and have
some *stokvish*."

They would go to the small apartment the Van Gogh brothers
shared on rue Laval and Henri would be introduced to *stokvish*
with fried onions or some other delicacy of Dutch cooking,
as well as to a number of unknown and very loquacious Inde-
pendents whose work Théo endeavored to market in his shop
between sales of Meissonier engravings and Barbizon pastorals,
and who flung their futile challenge to an unappreciative world,
waved their frayed sleeves and declared themselves the victims
of obscure and dastardly conspiracies.

Such was Henri's life in his last winter as an art student.
But these were only the appearances, and like most appearances
they were deceptive. Henri was leading a double life. He was
a man with a secret. How did you go about getting a girl?

It had seemed very simple that morning at the *atelier*,
but on closer inspection it wasn't simple at all. First, where
were you going to find her? L'Ely? That's where his friends
found most of their girls. They always seemed to ferret out
some beady-eyed seamstress, some young laundress eager
for adventure and romance. They plied them with *vin chaud*,
danced with them and while whirling on the dance floor told
them how lonely they were and what wonderful *nuits d'amour*
they could have together. Sooner or later—often the first
night—they took them to their rooms, and for a week or
two the affair would be on. But to do that you must be able
to dance. So—that was out.

The street? Oh, yes, sometimes you found wonderful oppor-
tunities in the street. "They all want it," said Rachou, the
acknowledged master of the sudden attack. "If you try often
enough, you're bound to succeed. It's mathematical . . ."
He had made some spectacular conquests on the short span
between Place Pigalle and Place Clichy. But for that you must
first overtake the girl. How could you overtake anyone, when
you could barely drag yourself about and had to halt every

few steps to rest your legs? And suppose you did overtake her, what did you say to her? What did she say to you when she looked down and saw you, puffing, leaning on your rubber-tipped cane? So the street was out, too.

Then what? The brothel? The Perroquet Gris, on rue Steinkerque, where he had gone with his friends the day Bonnat had disbanded his *atelier*. The narrow shabby-carpeted stairs that led to the *salon,* the oleograph of Cleopatra on the wall, the red plush banquettes, the stench of cheap perfume and bare flesh. The girls, naked under their flimsy chemises or long-fringed shawls. Their cold hands, their painted lips like scarlet sores on their faces. It made you retch just to think of kissing those girls, let alone making love to them. They were fetid; they reminded you of public urinals. So—anything but the brothel. Anything . . .

Well, then? Then you went on dreaming about Julie, undressing girls in your mind, turning hot and cold each time a midinette passed you by in the street. You tossed in bed, moaned in your sleep and awoke tired, fretful, spoiling for a fight just to relieve your nerves. But you went on as best you could. At the *atelier* you toiled on some damn Venus or Sleeping Muse, kept yourself in check when Cormon rattled on about prettiness and pictorial refinement. You worked on Icarus, drank beer at La Nouvelle and *vin chaud* at L'Ely. And thus you managed to live through one day after another, hiding your secret as though it were some shameful disease; and since there was no one in whom you could confide, you kept your mouth shut. Perhaps this new kind of pain, this throbbing hunger of the whole body would finally pass. Perhaps things would straighten themselves out—somehow.

In March Lucas announced that his "impulse" for Julie was on the wane and he was getting tired of her. "She's a nice girl and all that, and at the beginning when she used to say no and slap me, she was fun. She gave me a real fight and I enjoyed every minute of it. But, damn it, now the fight's over and she should see it's time to say *au revoir*. After all, you may work like hell to get to the North Pole, but that doesn't mean you want to sit there all your life, does it?"

Encouraged by his friend's sympathy he described with righteous annoyance how Julie didn't play the game and was unreasonable and harassed him with her protestations of love and brimming amorousness. "You'd never think that three months ago that girl was a virgin the way she goes for it! Always dying to take off her clothes and jump into bed . . ."

Which all went to prove, Rachou commented, that once

you got a woman's glands stirred up she was like a cat in season and you had a tiger on your hands, and how those slim ethereal-looking blondes often surprised you, while those Cleopatra-eyed women usually turned out to be nothing but flabby brunettes when you had them between the sheets.

Curiously the news of Julie's fall from her lover's graces and her lively sensuality made her only more approachable, more desirable and if possible more real to Henri. She had been an image, voluptuous and remote; she became a woman of flesh and blood, unwise, carnal and hungry-hearted like himself.

A thousand absurd and thrilling fabrications took shape in his mind. He tried to deride his fancies, but how could you deny something you could see, hear and touch? For he could see the pink convolutions of her ears, the flexure of her nostrils, hear her whispers, feel the buoyancy of her breasts under his fingers, the wetness of her tears, the silkiness of her blonde hair. She had become a three-dimensional hallucination, more real than Madame Loubet, Cormon or his friends. Strange how something as imponderable as an idea could inflict pain as real as the piercing of a needle into your flesh. But there it was, as real as the *attaques* had ever been.

Hot black rages swept over him like the breath of an oven. He would have liked to shout, bang his fists on the wall, pace the floor in long angry strides. Yes, that would help, to pace, to walk the tenseness out of him. But he couldn't pace, could barely walk, and so he remained hunched on his little stool, rested his palette, removed his pince-nez, cupped his hands over his eyes, only to find Julie, nude and taunting, coiled like a miniature ivory-skinned snake in the palm of his hand.

At other time he told himself that if he abandoned himself, let himself go, wallow all he wanted in the mire of his thoughts, he might reach lassitude and rid himself of this obsession, this yearning or whatever this thing was that was driving him crazy.

He did. In his imagination he wrenched her clothes off, clawed the chemise from her back, shoved her onto the bed and threw himself on her like a man dying of thirst on a mudhole; he crushed her lips, sucked her mouth, kneaded her flesh with his feverish hands, ravished her with savage brutality until she lost consciousness and became a warm and bruised corpse, eagle-spread on the bed.

Sometimes it helped; most often it did not. And one evening, when he couldn't stand it any longer, he drove to Brasserie Moncey on Place Clichy.

Although technically a part of La Butte, Place Clichy had none of the atmosphere of Montmartre. Artists seldom ventured there. It was a bustling, commercial thoroughfare, lined with shops and cafés and graced with a huge statue of General Moncey standing in the center like a giant chessman.

The moment he entered the Brasserie Moncey he knew he had come to the right place. A glaring, clattering café that catered to a transient clientele. Not a familiar face in sight. And women—women everywhere! Which one would it be? That blonde in the green pelerine, or that buxom brunette choking to death in her corset? Didn't matter, didn't matter a bit . . .

He ordered a benedictine and toyed with the frail stemmed glass while watching the women's maneuvers. The procedure seemed to follow a well-established routine. A man would enter, sit down at a table, order a drink. Almost immediately a lorette would mincingly step up to him and ask him what time it was. If the prospect growled his reply and pointed to the large clock on the wall, negotiations came to an abrupt end. With a shrug the girl would return to her table. But if the prospect pulled out his watch, held it to his ear and with a smile informed her it was a quarter to ten, then she would slither down to his side, chatter vivaciously about watches and how undependable they were and how once she had missed a train—or a fateful appointment—because of the inaccuracy of her timepiece. This was meant to create an atmosphere of convivality and give the prospect an opportunity to appraise the girl's charms, breathe her heady perfume, feel the pressure of her thigh against his.

At this juncture one of two things would happen. The man would suddenly announce he was waiting for his wife or a friend and would mademoiselle kindly take herself off and stop pestering him. Or he would offer her a drink. In the second alternative the preliminaries were considered over, and the negotiations began.

The girl would cuddle to him, absently trail her long-nailed fingers over the parts she knew from experience to be most responsive, whisper in his ear what an expert *amoureuse* she was, how she always made it a rule to give full satisfaction, and how with such an attractive, virile-looking man she would hardly be able to restrain herself, and not let herself go and commit the most reckless *folies*. As a final inducement she would mention the proximity of the hotel, the cleanliness and coziness of the room, the springiness of the mattress, the discretion of the whole episode.

Then would come a rapid exchange of views on the question of terms. Everybody knew her price was and had always been twenty francs. Never, never had she as much as looked at a man for less. But for him—because he was so handsome and the look in his eyes did something to her—she would, yes, she would do it for fifteen. To this the prospect would retort with a rude and unequivocal snort. What did she take him for? A tourist? *Un Américain?* Five francs was his last word. He could get any girl he wanted for five francs. Sure, he could, would remonstrate the lorette, but what kind of girl? Old *pouffiassas* with wrinkled necks and flabby breasts who did it with anybody. But she was in radiant health, inside and out. However, because she was crazy about him and wanted at all costs to do it with him, he could have her for ten francs. But he must never whisper a word of it or her standing would be lost.

During this debate her hand would advance arguments of its own, and the prospect would begin to lose some of his bargaining powers. All right, he would go up to eight francs. The girl would give him a reproachful look. Like all handsome men, he was mean, but she simply had to have her caprice. All right, eight francs and a two-franc tip . . . That bout would come to an end. They would drain their glasses, rise and leave the café together.

Twenty minutes later she would be back, freshly powdered and rouged—and alone.

Henri had been so taken by the spectacle of several such encounters that he was startled to discover he had been almost an hour in the café and no girl had yet come to ask him the time. Surprise mingled with anger took possession of him. What was the matter with those girls? Didn't they see he was alone? Did they think he was too young, had no money?

His wandering glance focused on a chestnut-haired girl who was smoking reflectively, chin in hand, at a nearby table. She had lustrous eyes, a hard mouth and a glossy pompadour under her flowered hat. He looked at her with such insistence that she finally turned her head in his direction. He flushed and shyly smiled at her while his lips moved in a silent invitation. She did not rise, but peered at him through the smoke of her cigarette. He felt the antenna-like beam of her gaze trail over his face, travel down to his short rubber-tipped cane, rest an instant on his feet dangling a few inches above the floor. Then with the same impassive slowness she took another puff and turned her head away.

Stupefaction blocked his throat. His breathing stopped for

a second or two as he stared at her with unbelief, the small glass trembling between his fingers. Why, she had refused him! A ten-franc tart had refused him! Didn't want to be seen walking out with a hobbling, panting cripple . . .

His breath returned in rushing draughts. His heart pounded in his chest, thoughts whirled in his brain. None of these tarts wanted him. That's why none had approached him, asked him the time. Perhaps no girl would ever want him, perhaps they would all turn their heads away . . .

He seized his cane, slipped down from the banquette, and leaving his drink untouched hurried out of the café.

During the following days he managed to shy away from the truth, and by a reflex of self-preservation to deceive himself into some precarious peace. The girl hadn't meant to refuse him . . . Anyone could see she was lost in thought, expecting someone . . . The others? They were too busy, and those who weren't just hadn't noticed him, that's all. Too many people around, too much noise . . .

He pretended to believe it and tried to dismiss the brasserie episode from his mind. He even tried to dismiss the matter of women altogether, and in a certain measure he succeeded.

With passion he flung himself into his work. At the *atelier* his Venuses and Ledas became marvels of minutious "licking," and Cormon was moved to enthusiasm. "Very good, Lautrec, good. You may not have pictorial refinement or natural talent, but you've proven that hard work can make up for everything." At the studio he toiled unrelentingly on Icarus, chatting with Madame Loubet to avoid the silences that led his mind into dangerous paths. At La Nouvelle he surprised his friends by his loquaciousness and relieved their gloom with many rounds of beer and provocative discussions about art. When the talk veered to women he did his best not to listen. The nights were the hardest. In the defenselessness of sleep dreams tormented him. He took the habit of reading in bed until he fell into exhausted slumber, the book still open on the coverlet, the lamp still burning on the bedstand.

Thus spring went on, and one morning he was awakened by the chirping of swallows. He climbed out of bed, reached for his cane and shuffled to the window. There he stood, barefooted in his long woolen nightshirt, looking like some ludicrous bearded angel. With a smile he watched the birds playing, racing, sliding down imaginary chutes, flashing by like winged bullets, filling the courtyard with their strident twitter. What a lovely day!

"Perfect for a picnic."

He whispered the words, and before he could check himself the tender and cruel mirage forced itself on his mind. A river bank—the Seine perhaps, or the Marne, or some unnamed lazy river . . . Julie stretched out on the grass at his side, pretending to sleep . . . The afternoon sunlight sieving through the foliage, dotting her face with moving little freckles of light which he tried to kiss . . . The pecking game turning into kissing, then fondling, then loving . . . Her blonde hair undone, like a puddle of sunlight on the ground . . . Her arms spread out, hands upturned in the crucifixion of pleasure . . . Ecstasy under the trees . . . Then later, much later, Julie sitting up, hastily smoothing down her skirt, refastening her blouse, picking blades of grass from her hair, pretending to be ashamed of their misconduct. And he, smiling, blaming the spring, explaining that that was what picnics had been invented for, not just for eating ants with your food . . .

With an effort he wrenched himself from the tantalizing fancy, turned away from the window and hobbled to the washstand.

"Get up, Grenier! Time to get up!"

That day he labored on "Andromeda on the Rock," the subject of the week. Cormon had told them the hoary legend of the mythical princess sacrificed by her royal parents to the lust of a fearful sea serpent that scourged the nation's shores. "Imagine, if you can, the terror of this lovely adolescent standing in the stormy night, naked, defenseless and chained to her rock as she spies the monster swimming toward her! This, *mes amis,* is the pose, the fleeting instant of dramatic beauty you must strive to capture. To do that you will raise the eyebrows, turn her eyes upward, part her lips as if an inaudible cry were passing through them. Yet, don't forget that even in her plight, Andromeda must remain alluring, artistically seductive . . ."

With a sigh he glanced at *la grosse* Maria standing on the model platform. How the devil did you make her alluring and artistically seductive? Look at that weary, brutish face, those tufts of coarse black hair under her arms, those meaty thighs! Oh, well—only a few more weeks and there would be no more Andromedas, no more "licking."

That afternoon he finished Icarus. With moist eyes Madame Loubet watched him scrawl his signature in the right-hand corner of the enormous canvas.

"He looks wonderful, Monsieur Toulouse. Just like a photograph."

It had been nice having him in the house. Always so polite and friendly and full of delicate attentions. Now it was all over. Next winter he wouldn't be here. He would rent a studio in some elegant district, not this disgusting Montmartre full of riffraff and hooplalas. It would be lonely without him in this big house. Not hearing any more his halting steps as he shuffled by her lodge, not being able to watch over him, bring him bowls of *tisane* . . .

"He looks just like he wanted to fly out of the canvas," she elaborated, pushing back the tears.

He laid down his palette and, smiling, turned to her. "I'm glad you like it, Madame Loubet. I'll tell you what I'll do. After the Salon, I'll have it delivered to you and you can hang it in your lodge. Yes, yes, I insist."

He saw she was about to cry and took her hand. "It'll be a little souvenir for all you've done and the happy hours we've spent together. We did have fun this winter, didn't we, Madame Loubet?"

He thought of asking her to come with him next winter and become his housekeeper. But it was too early yet. First he must be accepted at the Salon . . .

"Now I must go to Tanguy's," he added quickly, "and order a frame. Do you think I should wear my overcoat? It's quite warm outside."

Instantly she was herself again. "Of course you must wear your overcoat, Monsieur Toulouse. Don't you know you can't trust this Paris weather. One moment it's hot, and the next you catch your death of cold . . ."

Her warnings still rang in his ears as he left the house and started down rue Caulaincourt. The sun was warm, the sky pale blue and cloudless. His legs did not hurt and Icarus was finished—thank God! He felt free, happy, brimming with unspent tenderness. Good old Montmartre! Good old stinking rue Caulaincourt! He would be sorry to leave it, its saggy houses and grimy façades, its worn cobbles, its friendly people. Even its stench he would miss . . . It was a delicate, complex stench, a blend of various odors, none of them good: frying fat, garbage rotting undisturbed in dim hallways and the dank smell of poverty—real, unromantic, centuries-old poverty.

Now and then he paused to rest his legs, then resumed his walk, waving back at the laundresses who leaned out of their windows to call a neighborly greeting as he hurried by.

He did not know them, but raised his hat in reply, and his courtesy enchanted them. "A real *monsieur,* even if he's a midget," they sighed, returning to their tubs.

Home laundering was Montmartre's sole industry, tolerated only because it provided a livelihood for women too ugly, too old or too young to take care of themselves in easier, more pleasant ways. All Montmartre women were born to it; some never left it; most died at it. You began as a pig-tailed gamine of seven by delivering the wash in the district. At fourteen you graduated to the tubs. Ten hours a day—two francs. You scrubbed, rubbed, squeezed, swung the bat, endured the bite of lye on your hands, bent hour after hour over the steamy vat, your feet in the soapy mire. Then one day you bolted, swore never to come back. Whoring was fine; easy work after tubbing. But it didn't last forever. The day came when even the lowest brothel didn't want you any more. What then? How were you going to eat? No garret was too small, no basement too foul for a tub, and so you returned to the gagging steam, the lye, the aching back, the square bat, until one day you died.*

At the corner of boulevard Clichy he hailed a roving fiacre, "Rue Clauzel," he cried to the *cocher.*

Père Tanguy was smoking his pipe and sunning himself on the step of his blue-fronted shop when the carriage came to a halt. At the sight of Henri he sprang to his feet, made a windy gesture and inquired about his precious health.

"A frame, a frame for your *envoi* to the Salon," he said frowningly several minutes later when Henri had at last been allowed to explain the purpose of his visit. "I'll do it, but first I must make my position clear . . . With me it's a question of principles, and when it comes to principles I am rocklike, I don't budge a centimeter. As an anarchist I must warn you that I disapprove of the Salon and all capitalistic and bourgeois art manifestations. In my opinion all academicians should be shot." With this he plunged under the counter and reappeared holding four dusty samples of frame moulding. *"Voilà!* Take your choice."

Henri chose one and Tanguy wrote the dimensions of the frame on a scrap of paper. Then dramatically he put a finger to his lips, tiptoed to a portfolio in the corner and pulled out a Japanese print.

* One of Lautrec's greatest works is the portrait of a young Montmartre laundress gazing longingly out of the window. Daru Collection.

"Something *extraordinaire!*" he whispered, holding the print as if it were the Sacred Veil. "An Utamaro, monsieur. An Utamaro triptych."

It showed three geishas at the seashore. One was combing her hair, another knelt on the sand looking for shells, and the third gazed unseeingly at the shimmering waves. It was a thing of exquisite grace, a graphic whisper, music in lines.

"It's beautiful," said Henri sitting down on a chair and taking the print from Tanguy to study it more closely. "How much do you want for it?" he asked after a while.

Tanguy looked hurt. "It's not for sale. I just wanted to show it to you. I've grown as attached to these girls as if they were my own daughters."

"But they aren't your daughters, Tanguy. They've been dead a hundred years. Come on, be nice and tell me how much you want?"

"I told you I love these girls as if I were their father. You wouldn't want me to sell my own daughters, would you, Monsieur Toulouse?"

"But, Tanguy, they aren't your daughters. You have no daughters."

"I can't do it!" said Tanguy with a tragic gesture. "Ask me anything, but . . ."

A tired voice rose behind them. "Twelve francs, and fourteen if you want it framed."

Tanguy whirled on his heels as his wife shambled out of the back room, a heap of paint tubes in her arms. *"Chérie!* How could you? An Utamaro, an Utamaro triptych!"

Ignoring him, she walked to the counter, calmly began wrapping the tubes in an old newspaper. "Don't pay any attention to him, Monsieur Toulouse. He never wants to sell anything. Last week someone came in and asked for a Cézanne —the first one who ever did, mind you—and Tanguy asked him ten thousand francs! Thank God I was here and sold it for twenty-five. Imagine, just three little apples."

"Women don't appreciate art," sputtered Tanguy, flapping his short arms. "All they ever think is money, money, money!"

For a while husband and wife quarreled with the violence of people who are sure of their love. Finally they kissed and made up.

"Now you go and deliver these paints to Monsieur Degas," she said, pushing the package in his arms. "And don't stay all day talking with Zoé in the kitchen telling her what a wonderful cook she is and how you wish you could marry her."

Tanguy snatched his round straw hat and escorted Henri back to his carriage. "Between you and me women are an inferior species," he said when he was out of earshot. "They don't appreciate the finer things."

Henri said good-by and turned to the *cocher*. "La Nouvelle Athènes—and take your time."

He settled back on the seat and gazed upwards. Between the roofs the strip of sky was pink. It was the hour of sunset, unnoticed in cities, so beautiful and solemn in the country. His mind wandered back to the long-ago sunsets at the Albi château. In a flash he saw the lawn veined with the shadows of sycamore limbs, Dun asleep under the garden table, his mother bent over her sewing and himself at her feet, sketchbook in hand. "Please, Maman, don't move. I'm going to do your portrait." How far away it all seemed!

At La Nouvelle he found his friends talking about their *envois*.

"I'm sending an Early Christian," said Rachou. "You can't go wrong with a *sujet religieux*."

Over their beer they discussed women and various subjects, but their uneasy thoughts turned to the future.

"If I had to do it again, I'd be a pharmacist," said Gauzi. "Every time somebody gets sick you get richer."

"Dentistry, that's a career for you!" mused Anquetin through a cloud of smoke. "Every mouth a gold mine."

Obscurely they searched for a culprit and with the unfairness of youth they focused their resentment on Cormon, who had led them into an unprofitable career.

"That son of a whore should've told us you can't make a living as an artist," remarked Grenier, knocking the bowl of his pipe against the edge of the table, "instead of rattling on about his damn Venuses and Andromedas."

"Andromeda!" minced Gauzi, mimicking the professor's fluted voice. "*Ah, mes amis, quel sujet dramatique!* Imagine the terror of this poor girl as she spies the sea serpent swimming toward her!"

"And when you get raped by a sea serpent, let me tell you you do get raped," chuckled Rachou with an echo of the old boisterousness.

They dined at Agostina's and afterwards went to L'Ely. For Henri the evening wore on like countless others. He drank *vin chaud*, watched his friends cavort on the dance floor, waved at them whenever he caught their eye and made little sketches.

It was past ten o'clock when a girl whirled by in the arms

of a jerseyed lout. Because of the dimness of the hall he could barely distinguish her features, but he guessed she was young. Young and very much in love with that stupid, foppish hoodlum . . .

Suddenly, unreasonably, the cautious edifice of his peace collapsed. All at once his mind was on fire, his whole being rebelled against the injustice of his fate. What had he done that he couldn't dance like his friends? Why couldn't he hold a girl in his arms, why couldn't he be loved, he who wanted love so desperately? What crime had he committed, why was he punished? Why? Why? His palms were moist, his teeth clenched in fury, his body coiled in an unendurable spasm of desire and anger. He must have a girl—any girl. Now, right now . . .

Without waiting for the end of the dance he hurried out, climbed into a fiacre.

"Brasserie Moncey."

Why Brasserie Moncey? He couldn't have said. It was the first name that had come to his mind.

The café was as it had been that first night. Bright lights, waiters rushing about while others stood by, their napkins folded over their arms, watching their tables with the air of gloomy shepherds. Lorettes were sauntering to prospects, asking the time.

He ordered an absinthe, tossed a lump of sugar into the glass, added some water and gulped. The liquor had not had time to dissolve and tasted thick and oily. Yes, he was going to get one of these girls. This time he would be bold, he would make his intentions clear.

"Another absinthe," he called a moment later, as the waiter passed by.

Now the banquette was rocking under him, the marble top of the table was thawing out. In the room people had shuddering faces, the gas jets in their frosted globes looked like fuzzy balls of yellow wool. He felt extraordinarily light and free. A cripple—who was a cripple? Why he could leap over this table! He could fly like Icarus. And strong! Let anyone say a wrong word, smile the wrong way, and he'd show him! A shove, just a little shove, that's all . . .

A buxom young lorette came to sit at the next table. She had a bright red mouth and the face of a depraved doll. She crossed her legs, lit a cigarette and pulled a letter from her large black leather bag. He watched her as she read, forming the words with her lips, her face half-hidden behind the smoke. That was the one . . . To save her all embarrassment he

would meet her outside, they would drive together to her place . . .

He leaned toward her. "Mademoiselle," he whispered, "would you care to have a drink with me?"

She raised her eyes. "Can't you see I'm busy? If I had that face of yours and those stumps, I'd go and hide myself." She returned to her letter.

Her words coursed through him like an electric shock. For a moment he thought he was going to die. He closed his eyes. So it was true . . . Even a tart did not want him. No girl would ever want him. He would be alone—always. Until now being a cripple had only meant the pain in his legs, the panting and halting when he walked, the rubber-tipped cane. Now it also meant he would never be loved, never go on a picnic with a girl, never receive a loving kiss . . . Well, by the beard of Saint Joseph, he'd show them if he couldn't get a girl! Show them if he couldn't buy the thing anyone in Paris could buy for ten, five, three francs. He would go to a brothel, yes, to a brothel . . .

He opened his eyes. The girl had moved to another table. He reached for his cane and went out.

"To the Perroquet Gris, rue Steinkerque," he called to the *cocher*. "And hurry!"

When he returned to his room that night he sank on the little chair by the window and remained motionless in the darkness, his hands clasped between his knees, too tired to undress or light the bedstand lamp. No, he hadn't gone to the brothel. Up to the door though . . . almost rung the bell . . . Then his courage had failed him. From behind the yellow-streaked shutters came the muffled racket of the mechanical piano and the sound of laughter. He had visualized the crowded salon, acrid with smoke; the men red-faced with wine and lust, the girls sprawled on the banquettes, coaxing, obscene; the madame, like a grotesque idol, sitting behind the counter. What would they say when he dragged himself in? Laugh, make coarse jokes about his legs, his lovemaking? No, he would never go into those places. He couldn't, simply couldn't . . . And if he had to go on like this, moan in his sleep, endure those dreams of picnics and naked women, well, he would moan and endure.

Vacantly he gazed out, watched a moment the silhouette of Degas moving across his lighted window. His eyes trailed over the quadrangles of yellow light in the courtyard. Perhaps some couples were making love behind those windows. Well, let them . . . At this moment, all over Paris hundreds, thou-

sands of couples were caressing each other, searching each other's lips. Well, let them . . . He was a cripple—a dwarfish, grotesque-looking cripple. And he'd never be loved.

"You're a cripple, Henri. An ugly cripple. Never forget that . . ."

Despair surged through him like a wailing chant. He felt the wetness of tears rolling down his cheeks. His hands cupped over his face. Words came out in a sob.

"Maman, why didn't you let me die?"

VIII

The Chateau de Malrome slumbered in the torpor of
that August afternoon. It was the siesta hour when fields
and vineyards lay unattended in the sun, and farm hands,
their hats over their faces, snoozed in the shadows of haystacks.
All was stillness, heat and silence. But at Malromé silence
was not the restful pause that brought vigor and zest to
men and beasts alike; it was the oppressive breathlessness
of some mournful fairyland, the soundlessness of places from
which life had departed, a hush of time in suspense that fell
upon the vast walled-in garden with its winding sanded drive-
way, its dahlia beds, its glassy pond and crested iron gate,
tall and black like a cemetery's.

On the shady terrace at the back of the house, Adèle, Com-
tesse de Toulouse-Lautrec, sat watching Henri, in white linens
and espadrilles, stretched out on the ratan chaise-longue for
his usual after-lunch nap. He slept peacefully, his pince-nez
askew on his nose, one hand on his chest, the other hanging
limply at his side. His thick lips, scarlet and moist, moved
imperceptibly with each intake of air. The book he had been
reading lay on the flagstone floor near a half-filled glass
of lemonade.

He had come home at last! His foray into the world had
ended disastrously, yet mercifully. Poor Riri, he had been
brokenhearted over his failure to "make" the Salon, as he
said, but the pain had begun to dull. He was not restless;
he appeared content, almost happy. He strolled through the
garden in the morning, drove occasionally to the rectory for
a game of checkers with Abbé Soulac, read, slept a great
deal. Late in the afternoon they took long drives together.

He never complained about the monotony of this life or the lack of friends, never mentioned Montmartre. He had been hurt, terribly hurt. He had learned the truth about himself. Perhaps he had reconciled himself to his fate. Resignation was a form of happiness. Next year he would perhaps return to his books. Books would protect him. He would no longer be hurt . . .

She saw him stir on his chaise-longue and quickly lowered her eyes.

"Enjoy your siesta?" she smiled, adjusting her thimble.

"A fly awoke me." He grinned back. "Why is it that with all the world to land on a fly must always light on the tip of your nose? I've slept enough anyway. What time is it?"

"Exactly two fifteen," said "Tante" Armandine, rumpling her newspaper to glance at her lavalliere watch.

"Henri," said the countess after a pause, "how would you like to spend the winter in Italy?"

"Very much." Dear Maman, she knew he was dying of boredom and was offering him the diversion of a journey. "But hadn't we more or less planned to stay here until Christmas?"

In a flash he recalled the previous Christmas Eve in his mother's sitting room, how he had pleaded with her to spend the autumn at Malromé, how she had suggested asking Madame Loubet to become his housekeeper. Had there really been a time when he believed he would become a fashionable portraitist with a beautiful studio in some aristocratic district? Only four months ago, yet it seemed as unreal as the Canadian plans he had made with Maurice.

"Remember how we argued about it?" he said.

"I do, but I never was keen on spending the winter here. Malromé isn't a winter home. How would you like the Italian Riviera?"

"How about San Remo?" he said eagerly, delighted at being relieved of his sacrifice. "We saw it from a distance, remember, the day we drove to Menton. They say it's very lovely. Later we could go to Florence and Rome. I'd like to see Michelangelo's ceiling in the Sistina. They say Raphael almost fainted the first time he saw it. Do you think we could go to Rome?"

"I don't see why not. We could leave by mid-October."

"Why not leave the first—or even next month?"

She smiled. Impatient, impetuous Riri, ready to pack and leave this minute! Like Alphonse, who couldn't brook any delay. "The fifteenth will be soon enough. The autumn rains

will have set in by then and we'll appreciate the fine San Remo sunshine all the more."

"This evening I'll write to Bordeaux for some travel pamphlets." He leaned down to pick up his glass and emptied it into one of the flower pots on the terrace balustrade. "Annette would be hurt if she saw I hadn't drunk her lemonade. She must think I'm a sponge."

"It's her way of showing her love."

Hardly had she finished speaking when there was a flutter of light footsteps and Annette appeared, her white coif flapping, a glass in hand.

"Ah, thank you, Annette," Henri exclaimed, taking the fresh lemonade. "I was just saying you make the finest lemonade I ever tasted."

The old servant watched him sip the unwanted drink, gave him one of her adoring toothless smiles, and was off.

Again he emptied the glass into the pot. "This geranium is going to start sprouting lemons."

He set the glass down on the floor by his chaise-longue and picked up his book. For a while he pretended to read, but his eyes wandered up to the sky and he leaned back on the chaise-longue. That cloud there, was it a new cloud or had it been there all along? Clouds were tricky. Some appeared on the horizon no bigger than a rabbit's tail and by the time they sailed over the house they were as big as icebergs. Others frittered away into nothingness. Some highly moral fable could be written about clouds . . . There were friendly clouds that beamed down at you like jovial clownish faces; others frowned and grimaced. There were bachelor clouds, family clouds surrounded by their flock of cloudlets . . .

Idly he scanned the summer sky. What a lovely day . . . With an inner smile he recognized the words. That's what he had said the morning he had watched the swallows . . .

The image of himself standing barefooted at the window brought that of the imaginary picnic with Julie. Again he saw himself kissing the freckles of light on her face, but this time he did not allow the fancy to linger in his mind. Enough of that . . . He was a cripple, and cripples didn't go on picnics, didn't make love under the trees. They stayed home. Some people managed to live without love; he must learn to do the same, forget about romance, kisses in moonlight and all that nonsense. He must forget about women. Hadn't they cost him dear enough already? Cost him the Salon, his career?

What had possessed him that morning at the *atelier?* For

the thousandth time the question returned unanswered to his mind. What had possessed him to defy Cormon? He didn't know, couldn't explain it except that perhaps when you reached a certain point of despair, a certain limit of fatigue and discouragement you said things you never meant to say, you lost your self-control and went almost crazy for a while. He had not slept. All through the night he had heard the words of the *brasserie* tart, "If I had that face of yours and those stumps, I'd go and hide myself." He had been ill and feverish when he entered the *atelier*, and why he had gone there that morning he couldn't explain either . . . He still could taste the bitterness of absinthe. His eyeballs were hot and gritty, his nerves like filaments of torn flesh.

Cormon had stopped at his easel and started his usual patter. "Very good, Lautrec. One can see you try hard. Of course you have no pictorial refinement, no natural talent, but not everyone can be gifted, *n'est-ce pas?*" Any other day it would have meant nothing. He would have remained on his canvas stool and meekly gone on painting. But not that morning! Something had caught fire. A sudden white-hot fury had seized him. Swinging around, he had told Cormon what he thought of his pictorial refinement, his pretty pictures and ladylike nudes. Oh, he had had five minutes of fun! He had shouted and scoffed and laughed . . . Oh, yes, it had been a good show! And all the time he had been aware that he was smashing his future, committing artistic suicide, but at the time he hadn't cared. It had been one of those unexplainable outbursts, one of those flashes of madness when you reach the breaking point and nothing matters and you don't give a damn about anything any more . . .

He turned on the chaise longue to see Joseph coming onto the terrace, a small silver tray in his hand.

"The carriage is at the gate, Madame la Comtesse."

She took the card, looked at it with an incredulous gasp; then, forgetting her usual reserve, sprang to her feet.

"*Mon Dieu!*" she cried. "It's Angélique!"

Angélique? Angélique? Who the devil was Angélique? And what did she mean by calling at siesta time? And he, caught in espadrilles and without a tie!

He rose grumpily from his chaise-longue to follow his mother, who was already on her way to the perron, followed by a much-agitated Armandine. He picked up the card lying on the table and read "Madame la Baronne André de

Frontenac." The name meant nothing to him until he was halfway to the front terrace. Then it came to him in a flash. But, of course! Angélique was Maman's schoolmate at the Sacred Heart Convent in Narbonne. That inseparable friend of hers who had married a Navy officer and had gone to join him in Martinique. Or was it Madagascar?

When he reached the perron, an old-fashioned brougham was waiting in front of the steps. A footman leapt to the ground, opened the door and lowered the footboard.

Inside the carriage there was an indistinct stirring of veils. Like the head of a cautious snake the tip of a dainty black slipper appeared on the door sill. Presently a plump middle-aged lady, swathed in mourning veils, came into view and with a birdlike cry plummeted down into the countess' open arms.

"Adèle!"

"Angélique!"

So dramatic and eye-catching was the ladies' embrace that Henri almost failed to notice the appearance of another visitor in the carriage doorway: a young girl, seventeen or eighteen, he judged, dressed in mourning, gingerly lifting her skirt to ankle height as she stepped down on the footboard. He caught his breath. Julie! . . . The refutation followed on the heels of the thought. Of course, it wasn't Julie . . . Julie had been blonde; this girl's hair was chestnut, almost auburn. Besides, she didn't look in the least like a midinette.

"My daughter, Denise," introduced the baroness, weeping furiously, and pushing back her long black veils as she fumbled through her reticule for a handkerchief. "She was born at Fort-de-France."

Denise performed a graceful curtsy and demurely accepted the kiss the countess pressed upon her brow.

One hour later Henri had listened to endless convent reminiscences and learned the genealogy, the trials and tribulations of the Frontenac family in the last twenty years, for the baroness was a tireless talker. She could talk while fussing with her mourning veils, fanning herself with her handkerchief, sipping tea and dipping her pudgy hand in the Sèvres pastry dish.

"And now that my poor husband is dead—" tears gushed out of her eyes as she slipped a *petit four* in her mouth "—Denise and I are all alone in the world." She turned to her daughter. "*Chérie,* why don't you go and play the piano for Monsieur de Toulouse-Lautrec?" She added, turning to Henri, "She is an excellent pianist."

Dutifully the two young people rose from their chairs.

Henri hobbled to the living-room door and held it open for her.

While she played—and indeed she played well, without the usual girlish mannerisms—he observed her from the sofa, his hands on the crook of his cane, watching her graceful silhouette outlined in the sunshine against the French window at her back. It occurred to him that in her youth his mother must have looked very much as Denise did now.

"Shall I keep on, or have you had enough?" she suddenly asked, smiling at him across the length of the grand piano. "Wait!" she cried before he could reply. "I want to play you my favorite piece. It is by César Franck, a contemporary composer, not very well known. Papa loved it. He used to make me play it often when he was home. It's called Prelude, Chorale and Fugue."

When the last chord had spent itself, she swiveled on the piano stool, one hand still on the keyboard. "I can see you really like it. I am so glad! It's really a beautiful thing, isn't it?"

She rose and came to sit on the sofa next to him.

"I'm sorry we dropped in on you like this, but Maman has been beside herself since Abbé Soulac came to call on us this morning. To make conversation she asked him the names of the families who spend the summer in the neighborhood. Not that we can go anywhere, mind you, we are in full mourning, but you've seen how Maman is, she likes to talk . . ." They exchanged the conspiratorial smiles of young people discussing their parents. "When he mentioned that your mother lived only four kilometers away, I thought Maman was going to have a stroke! She could hardly eat her lunch, and rang for the carriage as soon as she left the table. It is an amazing coincidence when you think of it, their finding each other after all these years, isn't it? But I'm afraid we interrupted your siesta. I could see you from my seat and you looked furious when we arrived."

He swore that, on the contrary, he was delighted by their visit. Laughingly she replied that she did not believe a word of it. He protested all the more. She still would not believe him.

"You are a very poor liar," she teased. "I can lie very well, if necessary."

"Perhaps lying comes naturally to women," he ventured with a smile.

Whereupon the conversation veered to lying in general, women's natural aptitude to lying, the requirements of a

good liar, the differences between "real" lies and social courtesies. Ten minutes later they were old friends and called each other by their first names.

"Have you driven through the countryside?" he asked. "The surroundings are quite beautiful."

She leaped at the chance. "We haven't been anywhere. I told you we only arrived a few days ago. Henri, do you think we could go driving together? After all, even people in mourning can go driving, can't they?" With an almost imperceptible wink, she added, "It would give us a chance to escape from our families. Besides, our mothers are such old friends it almost makes us cousins, doesn't it?"

A new routine established itself. Every afternoon the Frontenacs came to Malromé, and Denise and Henri went for long drives together while their mothers and Armandine visited on the terrace.

For Henri, Denise's arrival broke the stifling monotony of summer and revealed to him the delicate pleasures of feminine companionship which he had never known. It occupied his mind, torn with regrets of a wrecked career and the prospect of a lifetime of idleness. More: it appeased the turmoil of his awakening manhood. From the beginning he discarded all thoughts of possible romance between them and set out to enjoy the fortuitous hazard that had landed this delightful *jeune fille* into his lonely life. He spent more time at his toilette, trimmed his beard with greater care, buffed his nails until they sparkled; he sent posthaste to La Grande Maison de Blanc in Paris for a dozen of their finest linen shirts and explained to Annette that the crease of his trousers must be razor-edged—*absolument comme un rasoir*—and took to wearing the massive gold-seal ring his mother had given him on his twenty-first birthday. But he did these things without romantic afterthought, merely because he had fastidious tastes and Denise appreciated good grooming.

While eating breakfast he planned the day's promenade with Joseph, skillfully varying the itinerary, selecting picturesque goals for their excursions. From Abbé Soulac he borrowed a book on local history and became an erudite as well as an entertaining guide. If they visited some ancient shrine, he was ready with an account of the miracles that had taken place there. Were they driving to the lichen-covered ruins of some medieval fortress, he could tell the story of the seigneurs who had built it.

Since they stood on old Aquitaine soil, ruled over for cen-

turies by his family, it was natural that the names of various Comtes de Toulouse should creep into his explanations, and a light of admiration would come to Denise's eyes.

"How proud you must be to be a Toulouse-Lautrec!" she remarked one day as they were driving home in the quiet of an early autumn sunset. "We Frontenacs come also from this region, but the family château was destroyed long ago. During the Revolution, I believe. Perhaps my ancestors were vassals of yours? Can't you just see my great-great-great-great-great-grandfather doing obeisance—" her use of the ancient word enchanted him "—to your great-great-great-great-great-grandfather? Perhaps they went to the Crusades together?"

As much as their genuine companionship and the similarity of their tastes, this bond of social kinship created an easy familiarity between them. She was no Montmartre midinette; like himself, she was an aristocrat. She belonged to his world, shared the same traditions, the same prejudices, the same code of etiquette. It made her seem very close, at times almost the sister he would have liked to have.

October brought the first heavy rains, and the drives had to be discontinued. But now they had found another diversion. He was painting her portrait.

She still came every afternoon, stopped in the glassed-in veranda to curtsy to the countess and Armandine; then, while her mother joined the ladies and pulled her knitting from her handbag, she scurried upstairs to the "studio."

"*Bonjour*, Henri," she would cry from the doorway, a little breathless from the climb, already untying her bonnet. "How's our masterpiece today?"

Babbling away she would walk to the mirror, smooth her hair, run her hands over her hips. "Well, do I meet the approval of *monsieur le portraitiste?*" She would take her seat on the model stand and resume the pose. With a professional frown Henri would direct, "Tilt your head a bit, Denise . . . Not so much . . . Good. Drop your right shoulder just a little . . . Perfect. Now see if you can sit still for a moment." When she tired, he would declare a fifteen-minute recess and ring for tea. Chatting and laughing they would devour mountains of *petits fours,* while outside rain sloshed against the windows and the wind rattled the shutters. Let it rain, let it howl! What could be more perfect than to be here, marooned in this room, the logs crackling in the fireplace—and Denise . . .

One day she set her cup on the table and impulsively took his hand.

"Henri," she murmured. "I'll never know how to thank

you. You have been so kind. No, no, don't protest! If I hadn't met you I don't know what would have become of me. I would have died of boredom, I suppose. You are the nicest man I've ever known."

"I haven't done anything, Denise." This unexpected departure from her usual reserve took him by surprise and sent the blood to his cheeks. "It was I who was dying of boredom when you arrived. You are the sweetest girl I've ever met."

For an instant his eyes rested on her, soft and intense. Then he gave a brisk little pat to her fingers and reached for his cane. "But this mutual admiration won't get your portrait done. Hurry up, drink your tea and back to work, young lady!"

Words can create feelings. This insignificant episode, this spontaneous outburst of gratitude on Denise's part changed their friendship to intimacy. Unconsciously the melancholy of autumn sharpened their respective loneliness; their relationship became the only outlet of their youth. In the insidious privacy of the sittings they began exchanging confidences. She told him about her father, who had just died of yellow fever in the Indo-China campaign and whom she had loved intensely, much more than she loved her mother; about the convent from which she had just emerged and the pranks the girls had played on the nuns; about Fort-de-France, where she was born; and about her creole *nounou*, who practiced voodoo in secret and made her wear amulets against the evil eye; about her childhood in Tahiti, where her father had been stationed for many years.

In turn he told her about his illness, blood brother Maurice and the Canadian project, his years in Montmartre as an art student, La Nouvelle, Agostina, how Rachou had moved his furniture in a hearse, and how Madame Loubet had refused to believe his name was Toulouse— "Toulouse isn't a name, monsieur, it's a town."

"Don't you ever miss Montmartre?" she asked one day.

"I did for a while—terribly. But I don't any more."

It was true. Indulgently he looked back on his ambition to "make" the Salon and become a professional portrait painter. He dismissed his former fancies of studio romances and picnics with tender-smiled grisettes as the fancies of an emotionally immature and very foolish young man. Life was serious; life was dignified. Almost unconsciously he began thinking of himself as a sort of youthful Grandpère Celeyran, a peaceful gentleman-farmer living retiringly on his land, supervising the exploitation of his domain, visiting his tenants and clinking

glasses with them, driving in a buggy to the winery, watching the harvest. Growing old without regrets or bitterness in a home warmed by the tender companionship of a wife and brightened by the laughter of children.

In the choice of this imaginary wife, his thoughts turned with increasing frequency to Denise. Gradually he ceased to see in her the unhoped-for diversion of a tedious summer, but the future Comtesse de Toulouse-Lautrec, the companion of his life. And with this change of attitude his peace of mind vanished.

She liked him; of that he was sure. But did she like him enough—he did not dare to hope for love—to become his wife? True, he was ugly and a cripple. The *brasserie* tart's words rang in his ears. Yet some girls did marry cripples. After every war, a number of them gave their hearts to crippled, blinded, mutilated veterans. Was Denise one of those admirable, selfless girls, or was she—well, like any ordinary girl, susceptible to a pleasant face and a handsome physique? Did she understand there was more to love than a brief romantic infatuation and that lasting happiness rested on something more than a pair of sturdy legs and regular features? Did she come to Malromé because she longed to be with him? Or did she come out of boredom, because her mother's company was even less attractive than his own, and mourning had momentarily excluded her from the companionship of more attractive young men?

Like a hunter in ambush he began watching Denise, noticing, analyzing, interpreting every look, every intonation, every gesture, for a hint of her feelings toward him. To the hungry heart every scrap is food. His mind lost its keenness; soon her laughter had a new caressing ring; her most banal remarks concealed tender innuendoes. Yes, she did like him, like him enormously, more than anyone she had ever met, she had said so herself. She was impressed by his title, his fortune. They belonged to the same social world. Did it take more to make a happy marriage?

By the very old, very simple and very human process of self-deceit, he came to find in Denise the qualities he wanted to find, and believe what he wanted to believe. As in the days of his convalescence, a bubbling, irrepressible exultation took possession of him. He lived a lucent dream. The world, even the dreary November world, became alive with songs that only he could hear.

Meanwhile everyone must share in his secret fortune; he must be surrounded by smiling faces. He had been good-

humored; he became effusive, an apostle of good cheer, a professor of optimism. In the morning he would greet Joseph with a jaunty, *"Bonjour,* Joseph!" If by chance it did not rain, he would remark, "Gorgeous autumn we're having, don't you think?" If it poured, "The crops will be splendid next spring. Nothing like rain, you know, for the crops!" While eating breakfast he would upbraid him for his lack of joviality. "Joseph, you're getting old. Old and gloomy!"

"Yes, Monsieur Henri." Placidly the old servant went about the room, opening drawers, laying out Henri's clothes.

"The trouble with you is that you never married. Everybody should get married. Man wasn't created to live alone."

"Yes, Monsieur Henri."

"Were you ever in love?"

"Yes, Monsieur Henri."

"Then why didn't you marry?"

"Never asked her."

"There, you see! No passion, no *élan.* Women love men who are forceful, daring."

"Yes, Monsieur Henri. Will you have your bath now or later?"

But most of all he wanted to make his mother happy. A change had come over her lately. She had welcomed Denise's visits at first, encouraged their drives; but in recent weeks he had found her searching eyes resting on him at dinner from across the table. Repeatedly she had reminded him of their project of spending the winter on the Italian Riviera. Of course she didn't know, couldn't possibly know that something momentous, something tremendous was afoot . . . Denise was going to marry him. Soon he was going to propose . . .

Thus, one evening, as they sat by the living-room fire, he was stunned when she lay down her needlepoint and said quietly, "Henri, I regret to tell you I have given orders to pack. We are leaving for San Remo the day after tomorrow."

He stared at her, speechless from shock. This couldn't be Maman ordering the closing of the house without even consulting him, treating him like a child!

"But I haven't finished Denise's portrait," he said at last.

"I am sorry," her face was set, her voice cold—not at all her usual voice. "You promised to have it finished a long time ago. It is the twentieth of November and we were to leave by the middle of October. I cannot delay any longer."

"But why? What difference does it make whether we go

this week or the next? Or next month? Or next year? No one is expecting us."

As he flung the words a thought crossed his mind. She was ill! She had caught cold in this big, drafty house. That's why she looked so pale, why she had urged him to finish the portrait. As usual she hadn't said anything, had sacrificed herself, waited for his convenience. His love surged through him.

"Forgive me, Maman. I didn't know. Of course, we should leave at once. But—but do you think you could wait until my birthday? It's only four days away. It'd be so much nicer to spend it here rather than in some strange hotel."

She looked at him through grave, uncertain eyes. "I don't know . . ."

"Please, Maman, please!" Unconsciously he had lapsed into the voice he had used as a child when he wanted to wheedle some favor from her. "It's only four days."

"Very well," she nodded at last. "Until after your birthday."

Uneasily Henri took a long sip of champagne and pushed back the bulging front of his dress shirt. His preoccupied glance swept over the lace-covered table, the white roses in the Limoges centerpiece, the silverware and crystal goblets sparkling mutely in the candlelight, the frail chalice-shaped champagne glasses. It brushed over the baroness, very dashing in that plum dress and aigrette; "Tante" Armandine, younger than ever in a new, brighter wig; his mother, looking beautiful in her simple black velvet gown and the emerald solitaire hanging from her neck; Abbé Soulac, his leathery face creased in a smile, looking as he always did in his patched cassock; Denise, exquisite in her décolleté white taffeta gown—almost a bridal gown.

Was he wrong? Did Denise like him as much as he thought, enough to become his wife? That last four days had been agony. He hadn't proposed, simply because no opportunity had arisen to propose. How could you propose to a girl who chattered away, told you how much she was going to miss the afternoons in the "studio," the fifteen-minute recesses, the teas, the *petits fours*, babbled as if she hadn't the faintest inkling you were ill with anxiety, dying to take her hand and say the words waiting on your tongue to be spoken, "*Chérie*, I know I can't expect you to love me, but I shall spend my whole life . . ." Whoever said women were intuitive? And what if it had all been a screen? If she had hidden her real feelings behind an apparent animation? After all you

couldn't very well expect a chaste, reserved *jeune fille* to burst into tears, could you? He drained his glass. Immediately one of the two liveried *valets de table* refilled it with champagne.

How beautiful she was tonight! Those shoulders! Like tightly stretched satin! The candlelight glowing in her eyes. If only he could paint her as she looked now! The deuce with painting! He wanted to kiss her, to . . . Imagine making love to a girl like that, patrician, reserved—yet ardent! Well, by God, she was his, she belonged to him! She had given him proof of her feelings—yes, proof! The way she had taken his hand, for instance, the way she had said, "You are the nicest man I've ever met." A girl like her didn't say such things unless she meant more—much more! And he wasn't going to be such a fool as to leave without speaking to her, and on his return find her engaged to someone else, simply because he had been too bashful to propose!

He noticed his mother was about to rise from the table and hastily gulped down the champagne in his glass. He felt a pleasant giddiness steal over him. When he reached for his cane and started walking, the floor seemed unsteady under his feet.

They filed into the drawing room for coffee. Abbé Soulac excused himself. The ladies gathered around the fire.

Denise leaned down to Henri. "Would you like me to play once more the Prelude—you know, the one you liked, the one I played the first day?"

He sat at her side while she played. In the background her mother went on talking unconcernedly.

"You wouldn't think it was only three months ago," she mused wistfully when she had finished. "We had fun, didn't we, Henri?"

Now was the time . . .

"Let's sneak up to the studio," he whispered.

"Now?"

"Yes, now," he urged in a hushed tone. "It's important."

How wise he had been to have the lamps lit and a fire going, he thought as he plodded short-windedly into the room. Champagne gave him a reckless exhilaration. No, no one but he was going to marry her. This was the perfect place to propose, the place where they had been happiest. If only his heart wouldn't pound so loud . . .

"What did you want to show me?" she asked.

"Come and sit here on the sofa."

She obeyed. With an agility that surprised him he found himself at her side, wedging her against the arm of the sofa.

"I've been wanting to talk to you," he said in a low, hurried voice, as though he feared he might be interrupted at any instant. "I'll be back in April. You will wait for me, won't you?"

"Of course." She looked at him, disappointment on her face. Was this why he had brought her here? "I told you we've rented the villa for a year, and our mourning ends only in June."

"That's not what I mean." He leaned toward her, grasped her two hands. "I mean, will you *wait* for me?"

She gave him a frowning glance. "I don't understand." Her voice was edgy, suspicious.

He had a vertiginous vision of an abyss yawning before him. For a few panicky seconds he struggled desperately with himself, tried to stop before it was too late. But already the long-rehearsed words were tumbling out of him.

"Chérie, I know I can't expect you to love me, but I shall spend my whole life trying to make you happy. I swear you won't regret marrying me. I'll make you happy. You'll see, I'll do anything you want. We'll go wherever you want, do whatever you say." Passionately he kissed one of her hands.

She was staring at him, too shocked to resist, her mouth slack, her face a conflict of astonishment, compassion and amusement at the enormity of his aberration.

"But—I don't love you, Henri. It never occurred to me that you . . ."

"I know—" he nodded understandingly—"I know you can't decide yourself and I should have spoken to your mother first. I understand, but before going away, I wanted . . ."

"But you don't understand!" She was recovering her self-control and her voice was rising. "You don't understand at all! I don't love you. I'm sorry, but I don't. Please let go of my hands."

Things were happening too fast. His mind was whirling with champagne. "I didn't say you loved me. I only said you liked me. You do, don't you? Remember the day you took my hand and said . . ."

"You are crazy! Please, let go of my hands, you're hurting me . . . I was just grateful for what you had done. It didn't mean anything. I've never loved you and never will. The idea is absurd."

Now she was frightened. Comprehension was dawning on him, dilating his eyes, making his lips tremble. In the lamplight his ugliness was becoming monstrous, gargoylelike.

"Why is it absurd? Why?" His face had turned an ashen

gray. His viselike fingers tightened on her wrists. "Because I'm a cripple? Is that it? Because I am a cripple?"

Pain mingled with rage made her forget her fears. She faced him, eyes blazing behind their tears.

"Yes!" she shouted. "Yes, yes! Because you are a cripple, and also because you are ugly. You are the ugliest man I've ever . . ."

She did not finish. With a sudden jerk he pulled her to him, clamped his mouth over hers like a bleeding-cup. Time ceased to exist. As in a fulgurant dream he tasted the moistness of her inner lip, tried to force open the wall of her clenched teeth. He felt the arching of her spine, the pressure of her breasts against his stiff shirt front, the clawing of her nails in his palms.

With a desperate effort she wrenched herself free and ran to the door. One hand on the knob she turned around, knowing he could not follow her. He had not moved and remained slumped on the sofa, gazing at the floor, his anger spent.

"You loathsome, ugly fool! No girl will ever marry you! Ever! Do you hear, Henri?"

The fury of her vindictiveness widened her nostrils, twisted her mouth. Slowly she repeated the words as though she wanted every one to nail itself into him.

"Ever! Do you hear? Ever!"

He did not see her go, but heard the drumming of her footsteps on the carpeted stairs, the muffled babble of excited voices in the living room, the loud ringing of a bell, and after a while the crunching of wheels on the wet sand of the driveway. Then there was nothing but silence, the room's soft enveloping silence, bronze-hued and merciful.

And outside, the weeping night.

For several minutes he felt nothing. Absolutely nothing. Then, like wisps of smoke after a fire, irrelevant little thoughts started to drift through the vacuum of his brain. The beat of his heart made him aware of the passage of time. Did a human heart beat faster or slower than a clock? How much pain did it take for a heart to break and stop beating?

Soon he would go down and face Maman. How like her not to come rushing up, confronting him with questions and reproaches! She must be sitting in the living room by the fire, waiting for him. Poor Maman, would she ever forgive him? How much grief he had brought her!

He felt for his cane and shuffled out of the room. From the foot of the stairs he saw his mother waiting by the fire,

as he had expected, gazing at the flames, her hands folded in her lap, her profile so still it seemed carved in stone.

He sat down across from her, in the chair the baroness had occupied a moment ago. He laid his cane on the floor and laced his fingers over his silk waistcoat.

For a moment neither of them spoke.

"You knew all along, didn't you, Maman, that I was going to make a fool of myself?" he began, keeping his eyes on the fire. "Deep, deep inside, I knew it, too, I suppose. But I wanted so much to believe that Denise was different from other girls, that she could love me, that I ended by believing it. You have no idea, Maman, how easy it is to deceive yourself when you are a cripple! By degrees you minimize your ugliness, your lameness. Before you know it you think yourself as a very presentable young man with a slight limp, instead of the grotesque, stunted-legged dwarf you are."

"Please, Henri, please, don't speak like that!"

"But that's what I am, isn't it, Maman?" he said with heaving anger at himself. "Do you know that twice in Montmartre I went to a cheap *brasserie* to find a woman, any woman, and twice I was refused. Do you know there has hardly been a day I haven't been tormented by images of nude women, that time and again I've awakened from dreams with a jolt and found I was drenched in sweat? You must know it, for you know everything about me. You know me better than I know myself. I swear to you I did not encourage these thoughts. Instead I pushed them away. But they kept on coming back, and back, and back, until I thought I'd go crazy!"

She did not move. Her face was suffused in the glow of the fire. Streaks of orange light ran up the folds of her dark gown.

"Finally," he went on after a pause, "one day you stumble on the truth about yourself. And it is like stepping on a snake. It cannot undo what has been done, but it wrenches the nonsense out of you. That's why, Maman—" he turned his eyes full on her "—I must return to Montmartre."

He saw the involuntary trembling of her lips, and the clenching of her folded hands.

"Forgive me, Maman," he said with desolation. "Forgive me for hurting you again. But it is the only solution. What's happened tonight was bound to happen. It would have happened in San Remo or Florence or anywhere. Denise was only a pretext. Any girl would have done as well. It would happen again in six months or a year. And I don't want it to happen again—ever! Only in Montmartre shall I be able to make some

sort of life for myself. And there at least I'll never hurt you again, as I've hurt you tonight."

She lowered her lids. Two tears rolled slowly down her cheeks.

"You will be terribly lonely in Montmartre, *mon petit.*"

"I'll be lonely anywhere, Maman. I know that now."

He picked up his cane from the floor and hobbled to her. For an instant he stood before her.

"Please, Maman, don't cry. We both need our courage. You know there is no other way. I'll come to see you often . . ."

The words strangled in his throat. He leaned forward and kissed her.

"And don't ever forget," he whispered in her ear, "no matter what happens, don't ever forget I love you and I'll always love you with all my heart."

She did not try to detain him. He was right. There was no other solution.

She saw him drag himself across the room and disappear. She heard the receding thump of his cane on the carpeted stairway, and after a while the closing snap of his bedroom door. Her eyes strayed back to the dying fire.

He was gone, and this time he would not return. She had been wrong to think she could shield him from his destiny. Destiny belonged to God. What would become of him? He was crippled, ugly, hungry for love and unresigned. What would he do? She did not know. But one thing she knew. He was her child and would be hurt. And she would not abandon him. She would love him, pray and wait for him—until the end.

Book Two

MARIE CHARLET

IX

"Monsieur Toulouse!"

Her skirt clutched in her two hands, revealing a pair of thick cotton-clad ankles, Madame Loubet came darting out of the house.

Since the arrival of the telegram she had lived in a turmoil of apprehension mingled with rapture. Something awful must have happened to make him return to this disgusting Montmartre, but he was coming back and that was wonderful! It had been lonely without him. All morning she had fretted in her lodge, unable to read the newspaper or say her beads, peeping out of the window every few minutes.

Now at last he was here!

"Monsieur Toulouse!" she repeated as the fiacre slowed down to a halt. "How are you, Monsieur Toulouse? The studio's just like you left it. I started the stove and the place is nice and . . ."

She stopped short.

Something was wrong. He looked the same, yet he didn't. His eyes! That's it. They were bigger, darker, not gay and boyish any more.

"You feel all right?"

He gave her a warm, sad smile, as he climbed down. "Yes, thank you, Madame Loubet. I feel very well. And it's good to be back. I missed you."

When they reached the fourth floor, he pushed open the door and hobbled directly to the window. For a moment he stood, leaning on his cane, gazing out at the familiar panorama of jagged roofs and chimney pots. The winter sky had a belated autumnal softness that reminded him of the last drives with Denise.

155

He turned around, sniffed the faint smell of turpentine still lingering in the air.

"It's good to be back," he repeated.

Still smiling, he glanced at the canvases on the wall, the easels, the wicker furniture, the potbellied stove, the Venus de Milo, still in the corner where Rachou had set it. It was like returning among old friends.

"I'm going to live here now, Madame Loubet. Not just work. This is going to be my home and I'll never go away again."

The balcony room, with its large window and its wallpaper of white and yellow daisies, was cozier than he remembered it. He set an old daguerreotype of his mother on the night stand, tacked a few Celeyran sketches on the walls and a yellowing Fontanes class photograph in which blood-brother Maurice and he stood side by side, barelegged and self-conscious. Two days later his trunks arrived. Madame Loubet stacked his shirts in the chest of drawers and hung his suits in the *armoire*. When he saw his monogrammed towels, his *savonnettes* and crested silver toilet set in the bathroom he began to feel at home. Yes, one could be very happy here.

He went to visit Rachou. Somehow he had expected to find him painting, or playing the mandolin, drinking beer with cemetery cronies or entertaining some midinette. Instead he found a tired worried giant bundled in an overcoat poring over tomes of art history in an ice-cold studio.

"As you see——" with a sheepish grin Rachou struggled to his feet "——I'm cramming for this damn curator's examination. You'd never guess the things you've got to learn to become a museum concierge!"

He had shed his bohemianism, his guffawing laughter. The bourgeois in him had returned, eager for security and respectability. He was no longer interested in cavorting at L'Ely or beer drinking at La Nouvelle.

"Those things are all right when you're a student, but what do they get you?"

For a while they talked desultorily, trying to recapture the past intimacy.

"You know Grenier's married and Lucas has returned to Normandy, don't you?"

Henri nodded. "You wrote me about them. How's Vincent?"

Oh, Vincent was still about, soaking up absinthe, still boring everybody with his damn art colony and his brotherhood of artists. During the summer he had held an exhibition at Agostina's—a fiasco, of course.

"He asked Agostina to marry him. Naturally she laughed in his face. *'Mio piccolo Vincente,'* you know how she talks —'you are crazy, you are *pazzo!* You've got a flea in the brain!' Between you and me I think she's right. He's a nice chap, but he's got something loose there." He tapped his brow significantly.

No, he hadn't seen much of Gauzi and Anquetin, although they both were in Montmartre. Too busy all of them, too busy trying to get something to eat. Wonderful profession, art!

All in all it had been a dull and very hot summer. Thank God, one day on the way to his studio he had spied a girl at the gate of the Montmartre Cemetery.

"I gave her the usual speech about posing for my Madonna and she swallowed it. She isn't very bright, and a little deaf, but a good girl. A heart of gold. She's a cashier in a hotel— that's what she says, but with women you never know when they tell the truth. I even painted her portrait—a little sketch on a scrap of canvas. She cried when I gave it to her."

He grinned affectionately. "A nice girl, Berthe."

For a few seconds he remained in thoughtful silence, his large hands cupped over his knees.

"And you, what are you going to do?"

"Paint, I guess. What else can I do?"

"At least you don't have to worry about making a living. You can paint any damn thing you want now. Remember that lorette at Agostina's, the one you wanted to paint because she had a transparent face and green shadows in her neck?"

"Yes." Henri nodded wistfully. "Now I can paint all the green shadows I want. That's one advantage of being an amateur. You can paint anything you want. Nobody cares."

Suddenly they had nothing more to say to each other. They still would have liked to be friends, but life had come between them. Their roads had forked. The things that had kept them together had collapsed. They were strangers with a handful of common memories.

"I should be going," said Henri, rising from the edge of the couch. "I mustn't keep you from your work. I hope we can see each other now and then."

At the door they shook hands with embarrassed smiles. Their eyes said their farewells.

"We'll see a lot of each other before I leave," said Rachou. "By the way, you know about Julie, don't you?"

"No."

"She drowned herself—about a week after you left."

"Where is she buried?"

Rachou shrugged in ignorance. "You know how it is. No money, no close relatives . . . It costs money to have a grave to yourself."

Henri waited to reach the first floor. Then he sat on a stair and quietly wept.

The evening at La Nouvelle was equally disappointing.

"Commercial art, that's the thing," said Gauzi, waving his frayed sleeves. "That's where the big money is. There's a tremendous future in catalogue illustration, advertising . . . Even signs bring good money—if you can get them."

Anquetin boasted of his skill as a wholesale painter of religious subjects.

"A Murillo Ascension takes me three days. I could do it in two, but all those damn angels take a lot of time. A Nativity takes four days. Lots of accessories, you know."

They tried their best to be gay. They churned the past, brought forth old *atelier* jokes. But in a little while they had exhausted the inventory of their student years that had seemed so exciting.

Beneath the bravado Henri sensed their anxiety of the future, their regrets of the wasted years.

"Funny, isn't it?" Gauzi chuckled glumly. "You sweat and slave to make that goddam Salon, and once you make it, you discover it doesn't mean a damn thing."

"Half the artists starving in Paris right now have made the Salon," confirmed Anquetin. "Degas was right, the old bastard. Art isn't a profession; it's a slow form of suicide. Well, you at least won't ever have to worry . . ."

From the first moment he had felt their surprise at his return to Montmartre and their involuntary envy. Of course, *he* could afford to fail at the Salon; he still could daub all he wanted in his beautiful studio; never have to worry about food, clothes, rent money. He was rich and they were poor. The thought poisoned their relationship, wiped out the years of companionship. In one great leap backward he was again the rich amateur of the Bonnat days.

They departed, swearing they would see a great deal of one another, knowing in their hearts they would not.

Vincent was the only one genuinely glad to see him back. His gemlike eyes glittered as he held out his bony, freckled hand. "I've missed you, Henri. I've a lot of things to talk to you about. Come on, let's go to the house and have some of Théo's *stokvish*."

Their deep understanding had not deteriorated and they spent a few happy evenings arguing as in the past. But Vincent

was a sick man, lost in his own vortex. He, too, had changed in these last months. Something monstrous, frightening was at work within him, at times choking his mind.

"I want to get out of here," he would shout. "I want to go where there is sun! I want to paint the sun, the fields . . ."

Paris had become unendurable to him. His chronic restlessness scraped his nerves raw. His lips would twitch convulsively. At moments his eyes would turn wild, almost demented. There was about him an air of impending disaster.

One day he staggered into Henri's studio, drunk, haggard, soaked to the skin.

"Do you think I am *fou?*" he groaned from the couch, his head between his hands. "Do you really think I'm *fou?* Do you think they're going to lock me up?"

That afternoon in Père Tanguy's shop he had met Cézanne who, after examining his paintings, had declared in his nasal drawl, "Truly, monsieur, you paint like a madman!" The remark had fallen on Vincent like a spark on a keg of powder.

After that incident all peace left him. He drank more. When he came to the studio he would make gesticulating incoherent remarks, lapse into Dutch. His stammering grew more pronounced, his sudden disappearances more frequent.

Finally one bleak February morning he left for Arles. Henri's last glimpse of his friend was that of a red-eyed alcoholic leaning out of a third-class carriage window, grinning in his wiry beard, receding in a cloud of steam, waving his hand like a drowning man.

A few days later it was Rachou's turn. He had passed his examination and had been appointed assistant museum curator at Draguignan, a sleepy, sun-baked town in Provence. Again Henri drove to the station and said the brave, futile things that are said in railway stations.

The last link with the past was broken.

Doggedly he plunged into work. He tackled two, three, four canvases at once, remained at his easel as long as there was a glimmer of light in the huge window, painting with ever-increasing speed and sureness of hand, while Madame Loubet read the newspaper to him. At dusk, however, loneliness became a whispering, tormenting thing. Loneliness is made of memories. In the darkening studio memories seeped through the walls, floated before his eyes, coiled around him. To escape them he put on his hat and went out.

He returned to La Nouvelle and discovered how unfamiliar the most familiar places can become. The café, a year ago,

so exciting and friendly was now a noisy, alien tavern. Students paused in their debates to glance at him, wondering why he was hanging around since he had failed to make the Salon. Older artists were too absorbed in their problems or their domino games to notice him. At twenty-two he was another Montmartre failure, too old to some, too young to others, uninteresting to all.

His evenings turned into aimless wanderings. He learned the acrid bitterness of solitude in crowded places. Alone, he went to the various *cafés-chantants,* and the Cirque Fernando, where he watched the clowns, the tutued bareback riders, the trained poodles, the acrobats in pink tights.

He even returned to L'Ely, where La Goulue came to sit at his table for a few minutes, then rushed away and forgot about him. Père la Pudeur welcomed him back with fresh complaints about the girls' behavior and told him about the terrible vice-squad sergeant who had just arrived in Montmartre. "His name is Patou, Balthazar Patou," he said in a frightened whisper. "And I hope you'll never have anything to do with him. The man is a terror! He prowls through the district at night looking for girls who do the streets without cards—you know, the Prefecture cards that prostitutes are supposed to carry. Since he doesn't wear a uniform they can't guess he is a gendarme, and so he pounces on them and packs them off to Saint-Lazare. If he ever comes here and catches the girls dancing without their *culottes,* there's going to be trouble, you'll see . . ."

Finally the bustling impersonal *brasseries* on Boulevard Clichy became his usual refuge. There he spent endless evenings, his derby low over his eyes, his feet hanging above the floor, his mind yawning with ennui. With his short rubber-tipped cane at his side, he sat hour after hour, reading the evening newspapers, watching the lorettes at work, making furtive drawings, gazing at the reflection of his ugly face in the curve of his glass, waiting for he did not know what.

Maman had said he would be lonely. Well, he was.

Then one day he ordered a cognac. Then another; then another. Something extraordinary happened. His legs stopped hurting. Another thing—gloomy thoughts disappeared. A cripple? Who was a cripple? Why, he was dancing with a beautiful girl and she was nestling herself against him, like the L'Ely girls did . . . She was resting her head on his shoulder, her eyes closed, abandoning herself to the sensuous rapture of their moving embrace . . .

With secret jubilation he discovered he was a "born" drinker,

able to down an astonishing amount of liquor without apparent ill-effect. He drew an inordinate satisfaction from this fact. Some people could climb mountains or take a horse over a six-foot hurdle. Well, there was something *he* could do—he could drink!

Liquor did something else. It gave him the courage to surmount his terrors and go to the brothel.

This time he drove to the door and resolutely rang the bell. Craftily he had chosen this forlorn, drizzily afternoon, hoping the red-plush salon would be empty, the girls idle.

"Come in, come in. Hurry up." The rheumy-eyed slattern motioned him inside. "Don't you see it's raining?" she went on, closing the door behind him.

A flash of recognition crossed her blowzy face. "Didn't you come here once, two or three years ago? With some friends? I got a memory that never forgets nothing."

He nodded and slipped her the silver coin he held ready in his hand.

"Now that's what I call a tip!" She let out a wheezy gasp of appreciation. "If only there was more like you I could retire to the country. I can see you and me are going to be friends."

She squinted at him not unkindly, as if sensing his apprehensiveness.

"You came at the right moment," she whispered leaning down, "there's nobody upstairs."

A sudden suspicion came into her eyes. "Even if you're a midget, you can make love, *hein?*"

On his imperceptible nod, she regained her expansiveness. "Then everything's all right. Big and small, old and young—it's all the same to us. *L'amour,* that's what we're here for. Now you go upstairs and I call the girls."

Grabbing the banister he hoisted himself up the steep, thin-carpeted stairs and pantingly hobbled into the dim, empty salon. Nothing had changed. At once he recognized the garnet portières, the worn plush banquettes behind the row of painted iron tables, the mechanical piano, the dusty palms in the corners, the flyspecked oleograph "Cleopatra at the Bath" hanging between two gilt-framed mirrors, the smell of face powder and stale tobacco. The room had an air of tranquil abjection, the slimy peacefulness of a swamp.

He sat down at a table, placed his rain-drenched derby on the bench beside him and with pounding heart waited. Things had been easier than he had expected. Upstairs the

house was stirring with unseen activity. He heard the snap of a closing door, followed by the patter of running feet down the stairs.

A girl in a filmy negligee and pink high-heeled mules irrupted into the room. At the sight of him she stopped short, her smile frozen. For an instant he was aware of nothing but a pair of startled, peering eyes.

Abruptly she whirled around and fled.

Above the hammering of his heart he heard other footsteps, an indistinct babble of giggles and excited whispers in the hallway.

A hand parted the curtains. Five women's faces crowded into the opening and ten beady eyes focused upon him. He felt himself turn scarlet.

"My God, it's Henri!"

With stupefaction he watched a plump cow-eyed brunette cross the room toward him, her great breasts wabbling beneath her chemise.

"You don't know me, eh?" she beamed standing before him. "But me, I know *you!*"

A lingering country freshness clung to her round face. Irresistibly she reminded him of Madame Loubet—a twenty-five-year-old Madame Loubet in a mauve chemise!

"I'm Berthe." She leaned down across the table, a smile in her bulging eyes, speaking as if she were giving the answer to some childish riddle. "Your friend Rachou told me about you."

Before he could speak she turned to the girls who had cautiously followed her into the room. "It's all right. He's an artist; he paints pictures, like my *chouchou.*"

Somehow this seemed to explain everything. The tension eased. The girls gathered around the table.

"That's Véronique," Berthe began, waving to a skinny, buck-toothed brunette who resembled a doleful mouse. "She hasn't worked here very long. Only three months."

Véronique extended a limp, formal hand. She opened her mouth to speak, but Berthe was already pointing to another girl.

"That's Suzanne. She comes from Brittany, like me."

Warming to her duties as a hostess, she turned to a tall, largeboned woman, nude under a yellow Spanish shawl. "That's Giannina. She's an Italian." Her tone dismissed Giannina as a negligible foreigner, unworthy of comment.

"And that's Minette," she wound up, sitting down next to Henri. "She's been here almost as long as me."

The girls shook hands with him and with skittish little smiles took their places at the table, blandly unaware of their nakedness. The thing was turning into a social affair.

A waiter in slippers and shirtsleeves shuffled into the room, a soiled napkin crumpled in his hand. Mechanically he wiped the table while they gave him their orders. Henri passed around the box of Turkish cigarettes he had bought on the way, struck matches, reached forward to bring the flame to their lips. They were not accustomed to such attentions and thanked him through pursed lips in affected ladylike voices. Furtively they peeped down at his legs, noticed the quality and cut of his clothes, feeling a vague compassion for this young cripple, so polite and well dressed who had come here because he could not get a girl of his own.

"You paint pictures, monsieur?" Véronique asked to make conversation. "All kinds of pictures?"

It was Berthe who replied. She did so with petulance and authority. Certainly he painted all kinds of pictures! When one was an *artiste-peintre,* one could paint anything. "My *chouchou,* he could paint anything that came into his head. He could paint your portrait just like that, if he wanted to." She snapped her fingers to show the portraits were mere trifles to Rachou.

"Once," reminisced Giannina, "I posed for an artist. An Austrian."

She had humid long-lashed eyes and classical features blurred by fat. With her thick hair loosely knotted at the base of her neck she reminded him of the stately Roman peasant women in Poussin's canvases.

In her liquid Venetian voice she described how the Austrian painter, an elderly melancholy man, would lay down his palette, rise from time to time to caress her breasts and her buttocks, then return to his easel to apply a few wistful brush-strokes.

"He said I was an inspiration to him," she concluded.

Tartly Suzanne objected. She didn't mind sleeping with a man, but she wouldn't pose nude for an artist. No, she wouldn't.

"It's disgusting." Under her lace chemise her breasts trembled with righteousness. "That's what it is—disgusting."

"But you don't understand," Giannina remonstrated patiently. "An artist, it's not like a man. He don't look at you like if he was a man. More like if he was . . ."

"More like a doctor," Berthe cut in with finality. Her affair with Rachou had established her as an authority on artistic

manners. "You don't mind showing your *derrière* to the doctor
when he comes every Monday for the *visite*, do you? Well,
an artist, it's the same thing . . ."

Soon all the girls had joined in the argument. With a smile
Henri watched them glare at one another, sip their drinks,
smoke the unfamiliar gold-tipped cigarettes.

Why, these girls weren't the fetid creatures he had anticipated
. . . They were nice, friendly; they didn't seem to mind his
legs. How simple, how very simple it had been! How much
anguish he would have spared himself if only he had come
here sooner!

"He used to say you were nice . . ."

He turned and saw that Berthe had withdrawn from the
discussion and was looking at him.

"It's true," she went on, a smile in her blue, protruding
eyes. "You're nice. He was nice, too, wasn't he? How he
could play the mandolin! And what a voice he had! And big
as he was he could be so gentle! He painted my portrait,
you know. I'll show it to you."

She paused, her eyes dim with memories.

"Is he well?" she asked, and Henri was struck by the
tremulousness of her voice, a moment ago so grating and
petulant. "Have you any news of him? You see, he can't write
me because I didn't give him the right address. I told him I
was cashier in a *hôtel de famille.*" She lowered her eyes.
"I didn't want him to know . . ."

"He is assistant curator of the Draguignan Museum . . ."

She did not let him finish. "A museum! He works in a
museum?"

Impetuously she veered to the girls, charging into their con-
versation. "Didn't I tell you my *chouchou* was a great artist?
He even works in a museum!"

"Once I had a *chouchou* that was divisional chief at the
Ministère de l'Agriculture," boasted Véronique with a haughty
lift of her eyebrows. "He said I reminded him of his daughter."

It was getting late. Octave, the waiter, turned on the gasolier
and served a fresh round of vermouth-cassis. Shortly afterwards
the first patrons began to arrive. Awkwardly they took their
places on the red-plush banquettes, avoiding one another's
eyes, twisting their caps in their hands.

One by one the girls rose and excused themselves.

"*Au revoir*, Henri," they said, holding out their hands.
"It's been a pleasure."

He watched them saunter over to the men, slip their arms
around their necks, drone the ritual "*Alors, chéri,* you buy

me a drink?" Someone started the mechanical piano. Night had come to the Le Perroquet Gris.

Now only Berthe remained at the table.

"Perhaps you'd like to go upstairs?" she suggested, remembering the object of his visit.

He nodded and followed her out of the room.

During the following months Henri was still lonely, but peaceful—at times almost happy.

He returned to the brothel, usually in the afternoon. At Berthe's suggestion he went "upstairs" with the other inmates and found them tactful, expert and solicitous of his pleasure. He liked their placid acceptance of him, their appreciation of his lavish tips, their compliments on his virility. In their arms he found a brief but complete forgetfulness and obscure revenge. Blessed be the whores who made up for the scorn of *jeunes filles!* They taught him the alphabet of sensation, the anatomy of pleasure. With them he explored the hiding places of voluptuousness and discovered the cold rapture of pure eroticism, uncomplicated by romantic pretense.

Among them he even found a measure of companionship. As in his *atelier* days, his talent for sympathetic listening stood him in good stead. As time went on he ceased being merely a generous patron and became a confidant to whom they told their autobiographies, their grievances, their hopes and their troubles, real and imaginary. Once more he discovered the acute need most people have to talk about themselves.

He brought them perfume, bonbons and the Turkish cigarettes they liked. He entered their birthdays in his notebook, and on such occasions sent them baskets of Beaujolais and cans of *pâté de foie gras*.

Gradually he began to distinguish personalities beneath the women's anonymous nakedness. Suzanne had a child and mailed every sou she earned to the family who was bringing her up somewhere in the country. Giannina was a Lesbian. Véronique gambled on bicycle races and invariably lost although she spent hours poring over the sports page of newspapers. Minette spent her day off at the theatre where she attended harrowing melodramas which she recounted on her return in hair-raising detail.

And then there was Berthe, good, motherly Berthe. Together they talked about Rachou. Over and over she relived the enchanted hours she had spent in the dingy studio on rue Ganneron. The portrait Rachou had painted of her—a small, darkish canvas which she had set in a tremendous gold frame—

hung in her room at the place of honor, right over the bidet.
That portrait! It was the icon, the Mona Lisa of Le Perroquet
Gris. Woe to any client who failed to admire it! "It's a master-
piece," Henri would declare. At this her large bovine eyes
would grow teary and her cheeks flush with humble pride.*

Such was his life when, a little more than a year after his
return to Montmartre, he happened to drop in at Le Mirliton
one evening. He liked this crowded, smoke-filled basement,
so deep below the street level that no amount of noisiness
attracted the attention of the police.

On a minuscule stage Artistide Bruant, in his usual black
velvet suit, knee-high boots and red muffler was singing a
ballade réaliste of his own composition when Henri made
his way to a small corner table and signaled to the *garçon*.

"A double cognac," he said in a whisper, not to break
the teary spell which had fallen over the women in the audience.

As soon as it was brought to him, he raised the frail-stemmed
glass and drained it in one gulp. For a few seconds he remained
motionless, his head tilted back, his eyes closed, feeling the
tingling warmth of the liquor ripple through his limbs. Then
he opened his eyes, beamed contentedly and ran his tongue
over the fringe of his mustache. Wonderful thing, cognac,
wonderful . . .

He cheerfully joined in the applause and received a greeting
smile from Bruant who had seen him enter and, although
a poet, knew a good customer when he saw one.

"And now," said the *chansonnier*, as he finished mopping
his well-fed cheeks, "with your kind permission I shall sing
my ballad 'A Saint-Lazare'."

A thrill ran through the audience. The accompanist pounded
a few sepulchral tremolos on a tinny piano. Bruant tautened
his broad clean-shaven face into a mask of intense pathos,
flung his muffler over his shoulder and began to sing.

"A Saint-Lazare" was Bruant's masterpiece. Everyone and
himself agreed on that. The plaintive melody was catching,
the lyrics oozed a viscous sentimentality which the Montmartre
lorettes found irresistible. Like Bruant's other *ballades réalistes*
this one concerned itself with a streetwalker, a sweet, lovable
girl who "did" the boulevards, not from greed, laziness or
natural inclination—no, no, no—but from too much *amour*.

Caught without her card—the famous red card delivered

* Lautrec painted two famous portraits of Berthe-the-Deaf: one
in his studio; the other in Père Forest's garden.

to prostitutes by the Préfecture de Police—she had been sent to Saint-Lazare, the dreaded prison hospital for street women. In this plight did her thoughts turn to her own misfortune? No. They turned to her man, now deprived of her earnings and justly apprehensive of the future. Who would pay for his vermouth-cassis and his hair pomade? In her distress she took pen in hand to write him a piteous, adoring letter of comfort, full of misspelled words and unfaltering devotion. How much she worried about him, lonely and without a sou, while she rotted helplessly in this damn hole of a place! But *courage, mon homme!* Soon she would be released and how joyously she would run back to the lamppost and make up for lost time.

Such loyalty, such devotion to duty raised streetwalking to the level of martyrdom and caused the women in the audience to shed hot self-pitying tears.

On the stage Aristide Bruant was letting out bellows of increasing mournfulness while clutching his velvet coat with his hand. Perspiration streamed down his face.

At last he intoned the last verse.

> *"J'finis ma lettre en t'embrassant.*
> *Adieu, mon homme,*
> *Malgré qu'tu soy' pas caressant*
> *Ah! j't'adore . . ."*

At this point all the lorettes in the room who at various times had received well-aimed and painful kicks from their men dissolved into sobbing forgiveness. How well they understood the letter-writing whore! What were a few kicks in the *derrière* between lovers?

Bruant ended his performance amidst thundering applause and the tributes of women's sniffles and watery eyes. He bowed, smiled wanly, climbed down from the stage and came to Henri's table.

"I am all in!" he sighed, plumping his two hundred pounds on the banquette. Still puffing, he ran his handkerchief over his face. "Each time I sing that song, it drains me. I put too much heart into it."

Henri repressed a smile. Did the man actually believe his own drivel? "May I offer you a drink?" he suggested.

"A drink! No, no, no, monsieur! On the contrary, it is I who insist on offering you a drink. Yes, yes, I insist." Peremptorily he turned to the waiter. "Jacques, another cognac for monsieur."

Henri's surprise at this unusual generosity did not last long. No sooner was the drink brought to the table than Bruant leaned forward confidentially, and in a lowered tone of voice informed him that "A Saint-Lazare" was about to be published.

"Yes. I have at last found a publisher. Now what I need . . ."

What he needed—his manner grew still more confidential—was a little sketch, a little "something" that could be used as an illustration on the cover of the sheet-music.

"It occurred to me that perhaps you might be willing to do it for me. Nothing elaborate. Just a little sketch that wouldn't take much of your time. Naturally," he added hastily, "I couldn't pay very much. I'm a poet, and you know how poets are." Here the deprecating sigh, the helpless shrug. "Always famished, always without a sou . . ."

The fact that he owned one of the most prosperous cabarets in Montmartre seemed to have entirely escaped his mind. He spoke with such a tone of sincerity that Henri concluded Bruant was indeed a poet who believed his own fabrications.

"Please don't worry about the money," he said reassuringly. "I'll be glad to oblige you."

A few days later he brought the sketch to Bruant, and promptly forgot all about it.

With Henri's drawing on the title page, "A Saint-Lazare" was an instant and phenomenal success. Bruant and his publishers grew rich on the tears of streetwalkers, brothel inmates, vagrant prostitutes, railway-station and barracks harlots, *brasserie* tarts, free-lance strumpets, kept women, demimondaines and *cocottes de luxe*—trollops of all rank and tariff who recognized themselves in the letter-writing whore. "A Saint-Lazare" became a sort of guild song, the anthem of the venery world.

To Henri, it brought no money, but it changed his life. The august and remote art world, which never before had taken notice of so lowly a thing as a song cover, became curiously excited about his drawing.

"A bitter and profound commentary on the age-old problem of prostitution . . ."

"A sketch of astonishing insight and sureness of hand from a young and hitherto unknown artist . . ."

"The future work of this young yet already masterful craftsman should be watched with interest by art lovers . . ."

Before long Bruant had another song published. Naturally he turned again to the obliging artist who understood poets

so well. Again art critics lifted excited eyebrows, rushed to their inkwells to write about the "stark realism," the "cruel objectivity" of this "young and daring" artist. Delighted with this "high-class" publicity, Bruant framed Henri's originals and hung them in his cabaret where they elicited considerable interest.

Now strangers tipped their hats to him on the street. The rue Caulaincourt laundresses had a new ring of pride in their voices when they called to him from their windows. Mysteriously waiters had learned his name and bent solicitously to take his order. *"Certainement,* Monsieur Toulouse . . . *Tout de suite,* Monsieur Toulouse . . . Will that be all, Monsieur Toulouse?" Of course his lavish tips helped, but some of their fawning was genuine. At Le Perroquet the whores whispered to their clients that the bearded dwarf was a great artist, and as proof pointed to his song covers tacked on the walls of their rooms or slipped in the frames of their dresser mirrors.

From nowhere appeared penurious editors of ephemeral publications. Wouldn't he have some little sketch, a little "something" he could spare or dash off in a few minutes that they could reproduce in their magazines? Of course they couldn't pay anything. The magazine was just starting, and beginnings were always so difficult . . . But later, oh, later! With a good-humored wave of the hand, Henri dismissed the matter of money and did the drawings. Usually the periodicals failed after the third issue, but others took their places. His work began to be seen and talked about, if not paid for.

Then it was the turn of the art dealers. Not the important ones; the little ones, the shady ones with dark musty shops on side streets. They knocked on the door of the studio, still panting from the climb, smiles like slices of watermelon on their wily faces. Their passion, they informed him, was to "discover" young talent. Nothing pleased them more than to give some obscure and promising youngster, like himself, his first chance. Perhaps he had some little painting, some trifle lying about, that they could put in their windows? Grinning they trouped out of the studio with armfuls of canvases for which they forgot to give receipts.

"Thieves, Monsieur Toulouse," protested Madame Loubet, outraged by this pilfering, "that's what they are, thieves!"

He appeased her, assured her it didn't matter. He had had his fun out of those pictures. They merely cluttered up the place.

Unexpectedly Gauzi and Anquetin paid him a visit. Yes,

they had seen his sketches; everybody in Montmartre was talking about them. Wouldn't that old bastard Cormon be surprised? Remember the *atelier*, "*la grosse* Maria," Agostina? . . . Those were the good old days, eh? By the way, how the devil did he get magazines to print his drawings? Did he have to pay the critics to write about him? How about slipping them a word about their work? How about a beer at La Nouvelle, one of these evenings? . . .

Then one day Pissarro came. Looking like a bohemian shepherd, the dean of Impressionism bowed graciously to Madame Loubet and stood by the stove warming his hands. Yes, those song covers and all those little sketches in magazines were quite interesting. "And Degas likes them too. He wants to see you, wants you to come to dinner next week. Bring some sketches along. He'll probably tell you they're terrible, but don't believe a word of it."

Now in cafés people who had never before paid any attention to him stopped at his table.

"Pardon, monsieur. You are Monsieur de Toulouse-Lautrec, *n'est-ce pas?* Permit me to congratulate you on your latest drawing. *Magnifique! Superbe, absolument superbe!* Such finesse, such economy of line! A drink did you say? Why, with pleasure. *Garçon, une absinthe!* As I was saying, I'm an admirer of your work. I am an artist myself . . ."

Or a sculptor, an illustrator, an etcher, a novelist, a playwright. The Montmartre kind. Always on the eve of taking Paris by storm with their next canvas, their not-quite-finished novel, their five-act tragedy in verse. *Bons garçons* most of them. Great talkers, great hand-wavers. Beards, intelligent eyes, black fingernails. Shabby top hats, enormous black felts, overcoats frayed at the sleeves. Most of them in their middle thirties, some in their early forties, but still clinging to the bravado of their student days in an obscure defiance of life, a sort of petrified adolescence. They still had great plans, great hopes. Their luck was bound to change soon . . .

"But never mind, never mind! It's not like the old days. We've got our own Salon now and can show our work to the public. By the way, Lautrec, are you a member of the Société des Artistes Indépendants? No? . . . You must, absolutely must. In Montmartre you simply don't belong if you don't . . ."

Oh, well, if you had to join the Indépendants to belong, then by all means . . . He had had enough of loneliness. He wanted friends, like in the old *atelier* days . . .

He was effusively welcomed into the howling mob of the

"Irregulars of Art." His illustrious name as well as his budding reputation made him a choice recruit. Soon he was elected to the *Comité Exécutif*, the directing board of the Société. He was rapidly becoming a Montmartre personality.

Then one day one of those improbable, melodramatic things happened that happen only in real life.

X

"MAURICE!"

There he stood in the doorway in his top hat and overcoat, tall, blond, handsome, with a murderous little mustache looking exactly like Théo van Gogh, a Théo without a beard, but with the same honest, serious face, the same blue eyes, patient, loyal and kind.

"HENRI!"

What followed was not clear, but Madame Loubet who had dropped her newspaper and was watching the scene above the rims of her spectacles decided that *le petit monsieur* had suddenly gone *fou*, while the tall young man who had burst into the room must be a fugitive from some lunatic asylum. Only after several minutes of incoherent gestures, frantic handshakes and strangled exclamations was she taken into the secret.

"Madame Loubet, this is Monsieur Maurice Joyant, my oldest friend, my best friend, my blood brother . . . We haven't seen each other for fifteen years. I thought he was in Lyons, he thought I was in Albi, and all the time we both were here in Paris . . . We used to go to school together, play Indians in Parc Monceau . . . We had planned to go to Canada together and trap bears . . ."

This introduction, spilled out in a single breath, with a face radiant from happiness, did not enlighten her very much but convinced her that the occasion was a happy one. Instantly she entered into the emotional mood of the moment, burst into tears, and declared there was nothing like friendship, and Monsieur Toulouse certainly could use one real friend . . .

She hurried downstairs to fetch two bowls of *tisane* which she forced on the young men before allowing them to go

172

out, explaining that it was only April and winter wasn't dead yet and there still was much treacherousness in the air, especially the disgusting night air of Montmartre.

An hour later in the quiet restaurant Maurice described to Henri the chain of unremarkable events that had led to the miracle of their reunion.

"Just a coincidence. As I told you I am assistant editor of *Paris Illustré*, and this afternoon I went to our printer with some galleys for the next issue. I was crossing through the lithography department to go to the type-setting room, when a trial proof of a new drawing caught my eye. Suddenly, I noticed the signature of 'Lautrec' in the corner, and the thought hit me it *might* be you. . . . You never saw anyone run so fast! I was so sure you would be in Albi it had never crossed my mind to inquire at your old address. Well, I rushed to Boulevard Malesherbes and the concierge told me your mother still occupied the same apartment. In two jumps I was on the second floor and Joseph opened the door. Your mother told me where you lived and—here I am!"

Thus after an absence of fifteen years, Maurice re-entered Henri's life. Without effort the old Fontanes intimacy re-established itself. The blood brothers spent many evenings, many Sundays together, reminiscing, arguing, confiding in each other.

"You know, Henri," Maurice said one day, "I haven't told you, but for the last two years I've been trying to get a job in an art gallery. I'd like to learn the trade and become an art dealer."

"An art dealer!" Palette in hand Henri swerved on his stool. "*You* want to be an art dealer when in a few years you may be editor of the biggest magazine in Paris! You're crazy! Why, it's almost as bad as being an artist! Don't you know that in France everybody paints and nobody buys paintings? Why should they, when they can make their own, which they like much better?"

And so the kindly spring of 1888 wore on. Henri was happy, happier than he had even been. His contentment seemed to be universal.

The coming year would mark the centenary of the Revolution and the storming of the Bastille. To commemorate these glorious events, the Government was preparing another of those mammoth *Expositions Universelles* for which Paris was justly famous.

On the barren vastness of Champs de Mars an enchanted city from a "Thousand and One Nights" was coming to life, a make-believe metropolis of white stucco palaces, harems and mosques, marble-floored patios, mosaic fountains, minarets, Tahitian palm-roofed huts, Cambodian temples, Ubangi jungle villages, Tunisian bazaars and Algerian kasbahs. The Eiffel Tower was on its way up, growing taller and slimmer every week. An army of antlike workmen clung to the monstrous, lacy iron structure, pointed like a defiant arrow at the sky. Newspaper editors rhapsodized over it and searched for superlatives. Tirelessly they reminded their readers that it was the highest edifice in the world, higher than New York's Flatiron Building, the dome of Saint Peter, the Washington Obelisk, twice as high as the Cheops Pyramid; that its foundations were sunk forty-eight feet into the ground, and that it would require two million four hundred thousand and twenty-six rivets to secure its iron girders.

Montmartre, too, was happy that year. Not because of *L'Exposition,* with which it expected to have nothing whatever to do, but simply because it was spring, and the gendarmes closed their eyes to many things, and sparrows chirruped in the chestnuts of Boulevard Clichy.

Soon it was summer. On the terrace of La Nouvelle, bushy-bearded artists sipped their absinthes and fanned themselves with their enormous hats. Families dined on the little balconies of their apartments and engaged in leisurely conversations with neighbors across the street. On rue Caulaincourt, the laundresses wiped the sweat from their brows with their sudsy arms. *Cochers* dozed on their boxes, the reins slack in their hands, while their horses, wearing absurd straw hats with holes cut out for their ears, stood patiently in the gutter and chased flies off their rumps with a swish of their tails.

Such was Montmartre in this summer of '88: an oasis of candid hedonism in a Victorian universe, the gay parish of bohemianism and carefree romance, a semi-rural district on the fringe of Paris where cherry trees insisted on blooming in vacant plots, lovers kissed in doorways, and adolescent laundresses danced the cancan for fun, because they had itching legs and light hearts.

It was still Montmartre of old—bawdy, clannish, sentimental.

And it was about to die.

Already the Angel of Death was circulating among the Montmartre population, but no one recognized him as such,

for he was a stocky man with thinning hair and a brush of graying mustache. In his ready-made overcoat and ancient derby, he could have passed for a farmer in city clothes, a retired bureaucrat or even a policeman on vacation. Unhurried and unnoticed, he strolled about La Butte, an unlit cigar stub clamped in his mouth, stopping now and then to rub his chin and spit meditatively in the gutter.

Henri came face to face with him one evening at L'Ely as he was finishing a sketch of the cancan.

The stranger walked up to his table, politely tipped his hat.

"My name is Zidler," he said. "Charles Zidler."

Henri glanced up.

"Delighted to meet you, Monsieur Zidler," he said, going on with his sketch. "Mine's Toulouse-Lautrec. Won't you sit down and have a hot wine?"

The stranger eased himself into a chair.

"No, thanks. I've had one already." For a moment, his leathery hand poised on the table like a meditative crab, he watched Henri draw. Then he said, "I've been coming here for about a month now . . ."

"You're Alsatian, aren't you?" smiled Henri, recognizing the accent. "My best friend is from Mulhouse. Perhaps you know him? Maurice Joyant."

The man shook his head. "I was born in Alsace, but not in Mulhouse. Besides, I wasn't likely to meet your friend, unless he was a poor boy like me. At seven I was already earning my living in a tannery. And hard work it was, believe me, for a little boy. I never learned to read till I was past twenty."

Behind his lenses, Henri considered the stranger. There was something oddly compelling about him, a hidden energy, a peasant's tenacity and also a peasant's shrewdness. What on earth did he want and what was he doing at L'Ely?

"As I was saying," Zidler went on, "I've been coming here every evening for about a month and I noticed you make little sketches of the cancan. It interests you, the cancan, eh? Me, too."

Still grinning he glanced about to make sure he could not be overheard.

"There's money in the cancan."

"In the cancan?"

Zidler nodded. "Plenty. But only for the man who knows how."

"How what?"

The visitor chuckled softly at the look of bewilderment on Henri's face. "How to exploit it. Commercialize it, if you prefer. And don't think I don't know what I'm talking about. I'm a theatrical man. Twenty years in the business. At present I am director of the Cirque Hippodrome."

Formally he held out his card.

Henri was impressed. The Hippodrome was the largest circus in Paris.

Later that evening, amidst the clatter of the midnight rush on a Montmartre *brasserie,* Zidler unfolded his plans.

"Yes," he said, setting his beer on the table and running his hand over his foamy mustache. "For more than a year now I've been looking for something new. Something different. Something that'll make me a million."

"A million! My God, you don't want much, do you?"

"If it's just to make a living, I might as well stay where I am. I want a million or nothing."

"And the cancan's going to make you a million—is that it?"

"Yes," nodded Zidler with tranquil assurance. "The cancan's going to make me a million."

"Well, let's drink to that."

They drank. Henri signaled to a passing waiter. "Another cognac."

Once again Zidler wiped the back of his hand over his mustache, and a sly grin twisted his lips. "You don't believe me. You think I am crazy, don't you? But I'm not. When I get through with it the whole world will know about the cancan. I've thought this thing out and I don't see how I can miss. Look!"

With a swift gesture he pushed aside his glass of beer.

"Next spring the Exposition is going to open. Thousands and thousands of people are going to flock to Paris. What are they going to do?"

"Visit the Exposition, I suppose."

"Oh, yes! They'll ride to the top of that tower they're building; they'll gawk at the Negroes, the Chinamen and the snake charmers. And the camels and the elephants. But what else will they do? How are they going to spend the evenings?"

From his vest pocket he pulled out a cigar stub and placed it, unlit, in his mouth.

"You see," he went on, rolling the stub between his teeth, "people are funny. They can't stand their own company. They can't manufacture their own fun. Somebody's got to do it for them. They've got to be entertained. They want

fun. And fun, monsieur, means one thing and one thing only. Women! If I've learned anything in my twenty years in show business, it's that. Silly, but that's how people are. And that's where the cancan comes in and why it's going to make me rich."

"You may be right," said Henri with polite disbelief. "You may be right. Although the cancan's been going on for several years at L'Ely and so far as I know it hasn't made anyone rich."

"L'Ely!" Zidler snorted the word with impatient derision. "Don't talk to me about L'Ely! How can you expect rich people, English and Americans, to go to a place like that. A place that hasn't even got a bar! I know Desprez, the owner, and he's no showman. He don't know a damn thing about show business. As a matter of fact he don't know his belly from his behind, if you'll excuse the expression. He's been sitting on a gold mine. But wait. I'll show him what he could have done with the cancan."

"How?"

The question lodged itself in Zidler's brain, like a banderillo in the flank of a bull. "How? I'll tell you how. First I'm going to hire all those girls who dance the cancan at L'Ely. Especially that blonde, the one with the funny chignon."

"La Goulue?"

"I don't know her name, but that girl can dance. She'll be a sensation. Then I'll hire the orchestra conductor. Then when I have everybody signed up, I'll build my own place, and I tell you it will have a bar. A bar, monsieur, that's where you make money."

"It depends on which side of it you are," Henri chortled.

Zidler did not listen and went on with his plans. "To make money you've got to have real liquor and a good bartender. As bartenders women are worth ten times more than men, and the one I have in mind is worth a hundred men. I've watched her work, and she's as smart as they come. At one glance she can spot the drunks, those who can't hold their liquor, those who're going to weep in their drink, those who want to pick a fight. Good-looking too. The way she purrs 'Another drink, m'sieu?', nobody can resist her. And on top of all that, honest and hardworking."

"Where is this remarkable person?"

"At the Folies Begère. Her name is Sarah and she tends the bar there. I'm going to get that girl if I have to give her a hundred francs a month and ten percent on the gross."

He stopped short, appalled by his own recklessness.

"No, not ten percent. But I'll go up to five."

"Speaking about drinking, how about another beer? I'm going to have another cognac."

Zidler shook his head. "No, thank you, monsieur. I am not a drinking man. A beer, that's about enough. Once in a while, when I feel depressed I'll have a rum. But that's about all."

Henri ordered his cognac and Zidler proceeded with his plans.

"And I'll not only have a good bar, and good bartender, but also a good show."

"A show? In a dance hall?"

"Yes. People can't dance all the time and, as I said, they've got to be entertained. I'll have a regular show. And not on a stage, either, like the Folies, where you need a telescope to see the girls' legs. Right in the middle of the dance floor where everybody can see. And what a show! First, as an hors-d'oeuvre, you might say, while the customers are still pouring in, I give them Yvette Guilbert. Never heard of her, have you?"

Henri shook his head.

"You will," said Zidler. "I spotted her in a little café concert where they don't appreciate her. I tell you the girl's got talent. A style of her own. With downcast eyes and the air of a constipated virgin she sings smutty little ditties that make your hair stand on end. You'll meet her when I start rehearsals. You'll like her, you'll see. She'll be a sensation. Then I let the customers have a few dances, to get warm and thirsty. After that while they're ordering their drinks, I give them Aicha. You don't know Aicha, either?"

Without waiting for Henri to reply he went on, "She's a little tramp, dumb as they come. But when she starts swaying her rump and doing her *danse du ventre* she makes you jump out of your trousers. That girl has a navel that does everything but sing the Marseillaise! After Aicha, a little more dancing. Then I give them the Morellis, an acrobat act I've used at the Hippodrome. That's for the women in the audience. You know how they are. They like to see men with big muscles in pink tights. Gives them a thrill. Then more dancing, a few more acts, until the cancan, and you'll admit you can't beat the cancan for a finale."

"It's eye-catching," admitted Henri. "It even catches the eye of the police now and then," he added with a smile.

Zidler dismissed the matter with a wave of the hand. A sudden shyness came over him. His face reddened with embar-

rassment. "Maybe you think I'm crazy, talking to you like this?"

Henri sketched a gesture of protest.

"Maybe you're thinking 'Why is he telling me all this?'" Zidler went on. "After all I've known you less than an hour. But, you see, I've been mulling these things over in my mind and there comes a moment when you've got to speak to somebody. Somebody you feel you can trust. Did you ever feel like that, when you just can't keep something to yourself any longer and you've got to talk to somebody who you know will understand?"

His eyes rested intently on Henri and their gazes fused for an instant.

"The moment I saw you I felt like that, monsieur—by the way, what did you say your name was?"

"Toulouse-Lautrec, but people call me Toulouse. It's shorter."

"Well, Monsieur Toulouse, that's the way I felt."

"I appreciate your confidence, and I won't betray it. Where are you going to build your dance hall?"

"Right here in Montmartre."

"Isn't it rather out of the way? It's quite far from the Exposition."

"No, Monsieur Toulouse. Montmartre's the place. I've been looking it over and it's got everything. It's picturesque, whorish, bohemian. Just what the tourists like. They think artists are romantic."

"Most artists do, too," Henri smiled. "But have you considered that there are already many dance halls in Montmartre?"

"Not like mine, monsieur! Not like mine. I tell you there's never been a dance hall like mine, even in San Francisco's Barbary Coast. And they have some pretty fancy places there, believe me. Mine will be different, unique. It'll be a combination saloon, dance hall and brothel. You can't beat a combination like that.

"Even the building will be different. It will have the shape of a windmill. Why? Just to be different. And it'll be painted red. Everything red, inside and out. Why? Because there's not a single red building in Paris. Besides red's a good color, especially at night. Makes the women look pretty, and the men feel thirsty and amorous. And it will have real vanes that turn, with hundreds of those new electric lights from America. Red ones, of course. You'll see them ten miles away. Can't you just picture them?"

He paused, staring into space, gazing with his mind's eye

at the scarlet, glittering vanes turning in the night. Then he raised his glass, drained it in a gulp and wiped the foam from his bristling whiskers.

"Yes, Monsieur Toulouse, with the Exposition on its way and all those English and American tourists coming to Paris, give me seven or eight months and I'll have the most famous dance hall in France. In France? What am I saying? In the world! I tell you I can't miss. I've got this thing figured out to the last detail. I've even picked the name already. The perfect name. You know what I am going to call it?"

"I haven't the faintest idea," confessed Henri, raising his glass of cognac to his lips.

"I'm going to call it Moulin Rouge, monsieur. Remember that name. Moulin Rouge. MOULIN ROUGE!"

XI

On April 2, 1889, the French flag was unfurled at the top of the Eiffel Tower. Monsieur Sadi Carnot, President of the Republic, resplendent in evening clothes at ten o'clock in the morning, declared *La Grande Exposition Universelle* officially open. And one million Frenchmen realized their dream to see the world without leaving home.

For months crowds streamed through the synthetic metropolis on Champs de Mars, gaped at blue-veiled Tuaregs, Timbuctu rug-weavers, Sudanese eunuchs, bare-breasted Dahomey amazons, Malgache princes streaked with red clay, Tahitian pearl divers, Congo chieftains, Annamite snake-charmers, voodoo priests from Martinique; a chanting, drumming, whirling humanity in *pareus*, turbans, *chéchias*, tiger skins, loin cloths, sarongs, kimonos and brocaded saris. Parisian schoolboys scrambled up onto the backs of patient elephants, and giggling midinettes rode camels and Arab ponies. Ladies in saucer bonnets and leg-of-mutton sleeves sampled Algerian perfumes and bought Tunisian bracelets, while their husbands got lost in the mob and somehow found themselves in the nautch dancers' tent.

From England came a tubby, frog-eyed *bon vivant* in white spats and silk-lapeled coat, and instantly the hearts of ten thousand cocottes fluttered in their whalebone corsets. At forty-eight, Edward, Prince of Wales, was still the *enfant terrible* of Victoria's court, but in Paris he was king. The grandchildren of the *sans-culottes* who had beheaded their virtuous king shouted themselves hoarse whenever they spied the debonaire cigar-puffing boulevardier who possessed all the vices they approved of in a king. When Monsieur Edison, the miracle man who made machines talk and captured the

181

sun in little glass balloons, crossed the Atlantic and rode to the top of the Eiffel Tower in the "flying cabin," enthusiasm reached hysterical heights.

As the newspapers had predicted, Paris was invaded by the universe. Now at the terraces of cafés every tongue was spoken. Waiters and bartenders learned that a dollar was worth five francs, a pound twenty-five, a ruble four, an Austrian kreutzer only two sous. and a Dutch florin two francs and fifty centimes. Cocottes turned linguists and solicited in strange idioms. "You, Ongleesh, yes? Ongleesh men veree nice, very *gentils,* but London veree sad, veree *triste.* No amour in London. In Paree, much amour. In Paree, women veree lov'ly, veree passionate. Me, veree passionate with gentil Ongleeshman. Oh-la-la! You buy me a leetle dreenk, yes?"

In Montmartre the Moulin Rouge started to whirl its scarlet glittering vanes, and Henri became its most faithful habitué. During the autumn and winter of the previous year he had watched Zidler's dizzy creation come to life, and the old circus man turn into a human dynamo, working sixteen hours a day, supervising every detail, climbing scaffolds, shouting at workmen, selecting carpets and china, hiring personnel, directing the rehearsals, haggling with wholesalers, thundering, joking, chewing his unlit cigar. Their acquaintance had grown into a genuine friendship. "I tell you, Monsieur Toulouse, I can't miss! I've thought of everything, and with that Exposition opening in a few weeks . . . Excuse me! Eh, you, up there! Wave that brush! *Nom de Dieu!* Think I'm paying two francs a day to catch flies? Yes, Monsieur Toulouse, as I was saying . . . By the way how d'you like the bar? Real mahogany. Cost a fortune, but wait till Sarah gets behind it! Did I tell you I got her? Yes, I did! Wasn't easy prying her loose from the Folies, but I got her, I finally got her . . ."

When did he sleep, when did he rest? No one knew. Everyone around him looked exhausted. Trémolada, a roly-poly, white-haired man who had been a famous clown and was now Zidler's assistant, ran himself ragged while mopping his round face with a red handkerchief.

In March the rehearsals began amidst the pounding of hammers, the clanking and sawing, the shouts of electricians, the acrid smell of paint. Again Henri saw La Goulue, Sardine, Nini-Patte-en-l'Air, and other nimble-footed laundresses he had known at L'Ely. Panting and sweating they flocked to his table between routines, for the cancan was no longer an improvisation but an exacting, disciplined routine.

Occasionally Zidler would plump himself on the chair

at his side, his unlit cigar working its way from one corner of his mouth to the other. "Well, how d'you like the show, Monsieur Toulouse? You see I got all those girls, and I made La Goulue the head of the troupe . . . I tell you it'll be a sensation . . . And wait till my poster comes out! The prettiest thing you've ever seen. Paid a lot for it, but that's what's going to bring the crowds . . . Publicity, monsieur, that's the secret . . . Excuse me. Eh, you, on the balcony! Get on with your work . . . Excuse me . . . Aicha! Aicha come here! What is this I hear about you and La Goulue getting into a fight? Do you think this is a dive like the one you used to work in? If I catch you two fighting, know what I'll do? Kick you both in the behind, and throw you out . . . I want peace round here, understand? Now go back to your corner and rehearse . . . By the way, Monsieur Toulouse, you wouldn't have a painting I could hang in my lobby? Something with red in it?"

After its opening, the Moulin became home to Henri. He knew everyone, could do anything he pleased. Rules did not apply to him. Although food was not served on the premises, he had food sent in and gave little supper parties whenever he wanted. The cancan girls sat at his table and told him about their love affairs; Aicha tried to win him to her side in her feud with La Goulue; Sarah, the bartender, gave him long lectures on the evils of alcohol.

Thus ended the wondrous spring and summer of '89. Parisians grew accustomed to the presence of foreigners and the Eiffel Tower in their midst; Montmartre residents, to the red whirling vanes of the Moulin Rouge. By October, tourists started going home. A month later the Exposition closed its doors. The enchanted city on the Champs de Mars melted away with the first winter snows. The exotic palaces bared their piteous frames of cheap lumber, and soon were no more. The colorful hordes of savages were shipped back to their islands, their deserts and their jungles. Only the Eiffel Tower remained like a bewildered giraffe forgotten by a departing circus. Paris became itself again.

To Henri the year's end brought a suspicious-looking letter with a foreign stamp that Madame Loubet handed him with misgivings.

"Nothing bad, I hope," she asked, fishing for information. "Nobody dead."

"On the contrary!" he exclaimed when he had finished reading the letter. "The Société des Vingt is inviting me to exhibit in Brussels in January!"

At once she was on the alert. "Does it mean you'll have to go?"

"Of course, Madame Loubet. It's a great honor."

"Honor, hmrff! Don't they have any painters in Brussels? It's none of my affair if monsieur wishes to go gallivanting to a foreign country. Monsieur is free, free like air. Monsieur can go to China or Africa if monsieur wishes."

Her thin lips, her trembling jowls betrayed her inner turmoil. Abruptly her belligerence ebbed out, tears welled up in her eyes.

"And suppose—suppose something happens to you? Suppose you fall . . . And you, all alone among those Bulgarians."

It took a long time to convince her that Brussels was only a few hours from Paris, that Belgians were not Bulgarians, that they spoke French and had excellent doctors.

"Besides, Monsieur Seurat—you know, the tall young man who comes here once in a while—has been invited also. We'll travel together."

Once again it was New Year's Eve and Henri was sitting with his mother by the fire. That afternoon he had sent her flowers, the white roses she loved and for which he had paid an exorbitant price. At dinner they had tried to be gay. He had told her about Madame Loubet and how last month, when he had caught a cold, she had turned into a fire-breathing dragon, installed herself at his bedside, tormented him with hot poultices.

"She almost drowned me in *tisane,* and read me *The Three Musketeers.*"

He had mimicked her grumblings and her scowls, and Maman had pretended to be amused. Then they had passed into the sitting room for coffee and engaged in polite conversation about the weather, Annette, Joseph. Gradually the talk had dwindled to a few uneasy remarks. Now they sat across from each other on opposite sides of the fireplace; she, bent over her knitting, her face amber-colored in the lamplight; he, in evening clothes, gazing woodenly at the fire, searching for some other safe topic of conversation.

Since his return to Montmartre their relationship had become a melancholy, infinitely delicate game they both played with consummate skill. Living in different worlds, they found intimacy almost impossible. He knew she did not and could not approve of his life and tactfully avoided speaking about it. They had not ceased loving each other; they had become strangers. And their love, indestructible as it was, merely

deepened the bitterness of their estrangement and the pain of their loneliness.

"By the way, Maman, did I tell you I've been invited by the Société des Vingt to exhibit next month in Brussels?"

"Really? How nice!" She smiled at him over her knitting. "I am delighted to hear it."

Sadly he looked at her through his thick lenses. Poor Maman, sweet Maman, she did play the game . . . She did try to sound delighted, although she was neither delighted nor impressed, nor even much interested. Of course she hadn't the faintest idea what the Société des Vingt was, but even if she had, it wouldn't make any difference. She was so distraught about his "sinful" Montmartre life and his drinking—especially his drinking—that she hadn't realized he was beginning to make a name for himself . . .

The "A Saint-Lazare" cover, for instance, had she ever seen it? His magazine drawings, his paintings that were beginning to be seen in a few art shops, the flattering things critics had written about him, did she know about them? She had never said a word. Perhaps this invitation from a foreign country would impress her, convince her he was more than a Montmartre wastrel, that his life was not all drinking and carousing at the Moulin, that he worked, worked hard . . .

Eagerly he told her about the Société des Vingt.

"It's a group of Belgian artists who invite a few foreign painters each year to exhibit with them."

What made their invitation significant was that in the past the "Vingt" had shown an astonishing flair for selecting men who had later become famous. Men like Renoir, Whistler, Sargent, Rodin . . .

"And I am the youngest man ever to be invited," he said, hoping for praise.

"That is very nice indeed."

"Arsène Alexandre, the art critic of *Le Figaro*, wrote an article about it. He said . . ."

As he spoke his hopes toppled. It was no use. She didn't care what Arsène Alexandre had said, what the invitation meant. To her he would always be a failure, a beloved failure, but a failure just the same. She would never forget that he had failed to make the Salon. She had the prejudices of her class: good musicians graduated from the Conservatoire, good actors played at the Comédie Française, good singers sang at the Opéra, and good artists exhibited at the Salon.

He choked down his disappointment and went on talking

to fill the silence. He was sending several paintings to the exhibition, among them a portrait of Mademoiselle Dilhau. (Not a breath of course about the other portraits, those of the Perroquet girls he had done last summer . . .) Mademoiselle Dilhau was a respectable spinster he had met through Monsieur Degas. She gave piano lessons and lived with her two brothers, also musicians. Désiré, the older, played the bassoon at the Opéra (there—that should sound respectable!) and his brother played the flute. On Sunday evenings the Dilhaus gave intimate musicales at home that Monsieur Degas never failed to attend, for he adored music, especially Mozart . . .

As long as he could he elaborated on the subject of the Dilhaus: what a delightful cultured family they were, the interesting people one met at their musicales, how much he enjoyed these evenings. She said how pleased she was to know he had such nice friends, how gracious it was of Mademoiselle Dilhau to take time to pose for her portrait . . . Then, like a curtain, silence fell between them, a silence full of unsaid things.

Another hour dragged by in this way, broken by intermittent, short-lived attempts at conviviality. The little alabaster clock on the mantel tinkled.

"It was sweet of you, Henri, to spend New Year's Eve with me, but I know you must have some other engagement . . . and I wouldn't think of . . ."

With a tender kiss and a whispered "Happy New Year, Maman," he made his departure.

In the street he hailed a passing landau.

"Moulin Rouge!" he cried, ducking into the carriage.

As the landau pulled away from the curb, Henri leaned forward to give a last glance at his mother's window, glowing blurrily through the black tracery of chestnut branches. Poor Maman, alone on New Year's Eve! Perhaps he should have spent the whole evening with her? What was the use, they only hurt each other . . .

With a sigh he raised the window, flipped back the lappet of his evening cape, settled back in the corner.

All right, he did drink a little too much, but what of it? He knew how to drink like a gentleman. And he could stop whenever he wanted. Besides, liquor dulled the pain in his legs, that goddamned pain that never let up . . . People didn't understand . . .

Irritably he tugged open the window.

"Nom de Dieu, can't you go a little faster?"

The man's voice wafted down to him through the rain.

"Doing the best I can, m'sieu . . . Everybody's out tonight . . . New Year's Eve."

"Well, see if you can't get there before next New Year's Eve!"

As he pulled up the window he heard the *cocher's* wheezy chortle and somehow this robust joviality improved his temper. The world wasn't such a bad place after all, when *cochers* could still chuckle in the rain. To laugh, that was the secret. laugh as much as possible, think as little as possible. How did La Bruyère put it? "Don't wait to be happy to laugh, for you may die without having ever laughed." Smart fellow, that La Bruyère . . .

Finally the landau drew up to the curb in front of Moulin Rouge, garlanded for the occasion with swooping festoons of red electric lights, its scarlet vanes blazing in the night.

"Good evening, Monsieur Toulouse . . . Good evening, Monsieur Toulouse . . . Good evening, Monsieur Toulouse . . ."

With a friendly wave to the barker, the cashier and various employees he made his way through the lobby without glancing at his large circus painting hanging on the wall.*

"Happy New Year, Monsieur Toulouse," beamed Trémolada, pushing open the glass door that divided the lobby from the foyer. "You're early tonight."

"I'm giving a little party and I came to make sure everything's all right. Come and have a drink with us later."

"I'll try, but we're expecting a big crowd tonight. Can use it, too," he added in a lowered tone.

They exchanged a knowing glance. The Moulin was not doing as well as expected. Even during the Exposition business had often been slack.

"Well, try to come if you can."

He reached the ballroom. Here the lights were so bright he was obliged to shade his eyes with his hand. The first sight of the ballroom was breathtaking, and he never entered it without being struck anew by its enormity and strident ugliness. It had none of L'Ely's decaying poetry, nor the shabby intimacy of the old Montmartre haunts. It was new, garish, functional, a meeting place of strangers, like a cavernous railway station transformed for one night into a dancing colosseum. At the far end of the ballroom, on a wooden platform, the orchestra was already playing. People were taking places at the rows

* This painting, "Fernando the Ringmaster," is today in the Chicago Art Institute.

of tables that encircled the dance floor. Because of the New Year, tricolor streamers of crepe paper had been fastened along the balcony railing and the central chandelier, giving the place an air of studied festivity.

He resumed his halting progress toward the mahogany bar where Sarah was bending over the sink, rinsing glasses against a sparkling background of mirrors and liquor bottles.

"My, you're early tonight," she cried from afar. Her comely face with its large eyes and straight black bangs brightened into a smile. "And all dressed up, too. You look nice in your evening clothes. Why d'you hurry so much?"

Now he stood before the bar, panting, trying to smile, clutching the ledge of the counter with one hand.

"Give me a cognac," he gasped.

Deftly she filled a small long-stemmed glass and leaned across the counter to hand it to him.

"See, you're all out of breath. You shouldn't hurry so much." She watched him toss down the drink. "And you shouldn't drink so fast. It burns your stomach."

He set the glass on the counter, hoisted himself on one of the high stools that lined the bar. Suddenly he seemed tall, his broad shoulders almost level with hers. She could see the reflection of her face in the lenses of his pince-nez.

"Really, Monsieur Toulouse, you drink too fast. Why don't you sip, like everybody?"

"I was thirsty." He took off his top hat and unfastened his cape. "As a matter of fact, I'm still thirsty. I had dinner at home and feel depressed. I haven't had a drink since six o'clock." He lit a cigarette and blew out the match. "How about another one?"

"How about a nice glass of water, if you're so thirsty? Cognac won't quench your thirst."

"Ha, that's where you're wrong! Cognac quenches thirst, aids digestion, strengthens the muscles, cleanses the blood, washes the liver, tickles the kidneys, warms the bowels and cheers you up. Now be a good girl and give me that drink. And don't look so gloomy about it. It's New Year's Eve, and —oh, by the way, speaking of New Year's Eve—" he fumbled with his cape and pulled out a thin square box "—here's a little something for you. Not that you deserve it, mind you. Always preaching to me, making me beg for each little drink. But I like you anyway."

"For me?" she cried excitedly, drying her hands on her apron and taking the box. "Oh, Monsieur Toulouse, you are

sweet!" Impulsively she leaned across the counter and pecked him on the cheek.

"Eh, what's this? A proposal? Control yourself! Now what about that drink?"

She pretended not to hear and unwrapped the box. "They're beautiful. And with my initials!" With delight she fingered the delicate cambric. "Handstitched, too!"

"In the old days people gave chamber pots for New Year. Lovely ones with portraits of famous people painted on the bottom. We are more refined, we give handkerchiefs. Now for Heaven's sake, where's that drink?" He slapped his palm on the counter. "The service is deplorable in this place."

"You already had one," she said still looking at the handkerchiefs. "Liquor is no good for you."

"What kind of talk is that? Is that the way you drum up business? And Zidler thinks you're such a wonderful bartender!"

An odd tenderness came into her eyes. "I don't care if the others want to burn their insides, but you, Monsieur Toulouse . . ."

"But I told you liquor doesn't affect me."

"That's what they all say."

"In my case it happens to be true. Did you ever see me drunk? Did you?"

"No," she admitted reluctantly. "Just the same it's not good for you."

"No use arguing with women! *Nom de Dieu,* are you or aren't you going to give me . . ."

"All right," she pouted. "Have your drink. There!" Ungraciously she filled his glass.

He drank, smacked his lips and grinned contentedly. —

"Now put away those handkerchiefs. and let's talk business. Did Drouant's send in the lobsters?"

"They're here in the ice box," she said, still peeved.

"Good. What about the champagne?"

She pointed to a row of gold-capped bottles cooling in silver buckets. "Moet et Chandon, '78. Just like you said."

"You're a jewel, Sarah."

He glanced in the mirror at the back of the bar and caught the reflection of Zidler advancing toward him, stoop-shouldered and dispirited, an unlit cigar in his mouth.

"What's the matter, *mon vieux?*" Henri cried, swirling on his stool. "You look as if you had buried your last friend. What you need is a drink. Quick, Sarah! *Two* double rums!"

Zidler climbed onto a stool, sagged wearily on the counter.

"I can't figure it out," he mumbled staring into space, "I just can't figure it out."

"What is it you can't figure out?" Henri slipped his arm around his shoulders. "There are a few things I can't figure out myself. What's the trouble?"

"That's just it, I don't know." He looked at Henri despondently. "Remember how I used to say I couldn't miss, I was going to make a million? Well, I've just been going over the books and things aren't going right. But I can't figure out why. The show's good, the music's good, the liquor's good, people like the cancan, the prices are right. Then why isn't the place crowded every night?"

"It is tonight," soothed Henri. "Look, people are pouring in."

Zidler shrugged. "Every place is crowded on New Year's Eve. No. There's something wrong. Even during the Exposition I didn't get half the English I expected, and very few Americans. And you can't run a place like this without Americans." Absently he twirled the stem of his glass between his fingers. "I was too cocky, I guess. I was wrong."

"There's nothing wrong with your Moulin except people don't know about it."

Zidler's despondency turned to petulance. *"Nom de Dieu,* what do they want? I spent a fortune on publicity. My poster is on every kiosk, every *pissotière.* You can't take a step without seeing it."

"It's true, but people don't see it."

"What d'you mean, they don't see it? Why don't they see it?"

"Because your poster is not a poster."

"I don't understand. It was done by the best man in the business."

"I don't care if Michelangelo did it. It's a pretty picture, but not a poster."

A new awareness lurked in Zidler's eyes. "What's the difference?"

"About the same as between the blast of a cannon and the peep of a flute. A poster should be striking, original, even shocking. It should hit you between the eyes, stop you dead in your tracks, stick to your brain like a tick to a dog's back. Look, Zidler, what does your poster show you? A pretty girl sitting on a donkey, smiling inanely and showing her legs. What has that to do with your Moulin?"

"What should she do then?"

A wide grin split Henri's lips. "But, *mon vieux,* it's obvious. She should do the cancan!"

"The cancan!"

Zidler's eyes seemed to grow larger in his face. "By God, I think you're right! I think you've got it!"

"She should rustle her petticoats and kick up her legs," Henri went on, warming to his subject. "And she should do it amidst a group of spectators to show that this sort of thing goes on every night, and not on a stage, but right on the dance floor where people can see it. She should . . ."

He stopped short as he read Zidler's thoughts on his face, "Eh, wait a minute! If you think what I think you're thinking, you'd better forget it. I am not going to do your poster. Not a chance! Not in a thousand years . . . I've never done a poster, never studied lithography. It takes years to learn to draw on stone . . ."

"Père Cotelle could show you," Zidler broke in coaxingly. "He printed the other poster. He's very nice."

"I don't care how nice he is. I don't want to do your poster. I'm not interested in posters. I have no time, I'm going to Brussels next month, and I have a million other things to do. Nothing you can say or do . . ."

Half an hour later, after protesting nothing could induce him to do the poster, explaining over and over again he never had done a poster, had no interest in lithography, shouting at Sarah who was adding her pleas to Zidler's, reasoning, arguing, pleading, cajoling, compromising, exploding, slamming his fist on the counter, threatening never to set foot again in the Moulin, Henri finally gave in.

"It's going to be a wonderful poster," purred Sarah, after Zidler, tearful with gratitude, had gone away.

Henri glowered at her. "Go away from me. I'd like to wring your neck. I almost had him convinced when you had to barge in and say everybody stops to look at my painting in the lobby."

"It's the truth. They do."

"Maybe they do, but you didn't have to tell him. Why can't women keep their mouths shut? Now see what you've done. I'll have to go and see his damn Père Cotelle, start learning lithography. It'll take me five years to do that poster."

He glanced at his watch, absently wound it, slipped it back into his pocket. "I suppose I'd better be going to my table. My friends will be here soon. Have Gaston bring me a bottle of cognac. And no sermon this time! Remember, no cognac, no poster."

She watched him hobble away from the bar, a ludicrous, pathetic figure in his evening clothes.

"Thank you for the handkerchiefs," she called after him, "And a Happy New Year, Monsieur Toulouse."

He stopped, grinned at her over his shoulder. For an instant she felt the impact of his sad brown eyes. Poor ugly little man, how hard he tried to forget . . .

People were streaming into the ballroom, filling the *promenoir*, invading the circular balcony, standing in the aisles, squinting about for vacant tables. Here and there revelers donned paper hats and tooted the cardboard trumpets provided by the management. The first serpentines were whizzing through the air, describing huge arcs and plummeting down into the whirling crowd of dancers. At the tables women unbuttoned their gloves, unclasped their pelerines while the men took off their overcoats, importantly gave their orders to the waiters.

Henri took his place at the long ringside table already set for supper. For a moment his attention was taken by a party of flushed and hilarious Americans who were explaining to their waiter in their collective French that they wanted the biggest bottle of champagne in the house and the four prettiest girls. *"Voo comprenay, garsonn? Cat joo-lee p'tit femmes. Oui, oui. Tray joo-lee. Oh-la-la. Vive la France!"*

"Bonsoir, Monsieur Toulouse. Here's your cognac." Gaston set the bottle and glass on the table. "Sarah said to tell you . . ."

"Never mind what she said. I can guess. How's your wife?"

"A little better, I think. I went to the hospital this afternoon and she said to be sure to thank you for going to see her. Excuse me, Monsieur Toulouse. Everybody's in a hurry to-night."

Henri watched him rush off in the direction of a tableful of impatient customers. He filled his glass, and idly began counting the gleaming white plates, muttering the names of his guests as he went along. First, Maurice; then the others . . . The Montmartre friends, the colleagues of the *Comité Exécutif*, the spongers who came for the lobster, the champagne, the free entertainment . . .

He drank, tossing down the cognac in one gulp as usual.

He was dabbing his mustache with his handkerchief when he spied Maurice hurrying toward him. A rush of affection for this handsome young man who was his only real friend swept through him. How nice it was to have him back, spend New Year's Eve with him . . .

"Sorry I'm late." Maurice unfastened his evening cape and sat down at the table across from him. "It's started snowing, and the traffic is snarled up. I bumped into Dreyfus in the street. Remember him? You met him at my house. We only talked for a minute. He is a captain now and expects to be transferred to the General Staff one of these days. He told me he's going to get married next spring."

"Good. How about something to drink? We'll have champagne later."

"Nothing right now." He glanced significantly at the bottle of cognac on the table. "But I see you've started. Henri, honestly you shouldn't . . ."

"Please! I've already had a sermon from Sarah. Let me enjoy myself on New Year's Eve."

Maurice nodded reluctantly. "All right." His eyes ran down the table. "Quite a party. Who's coming?"

"A few distinguished personalities of the world of arts and belles-lettres. If you're going to be an art dealer . . . Speaking of art dealers, why don't you go to see Monsieur Boussod?"

"Who?"

"Monsieur Boussod. He might give you a job as Théo's assistant. No one could teach you the trade like Théo, and I'd think he would be glad to get someone to help him. Last time I saw him I almost didn't recognize him. He looked sick. He's married now, and first his child was very ill. Then there was that Vincent business in Arles I told you about. You can imagine what it did to him . . ."

"Thanks. I'll go to see him after the holidays. Incidentally, did you see the article in *Le Figaro*, about La Société des Vingt?"

He was interrupted by the arrival of an attractive and obviously very agitated young lady.

"Seen Sharlie?" she asked, flashing her black enamel eyes. "He said he'd be here."

"He'll be here in a minute. Sit down, Germaine, and have a drink." Henri waved in the direction of Maurice. "This is my friend, Monsieur Maurice Joyant. And this, Maurice, is Mademoiselle Germaine. Conder's—fiancée."

"Fiancée! That's a good one!" She tossed Maurice a curt nod and sat down. "I have as much chance of marrying him as marrying the Pope. Why I go on sleeping with that lazy, drunk, good-for-nothing Englishman, I sure don't know. Shows you how dumb I am."

She tugged off her gloves, raised her veil and continued

without pausing for breath. "He went out with that big fat English friend of his—the one with his hair all crimped up and his cheeks painted like a girl's . . ."

Henri waved to Gauzi and Anquetin who were making their way through the crowd. Anquetin was still wearing the same old battered topper he had worn as a student. His blond beard was curly as ever, though a trifle bushier than in the old days. Gauzi was his old sallow self, gaunt and worried-looking.

"Brrr! What weather!" he shivered as he reached the table. "My shoes are soaking wet. I'm going to catch my death of cold."

"Take them off," suggested Germaine impulsively.

"I can't. I've got no socks."

He shook hands with Maurice. "Not an artist, I hope. If I ever have a child who wants to be an artist I'll drown him."

Meanwhile Anquetin was blowing the snow off the brim of his top hat, sending an icy spray down the necks of the ladies at the nearest table. "Don't mind it," he explained airily. "Just a little water."

Another group of guests arrived, led by Desboutins, the old etcher, in a soiled trailing black cape, a long clay pipe jutting out of his wild gray beard.

"To you all, greetings!" he bellowed plunging into an abysmal reverence and sweeping the floor with his dilapidated hat. A medieval courtliness was part of his style, increasing with each successive stage of drunkenness. At its peak it reached paroxysms of floweriness. "Let Bacchus and Venus forever be your guides, and the art critics and dealers fry in everlasting oil. Amen!"

Henri flipped a wink at Maurice while the old bohemian scrambled to a chair.

"Food! The sweetest sight on earth!" He seized one of the lobsters that had been brought to the table, and considered it lovingly. "Look at those lines, those planes, those curves, that sad expression in its eyes! What an etching I could make of it! Another Rembrandt, another Dürer. But I'm too hungry, I've got to eat it! In conflicts between the heart and the stomach, the stomach always wins."

Other guests were arriving, in pairs or in small chattering groups. Maurice was introduced, and the women flashed him appreciative, skittish smiles. Soon they were all eating, sipping champagne, cracking lobster claws, shouting to one another across the table.

"Eh, Lautrec, how did you get yourself invited to Brussels?"

yelled Dethomas from the end of the table. "Why didn't they ask me?"

Henri's reply never reached him.

"In the second act my script calls for twenty-eight elephants on the stage!" roared Bouleval, the playwright.

"Marriage should be abolished as immoral and unbiological . . ."

"Did you see Renoir's show at Durand-Reul's?"

". . . the greatest painter of women since Rubens . . ."

". . . the Boucher of the kitchen wenches. All pelvis and buttocks . . ."

"Eh, Lautrec, did you hear that Seurat . . ."

"My next painting will be a blend of Veronese and Cézanne . . ."

On and on it went amidst the mounting tumult, the whizzing serpentines, the laughter at surrounding tables, the confetti, the raucous bray of paper horns. The men, stimulated by rich food, and the proximity of women, talked with sweeping gestures and the passion of people for whom talk has become the last deception, the only escape from the premonition of failure. From time to time they interrupted themselves to gulp a mouthful of lobster, raise their glasses to their lips; or they rose to dance only to return a moment later, red-faced and panting, ready to plunge back into whatever argument happened to be in process at the time. Or, in a mood of amiable lecherousness, they flirted with their friends' mistresses, engaged in discreet but active exploring under the table.

The women—there were eight of them—were typical Montmartre women in leg-of-mutton blouses and homemade hats. They had done many things, none of them with great success. They had been artists' models, music-hall figurantes, semi-professional dressmakers or modistes, semi-professional cocottes. They had loved neither wisely nor well, but merely often. Now in their late twenties or anxiously concealed early thirties they had renounced their youthful dreams and resigned themselves to whatever life had in store for them.

Tonight in this ear-splitting pandemonium that titillated their senses and silenced their regrets, they were enjoying themselves. Flushed, their eyes bright from champagne, their femininity aroused by the impact of animality loosed in the room, they chatted, laughed, tossed serpentines, danced, murmured insincere protests at the men's advances, happy to be a part of this night of revelry, to be courted once more, told they were ravishing—and misunderstood—creatures.

"Guess how much that crook of a dealer offered me for my etchings?"

"'But, *chéri*,' she told her husband, 'how could I resist him? He looks so much like you.'"

"It's not true that the best things in life are free; they're damned expensive . . ."

Hoarse from talk, a little giddy from drink, Henri reached for the bottle of cognac in front of him and mechanically refilled his glass. His eyes wandered over to the party of Americans, huddled in doleful harmonizing of "Genevieve, Sweet Genevieve," completely oblivious to the four tarts at their table. At the bar, Sarah, now a marvel of efficiency, was rushing from one end to the other, as if playing some giant xylophone. Waiters ran hither and yon, like mechanical toys out of control, their round trays high on their fingertips.

In steady crescendo, hysteria rose through the room with the approach of the New Year. On the dance floor women clung to their partners, their lids closed, their lips parted, as if in some obscure fear. The air, vapid with human breath and thick with smoke, was speckled with confetti and streaked with serpentines.

Yes, this was fun, this was life, this was the way to spend New Year's Eve. Much better than brooding by the fire in Maman's sitting room. La Bruyère was right: "Don't wait to be happy to laugh . . ."

He drank, ran his crooked finger over his mustache. The warmth of the liquor spread over him like a blanket.

He noticed Charles Conder advancing jerkily toward the table, accompanied by a tall, massive man with wavy chestnut hair that fell over his ears, and a pendulous clean-shaven face that seemed to gutter down in adipose rolls into his tremendous wing collar. Both wore evening clothes. Their shirt fronts were crumpled and their top hats askew on their heads. Both were very drunk.

"Here comes your Sharlie," Henri signaled to Germaine, who had reached the stage of lachrymose self-pity and was unburdening her heart on Anquetin's solicitous shoulder.

Instantly she spun on her chair, glaring-eyed. "The pig! Look at him! Didn't I tell you he'd be drunk as a pig?"

"Henri ol' chap," slurred Conder with British formality, "let me intr'duce my ol' frien' Oscar Wilde. Marv'lous writer, and all that sort of thing. Just breezed in from London . . ." The effort of introduction exhausted him. His knees buckled under him and he collapsed into a chair.

"Ah, Paris!" exclaimed the newcomer while easing down

his bulk. "The only civilized city in the world. Two days ago I arrived worn by the cares of domesticity—a wife and two boys, y'know—the cackle of London hostesses, the chores of business. And already I begin to revive." He expanded his chest and took a long breath of smoke-laden air. "Here, in this wonderful Paris I can breathe, I can think . . . Ha, champagne!"

From behind the smoke of his cigarette Henri studied the man's face. Complex yet transparent, it betrayed the inner conflict of people who are not at peace with themselves. Guilty yearnings lurked in the troubled, bulging eyes. The mouth, faintly rouged, was small, pouty, feminine; but the brow was magnificent, marmorean, suffused with an almost imperial greatness.*

He would have liked to listen to this disturbing but magnetic foreigner, but already he was called by Anquetin.

"Eh, Lautrec, isn't it true that the dealer on rue des Martyrs is a crook?"

Dealer! The word seemed to provoke a spontaneous combustion around the table. Desboutins, Ibels, Gauzi, Dethomas —all had grievances against dealers and they vented them with a vehement, almost sensual pleasure that swelled the veins in their necks and brought flashes to their eyes.

"I used to get twenty-seven francs for an Ascension," shrieked Anquetin, "and now that damn Shylock pays me only twenty-five. He says religious sentiment is waning. Now, you know that's a lie. Go in any church on Sunday. Packed to the doors."

Henri exchanged a swift glance with Maurice.

Ah, the dealers! There you had the real maggots of art, the scoundrels who made fortunes—yes, fortunes—from the genius and distress of great artists. How they loved to see the brilliant, original artists grovel in desperate want, in abject poverty!

Already spirited, the conversation grew more fiery still when Bouleval added his complaints against theatrical producers.

"There you have a really contemptible breed! Just last week the director of the Comédie Française declined the honor to produce my 'Death of Hannibal'. And do you want to know what this congenital idiot said?"

* Lautrec made a portrait of almost everyone at this party. His portrait of Boileau is in the Cleveland Museum. His portrait of Oscar Wilde—done in 1895—is world famous.

Nobody did, and the playwright continued his imprecations amidst the general indifference in a sort of booming counterpoint to the chorus of laments against art dealers.

"Eh, Dujardin," cried Henri, who was wearying of these everlasting complaints, "how's the pornography business these days?"

"Flourishing, I regret to say," Dujardin rumbled cheerfully. "Most flourishing, like all businesses founded on Man's abysmal stupidity."

He took his hand from under the table and swerved the flambeau of his beard in Henri's direction.

"At present I'm busy writing the *Secrets Mémoires d'Amour* Madame de Pompadour should have written, but didn't. The poor girl was frigid, but in this book she sears the bedsheet. It will sell like *frites* at the fair."

"Shame on you, Monsieur Dujardin! Shame!"

The reproof came from Georgette, a luscious-eyed brunette known in Montmartre circles as "the Man-eater."

Dujardin screwed his monocle into his eye socket and considered Georgette with a look that managed to convey warm appreciation of her visible charms and utter disregard of her mental powers.

"You are right, mademoiselle, absolutely right. I should be ashamed of myself. I have a mind like gorgonzola. It stinks. But I am too poor to afford a literary conscience. Two years ago I brought my publisher a brilliant manuscript on incunabula and fourteenth-century missals. The next day he flung it in my face. Since then I have been writing about *l'amour* and eating regularly. Of course it is a very limited and somewhat tedious subject. After all, strictly speaking *l'amour* is something that starts at one end of the alimentary tract and ends at the other."

He caressed the frozen fire of his beard and let out a sigh.

"But can I help it if it's the only thing people want to read about. Especially women."

To this the ladies opposed a wall of cackling protests.

"Women don't read dirty books!" yelped Ponpon, a comely seamstress, who couldn't read anyway. "It's men who do. They all have dirty minds."

These remarks extinguished the various discussions in progress around the table and ushered a general controversy on the ever-popular topic of *l'amour*.

Even Bouleval paused in his denunciations of theatrical producers to declare that women had no mind whatever—dirty

or otherwise. "The mental alertness of the average female is that of a hippopotamus squatting in a mud bank."

The debate was momentarily interrupted by Desboutin's announcement that he was going to urinate. "A hint from the bladder is more imperious than a king's command." Majestically he disappeared in the direction of the lavatories, his felt hat crumpled on the back of his head, his cape sweeping the floor behind him.

As soon as he was gone the battle of the sexes was resumed with fresh gusto on both sides. The women attacked with low, unsportsmanlike blows and disparaging remarks about men's amorous performances.

"They talk like they were Herculeses!" sneered the Man-eater, obviously drawing on personal reminiscences. "And after a few tussles they pant and they gasp and they wheeze and you've got to get out of bed to give them salts."

It was almost midnight. The ballroom had become a gigantic cauldron of simmering humanity. On the dance floor, now too small for the mob packed upon it, dancing had turned into a shuffling stampede, a promiscuous rubbing of backs and buttocks. In the enveloping tumult, the paper horns sounded like sheep bleating in a storm. On the podium, Dufour, the conductor, swayed his hips, flapped his elbows, waved his baton.

Henri refilled his glass, drank, and leaned back in his chair. It was the exquisite moment when his legs stopped aching, when the pain vanished. The faces at the table had become blurred spots of color; the chatter of voices floated to him in an indistinct drone.

Yes, this was the way to spend New Year's Eve! After all, you lived life a minute at a time—as you ate grapes, one by one . . . If you managed to enjoy every single minute, every little mouthful of time, before you knew it you were enjoying life . . .

Abruptly the orchestra broke off in the middle of a bar. The conductor rapped his baton sharply on his music rack, veered around and stretched out his arms.

"*Mesdames et messieurs,*" he trumpeted in a reedy, clipped voice, not unlike the barking of a small dog. "It is exactly midnight! On behalf of the management of the Moulin Rouge, I wish you a happy and prosperous New Year! *Vive la nouvelle année!*"

Then he whirled back and broke into a fit of epilepsy. The orchestra let out a screech of brass. Bedlam broke loose

in the room. People kissed, yelled, stamped their feet, shook hands, clinked glasses.

Maurice leaned across the table. *"Bonne année,* Henri. *A la vie et à la mort!"*

"Bonne année, Maurice."

He doffed a funny paper hat, snatched a trumpet from the table, and puffing out his cheeks, blew into it with all his might.

A new year had begun.

1890 . . . The year of Marie Charlet.

XII

"Well, how was Brussels?" Degas spread a napkin over his chest, pushed back his cuffs and sprinkled a few cautious pinches of salt into a large horn salad spoon. "How was the show? What did the critics say?"

"The show itself was a success," Henri replied. "But the critics! The things they said!"

"The critics!" Degas let out a hoot of high-pitched laughter and turned to Camille Pissarro who, watching him across the table, was fondling his Santa Claus beard. "Do you hear that, Camille? The critics didn't like his pictures. Sounds familiar, doesn't it? Remember what they used to write about my ballet girls ten years ago?"

He was in high spirits tonight. These informal dinners at home were a diversion in his solitary life. His cheerful mood expressed itself in nervous, birdlike gestures and a stream of pessimistic remarks. Each successive course brought a new denunciation. By the time Zoé, his faithful hatchet-faced housekeeper, had brought the roast, he was uttering prophecies of cataclysmic doom and universal disaster.

"First, the vinegar!" he said, reaching for the cruet. "The seasoning of a salad—" he glanced over his shoulder to make sure Zoé was back in the kitchen, "—is much too delicate an operation to leave to the mercy of an ignorant servant."

With considerable formality he counted a few drops of vinegar on the salt and pepper and mixed them into a gritty paste.

"Now for the oil!" His manner had become solemn, judicial. "Camille, how do you like your salad? Well-oiled or on the dryish side?"

201

"I don't care," Pissarro chortled. "Any way you like. *Mon Dieu*, what a fuss over a head of lettuce!"

Degas swung back to Henri. "There! You see!" The words exploded into a barking snort. "There's your Impressionist! Can't understand why you should spend some time and thought over the seasoning of a salad! Why, any old way will do! Toss in the salt, throw in the garlic, pour in the oil, scramble the whole mess together, and there's your salad! All Impressionists are like that! Why bother about little things like drawing and anatomy? Why exert yourself? Smear a blob of paste, splash daubs of pink and blue all over your canvas, call the confounded thing *une impression*, and there you are!"

"Now, now, Edgar, don't get so excited!" remonstrated Pissarro genially, "You're tossing lettuce all over the table."

"Who's excited? I am perfectly calm!" shrilled Degas flinging lettuce leaves right and left.

He veered away from his guest with an assumption of supercilious indifference and addressed Henri. "Tell me about Brussels. Of course you saw Sainte Gudule and the Verbruggen pulpit? Wonderful, aren't they? But did you have a chance to go to the museum and study the Van Eycks? There, young man, you have perfection! Absolute perfection! Those hands, those draperies! Only God could paint better than that, and I for one doubt it very much. And what's this I hear about your fighting a duel? Well, well, come on! Don't sit there as if you'd lost your tongue."

Henri had expected the question. The news of his "duel" was all over Montmartre.

"I didn't fight a duel, Monsieur Degas," he said blushingly. "I merely challenged a certain De Groux. I couldn't stand the remarks he was making about Vincent. It happened at the closing banquet of the exhibition."

As he described the incident, he recalled the brilliant function, the long white-clothed table, the sparkling glasses, the glistening shirtfronts, the buzz of conversations mingling with the muted clatter of knives and forks. Suddenly his attention was caught by De Groux, a pale, blond aesthete who was sitting at the foot of the table waving his amethyst-ringed hands, and lisping his opinion that Vincent Van Gogh should never have been invited to exhibit. Why, the man was a raving lunatic. Even slashed off his own ear! As for his work— well, what could you expect from an inmate of a lunatic asylum.

For a while Henri had tried to keep himself in check; but soon anger had overcome his patience.

"Monsieur De Groux!"

His fist crashed on the table with a violence that sent a ripple of clinking glass around the table. Even the waiters stood frozen, their bottles of champagne in mid-air.

"Only a coward will attack a man who cannot defend himself. All great men have been called maniacs by fools like you! If Vincent were here he'd knock you down. Or he might forgive you—I don't know. But I'm his friend and I won't forgive you. I wish I could challenge you to a duel with swords. It would give me pleasure to slice *both* your ears off. But I can pull a trigger, and . . ."

". . . And if Monsieur de Toulouse-Lautrec is killed," cried Seurat springing to his feet, "I'll take up the challenge!"

In the ensuing bedlam De Groux had attempted some sputtering remonstrations, but they had been cut short by the club's president who had thundered him out of the room.

"And so," Henri wound up with a sheepish smile at Degas, "as you see, there was no duel. De Groux tossed his napkin on the table and stalked out. The president apologized on behalf of the Société. And that ended the incident."

"Wonderful!" Degas was enthralled. "It reminds me of the duels people used to fight over Olympia. People would get up at dawn, drive to the Bois, catch their deaths of cold because of that painting. Remember, Camille? By the way, what became of that girl who posed for Olympia? Pretty chit of a thing, wasn't she? What the devil was her name?"

"Victorine. Victorine Meurend. She must be a grandmother by now."

"She had the sauciest breasts I ever saw," continued Degas warming to memories. "And the loveliest pear-shaped *derrière*. You could see by the way she swayed it she had a lot of *savoir-faire* . . . Good Heavens, almost eight!" he broke off, looking at his watch. "I told the Dilhaus we'd go to their musicale after dinner. Clémentine promised to play some Mozart for me. Mozart! Ah, what a musician!"

They finished their dinner. Henri complimented Zoé on her *confiture à l'orange,* and the old servant blushed with pleasure.

"Personally I loathe *confiture à l'orange,*" grumbled Degas, as they were leaving the apartment. "But she thinks she is a wonder at it and serves it every day of the year. Women are extraordinarily vain about their smallest accomplishments, even the imaginary ones."

Pissarro left them at the street corner and, pulling his round

black hat over his eyes, made his way toward the Gare du Nord. Degas and Henri walked the short distance to rue Frochot, where the Dilhaus lived. It was a blustery January night, with gusts of wind that rattled the shutters and furrowed the rain puddles between the cobbles.

As they started climbing the stairs, they could hear the deep arpeggios of Désiré Dilhau's bassoon mingled with the lighter scales of his brother's flute. There was something unconcerned, faintly sylvan about this frolic between instruments that reminded one of the capers of a mother bear playing with her cubs in the deep forest.

All sound stopped when Degas rang the bell.

"Come in, come in," beamed Désiré Dilhau, opening the door. "You're just in time to hear some good music."

With his fearsome mustache, his blue-veined nose, he looked more like a tippling *cocher* than a respectable bassoon player at the Opéra.

"Clémentine is in the kitchen preparing coffee," he went on, taking hats and coats and hanging them in a closet. "Coffee goes well with music. So does beer. I remember during the rehearsals of *Tannhäuser,* Wagner used to drink barrels of beer. Can you believe it, he made us go through a hundred and fifty rehearsals of that damn opera, and all we got on the première was rotten eggs!"

Still talking he ushered his guests into the stuffy, over-furnished parlor in which a few people were already assembled, just as Clémentine fluttered in, her bony spinster's face pink from the heat of the kitchen stove.

"Mon Dieu," she fretted, setting the tray on the table, "I hope the poor man finds our house! I wrote the address down, but he is so absent-minded, he probably forgot it. Always thinking about music . . ."

She noticed Degas and Henri.

"Ah, Monsieur Degas and Monsieur Toulouse, how nice of you to come on such a beastly night!"

She was distraught with anxiety. Absently she brushed back a loose strand of hair as she glanced at the clock standing under a glass bell on the mantelpiece.

"Mon Dieu, nine o'clock already!" she muttered to herself. "I am sure he's lost. Well, let's have some music. We'll start with the Mozart sonata I promised Monsieur Degas."

She was about to start playing when the bell rang. Her brother hurried to the door and returned accompanied by a stocky, round-faced man, smiling apologetically between fluffy gray side-whiskers.

"We thought you were lost." Clémentine rushed to him, hands outstretched.

"I was," admitted the old man, pumping her hand. "I know you gave me your address but I misplaced it. Forgive me, my good *demoiselle*. At sixty-eight, you know, you forget things . . . Sometimes I even forget the address of my pupils. But while I was searching for your house, the *bon Dieu* sent me a lovely modulation—oh, such a lovely modulation! Just a diminished seventh and a little bit of reverse counterpoint. I jotted it down under a lamppost."

Cutting short his apologies, Clémentine seized him by the sleeve as though she feared he might escape and introduced him to her guests. "Monsieur César Franck . . ."

At three o'clock that morning Henri, exhausted, drenched to the skin, sat in a dingy bistro peering shortsightedly through the window at the unfamiliar side street, wondering where he was and how he would possibly get home at this late hour.

"How on earth am I going to find a fiacre?" he mumbled under his breath, staring at his own reflection in the glass.

Not that it mattered. This was a nice little dive, warm and quiet—oh, so quiet—with its sputtering gas jet and its fly-specked calendars of beautiful ladies in evening dresses drinking vermouth.

Thank God, the crisis was almost over! It had been a hard one. And so unexpected!

It had all been very pleasant. Clémentine had played her Mozart sonata, fragile like the clinking of crystal glass. Then someone had produced a violin and this Monsieur Franck had gone to the piano and accompanied his own sonata. Very beautiful, incidentally.

And then it happened. Clémentine, kittenish as you please, had begged him to play something. "Please, Monsieur Franck!" And to oblige her, he had complied. And damned if he didn't play Denise's Prelude! Well, that had brought it all back.

Strange how you could live in peace for months, almost forget you were an ugly runt of a cripple. And suddenly, bang! It hit you again full in the face. The same old thoughts. You'd never take a straight step; no girl would ever love you; you'd always be alone . . .

He turned to the counter where the *patron* was talking in whispers to a weasel-faced pimp in a tight-fitting suit and a brown derby.

"What's the name of this street?"

"Rue Lallier, monsieur," replied the owner, a gracious smile in his beefy face.

"Are we far from Boulevard Clichy?"

"No, no, monsieur. At the end of the block you turn to your left and you're there."

"Thanks. Bring me another cognac, will you?"

Again he leaned forward and squinted at the darkness outside. It had stopped raining, but he could hear the howl of the wind. What a night! Well, he would find a fiacre on Boulevard Clichy and go home.

He gazed a moment at the fan-shaped gas-jet. Lovely thing! Flowing, alive, throbbing like a butterfly of light caught in a cobweb. In a corner, a bawd in a white calico blouse slept crumpled on the table, her face buried in her arms, an empty bottle of wine in front of her. Her hat had fallen to the floor and lay in the sawdust at her feet. She breathed regularly, like a child, and now and then lapsed into a gentle, dreamy snore.

He heard the owner say, "Excuse me, please," to the pimp and watched him slapfoot to the woman, shake her by the shoulder and wait for her to awake. Leadenly she stirred, raised her blowsy face to him, gave a smiling, jellied stare. The man struck her across the face with the back of his hand.

"Shut up, Gueule-de-Bois! You know I don't like snoring. Besides, it's not polite. Next time I'll kick you out."

He trudged back to the counter. "Excuse the interruption," he said to the pimp. "But I've got to keep order in the place."

"Naturally," approved the man in the brown derby. "Naturally."

It had happened so fast Henri had not grasped the cold brutality of the scene. Now he was furious.

"The pig, the filthy pig, the son of a whore!" he raged to himself. "Oh, to be tall and strong! To seize this brute by the neck, smash your fist in his meaty, stupid face."

But already another feeling was pushing his indignation aside. Still dazed by the blow, the woman had not moved. She was rubbing her knuckles against her cheek, gazing abstractedly at the empty wine bottle. Her sottish face was gray with drunken weariness. She was a moment in human abjection.

Swiftly he pulled a pencil stub and a scrap of paper from his pocket. If she only would stay like this for one minute . . . Please, don't move . . . Feverishly he raced the pencil over the paper. In a matter of seconds the brutish profile had come to life. The matted, disheveled hair, the glassy, unseeing

eyes fixed on the bottle . . . But already the masterpiece
was dissolving, thawing under his eyes. The woman listed
waveringly. Her lids drooped. With a soft thud she crumpled
across the table, fast asleep.*

He paid for his drink. "And this is for a bottle of wine.
Give it to her." He waited until the new bottle had been taken
to the woman. Then he hobbled out of the bistro.

The cold air sent a shiver through him. He raised the velvet
collar of his overcoat and made his laborious way up the
street, leaning against the wind, holding his derby with one
hand. High in the sky a pale winter moon swam among the
stormy clouds. At the corner he looked about for a fiacre,
but the wide thoroughfare, usually so animated, was empty
and ominously silent. He resumed his advance, pushing himself
forward with his cane, breathing noisily through his mouth.
In this fashion he had learned he could cover twenty, some-
times thirty feet without having to stop. Twenty minutes and
he would be in bed . . .

Already he had passed the Moulin Rouge, black and silent
like a charred ruin. He was forging ahead and was shuffling
along the deserted boulevard when he heard the sound of
light running footsteps behind him.

A girl appeared at his side.

"Please, monsieur," she begged in a panting whisper, "Please,
say I am with you."

Presently there were other footsteps. A man's hand reached
out of the darkness and seized the girl's wrist.

"Show me your card!"

She kicked, clawed, tried to bite his hand. The man let
out a muffled curse and twisted her arm savagely. She screamed
and bent over with pain.

"Now," he said, "will you come? Or do I make you come?"

"Let go her hand," broke in Henri. "Can't you see you're
hurting her?"

The man turned around. "I saw her solicit someone and
she's got no card. You've got to have a card to do the streets.
Besides, what business is it of yours?"

"How could she solicit anybody when she was with me
all evening?" The lie had sprung naturally to his lips.

"All evening?" the man echoed derisively. "Don't try to
slip that one on me. I tell you I saw her myself." He stopped

* This sketch was elaborated into the famous painting, 'Gueule-de-
Bois', one of Lautrec's masterworks.

short and a tinge of deference came into his voice. "You're Monsieur Toulouse, aren't you?"

"Yes. And I'll report you to the police if you don't stop molesting people."

"Police? That's a good one. Why, I am the police."

"How do I know? Why aren't you in uniform? Show me your credentials."

Reluctantly the man let go the girl's wrist and began unbuttoning his coat. "I'm Sergeant Balthazar Patou, of the Vice Squad. In our line of work we don't wear uniforms."

"Never mind. I believe you. I heard all about you at L'Ely from Père la Pudeur. He said you were the most conscientious officer in the district. We certainly could use a few more like you. But, believe me, you're mistaken about this girl. She really was with me all evening."

"But I tell you I saw her myself with my own eyes."

"In this darkness how could you be sure? As a matter of fact, I just saw a woman running down that way." He pointed down the street. "She must be the one you're looking for."

"See her face?"

"How could I? She just flashed by."

His assurance disconcerted Patou. "Did you say she was running down that way?"

"Yes. She ducked into rue Fromentin." He turned to the girl. "You saw her, too. Didn't you, *chérie?*"

"Yes, I did," she mumbled surlily, still rubbing her wrist. With a toss of her head she added, "She went down that way."

Undecided, the detective twisted his mustache, looking at each of them in turn.

"If she's taken rue Fromentin, I guess I'll never catch up with her," he muttered to himself. "Sorry to trouble you, Monsieur Toulouse. But we've got our orders, you understand, don't you? Somebody's got to watch the public's health and keep an eye on these girls."

"Of course! I understand perfectly. Well—*bon soir,* Monsieur Patou." He signaled to the girl. "Come on, *chérie,* let's go. It's getting late."

They walked away in silence, feeling the policeman's eyes upon them.

He hurried as best he could, strangely aware of the girl at his side, vaguely resentful of her springy gait. Why on earth had he gone through that elaborate fabrication?

"Say, can't you walk a little faster?" she urged under her

breath, as he paused for a second time. "What's the matter with your legs?"

There was neither sympathy, nor revulsion, nor even curiosity in her voice, but mere annoyance at the delay.

Her remarks infuriated him. Was that all she could find to say?

"If you don't like the way I walk, why don't you go ahead? He's gone now. You don't have to stay with me. He won't run after you."

She was silent for a while.

"You born like that or what?" she asked a moment later in the same unconcerned tone. "Once I knew a man who got his arm caught in a machine. He was lucky, that one, he got five hundred francs from the insurance company." She glanced over her shoulder. "Please, hurry."

"For God's sake, can't you see I'm hurrying as much as I can!" His panting made it difficult for him to speak. "I told you you can go now. He won't run after you. You're safe."

"I'd like to break his teeth." She muttered the words with a fury of vindictiveness. "I'd like to spit in his mouth!"

"He let you go, didn't he?"

"Just the same, he's a *rouquin,* and I'd like to kick the whole damn lot of 'em in the belly!" Her words rang with a fanatical yet impersonal hostility, the age-old hatred of the hunted for the hunter. "But you fooled him. It's hard to fool the police," she said unexpectedly, after a pause. "You're a sharp one."

Again there was the same indifference in her voice. She was not thanking him, not complimenting him—merely stating the fact that he was a "sharp one."

They reached the corner of rue Caulaincourt, and he stopped under the street lamp.

"Look, here's a hotel." He pointed to the blurry globe of light over the door of a dingy building. "It's open all night and you can get a room. Have you any money?"

"I don't want to go to a hotel," she sulked. "First, they don't let you in unless your card is in order. And if they let you in, they charge twice the price, and in the morning they tell the police, just to get the ten-franc reward."

For the first time he could see her face. She was blonde and younger than he had imagined. Eighteen, nineteen at the most. In the darkness her eyes were *terre-verte*—probably light hazel in daylight. The mouth was mobile, wide, awkwardly rouged. She wore neither hat nor coat and he suspected her

to be nude under her dress. Yet she did not appear to be cold. The thin fabric clung to her pointed breasts, outlining their contours, as in Greek statues. She was tough, sordid, pliant, dangerous—and intensely desirable.

"You live around here?"

"Yes. I have a studio a little farther up the street."

"Let me stay with you." For the first time there was cajolery in her voice, and it sent a ripple of pleasure through him. "I won't make any trouble and in the morning I clear out."

She gave him a low-lidded glance.

"And if you want me, you can take me. For nothing. Honest, it won't cost you a sou. Got a cigarette?"

He handed her his gold case.

She examined it, ran a finger over it and returned it after taking a cigarette. "Looks like real gold. Once a man gave me a pair of gold earrings, but I lost 'em. Got a match?"

He struck one, and she leaned down, hands cupped around the flame.

"God, you're ugly!" she mumbled between puffs, looking at him through her lashes.

Blood drained from his cheeks.

"Go away!" he snarled. "Go away and leave me alone! I don't want you."

"Oh, yes, you do."

Calmly she blew out the match and sucked on her cigarette. "I see it in your eyes."

"Leave me alone." He started shuffling away from her. "Leave me alone, or I'll turn you over to the police."

She joined him in a few easy strides. "Why'd you get so mad? I just asked if you'd let me sleep in your room, that's all. I won't steal anything. And if you like me, you can take me. I don't care if you're a cripple. I'll be nice to you just the same." The cajolery returned. "You'll see, I can be nice when I want to."

He did not reply and kept plodding up the silent, empty street, avoiding the rain puddles, shimmery with moonlight. She walked by his side, blowing smoke through her nostrils, pausing whenever he did.

"If you've got a studio, then you must be an artist," she remarked as they neared the house. "Once I knew one who painted cupids on soup plates."

They filed past Madame Loubet's lodge and began climbing the stairs. The gas jets hissed gently, made flickering patterns of light and shade on the walls.

"Don't you lock your door?" she asked as he turned the knob.

"Why should I? There's nothing to steal. Wait here till I light up."

He hobbled through the familiar darkness and lit the kerosene lamp on the drawing table. The huge room came to life in an amber luminescence that revealed the beamed ceiling, and canvases on the walls, the angular silhouettes of easels. In the center the stove made a rosy glow.

Her eyes swept idly around. "It's a big room. And the stove's still going. D'you have it going all the time?"

She sauntered to the window, sat down on the couch, and with complete unconcern began to undress.

He watched her, the burnt match still between his fingers. The first woman ever to spend the night in his studio! . . . How graceful she was! Even the magnified shadows of her gestures on the walls were lovely. Why did she irritate him so? Because she hadn't thanked him? No, it was her casualness, her tranquil certitude he wanted her. How did she know? Could she really see in his eyes he wanted her? She hadn't been here five minutes and already she was undressing as if she were in her own room. At Le Perroquet the girls chatted while they undressed, called you *"chéri."* It might be make-believe, but at least they pretended. This girl didn't even trouble to pretend.

"What're you staring at?" she said, raising her catlike eyes. "Never seen a girl take her clothes off before?"

She removed the cigarette butt from her lips and crushed it on the floor. "For an artist you sure don't talk much," she went on as he failed to answer. "The one I told you about who painted soup plates, he was a real talker, that one. Always telling stories and funny jokes."

He felt a stab of jealousy for the artist who had known how to amuse her, for all the men who had seen her undress, possessed her. How many times had she unrolled her stockings like this in front of strangers, slept in strange rooms, in strange beds—this girl of nineteen?

She rose to slip off her dress. As he had guessed, she wore no petticoat. Swiftly she stripped off her *culotte*. Now she stood before him in a flimsy chemise hemmed with cheap lace.

"Where's the toilet?"

No, he wasn't going to let her use his nice bathroom. Let her wander through the house, let her catch cold! It would teach her manners . . .

"At the end of the corridor."

His elation was short lived.

"You mean on the same floor?" Wonder made her gasp. "Sometimes you got to climb two or three flights to find the place."

He looked at her. In what verminous houses, in how many abject corridors had she groped? How long had she been a prostitute? Probably from childhood.

"You wouldn't let me have the matches, would you?" she asked with an imperceptible hesitation, a trace of entreaty in her voice. "I don't know the house."

"Here, take the lamp."

At once he regretted his words. She had looked pitiable, touchingly ludicrous standing there in her chemise, barefooted. But he shouldn't have followed the impulse; he should have tossed her the matchbox. That's what the other men, the painter and all the others would do. That's how they'd treat her—like the vagrant tramp she was. They wouldn't inconvenience themselves on her account. She wasn't used to kindness, didn't understand it . . .

Without a word she took the lamp from him and crossed the room.

He was alone in the blue dimness. If he hurried, he could slip into bed before she returned . . . She wouldn't see his legs. Thank God, the couch was made up as a bed . . .

Quickly he unlaced his shoes, tossed his clothes haphazardly on the armchair. He had just crept into bed when he heard the patter of her bare feet.

"In bed already? My, you didn't waste time, did you?"

She set the lamp on the table, pulled her chemise over her head. "Want the light on?"

"No. Blow it out."

She leaned forward, curved her hand around the glass chimney in a gesture of breath-taking loveliness. For a fleeting instant he saw the saffron outline of her profile, the roundness of her throat, her rose-nippled breasts. Then she was gone—a fluid shadow in the cobalt darkness of the room.

"Afraid I'll see your legs?"

The ripple of sarcasm in her voice enraged him.

"Get out!" he bellowed, shaking with anger. "Get out, damn you! Get your clothes and get out of here! I don't want you. I didn't ask you to come."

Oh, to be tall and strong! To be able to slap her face, or twist her arm as Patou had done!

"Haven't you ever slept with a cripple? You've slept with everything else!"

Calmly she parted the sheets, slid into bed. He felt the silky length of her body against his.

"Don't shout so loud," she said softly, "you're going to wake everybody in the house. I just said you didn't want me to look at your legs, that's all. What do I care about your legs? I don't care if you're a cripple. I told you I'd be nice to you, if you'd let me stay. You want me to stay, don't you?"

Her words fanned in hot puffs on his neck. The tips of her fingers trailed down his loins. Her voice ebbed to a whisper.

"You'll see, I'll be nice to you. I can be nice if I want to."

She raised herself with reptilian grace, slipped her arm under him, clamped her mouth over his.

And suddenly there was nothing but her enveloping nakedness, the moistness of their tongues . . .

And high in the window, the moon.

When he awoke, he knew by the fire crackling in the stove that Madame Loubet had come. Come—and gone. The silence was alive with her disapproval. Outside a churlish drizzle trickled down the windowpanes. Another dreary winter day.

Cautiously he moved his head on the pillow and looked at the girl at his side. She slept with her cheek pressed on her arm, her lips parted, one breast exposed. Despite her painted mouth and the black pencil lines on her eyebrows she reminded him of Clouet's adolescent virgins. How peacefully she slept! She would sleep just as soundly in any other bed . . . Or on a pallet, or on a public bench. Or curled up in some hallway . . . She was used to sleeping anywhere, as she was used to wandering at night through dark corridors, roaming the streets without hat or coat. Chance had brought her for a few hours, like those bluebottles that strayed into the studio in summer. Soon she would awaken, dress and go. Where? God only knew. She would wander through the rain, prowl in ill-smelling alleys, hide from the police, lunch on an apple filched from some pushcart. At dust she would wait in shadows, offer herself to strangers for five, four, three francs—perhaps simply for a bed, a place to sleep, as she had done with him. Tonight some other man would watch her undress, possess her lithe, wild body. Another man would feel the touch of her fingers, discover the exquisite depravity of her mouth. She would give herself with the same abandon, the same wantonness that had intoxicated him—without love,

without tenderness, simply because she was born lewd, born with a genius for debauchery.

Perhaps . . . perhaps . . . if he paid her, paid her well . . . Don't be a fool! Let her go! She is a slut, nothing but a hard, cheap, stupid slut . . . A girl like her could only bring trouble . . .

He was at his easel when she awoke.

"Good morning," he said from his stool. "Sleep well?"

She sat up, clasped her arms around her knees. With a toss of her head she swayed back a strand of yellow hair.

"Got a cigarette?"

He felt her anger return. Why couldn't she be civil? Never mind, she'd be gone soon . . . He hobbled to the armchair by the couch, with deliberate slowness pitched her his gold case. "You'd better get up. It's past noon and I have work to do."

"Got a match?"

She pulled on the cigarette, inhaling the smoke. "You do all those pictures?" Her eyes traveled over the walls. "What d'you do with 'em? Sell 'em?"

With the tip of his cane he lifted her *culotte* from the floor and tossed it on the bed. "Put this on and get up. I want to work."

She did not move and went on smoking.

"*Merde!*" She glanced through the window. "Raining again! Ever see so much rain?"

Her upturned face was bathed in the grayish daylight. He noticed her eyes were a light hazel, clearer than he had expected. The shadows of her shoulder blades and down her armpits were a powdery blue. He thought of asking her to hold the pose and let him make a sketch of her, but checked himself.

"What's that you got on your head?" she laughed, turning round.

He was annoyed at being caught with the absurd paint-streaked hat. "My working hat," he scowled. "I wipe my brushes on it. A habit I have."

"That's a silly thing to do."

Again he felt the blood drain from his face.

"If you don't like it, you don't have to look at it. Now you would oblige me if you'd pick up your things and go. Patou isn't waiting for you downstairs, and I'd like to do some work."

"You get mad easy, don't you? Always shouting, telling me to go. I don't care about your hat. Just makes you look funny, that's all."

She gave him an amused glance and leaned aside to tap the ashes of her cigarette on the floor.

"What's up there?" she asked, noticing the stairway to the balcony.

"My room and bath."

"A BATH!"

In a flash she was out of bed, running up the stairs. He heard her exclamation of delight at the sight of the bathtub.

She rushed to the railing, leaned over it.

"Please, please, let me take a bath." Her voice had the whimpering eagerness of a child's pleading for a toy. "I'll clean it real nice. I promise."

A small, inner voice warned him: "Refuse. Tell her to dress and go."

"If you want to."

The words seemed to speak themselves, and they gave him a weird feeling of a foreign presence within him, a rebellious self over which he had no control.

"But don't be too long," he added ungraciously. "I have work to do." With the help of his cane he heaved himself out of the chair and returned to his easel.

He heard the gush of water, the humming and clanking of plumbing and a moment later a disturbance accompanied by a volley of gutter oaths.

Again she rushed to the balcony railing. "Please come! I can't shut off the tap. The water's going to run over."

When he reached the bathroom, all was quiet. She lay in the tub, giggling.

"It's all right. I fixed it. D'you know I've never taken a bath—a real bath, I mean. In a tub."

From the doorway he watched her splash her shoulders, wiggle her toes, glide deeper into the water with little squeals of sensuous delight. Her excitement was pathetic: the jubilation of a street urchin wading for the first time in the ocean. Her blonde hair, hastily tossed up in a loose chignon on top of her head gave her a saucy, puerile look. Her small glistening breasts were those of a girl barely nubile. She looked sixteen. Again he was struck by the unstudied grace of her motions. Once she raised her arms to secure the crumbling equilibrium of her hair, and for a few seconds she assumed the pose of a Pompeian figurine he had sketched in the Louvre. The adolescent courtesans who frequented the Stabian baths must have looked like her . . .

With tight muscles he feasted his eyes on her.

One night . . . One more night of her, her nervous thighs,

her pulpy mouth . . . No. She was evil, dangerous . . . But
how could she be evil? Look at her. A sixteen-year-old *gamine*
. . . Perhaps there was still some freshness in her, some hidden
tenderness . . .

"I know why you didn't tell me about your bath." She
soaped her armpits, spattering suds over her chest. "Because
you didn't want me to use it and see your nice things. That's
why you sent me down the corridor last night. I know you
don't like me. You're always shouting at me."

She glanced at him through wet lashes.

"But I was nice to you, wasn't I? I kept my word, didn't
I? You liked me, didn't you? Don't say you didn't, because
you did. If you didn't wear those glasses, you'd have beautiful
eyes," she remarked irrelevantly.

He heard her voice through the haze of his thoughts.

"What difference does it make whether I like you or not?"
She wasn't going to deceive him with her wheedling glances
and her silly chatter . . . "I got you out of trouble, you've
slept in a bed and taken a bath. That's what you wanted, wasn't
it? Now get dressed and leave me alone. I have work to do."

He turned to go.

Luxuriously she sank deep into the warm water.

"If you like—" her voice was a coaxing purr "—I can come
back tonight. And I'd be nice to you again."

The temptation . . . There it was, unmistakable, throat-
drying, bone-melting . . . That's how it looked, how it sound-
ed. . . In the Garden, the snake must have spoken like this,
in this soft, insinuating voice. "Tell her no, tell her no!" cried
the small voice within him. "She only wants your studio,
your bathroom, your money . . ." But the other voice, the
voice of the rebellious self was also speaking. "One more
night . . . Just one more night . . ."

For two or three seconds the two voices clamored amidst
the pounding of his heart. He removed his pince-nez, slowly
polished the lenses in a delaying gesture.

"Suit yourself." The shrug was emphatic, too emphatic.
"I don't care."

A tiny flame leapt in her eyes. "You didn't even tell me your
name. Mine's Marie. What's yours?"

"Henri."

"That's a pretty name."

She stretched a glistening arm out of the bathtub.

"Hand me the towel, Henri."

Two hours later he was hurrying down rue Caulaincourt,

deftly avoiding the rain puddles, humming to himself in his deep, chesty baritone, as he always did when he was happy.

He would have liked to skip, turn somersaults, blow kisses at the laundresses.

Marie was coming back!

Ten minutes ago she had left saying, "Seven o'clock. No, I won't forget. And you'll see, I'll be nice to you . . ." Her words had trailed after her like a caress while he listened to her light footsteps down the stairs. Only then had he discovered he was ravenous.

Of course he couldn't possibly drive to Père Cotelle's, as he had planned. It was too late anyhow. Besides, his mind was on more interesting, much more interesting things than lithography . . . Zidler's poster would have to wait, that's all, and to hell with it!

Marie—such a simple, lovely name! She would have dinner with him. She had promised. At first he had planned to take her to Drouant's, but now he had a better idea. They would dine in the studio. Just the two of them, as lovers did in books. A fine dinner with some really good wines. Champagne? Why not? Champagne would make her laugh, wriggle her nose, say silly things. Some flowers, too. Nothing like flowers to make a place look homelike. She would see how it felt to be treated nicely for a change, see the difference between a gentleman and those ruffians she had known until now.

For that's all that was the matter with her. The poor girl had been ill-treated all her life. Cold, hungry, afraid. No wonder she had grown hard. Even dogs turned mean when they were beaten. Kindness, that's what people wanted, what the world needed. Just a little kindness. And he was going to give it to her, make her forget the cold nights, the police, the artist who painted soup plates, and all the others . . .

Astonishing how wrong you could be in judging people! He had thought her selfish, callous, stupid, when, as a matter of fact, she was none of these things. Of course she was uneducated, but everybody was born uneducated. She had grown a protective shell. Who wouldn't with the kind of life she had been forced into? Beneath it all she had a nimble mind and a good heart.

It was shortly after he had handed her the towel that he had begun to change his opinion of her. With exquisite swiftness —all her motions were graceful—she had sprung out of the tub, dried herself, and still nude, started combing her hair, all the while chatting like a magpie. She possessed the Parisian urchin's gift for mimicry. With startling justness she had aped

Patou and his rumbling voice. Holding a comb over her upper lip she had imitated his grumble coming through his mustache. "I'm Sergeant Balthazar Patou, of the Vice Squad. In our line of work we don't wear uniforms." Before long he was smiling at her impish gestures, her slangy repartee. He was calling her Marie, thrilling at the proximity of her flesh, at her tranquil immodesty as she rouged her lips, penciled her eyebrows with a burnt match. They had even joked about the "working hat." Wearing nothing but her *culotte* she had set the paint-spattered hat on her blond head at a rakish angle, made faces in the mirror. It had been silly; it had been delightful . . .

Tonight when she returned she would be wearing a new dress. Oh, it hadn't been easy to make her take the money! "I said you could have me for nothing, didn't I?" she had protested. Finally she had admitted her dress was shabby, her lingerie could be improved upon. They had joked about her *culotte*. Risqué little jokes—the kind lovers exchange between a laugh and a kiss. At last she had accepted the money, and he would never forget her expression at the sight of the hundred-franc note. "Hundred francs! . . ." She was actually stammering, gulping. Poor girl, life had been hard on her; she had known nothing but squalor and bitterness. But he was going to change all that . . .

On Boulevard Clichy he hailed a fiacre and drove to Drouant's, where he gave his order for the dinner to be sent in. "And don't forget the champagne. Moet et Chandon '78. Also send a few bottles of cognac at the same time."

Then he drove to a florist's; coming out of the shop, he dismissed the fiacre. As he was making his way to a nearby *crémerie,* he heard a genial rumble at his side.

"*Bonjour,* Monsieur Toulouse. Imagine meeting you like this! Talk about a coincidence! Just as I was about to come and pay you a little visit!"

It was Patou, the same Patou who the night before had twisted Marie's arm and made her scream with pain. His heartiness seemed genuine enough, but there was something ominous in his sudden appearance. Coincidence, indeed! . . .

"What did you want to see me about?"

Again the jovial smile. "Oh, nothing, Monsieur Toulouse, nothing at all. Going in for a snack? Hungry, aren't you? Nothing like a little *amour,* eh, to give you an appetite. Mind if I join you?"

The *crémerie* was a unit in a chain of *restaurants sanitaires*

sponsored by the City to combat alcoholism and foster the consumption of dairy products among the lower classes. Meals consisted of eggs, butter and cheese; the only beverage served was milk. These establishments prided themselves on their cleanliness, their white-tiled walls and their virtuous atmosphere. Poorly patronized at all times, the place was deserted at this hour of the afternoon.

They sat down at a marble-topped table, and Henri gave his order to a starched, aseptic-looking waitress.

"I'm afraid, Monsieur Patou, I can only offer you a glass of milk," he said with an effort at geniality.

In the same spirit of sociability the detective accepted. Leisurely he removed his derby hat, set it on the chair next to his, and proceeded to fill his pipe. He seemed to have all the time in the world, and while Henri devoured his omelet he discoursed at length about the weather and the Panama scandal that had just broken into the newspapers.

It was not until dessert that he remarked in an offhand manner, as if the thought had just occurred to him, "You know, Monsieur Toulouse, that was a good one you slipped over on me last night. You had me fooled for a while. Your little story about that other girl ducking into rue Fromentin, that was a smart idea. It sounded pretty convincing at the time."

He let out a good-humored chuckle while thumbing the tobacco in the bowl of his pipe.

"But after you and your *demoiselle*—" the irony of his tone made Henri glance up from his plate "—had walked away, I got to thinking. 'How come,' I said to myself, 'how come he could see that girl ducking into rue Fromentin when it's so dark you can't see an elephant at ten paces? Balthazar Patou, my friend,' I said to myself, 'that Monsieur Toulouse is a sharp one. He's made a fool of you. He sold you a bladder for a lantern,' if you'll excuse the expression."

He took a sip from his glass of milk and sucked the fringe of his mustache.

"Now, Monsieur Toulouse, you're young, and I'd like to give you a little piece of advice."

There was an imperceptible change in his manner.

"You shouldn't have done it. You really shouldn't. I don't mind your tricking me, although I know for a fact Marie was not with you, as you said, but . . ."

"How do you know her name?"

A condescending smile passed over Patou's features. "We have our means of information. It's not difficult finding out

about people, if you really want to. Later I'll tell you how I know her name. For a moment I'd like to warn you to have nothing to do with her. She is no good, believe me. She is a rotten apple. I know that she slept with you last night, and that's all right. No harm in that. But don't keep her around. Kick her out."

He snapped the last words with trenchant, surgical finality.

"Kick her out!"

"How do you know she stayed with me last night?"

"How?" Again the condescending smile. "I tailed you, that's how. I saw you both turn into rue Caulaincourt where you live." He made a deprecating gesture with his hand. "And don't try to tell me she slept at the Hôtel de la Lune, because I checked up. Oh, it's all right. No crime in sleeping with a girl, especially a pretty one like her. We've all been young once and we understand these things, but . . ."

He paused and the smile vanished from his face.

"—I—don't—want—her—in—my—district."

He stressed every word with a tap of fingers on the edge of the table.

"She has no card, no right to solicit. She's a vagrant. She might be healthy, and then she might not. We've got to watch over the public's health. That's what we're paid for. Please, don't think I'm butting into your affairs, Monsieur Toulouse, but keep away from her. Kick her out, believe me, kick her out. And if she doesn't want to go, just send me word. I'll take care of her. I've seen hundreds like her. They're born in the slums; they suckle vice with their mother's milk. They grow up in the gutter. Their parents send them to beg when they're five. At twelve they give themselves for five sous in hallways and *pissotières*. At fifteen they start doing the streets.

"But they don't want to register as prostitutes at the Prefecture and get the card, because they're scared to report twice a month to Saint-Lazare for the medical *visite*. Besides, they think it's smart to do the streets without a card; they like to see how long they can give us the slip. It's all very well, but I don't want her around."

His tone turned ominous again.

"What she does elsewhere is none of my affair, but if she tries to do business in my district, I'll pack her off to Saint-Lazare with a recommendation for a six-month detention. That'd quiet her down."

Henri stared at the tip of his cigarette.

"You seem to know a lot about a girl you only saw for

a minute in the dark. Has it occurred to you you might be mistaken?"

The policeman's eyes crinkled with laughter. "Not this time, Monsieur Toulouse, not this time! I know all about that girl. Who she is, where she comes from—everything. Remember when you stopped under the street lamp and she asked you for a cigarette? You didn't see me, but I was less than ten meters behind you. When she leaned down to light her cigarette, I had a good look at her and recognized her face. Not right away, but I said to myself, 'Balthazar Patou, my friend, you've seen that *hooplala* somewhere.' Then this morning it came back. So I went and did a little checking up. And I was right."

He enjoyed the look of surprise on Henri's face. He refilled his pipe and took a few noisy puffs.

"Yes, I was right," he nodded, waving away the cloud of smoke. "Her name is Marie Françoise Charlet. She was born in rue Mouffetard. You don't know rue Mouffetard, *hein?* Well, you don't miss much. Even in the Temple district, they haven't got streets like that. It's dead in the center of the wine and liquor district, and the stench makes you gag. That's where Marie was born. Her father was a bottler in one of the rum warehouses, and naturally a drunk. Her mother used to do the streets when she was young, but now she has a license as a pushcart vendor. Marie's older sister, Rose, ran away from home when she was sixteen and went to live in the Sebastopol district, where I was stationed at the time. Marie joined her there two years later. As I said, I was stationed there, and that's how I happen to remember her. You can't help noticing her with that mop of yellow hair and those slanting eyes. But she's a rotten apple, just the same."

He fussed with his pipe for a moment before going on, as though he wanted his words to sink into Henri's mind.

"So this morning I went to see my old friend, Inspector Rampart, of the Sebastopol Vice Squad. I told him about Marie, and sure enough they had a file on her. She used to have a pimp, a certain Bébert, one of those bullies who aren't satisfied with leeching on girls, but go in for a little burglarizing on the side, and wind up by killing somebody and having their heads chopped off on the guillotine. Well, she was crazy about Bébert. Always hanging around him, rubbing herself against him, buying him drinks and hair pomade when she had money. A regular bitch in heat. One day he kicked her out."

His eyes still on the tip of his cigarette Henri let the words

scorch through him. Why did it hurt so to hear Patou say these things? He had known she was a tramp. Now he knew that she had the traditional, almost classical background of the prostitute. A drunken father, a slatternly mother, a whoring sister, a pimp . . . Why then did it hurt so to know that she had loved this Bébert, rubbed herself against him, bought him drinks and pomade? So, she had a heart after all, she was capable of love . . . And of course she would choose some cretinous, husky brute. That also was part of her "classical" background. Why then did it hurt so, why did he want to bury his face in his hands? He hadn't hoped she would fall in love with him, had he? He couldn't be that much of a fool . . .

"Why did he kick her out?" he asked, trying to sound merely curious.

"Why?"

Patou burst out laughing.

"Because she didn't bring in enough money, of course. She was too young—hardly seventeen at the time—and too much in love to make a good *pigeon*. Her mind wasn't on her work. She wanted to hang around him when she should have been out looking for *michés*. Finally Bébert lost his patience and kicked her out. That was two years ago and maybe she's learned a little sense by now. But I doubt it. Anyhow, one thing is sure, she's never returned to the Sebastopol district. But I don't want her here in my district."

He leaned forward and an unexpected gentleness came into his eyes. "I can see it hurts you to hear all this, Monsieur Toulouse, but I had to show you she's a rotten apple. A high-born gentleman like you." He grinned at Henri's glance of surprise. "Oh, yes, I know all about you, too! You see, it's our business to know about everybody in our district. I even know about Monsieur le Comte, your father. His horses, his birds, his . . ."

"Since you seem to have been investigating everyone," Henri said with a forced smile, "would you mind telling me if you have a family of your own?"

A startling change came over Patou's face. The keenness of the pupils, the hard line of the jaw, the hint of brutality in the square chin—all seemed to melt at once.

"Only a daughter, Monsieur Toulouse, but what a girl! No one could wish for a better daughter than my little Eulalie. A treasure! Cooks like an angel, makes her own clothes, keeps the house neat as a pin. You should see the slippers she knitted for me!"

The image of the vice-squad sergeant in knitted slippers flitted before Henri's mind.

"You are a very fortunate man."

To his surprise, Patou let out a sigh and shook his head despondently. "I used to be, but not any more. My little Eulalie's going to get married. Not that I object to her getting married, mind you. No, nothing like that. Her fiancé's a good man. I've investigated him . . ."

"I'm sure you have."

His irony was wasted on Patou, who went on with enthusiasm. "A fine, upstanding young man. With a future, too. At present he is a guard at the Roquette Prison, but he's just been promoted to the guillotine section. A position of trust. Mark my words, some day he'll be a captain, perhaps an inspector."

He took another sip of milk and brushed his luxuriant mustache with the back of his hand.

"Just the same, I shall miss my little Eulalie."

Somehow Henri couldn't bring himself to hate this poor devil who had shattered his happiness. He, too, in his way, was lonely. He snuffed out his cigarette and signaled to the waitress.

"I am grateful for what you've told me about Marie. I agree with you and I'm sorry I tricked you last night. I wish you had sent her off to Saint Lazare. If there's something I can do to repay you for the trouble I've given you, I'll be glad to do it."

"There is, Monsieur Toulouse." Something like a blush suffused Patou's hard face. "For a long time I've wanted a portrait of my little girl. Now that she's going to be married, if I had a portrait of her I could hang it over my mantelpiece. It'd keep me company."

Life was full of ironies, indeed! A man broke your heart and you thanked him by painting his daughter's portrait.

"It will be a pleasure to paint Mademoiselle Eulalie's portrait. Bring her to the studio whenever you want." He smiled. "I need not give you my address. You already seem to know everything about me."

When he returned to the studio that evening, he noticed that Madame Loubet had set the dinner on the table. A bottle of champagne cooled in a bucket. Flowers bloomed in a vase. The room had been swept, the stove freshly stocked, the bed made up. Good Madame Loubet! What her thoughts must have been he easily guessed. He could almost hear the disapproving cluck of her tongue.

Well, tomorrow everything would be forgotten and forgiven.

Tonight, after dinner, he would send Marie away . . . Patou was right. She was a rotten apple . . .

"Look!"

She was standing in the doorway, dressed in a cheap, black velveteen dress, a feather boa slung lorette-style over her shoulder.

"Real velvet! Nice, *hein?*"

She started across the room.

It was almost midnight. For five hours he had sat hunched on the edge of the couch, a bottle of cognac at his feet, listening to every sound, feeling his heart leap each time he heard footsteps on the stairs, getting angrier with each disappointment. The slut, the miserable slut! She wasn't coming back! How she must be laughing with Bébert about the wabbly-legged midget who had rescued her from the police! For of course she had run to her pomaded pimp, handed him the crisp hundred-franc note that fool of a cripple had given her . . .

He was staring at her, too angry, too weary—too happy to speak. She had come back . . .

"What's the matter with you? You sick? Why don't you say something? You don't like my dress? I got it cheap from a friend." She sat down on the couch next to him. "Just the same I had to give fifty francs for it. Real velvet's expensive. Feel it."

"Fifty francs for that rag?" His anger returned with his relief. "You didn't pay ten francs for that dress! But I don't care. How about our dinner? I thought you said you'd be here at seven?"

"Ten francs!" She spat the words at him. "Shows how much you know about dresses! What d'you know about dresses? In a dress it's the material that counts. Feel that material." She pressed herself against him. "Feel it! See if you can get it for ten francs!"

He shoved her away. She reeled back on the couch, and he sensed her surprise at the strength of his hands, his steel-muscled banister-gripping hands.

Suddenly he wanted to be alone, go to sleep, never see her again. He wanted her to take herself, her lies, her gritty voice, her cheap dress, away.

"All right," he nodded wearily. "Yes, it's real velvet and you paid fifty francs for it. You're a good girl and I'm glad you came back. But, I've been thinking things over, and it'd be better if you . . ."

"Because of the dinner? Because I couldn't come for dinner? And me, who thought you'd be so glad to see me in my new dress! I walked all afternoon to find that girl so I could buy it from her. Then I went to see my sister. And she was sick, real sick. She wanted me to stay, but I said I had promised . . ."

"Oh, stop lying! It doesn't matter. I don't care about the dinner, I don't care about your dress, your friend, your sister . . . Just leave me alone, will you? I'm tired. I'd like to sleep. Here take this . . ."

He reached for his inside pocket, but she had coiled her arm around his neck. He could feel her breasts, the supple tenseness of her waist.

"But it's the truth, I swear it!" Her lips brushed against his ear. "I tell you I went to see her and she was in bed with a fever. I even gave her money to call a doctor. But I didn't stay. She wanted me to, but I said 'no'. And you see I came back. I came back, didn't I?"

Vainly he tried to disentangle himself from her. "Yes, yes," he muttered tiredly. "All right, you came back. I'm glad you came back. I'm glad you bought the dress, but please . . ."

His protests died in the enchantment of her kiss. Again he felt the slitheriness of her tongue, the flexure of her loins. His lids closed.

All night he struggled against her and himself. Again and again through the vehemence of their lovemaking, he started his remonstrances, now in angry commands, now in a pleading whimper, finally in a confused, sleep-drugged mumbling. But she did not listen. She forced her nakedness on him, lashed his sensuality with the inventions of her debauchery.

"You like me, *hein?*" she crooned in the blueness of the moonlit night. "Like me a lot, eh? I can tell. You think I'm nice, don't you? You're glad I came back. You don't want me to go, you want me to stay, don't you?"

Finally they collapsed in an exhausted slumber, their limbs mingled, their lips touching, her hair streaming like yellow silk on his shoulder.

At dawn he awoke for a moment, looked at her through slitted eyes.

No use, it was no use . . . It didn't matter what Patou had said, what Madame Loubet thought, what he had promised himself, what she was, where she had been. Nothing mattered but that she was here, nestled against him. That he could

feel the warm pressure of her body, could fondle her, do with her what he pleased . . . That tonight she would be his again . . .

His eyes closed. The conflict within him expired. Like dusk falling over a battlefield, peace descended upon him—the peace of defeat.

XIII

She moved in.

His bathroom became cluttered with her tawdry belongings. Her comb, her hairpins, her curling iron mingled with his crested toilet set. She used his brushes, his nail buffers, his expensive soap. He grew accustomed to the small indignities of cohabitation: towels smeared with lipstick, crumpled stockings on the floor, the smell of rice powder, lingerie tossed on the furniture.

He loved it all.

For the first time in his life he shared a woman's secret intimacies. He watched her bathe, rouge her lips, pencil her eyebrows, curl her hair. It was like a second form of possession, almost as thrilling as the other, this revelation of the backstage of her femininity. You didn't know a woman well until you had seen her at her toilette.

For the first time he had a mistress. No—not quite . . .

"If you want me to come again, then you've got to pay me," she said one morning.

He felt that she was not so much actuated by greed as by a prostitute's notion that her lovemaking must be bought. Her body was her stock in trade. It was for hire, by the hour or by the night, but in no case could it be enjoyed free.

"And if you want me the whole night"—she read the answer in his eyes and mentally thumbed a price chart "—then you must pay me ten francs."

When he told her he wanted her to stay with him during the day also, she looked at him incredulously. Why should he want her to stay with him? Nobody had ever asked her any such thing before. Well, if that's what he wanted . . .

Another laborious computation took place in the labyrinth

of her brain. "Then you must pay me five francs extra."
She was prepared to bargain, and was surprised when he
accepted without discussion. He must be rich . . .

His second disappointment came a few days later. He
had hoped to show her off to his café friends, enjoy the tribute
of their envy. She swept away his illusions.

"I don't want to meet any of your friends. Why should
I listen to a lot of twaddle about art I can't even understand?"

Nor did she want to accompany him to the Moulin or
go out with him to Drouant's. "I don't want to go to those *chichi*
places where the waiters look down their noses at you."

He discovered she had no ambition whatsoever, no wish
to improve herself. The dream of every lorette of finding
a *riche monsieur* had never crossed her mind. She came from
the slums and had no desire to free herself from them. He
understood he would have to take her on her terms or lose
her. She wouldn't change her habits on his account. If he
wanted her to stay, he would have to change his.

He did.

He forsook his friends, his apéritifs, his evenings at the
Moulin. Since they did not fall asleep before dawn and did
not rise before mid-afternoon—when the brief winter daylight
was already waning—he also forsook his work. He did not
go to Père Cotelle's, did not finish the painting he had promised
Sarah, forgot about Zidler's poster. He stopped attending
the meetings of the *Comité Exécutif*. He avoided Maurice.
The pattern of his life dissolved, as if unraveled by an invisible
hand.

Their liaison became a furtive, clandestine affair that
admitted no outside friendship, no diversion. They dressed
leisurely, ate their breakfast-lunch in some dingy *gargote*,
served by a seedy proprietor in shirtsleeves and slippers. And
they spent most of their time at the Carmen Bar, a sordid
haunt of pimps and prostitutes which reminded her of the
dives of her Sebastopol district. There they sat for endless
hours, smoking, drinking, hardly speaking, watching the
pimps play billiards, waiting for night to come. Then they
shambled back to the studio—for she insisted on walking
and refused to drive.

A thousand times in the first weeks of their affair he
wondered why he put up with her, with the kind of life
she forced upon him. "What's the matter with me?" he asked
himself angrily.

The answer was always the same. He wanted her—her de-
pravity, her lust, the intoxicating and ever-renewed rapture

of her flesh. To keep her, he must endure her presence . . . To let her go would be dangerous. She was a vagrant with the street in her blood. She might meet someone . . . She might not return . . .

She had a quality of inertness, a mental vacuousness that stupefied him. He could not explain the contrast between her lyrical sensuousness, the inventiveness of her body, and the crassness of her mind, except that she was born like that with a genius for debauchery, as some people were born with a genius for music or mathematics.

In vain did he upbraid himself for his shameful surrender to her terms. For the first time he discovered within himself a capacity for cowardice and touched the slime of abjection lying deep in all men. He learned tolerance from self-knowledge.

Meanwhile he wouldn't have changed his condition for anything in the world. She was his. Every inch of her long and supple body was his. Every night he thrilled anew at the touch of her hands, the taste of her nipples, the caress of her pointed tongue—all the things she sold to him for fifteen francs a day.

One March morning she awoke earlier than usual.

"Got a cigarette?"

She gazed through the window, smoking in silence for a while. Then she sprang out of bed, began to dress.

She was pulling her stockings on when she asked, "How d'you open a savings account?" Obviously she had been mulling over the question for a long time.

"It's very simple." He concealed his surprise at the strangeness of her inquiry. "You go to the district branch of the Caisse d'Epargne on rue Provins and tell the cashier you want to open a savings account. That's all there is to it."

"That's all? He won't ask a lot of questions?"

"People don't ask questions when you hand them money. However, he'll probably ask your name. For his books."

"Nothing else?" She ran her fingers up the length of her leg, snapped the garter above the knee and leaned down to pick up the other stocking. "They won't ask anything else?"

"Nothing else."

"And I can get my money out any time I want?" She watched him warily through her lashes.

"Any time you want."

This sudden impulse to save money was the first domestic trait she had ever shown. Could it be she was settling down?

"May I ask you why you want to open an account?"

She did not reply at once. "It's for my license—the pushcart license." Memories of a hunger-haunted childhood echoed in her voice. "My mother always said the first chance I got I must put money aside for a license. When you've got a pushcart license, you never starve."

"How much is it?" he asked gently.

"Fifteen hundred francs," she said, staggered by the enormity of the amount. "But it's good for life. Once you've got it you never have to buy another one."

"How much do you have?"

"Almost three hundred."

He thought of giving her the balance, but checked himself. She might leave him . . . "It won't be long now, you'll soon have enough," he said.

When she returned from the bank, she was as excited as a child.

"Look!" she cried waving the bankbook. "And the man didn't ask any questions. Only my name—just like you said."

There it was, neatly written in flowery cursive—Marie Françoise Charlet. And the amount. The price of her nights, of the dreary hours spent with him . . .

"Congratulations," he said with a forced smile. "If you keep on like this, you'll soon be a rich woman."

From then on the bankbook occupied an important place in her life. She carried it with her, took it out of her purse, held it in her hand. She talked about it, and thus indirectly came to talk about herself.

"Ever been to rue Mouffetard?" she asked one day, unexpectedly. "That's where I was born . . ."

Her simple words brought to life the putrescence of the slum, the livid abjection of a swarming, horny-handed humanity of coopers, bottlers, warehousemen in grimy leather aprons and hobnailed shoes. She described the rumblings of Percheron-driven wine wagons, the hammering of barrel corks, the vinous slime over the cobblestones, the stench of fermenting vats mingling with that of rotting garbage.

She told him about her games with other pigtailed *gamines* in dank courtyards, the cold hungry Saturday nights when her parents were too drunk to think about dinner, her mother's slaps, her father's beatings followed by fits of ambiguous tenderness.

"First he'd make me take off my *culotte*, then he'd thrash me. Then when I was crying in bed he'd come and kiss me, and beg me to forgive him."

Abruptly she would stop in the middle of her reminiscences, squint at Henri with the malevolence of the poor for the rich.

"I don't know why I tell you these things. You've never been hungry; you can't understand . . ."

He did not press her, and unexpectedly an hour or a week later she would resume her confidences.

With total absence of shame or feeling of guilt she would describe the awkward promiscuities with the neighborhood youngsters.

"One Saturday night—I was fourteen then—a man took me in the hallway of our house, behind the stairs. He was a cooper in the same warehouse where my father worked. He was drunk, but just the same he paid me. One franc. With the money I bought a knot of ribbon for my dress."

After the inevitable brawl, she had fled from home and joined her sister in the Sebastopol district. There under the tutelage of her elder she had begun her apprenticeship as a streetwalker. In naive, ingenious words she described the rapture of her first hat, her first scrap of lace, the wonder of easy money, the thrill of the evenings in smoke-filled dives, the first waltzes with pomaded louts.

"One day I met Bébert." A dreamy look came into her eyes. "He was real good-looking and the girls were crazy about him." Then because lying came instinctively to her, she added, "But me, I wouldn't give him a look."

At last after a fight with a girl—that was her version—she had had to clear out of the district. Since then she had lived the vagrant's existence, wandering through Paris, eating whenever she could, dodging the police, sleeping on public benches, in strange beds.

"Then I came to this damn Montmartre and that pig of a *rouquin* would've shipped me to Saint-Lazare if you hadn't come along. You sure fooled him that night."

For the first time there was something like gratitude in her voice.

She looked at him with a mixture of amusement and pity. "You're ugly and can't walk, but you're nice. You've been nice to me."

These last dreary March days were the happiest of their affair.

Before long the novelty of the bankbook palled. She still went to the Caisse d'Epargne to deposit her savings, but the excitement had gone. She stopped talking about herself. Once again her eyes swept over him without seeing him. The fissure in her indifference had sealed.

With the first stirrings of spring a change came over her. Like an animal stirring out of its hibernation, she emerged from her winter lethargy. She grew moody, restless. Apprehensively he watched her stare out of the window, a frown between her brows, or lie motionless on the couch, eyes open and glassy.

"She's getting bored," he told himself in panic.

He did what he could.

He bought her expensive dresses, a charming spring bonnet that was delivered in a frivolous pink-ribboned box. She opened it apathetically, held the hat in her hand a moment; then tossed it aside.

Now she snapped at him, turned erratic, purposely contrary. Were they about to go out, she would announce she wanted to stay in. Returning home and hearing his laborious breathing, she would insist on walking to some other bistro—always distant. She stared at his legs, sent him on petty errands, berated him for his slowness.

"Damn it, can't you walk a little faster?"

Still he tried.

"Would you like to drive to Versailles?" he asked one afternoon, sitting at her side on the couch.

"What for?"

"The palace is full of interesting things. The gardens are beautiful. The fresh air would do you good."

She did not reply and turned her back to him.

"Perhaps you'd like to go to the theatre? Sarah Bernhardt is playing *La Dame aux Camélias* at the Renaissance . . . Perhaps you'd like to go to a music hall?"

"I don't want to go nowhere with you," she replied with sudden violence. "Think I want people to see me with a cripple?"

He turned white and limped away.

Boredom sharpened her latent cruelty. She hurt him for fun, to pass a moment. An obscure class-hatred, the immemorial enmity of the poor toward the rich, goaded her into tormenting him, to see how much this wealthy cripple, who had never been cold or hungry, would endure from her.

She jeered at his fastidiousness, his habits of meticulous cleanliness. "Fussy, ain't you? Fond of yourself? The men I know don't go in for so much washing and brushing. But then they're real men, not cripples like you."

She knew the word "cripple" made him wince, and she began to use it constantly, just to see the reflex of pain on his face.

They began quarreling, and he was stunned by the senseless violence of her temper. She did not attempt to argue. She shouted, made obscene gestures, spat indecencies. Her shrieks could be heard throughout the house. Doors opened. Tenants gathered on the landings to listen to her shrill profanity. In her lodge, Madame Loubet wept.

When she sensed he had reached the limit of his endurance, Marie would sidle to him, beg his forgiveness, coax him to the couch. Quickly, in one of her swift and graceful gestures that enchanted him, she would unfasten her blouse, pull up her skirt. Like the vibrating pistil of some evil flower her tongue would slither through his lips. And once again the old magic would succeed. In the moist fusion of their breaths he would forget his shame and his disgust of her. For a day or two she would be gay, cajoling, almost tender.

It was during one of these repentant interludes that he asked her to pose one afternoon. To his surprise she accepted with alacrity.

"My portrait? A real portrait?"

"Yes. And if you like it I'll give it to you."

She scuttled upstairs and spent a long time in the bathroom making up and crimping her hair. When she came down she wore the black velveteen dress—the fifty-franc dress. Her feather boa slung over one shoulder.

His first impulse was to tell her to change, but he checked himself. His request might provoke another scene. She had been pleasant for the last two days.

She insisted on posing herself.

"My profile's my best feature." She took her place on the model stand and patted her hair. "And make my mouth real small, don't forget."

All naturalness had gone out of her. She, who was innately graceful, had become an ungainly model.

"It's hard work sitting still," she fretted after a while. "Can't you paint a little faster?" Then, as if the thought had just struck her. "How much do you pay your models?"

"I seldom use professional models. But the usual rate is three francs for the morning, five francs for the whole day."

"Then you should pay me," she flung over her shoulder. "You asked me to pose, didn't you? I didn't ask you to do my portrait. You said you wanted to paint me, so you must pay me the same as a model."

Of all her characteristics, he loathed most this prostitute's trait to put a tariff on everything she did, because it deprived

him of the pleasure of giving spontaneously. Patou was right —she was a rotten apple . . .

"I said I'd give you the painting, isn't that enough?" he asked wearily. "And how about the money I give you every day?"

She whirled around, eyes flashing. "That's for staying with you. And let me tell you you wouldn't find many girls to stay all day with you for five francs. If I've got to work as well, you got to pay extra. Three francs."

"A model poses four hours to earn that much. You haven't posed even an hour."

She leaped down from the stand. "If you won't pay me then I won't pose for you."

She flounced across the room, rummaged in her bag for a cigarette and returned to examine the painting. "It don't look like me. I'm prettier than that. I knew you didn't know how to paint. The man who painted soup dishes, he was a real . . ."

"Oh, get out!" The words exploded out of him. "Leave me alone! Go back to him, go wherever you want. I don't care!"

"What about my three francs? Now you don't want me to pose for you, so you won't have to pay me. You owe me the money."

From experience he knew there was no use trying to reason with her. He took the three small silver coins, tossed them to her. She caught them in mid-air, slipped them in her bodice and walked to the door.

"Where are you going?" he called.

"What d'you care? You told me to get out, didn't you? Well, I'm going out! I'm sick of this place, sick of you. If you want company, you'd better buy yourself a new face and a new pair of legs!"

The door slammed.

One hour later she returned, contrite, smiling.

"Forgive me, *chéri.*" She curled herself at his feet, pressed her cheek to his knees. "I don't want to quarrel with you. It's staying in this room that gets on my nerves."

He wanted to remind her how many times he had urged her to go out with him, but he kept silent. What was the use?

"You see, I've never stayed so long in one place. If only I could . . ."

"Could what?" Ruefully he stroked her blond hair.

"If only I could go out once in a while. If you'd let me go and see my sister, I wouldn't be nervous any more. And I'd be nice to you, real nice . . ."

She was lying, of course, but what did it matter? She wanted

to strut about the Sebastopol dives, snub her former rivals, boast of her bank account, gloat over the rich *miché* who was crazy about her. She was slipping away from him . . . He had known it would come some time, but at the moment he was too tired to care. He couldn't stand this constant wrangling any more. He still would have her nights . . .

"It isn't much fun living with a cripple, is it?" he said looking at her through eyes dulled with pain. "I understand. Go to see your sister, if that's what you want."

She sprang to her feet, rushed upstairs to put on the hat he had bought her. She had never worn it for him, he reflected sadly when she came down, but she wore it for her Sebastopol friends . . .

"I'll be back early, and you'll see I'll be nice to you," she cried from the door. "Real nice."

He did not reply.

On the stairs her footsteps sounded like a joyous flapping of wings.

Now she would wake before noon, dress in a hurry, ask for her money, and be off. She would return in the evening, cheeks flushed, eyes sparkling from the excitement of the day. While undressing she would launch into a stream of transparent lies about the hours she had spent at her sister's bedside. Not being clever, she would get entangled in her stories, let slip revealing asides about dancing, riotous gatherings in Sebastopol dives, trips to local fairs, rides on carousels.

From her jumbled yarns he deduced she was having the time of her life, renewing old acquaintances, knocking about with her sister, squandering the money he gave her. He said little, asked few questions, and pretended to believe her.

Suddenly he found himself with an enormous amount of leisure. It felt strange being alone in the studio again, not seeing her sprawling form on the couch, not hearing her familiar "Got a cigarette?" Perhaps it was better that way. They no longer quarreled, and she still came in the evening. He still had her nights. Perhaps he would keep her longer that way . . .

He tried to work and discovered he had lost the taste and the habit of work. A few tentative sketches of the Moulin poster ended in desultory, half-hearted pencil strokes.

He puttered about the studio, dozed.

One afternoon he heard a timid knock on the door. It was Balthazar Patou, accompanied by his daughter.

"Little Eulalie" turned out to be a formidable-looking

demoiselle with a long nose, a downy upper lip and a comb of black bangs. Henri's heart went out in sympathy to the unsuspecting young jailer who was about to marry this terrifying bit of femininity.

"We've come about the portrait." Patou fidgeted with his derby. "That is, if it's all right with you, Monsieur Toulouse."

For three consecutive sittings Eulalie posed, rigid and silent, choking stoically in her wine-red bodice and whalebone collar.*

The portrait moved the detective to tears.

"I'll never be able to thank you, Monsieur Toulouse. I'll hang it over the fireplace and it will remind me of my little girl after she's gone."

He told Henri about the wedding that was to take place in July and invited him to the afternoon *réception dansante*. Such a wedding it was to be! "Monsieur le Préfet de Police will be there—" Patou almost crossed himself while pronouncing the august name "—also several inspectors of the Sûreté and chiefs of departments."

Henri accepted the invitation with well-feigned delight.

As he was about to leave, Patou gave a circular glance, took a few knowing sniffs and said in a low tone of voice, "Rice powder. She's still here, eh?"

Henri nodded.

"I'm sorry you didn't take my advice, Monsieur Toulouse." Thoughtfully Patou twisted his mustache. "That girl is no good, but I understand. Sometimes a woman gets under your skin, and then you're helpless. I've seen it happen many times. Half the people in prison are there because of some woman. It's terrible to be in love with a bad woman."

He was silent for a moment; then shrugged, "Well, it's your affair. So long as she doesn't try to 'do' my district, I'll leave her alone. But remember, one word from you, and I pack her off to Saint-Lazare."

After finishing Eulalie's portrait Henri spent most of his time out of the studio. He paid a long-delayed visit to his mother, who was unable to conceal the distress in her eyes. "Please, Henri, please be careful!" she whispered as he was leaving.

He had dinner with Maurice, who noticed his nervousness.

"What's the matter? Are you in some sort of trouble? What is it? Are your legs hurting you? Are you worried over something? A woman?"

* The famous canvas "The Policeman's Daughter" is listed in the Joyant catalogue as being in the Bernheim collection.

Henri swore he had never felt better in his life, attributed his restlessness to overwork.

"Summer will soon be here and perhaps I'll leave Paris. I may rent a little villa somewhere in the country. Perhaps Dieppe or Trouville or Arcachon."

He returned to the cafés, where he found his friends still engaged in the familiar denunciations of dealers and critics, eager to quench a thirst they had been forced to keep in check during his absence.

He killed time as best he could and discovered how hard it is to kill.

He became the loafer who importuned his friends, dropped in for a few minutes and stayed all afternoon. For hours he watched Seurat apply his colored dots with monastic patience. He spent an afternoon with Gauzi huddled over catalogue illustrations; another with Anquetin at work on four Ascensions at once. He ferreted out Desboutin's studio and found the old etcher, swaddled in a soiled bathrobe, unwashed and bleary-eyed, leaning over a solution of nitric acid.

He wandered through the Louvre, studied the Lippis and the Pollaiuolos, attended matinees and dozed in his stall; fed peanuts to the elephants at the Jardin des Plantes and watched the antics of monkeys in their cages. He spent long hours in Père Tanguy's shop rummaging through his portfolios of Japanese prints, ordering tubes of paint he did not need. Gratefully he accepted a dinner invitation from Madame Tanguy.

"Toward the end of the month," she said, "when the evenings are warm."

With a sweep of his arm, Tanguy pointed to the courtyard at the back of the shop. "We'll dine in the garden. Just as though we were in the country."

He visited the Dilhaus, where he learned that César Franck had been struck by an omnibus.

"I knew it would happen!" wailed Clémentine. "I knew it! He was too absent-minded. Instead of watching the traffic he was thinking of his music as usual . . ."

He even returned to the Moulin, where Zidler came to sit at his table and pleaded with him to start work on the poster.

"Monsieur Toulouse, when are you going to do that poster? Look, half the tables are empty."

And so it went.

He rode in fiacres, drank cognac, talked, even laughed, but he did these things in a sort of trance, as if he were watching

some stranger do them. He found he could discuss painting, chuckle at studio gossip, while wondering what Marie might be doing at the moment. It gave his life a shadowy, unreal quality that vanished only when she returned and he held her in his arms.

One evening she arrived bubbling with excitement. Her sister, she announced, had finally recovered from her strange illness.

"And d'you know what we did?" she said with the false spontaneity of people who are telling a lie. "We went to a bistro together, and were they glad to see her! Some friends came to our table and we had a few drinks. I started telling them about your nice studio, your bathtub and your fine pictures. They wouldn't believe me, so I told them to come and see for themselves. They'll come tomorrow night, and we'll have a little party . . ."

"There won't be any party. I don't want your friends here. I don't want to meet them."

She jerked herself away from him. "Think you're too good for my friends! Let me tell you . . ."

"I didn't say that." Wearily he shook his head. "I merely said I didn't want to meet them, that's all."

"Not even my sister?"

"No—not even your sister."

He saw the pinpoints of anger in her hazel eyes and knew that their truce was at an end. She would make him pay for this.

Something in his tone warned her not to insist.

"Just as you say. I thought you'd like it. Eugène—that's Rose's *chouchou*—was going to bring his accordion and we could have danced. But if you don't want . . ."

The party did not take place, but she began to arrive increasingly late. She arrived bitter-mouthed and sullen, bringing with her the smell of bistros and the echoes of accordion music from the dives where she spent the afternoons. When he asked her where she had been she grew defiant.

"None of your business where I've been. If you don't want my friends to come here, I don't have to tell you where I've been."

If he refrained from asking questions, she taunted him with inventions calculated to arouse his jealousy.

"On my way here a gentleman followed me. Real elegant. He winked at me. I had a good mind to go with him."

Or she would speak about his legs.

"How did you break 'em?"

"I told you. I slipped on the floor."

"There must've been something wrong with you. Boys fall all the time and they don't break their legs. Did you have to use crutches?"

"Yes. For a while."

"What did your mother do when . . ."

"God damn you, shut up! Shut up and get out!"

"There you go again, swearing and shouting. You're a hard one to get along with. I was only talking about your legs."

"Well, stop talking about them."

Tirelessly she badgered or wheedled him to let her sister and friends come to his studio. It was the only point on which he would not capitulate, and it became a rankling issue between them. She began threatening to leave him.

"You'll see, one of these days I won't come back. You'll be waiting for me and I won't be coming back. Then what'll you do? See, you're white as a sheet. You don't like that, *hein?*"

She started asking for more money. "Ten francs ain't enough. I want twenty now."

A week later it was thirty. Then fifty . . .

It was this constant nagging for money that convinced him she was seeing Bébert again.

Now to the torment of waiting was added the torment of jealousy. Why did it hurt so to share what had never been his? Wasn't she common property, a prostitute? Did it matter whether she had a lover or not? He tried to reason with himself, but found he could not.

Finally his nerves gave way. He broke into fits of foaming, helpless rages. He shouted back at her, matched insult with insult.

Their evenings turned into drunken brawls, their nights into joyless debauches that became the outlet of their mutual rancor—a blind foraging of hands and tongues, an erotic scuffle that bruised their flesh and sent them into a brief, shattering oneness from which they emerged, panting, spent—and hostile as ever.

When she was not with him, an overwhelming lethargy settled upon him that made the simplest action a tremendous effort. Somehow during the day, he managed to bathe, dress, lunch, but he stopped going to the cafés, no longer saw his friends. His frayed nerves could not endure the hubbub of the streets, the prattle about dealers and critics, the clatter

of *brasseries*. He remained in his studio, stretched out on the couch, his hands behind his head, a bottle of cognac at his side, torturing himself with thoughts of Marie, loving and hating her, building fanciful plans for escape. After a while—and many cognacs—his brain lost its lucidity. Marie's image floated swimmingly before his eyes. The pain dulled. Sometimes he fell asleep.

Thus Maurice found him one afternoon.

"Overwork, *hein?* I knew you weren't telling the truth. It didn't sound like you. You always could work harder than anyone I knew. Remember Fontanes? Look at you!"

"Leave me alone. Why aren't you at the office? It's not Sunday. Why aren't you working? I thought they couldn't spare you at the magazine?"

"Sarcasm won't help, *mon vieux.*"

Deliberately Maurice sat in the wicker armchair, tossed his hat on a table and lit a cigarette.

"I took an afternoon off. I was worried about you. And I won't leave until you tell me what's the matter with you."

"Have you been to see Monsieur Boussod?" As Maurice nodded his reply, he went on, "How was he?"

"Quite nice. You were right, he's worried about Théo. Business has been falling off at the gallery. He realizes Théo needs a rest, but he can't afford to give him an assistant. And so, he took my name and address and told me he'd get in touch with me if anything happened—the usual thing. But I didn't come here to talk about myself. I came to see what's wrong with you, and I won't go until you tell me."

"Why don't you mind your own business?"

"I won't!"

"Go to hell and leave me alone."

"I told you, I won't. You *are* in trouble, and you can tell me to go to hell as much as you like. I won't budge until I know what's wrong with you." He leaned forward and his voice became urgent. "You must, Henri, you must tell me. Whatever it is, you cannot keep it bottled up inside you. And to whom will you talk if not me? We are blood brothers, remember?"

"All right! What do you want to know? I met a girl. Her name is Marie. She is a tramp—a stupid, vulgar, lying cheat of a tramp. And—" He took a long puff and blew the smoke through pursed lips. "—and I can't live without her. That's all. Well, now you know everything. Satisfied?"

"Are you in love with her?"

"Love? Huh!" The word ended in a shrug and a ripple of

morose laughter. "Who said anything about love? I didn't
say 'I love her', I said 'I can't *live* without her'. One of the
reasons why this sort of conversation is a waste of time, is
that the word *love* has a hundred different meanings, and you
never know which one you are talking about. You love God
and you love crêpes-suzette; you love your mother and you
love your dog; you love Rembrandt and you love hot baths.
No, I don't love Marie, if that's what's worrying you. I have
no desire to hold her hand in the moonlight or write sonnets
to her. But I love her mouth, her nipples, the way she kisses.
And I hate her—hate her as I have never hated anyone. From
the moment I met her everything she said, everything she did
infuriated me. Her first remarks . . ."

To his surprise, he experienced a strange relief, almost an
exultation at speaking about her. He described their meeting
in the night, the Patou episode, the way she had said "God,
you're ugly!" under the lamppost, her stupidity, her coarseness,
her greed—and the intoxication of her flesh.

"Don't ask me how you can hate a woman and want her
at the same time. I don't know. But one thing I know: hatred
is probably the most powerful aphrodisiac of all, and love
performed in the heat of anger is perhaps the most thrilling
of all."

For an instant he stared at the ceiling.

"The only trouble with that kind of love is that it doesn't
quench your desire, doesn't bring you either peace or relief,
doesn't solve anything, and . . ."

He sat up, snuffed his cigarette, calmly poured himself a
drink.

". . . and slowly drives you crazy."

Maurice watched him toss down the cognac and waited for
him to set the empty glass on the window sill.

"What makes her so irresistible?" he asked, a puzzled look
in his level eyes.

A smile of amused weariness played about Henri's mouth.

"I knew you'd ask that. I've asked myself this question
a thousand times, and I still don't know the answer. You
see, Maurice, when you start probing into sex you almost im-
mediately lose your footing. You don't know where you are,
you see nothing clearly, and you don't like what you do
see. You think you are perfectly normal, the sanest man in
the world; and suddenly you discover that for two sous you
could turn into a sadist, a rapist, a homosexual, or one of
those maniacs who frequent the *maisons de spécialités*. Sex
is like those great ocean depths where it is always night, and

where monstrous creatures move. Why is Marie irresistible to me? Again I can only tell you I don't know. She isn't irresistible to anyone else. She has slept with men since she was fourteen, and nobody has ever committed any folly on her account." He let out a brief joyless chuckle. "Except me."

He raised himself on his elbow and looked intently at his friend, his brown eyes enormous behind their lenses.

"She's crazy about some lout of a pimp and can't even make him fall in love with her! Then, why is she irresistible to me? I don't know. First I thought it might be the grace of her gestures—she does have an innate plastic loveliness of attitudes that thrills me. Living with her is like living with a Tanagra figurine. But of course that's not it. Then I thought it might be her lewdness, the depravity of her lovemaking. She is all sex, all female. There is a sort of poetical obscenity, a slimy enchantment about her."

He stopped abruptly. "Do I make any sense? Can you understand me at all? Perhaps it's her indifference. The maddening way she has of looking at me as if she didn't see me. I don't expect you to understand, for you are not a cripple, and a girl has never looked at you like that. But, believe me, Maurice, if there is something deeper, more complicated than sex, it is pride—not social pride, but your pride as a human being. She looks at me as you might look at a worm or a toad, as if I were some ludicrous bearded creature masquerading as a man. There is a type of derisive, insulting indifference that can drive you crazy faster than anything else. Once I read the account of the first climbing of the Matterhorn. Seven times the man had tried to climb that 'awful mountain' as the Swiss call it. When he finally succeeded people asked him what had made him return year after year, risk his life a thousand times. And do you know what he replied? 'Because that slut of a mountain was laughing at me!' That's exactly how I feel toward Marie. It enrages me to see I can possess her but cannot make her feel anything toward me. She has become an obsession, an *idée fixe;* the embodiment of the indifference, the piteous contempt I've felt in numberless other women."

Dusk had come into the room. In the huge window the sky was turning purple.

"And now?" Maurice asked quietly.

"Now? We are like two wrestlers entangled in the same net. We hurt each other as best we can. She wants to bring her friends here to show them the phenomenon, the rich midget who gives her fifty francs a day. She threatens to leave me; she humiliates and torments me in a thousand ways. And

all I can do is hate her and make love to her. For, among other things, lovemaking is the greatest humiliation you can inflict on a woman, and as such it is a wonderful outlet for vindictiveness and contempt."

They remained silent for a moment. Like a stain darkness spread through the room.

"What are you going to do?"

Henri shrugged. "I don't know. Perhaps things will straighten themselves out somehow. She'll probably leave me one of these days, and that will be the end of it. Or I may surprise myself and find enough courage to throw her out . . . Or I may tire of her. I don't know . . . I just don't know . . ."

XIV

"It's my money, ain't it? I earned it, didn't I? I can do what I want with it, can't I?" She had barked the words at him, her eyes two glittering slits. "Sure I gave it to him. I love him, see? I'm crazy about him. And now I'm going back to him and I never want to see your ugly face again."

On the stairs she had started to sing.

That day he had come across the bankbook on the bathroom shelf and found she had withdrawn her savings. An uncontrollable jealousy had swept over him. In a sputter of insults he had ordered her out, raised his cane at her, and would have struck her if she hadn't swiftly stepped aside.

That was two weeks ago. Now his anger had spent itself; pain had set in. Every hour had brought its torment of longing. Oh, yes, at first he had tried to applaud himself for his courage, assure himself he was delighted to be rid of her. But it was no use. You didn't placate the hunger of your body with self-awarded tributes. The memory of her small breasts, of her yielding thighs had agonized his nights.

He had scoured the labyrinth of the Sebastopol alleys in search of her, peered into obscure bistros. He had spent his evenings at home, drinking, waiting, trembling each time he heard the sound of footsteps. Now he knew she would never come back.

That morning—it was the twenty-seventh of May—he was sitting on the edge of his couch gazing at the small carpet of sunshine on the floor, when he heard the sound of footsteps outside. Once more the senseless hope soared.

No, it wasn't Marie. These were a man's footsteps—heavy, thudding and tired.

244

Hurriedly he got up, tottered to his easel, started loading his palette.

There was a knock at the door.

"Entrez!"

As the door opened, his voice rose to an exclamation of joy.

"VINCENT!"

He dropped the tube of paint he held in his hand, snatched his cane. "When did you arrive? How long are you staying? Come and sit on the couch and let me look at you! How do you feel?"

While he spoke his eyes flashed their messages to his brain. Yes, it was Vincent, but a different Vincent . . . Quiet, cowed, with dull, haunted eyes . . . No portfolio, no gourd of rum, no gesticulation . . . A proper, well-behaved Vincent, self-conscious in a new ready-made suit that was too tight for him and a felt hat that was too big.

"I feel fine," Vincent said in a toneless voice. He sat down. "It's good to see you again, Henri. I arrived yesterday, and spent the day with Théo and Johanna. Did you know they named the baby after me?"

For the first time he smiled, an incredulous, ecstatic smile that flooded his gaunt, haggard face with light.

"Would you believe it? They called him Vincent—after me! And such a beautiful baby! Red-headed, too, like me."

Still smiling, he filled his pipe, and looked out of the window.

"The sun feels good, doesn't it?" His voice was remote, as if he had just recovered from some long illness. "In Arles it gets almost too hot at times. I think it's the sun that drove me crazy."

"You finally had a chance to use all the yellow you wanted, didn't you?" Henri said hastily. "Remember how you wanted to use yellow because it was God's color, and I told you Cormon liked Vandyke better?"

Their initial uneasiness was disappearing. The old intimacy was coming back. They smiled at each other.

"I'm glad you're back, Vincent. I've been thinking about you a lot. Montmartre hasn't been the same since you left . . . Remember Cormon's? Remember the sterno-cleido-mastoid and the rhomboeidus major?"

"Yes. I wish I'd gone to the *atelier* that winter instead of painting at home or in the streets as I did. My anatomy is still weak."

"To hell with anatomy! You have life. You've really found yourself at last."

"Yes, I suppose I did." Vincent stared at his knotty hands. "It almost killed me though. But perhaps it was worth it—even the asylum . . . Henri, you can't imagine what it means to be shut up in an asylum!"

"Don't talk about it. Try to forget it. You're all right now."

"But I want to talk about it," Vincent insisted gently. "Perhaps if I do I'll stop thinking about it. It wasn't the seclusion that was hard, it was the proximity of madmen. Some of them awoke at night with terrible cries, and you could hear them long after the guards had dragged them away. At times I felt I *was* going crazy . . ."

Something inside him seemed to have unlocked the floodgates of speech. In a torrent of words he told Henri about his life in Arles: the hours spent in the fields under the broiling sun, painting with a frenzy that grew into a sort of madness; the staggering walk back to town at sunset over dusty country roads, his easel strapped on his back, the still-wet canvas in his hand. Then Gauguin's long-awaited arrival; the happy companionship of the first days; their trip together to Avignon; then back in Arles the first quarrels; the arguments degenerating into brawls; the reconciliations in absinthe at the Café de la Gare; the evenings at the brothel, and the awkward pity of the whores. Finally the crack-up: the glass of absinthe flung in Gauguin's face; the scuffle, the murderous rage. Cymbals crashing in his head. His brain starting to whirl in his skull . . . The temporary madness when the walls shook before his eyes, and the floor rocked under his feet. The razor; the slashing of his ear; the tramp to the brothel in the night with the gruesome gift of flesh wrapped in a newspaper. Then the return to the hotel, with the blood trickling down his neck. The cymbals in his head growing louder, louder, louder . . . And at last the epileptic fit. The collapse on the bed. The cymbals fading away . . . Then silence, darkness—peace . . .

"You know the rest. Théo rushed down from Paris and arranged for me to be taken into the asylum at Saint Rémy, so that I wouldn't be locked up in a state institution or shipped back to Holland. The nuns were very kind there. They let me paint in the courtyard. They came to watch and tittered among themselves. But without malice. And so the months passed. You lose track of time in an asylum. And now here I am. I feel as if I had just awakened from a dream, and never left Montmartre."

Gently Henri put a hand on his arm. "It has been a dream, Vincent, a bad dream. But you are well now. On the threshold of a new life."

Vincent smiled his slow, wistful smile.

"Yes, perhaps . . ."

He was silent for a moment.

"And here?" he asked. "How are things in Montmartre? What have you been doing?"

"Me?" Henri shrugged. "Nothing ever happens to me. I pass the time as best I can. I paint. I've done a few magazine drawings, a few song-covers. I even promised to do a poster. Are you going to stay in Paris a while?"

Vincent shook his head. "I'm leaving tomorrow for Auvers. Théo's apartment is crowded as it is . . ."

"Why don't you stay with me? We could work together as we used to. I am quite alone—now . . ."

Vincent lay his hand on Henri's. "Thanks for asking me, but I'd better go. Paris is not good for me."

He rose from the couch and walked to the wall.

"May I look at your paintings? I haven't seen any new paintings in months."

"Certainly. Look all you want while I go upstairs and wash. Then we'll have lunch together. How about going to Agostina's?"

Their eyes met. For an instant they looked at each other in silence, smiling, thinking of the past. The past so near, yet so far, so very far . . .

Agostina came rushing out of the kitchen, followed by her two wolfhounds.

"Vincente! Carissimo Vincente!"

She clasped Vincent in her arms, hugged him and kissed him on the cheeks. When she finally released him, her face was streaked with tears.

"I'm so happy!" she sobbed, fumbling in her bosom for a handkerchief. "I thought I'd never see you again! I said to myself, 'Vincente, he'll never come back'. And you too, Monsieur Toulouse, I haven't seen you for a long time. And now you come when everybody's gone, and the *past' asciutta's* cold . . ."

The old effusiveness was still there, but Agostina, also, had changed. Her cheeks had begun to sag. Silver threaded her luscious black hair.

They ate quietly in the deserted restaurant. When they had finished she brought a bottle of liqueur and came to sit with them.

"It's for the celebration," she said, filling the three glasses.

"It's called *la Strega*. The most *meravigliosissima* liqueur in the world. It consoles the heart," she added wistfully.

"What's the matter, Agostina?" Henri asked. "Feel sad?"

A faraway look came into her beautiful eyes. "I want to go back home, where the sun shines all the time and the earth is brown and warm under the feet. I want to look at the sea and watch the waves make foam in the sunshine . . ."

They finally broke away from Agostina's and climbed into a fiacre.

"A perfect day for a drive," Henri remarked. "Have you seen the Eiffel Tower?"

They drove through the bustling streets, passed the Opéra, crossed Place de la Concorde, and turned into the Champs Elysées.

"I had forgotten how beautiful Paris was," said Vincent, after a long silence.

"Yes, it is beautiful—a stage where the scenery overwhelms the actors. Sometimes I wonder whether architecture is not the most moving of all arts. Even more than music."

They saw the Eiffel Tower, the Conciergerie, the square mass of the Louvre in the distance crouching like a brooding griffin over its treasures, the shiplike silhouette of Notre Dame anchored in the heart of Paris. Then they crossed the Seine and meandered through the Left Bank, their fiacre jostling and squeaking over the cobbles of dark, narrow streets. They passed by drowsy little shops, peaceful bistros, ancient churches wedged between grimy houses. They came across unexpected little squares, each with its bubbling fountain, a bronze statue of some general, four or five plane trees, a wooden bench on which sat a goateed *rentier* in a derby and overcoat reading the newspapers. Sometimes a small merry-go-round clanked for a cluster of wide-eyed urchins.

"Would you like to go in?" Henri suggested as their fiacre was crossing the parvis of Notre Dame.

They entered the immense shadowy nave redolent with incense and the mustiness of very old structures. Here and there cowled figures of women knelt, their hands clasped before their mouths. Behind a pillar a young woman sobbed noiselessly.

Henri glanced at Vincent, who was staring at the tiny flame burning in front of the tabernacle, moving his lips imperceptibly as if conversing with the God behind the golden door. Poor Vincent, he had won, but he was tired . . . The furious torrent of vitality was ebbing, ebbing fast . . .

"I was supposed to have dinner with the Tanguys," Henri

said, as they were coming out of the church. "Won't you come? They'd be delighted to see you."

Rue Clauzel was already filled with evening mist when the fiacre pulled up in front of Père Tanguy's shop. The jangling of the doorbell brought the old color grinder rushing to the door. At the sight of Vincent he flung up his short arms.

"Monsieur Van Gogh! What a pleasure, what a surprise!"

He pressed Vincent to his chest, and raising himself on his toes managed to kiss the Dutchman's chin. "Now the party is complete. You've come just in time to eat the *ragoût à l'oignon!*"

Still talking he led them to the kitchen, where his wife, bare-armed and perspiring, hovered over a simmering marmite like a solicitous witch. After renewed exclamations of delight at Vincent's unexpected appearance, the three men filed into the courtyard at the back of the shop. There the table was already set for dinner.

"Just like the country, *n'est-ce pas?* Smell that air!" beamed Tanguy, swelling his chest. "And look at my tree!" He pointed to a gnarled linden bedecked with swooping clothes lines. "I always did say you don't have to leave Paris to enjoy the country."

A moment later Madame Tanguy appeared, carrying a steaming marmite which she set on the table. The dinner began. The *ragoût à l'oignon* was declared a masterpiece.

"This is the most delicious *ragoût* I've ever tasted. How do you do it?" cried Henri.

"It's nothing," she blushed with pride. "You just put in a few bay leaves, a little sage, a little thyme, a little parsley, a little dandelion, a little rosemary, a little chive, a few onions . . ." Her happiness shone in her weary eyes.

Henri noticed that Tanguy had hardly eaten anything and left his wine untouched. "What's the matter, Tanguy? Don't you like wine any more?"

The old anarchist turned his round stubbly face and looked at him piteously. "It's my stomach, Monsieur Toulouse. It hurts me but I don't know what it is."

"I told him to go to a doctor, but he's more stubborn than a mule," broke in his wife.

She rose from the table and began to stack the plates.

"I'm not going to have a bourgeois of a doctor peer down into my stomach. With me, it's a question of principles," declared Tanguy with finality. "Now, messieurs, I'm going to show you a beautiful little Hokusai I picked up the other day . . ."

"Tanguy, come here and help me with the dishes!" cried his wife from the kitchen.

He looked dejectedly at his guests, sighed, and went obediently towards the kitchen.

Night had come. The air was soft. The courtyard lay still and dark, except for the small patch of light from the lamp. The linden tree was now a tracing of lacy blackness. Moths fluttered clumsily around the lamp, hurled themselves against the scorching chimney, fell on the table. After a while they stirred, flapped their feeble wings and started all over again.

"They too want what they can't have," mused Henri, "So much is written about the wonderful instinct of animals, and yet look at those silly moths . . ."

"Henri?"

"Yes."

"While you were dressing, I looked at your paintings. That girl—the blonde one. Be careful—don't let her ruin your life! Don't let her stop you from working." He smiled ruefully. "You are ten years younger than I am, and you haven't said all you want to say. Put it all on canvas, for perhaps nobody will ever say it if you don't. And don't let a woman stop you from saying it."

Henri had a sudden premonition he would never see Vincent again. Already the Vincent he had known was dead. His ugly-beautiful face had assumed a new serenity. His blue eyes seemed turned on some nearing shore.

They talked for a long time after the Tanguys had gone to bed. Then they drove back in silence to the Cité Pigalle, where Théo lived. At the door Vincent climbed down and thrust out his strong bony hand.

"*Vaarwell, myn vriend.*" A last time he smiled his dolorous smile. "In Dutch that means '*Adieu, mon ami*'."

Adieu? Then he, too, knew they wouldn't see each other again.

He held Vincent's hand for a moment, looked once more at the gaunt, red-bearded face.

"*Adieu, mon ami,*" he said huskily. "*Adieu,* Vincent."

Little Eulalie's wedding was all that her doting father had hoped it would be. The *réception dansante* in particular was a glamorous affair with a four-piece orchestra borrowed from the Police Band. There were delegations from the Sûreté, the Homicide Squad, the Treasury, the Secret Police, swarms of inspectors and high officials. And—Monsieur le Préfet

de Police in person! At close range this almost superhuman dignitary turned out to be a bald, unctuous, spade-bearded gentleman in pin-striped trousers and cutaway, and the air of a master of ceremonies of an undertaking establishment. He delivered a beautiful address, remained a few minutes, and departed, waving pontifical blessings to his subordinates, escorted by a bowing, stammering Patou. At the door he stopped to shake hands with Henri and exchange a few apt urbanities.

After the Préfet's exit, the orchestra launched into a spirited polka. The gendarmes grabbed their wives by the waist and hopped about with martial zest.

Patou, beside himself with pride and excitement, insisted on introducing to Henri the various personalities present. "Monsieur le Comte, allow me to present Captain Culot, of the Homicide Squad. He sent twenty men to the guillotine . . . This is Captain Guilguet. A specialist in jewel robberies . . . That's Warden Ponjel, of the Roquette Prison . . ."

The reception was coming to an end when he returned, accompanied by a stocky, jovial-faced man.

"Monsieur le Comte, this is my old friend Inspector Rempart, the Vice Squad chief of the Sebastopol district. You know, the one I told you about . . ." With a significant wink he was off.

Inspector Rempart sat down by Henri's side and began by speaking feelingly about Patou, praising his honesty and his efficiency.

"He mentioned your interest in one of the Charlet girls," he said, lowering his voice. "Believe me, you're well rid of her. She is no good, that girl. She is back in my district, but I've got my eye on her. She's taken up again with that pimp of hers, and loafs all day long in the little bistro on rue de la Planchette. But she'd better watch her step. One slip, and out she goes."

When Henri returned to the studio that evening, his temples were pounding. The darkness was full of whispering voices. "Rue de la Planchette . . . Rue de la Planchette . . . She is there . . . Go, and you'll see her . . . Perhaps you can bring her back . . ."

For hours he fought against the haunting memories of her thrilling mouth, her fluid body. He recalled her sluttishness, her greed, her stupidity.

After midnight, he surrendered . . .

Rue de la Planchette was a dingy alley, a mere trench

of darkness between two rows of verminous houses. Telling the *cocher* to pull up, he made his way to the bistro, peered through the fogged window, through which he could make out the blurred silhouette of the owner rinsing glasses behind the counter, and two men playing cards together.

And then he saw her! She was sitting next to Bébert, speaking to him with a pleading expression in her eyes. Those same eyes that could be so cruel . . . He saw the bully push her away, shout something at her, raise his hand as if about to strike her. Humbly she nodded, gave him a tremulous smile. What abjection love could be!

He returned to the fiacre.

"Please," he told the *cocher*, "will you go in there and ask for a girl named Marie Charlet? Tell her someone outside wants to speak to her."

The wait seemed interminable. At last he recognized her slender silhouette against the lighted doorway.

"Marie!" he called tensely. "Marie!"

"Oh, it's you!" She walked toward him. "What d'you want?"

"I want you to come back, Marie," he begged, glad she could not see the shame in his eyes. "I was wrong. Please, come back."

"I don't know," she teased. "I'm doing very well and I have a lot of rich messieurs after me. Besides you're always shouting at me."

"I won't, I promise. Please, Marie!"

"Another thing. If I come back, you must pay me sixty—no, seventy-five francs." She had won and was imposing her terms. "You will? . . . Then wait here a minute."

She ran back into the bistro and he waited for her, slumped on the carriage seat, defeated, miserable and despising himself. Yes, what abjection love could be!

She returned a moment later. From the doorway she blew a kiss at her lover; then, with a swirl of her skirt, she hopped into the fiacre.

"Rue Caulaincourt," he said to the *cocher*.

"I knew you'd come," she whispered, nudging herself against him. "I'm glad you came, Henri. Me, too, I missed you."

Did it matter if she lied? Did anything matter? She was here at his side, and he was bringing her back.

The old routine was resumed. He paid her; she spent the day away, returned at night and "was nice" to him.

But there was a difference and it did not take him long to notice it. The Marie he had known had been a free agent,

a nomad, enigmatic and cruel. The new Marie was a woman in love, working under orders.

"You wouldn't believe it," she said, a few days after her return, "but the same night you came to take me back, Bébert was talking about you. And d'you know what he was telling me?"

"No, I don't."

She was not clever. He could see on her face the frown of concentration as she recited the prearranged lie.

"He was telling me it was a shame the way I'd treated you, when you were always so nice to me, and I should come and apologize."

Yes, Bébert must have said something like that that evening, when he raised his hand to slap her. He must have told her what a fool she'd been to lose a *miché* that "spat" fifty francs a day, and she'd better get him back if she knew what was good for her . . .

He looked at her. Gone were the rebellious toss of the head, the scornful twist of the mouth. She had become an obedient whore, doing what her pimp had ordered her to do—and doing it badly.

"It's all right, Marie. You needn't apologize. It was I who was wrong. After all, it was your money, your bank account, and you had the right to do whatever you wanted with it."

"No. It was me that was wrong," she insisted. "He said I should apologize."

"All right. You can tell him you've apologized." He refilled their glasses. "Let's not speak about it any more."

"I never want to quarrel with you any more. I like you too much for that."

"Good." He watched her across the table. Even the glint in her clear eyes had vanished. She was smiling at him, inept in her deceitfulness.

One morning, instead of hurrying away, she offered to pose for him.

"Even naked, if you want."

The thick casualness of her tone gave her away. He could almost hear Bébert briefing her, mapping the campaign of seduction.

"Look!" She flung back the covers. "Don't I have a nice body? Not a pimple or anything. And my skin's real smooth, not rough like so many girls. Touch it."

She took his hand, ran it down her thighs.

"And my breasts are hard, aren't they?" she said, lifting his hand to her bosom. "You like 'em, don't you?"

"Yes, Marie. You have lovely breasts," he said gently, without withdrawing his hand. "But don't you think you should go? You may be late."

"You wouldn't have to pay me for posing. I'd do it for nothing."

"That's very kind of you. Perhaps some other time . . . Now you'd better get dressed."

Another day she volunteered to tidy up the studio.

"I'm good at cleaning. My mother used to make me scrub the floor. If I had a little wax I could polish the furniture, make it shine."

Her servility made him wince. The things women did for love! He turned his head away when she pretended to admire his paintings, for that, too, was part of the strategy of enslavement planned in the Sebastopol bistro. "Flatter him, tell him you like his pictures," Bébert must have said. And dutifully she obeyed, so that she would receive her reward—a kiss or a caress—for having admired the midget's pictures.

She did more.

For love she renounced love, stopped seeing Bébert, except once a week, when she was supposed to be spending the day with her sister.

"You know the man I told you about, the one I used to be so crazy about, well—I don't love him any more," she announced one evening. Her red-rimmed eyes told him how much each word cost her. "I never want to see him again. I like you much better. You're a real gentleman."

For the first time she became his mistress, lived with him, cooked little meals in the back kitchen, did all the things he had dreamed she would do. She offered to meet his friends, go out with him, and he wondered at the capacity for abnegation in this prostitute, as in so many of her kind. What made them accept the most ignoble tasks, only to give away the rewards of their degradation? Whence came this thirst for self-abasement?

Now she was constantly with him, importuning him with her awkward attentions. At times, however, she would forget herself, lapse into a dreamy silence, and her face would assume a tender radiance. He knew that she was thinking about her man, caressing him in her mind, dedicating to him her boredom, her pitiful deceitfulness. There was something monastic about her passion for this cretinous bully. Even her gestures

had lost their feline grace. She was heavy with her love as with a child.

The change in her attitude brought also a change in their sexual relationship. Their mutual hostility had been the seasoning of their lovemaking. Now she turned into a diligent prostitute, eager to please. She exerted herself, simulated ecstasy, embellished her task with sighs and whispers of love.

"You're a wonderful lover, Henri."

A silence.

"I said you're a wonderful lover."

"You'd better go to sleep, Marie. It's late."

"You love me?"

"I like you very much."

"I don't mean that. I mean, do you *love* me?"

"Love means so many things . . ."

"But you love me, don't you? You're pleased with me? I'm being nice to you, ain't I? I do everything you want? You never had a girl like me, as good as me? Say you never had a girl as good as me."

"Never . . . It's almost daybreak . . . Please, Marie, go to sleep."

He would feel her lips trailing over his mouth.

"Good night, *chéri*. Put your head on my shoulder."

How wonderful if such words had been true! But they were lies, and they merely hurt . . .

"Good night, Marie."

Gradually he came to realize that his desire for her was on the wane. This artless, cloying whore aroused in him an obscure pity. The vixenish quality of her sensuousness had spurred his anger and his desire. Now she was spongelike in her servility, no different from brothel women.

Politeness often cloaks the weariness of love. As his yearning began to abate, he treated her with detached courtesy which she mistook as proof of his enslavement. When he lighted her cigarette or helped her button her blouse, he saw a flash of triumph in her eyes. He did not disillusion her. He was tired; he wanted peace. Their affair was at an end. He wanted it to break naturally, quietly—as a rotten fruit falls to the ground.

On Assumption Day—a sweltering August day—he presented her with a pair of gold earrings.

"Real gold?" she cried, holding the ringlets in her cupped palm.

He nodded. "The night I met you, you said you had once

owned a pair of gold earrings and lost them. Remember? These will replace them."

"But they weren't real gold."

"These are. In an emergency you'll always be able to pawn them."

"Never!" I'll keep them always. I'll never . . ."

"All right," he nodded tiredly. "Anyway, try them on. Let's see how they look on you."

He watched her slip them through the lobes of her ears, wondering how long Bébert would let her keep the valuable baubles. To his surprise he did not feel any jealousy at the thought. With an imperceptible shrug, he walked back to his easel.

It was during the final weeks of August he admitted to himself he was cured of her. Cautiously he began to plan the termination of their liaison. The ending must be clean this time, irrevocable. And, if possible, dignified—at least, decent.

Like a convalescent testing his strength after a long illness he announced he had been called out of Paris and would be away three days.

"Three days!" she cried.

He saw the gleam of rapture spring to her eyes. Three days and three nights with Bébert . . .

She checked herself. "I'm sorry you've got to go," she forced the words out. "If you want I won't even go out. I'll wait here for you. I'll just stay here and wait."

It sickened him. He assured her it would please him more if she spent the three days with her sister, insisted on paying her for the duration of his absence, added a substantial bonus, and went through the motions of hasty packing.

For three days he remained closeted in his studio, eating meals sent in from Drouant's, working with relish, hardly thinking of her.

He was cured!

Now for the *coup de grâce!* . . .

At once he discovered how painful and difficult was the breaking of any sort of domestic establishment, even of the flimsiest kind. He understood why so many unhappy couples preferred to drag their enmity through life rather than face the ordeal and complexities of a separation. Her clothes, her few belongings, her piteous *articles de toilette* still cluttered his closets and bathroom. These would have to be packed and shipped to some address, probably her sister's. Then there was the question of money. He must make some

final gesture, give her some parting gift. Of course, he owed her nothing, but he had grown sorry for her in these last weeks. What would become of her? He was "throwing her out." Bébert would probably follow suit the moment she stopped bringing money. She would find herself without lodgings, without money, without love. What would she do? She had not the makings of a *grande cocotte* and would probably revert to her previous way of life. The furtive prostitution of hallways and dark alleys . . . Then Saint-Lazare, the "card," perhaps the brothel . . . Later, the gutter . . . And one day—the pine coffin, the common grave . . .

He waited another week. Then, one September afternoon, he said what he had tried to say the night of the "fifty-franc" dress.

"Marie," he began quietly. "I have been thinking things over, and it would be better if we stopped seeing each other. Tell me where you'd like me to send your things."

She stared at him uncomprehendingly.

"You mean—you want me to go?"

"Please, try to understand. You came here for one night and you've stayed seven months. It's all been very pleasant, and I am grateful to you. Now the time has come for us to part. Let's not have a scene. Let's do it decently."

He pulled an envelope from the inside pocket of his coat.

"Look, I have a present for you . . ."

He stopped. Her face had turned gray. He noticed she was trembling from head to foot with an aguelike tremor. Her feeble mind had not yet grasped the full meaning of the disaster befalling her, but her body—always more perceptive than her brain—shook like an animal's at the approach of death. This reflex of organic terror preceding comprehension was frightening to behold.

"You'd better sit down, Marie," he said gently.

She did not move.

"But what—what've I done?" she stammered through chattering teeth. "I've been nice to you, haven't I? I did all you wanted . . . I—I even said I'd pose naked for you, if you wanted . . . Clean the furniture . . ."

She offered her pitiful defense in halting gasps, blinking incredulously at him, speaking as through a contracted gullet. Between sentences she ran the tip of her tongue over her lips. He sensed that her mind was numbed by an overwhelming feeling of injustice. She had applied herself, done what she had been told to do, and now she was being punished!

"You haven't done anything," he soothed her. "You've been very nice. It's just that I . . ."

"See!" She clutched at the merciful deception, mistaking it for an admission of guilt. "See, you say yourself I've been nice!"

"Please, Marie, let's not . . ."

"But you just said yourself I've been nice!" To her it all had the impossibility of a self-contradicting axiom. "Show me a single time that I didn't do what you . . ."

"Please, Marie!" he entreated. "Let's not argue. Explanations never explain. Let's say it's my fault."

He held out the envelope.

"Here's your pushcart license. You wanted it, didn't you? Here it is. It's made out in your name. You can't sell it or give it away. Remember, that's why you started the savings account?"

Comprehension was now flooding her mind. He could feel its progress in her dilated eyes.

"But what's he going to say?" She had forgotten Henri and was moaning in terror to herself. "What's he going to say when I tell him you don't want me any more?"

She looked up and with a flamelike swiftness leaned to him in a gesture of beseeching grace.

"Please, Henri, please! Don't send me away . . ." Despair had brought back the felinity of her movements and her whole body slanted to him in an imploring attitude. "Please, Henri . . . I'll do anything . . . anything . . ."

The words ended in an ululation of pain. Her eyes had grown enormous, two green irises floating in vitreous puddles of tears.

"Anything you say . . . Anything you want . . ." she repeated.

As she spoke she knelt before him, grasped his hand, covered it with moist, blubbering kisses.

"Please, Marie, don't." He averted his eyes unable to endure the spectacle of this human laceration. "Please!"

But in her flagellant mood she did not listen, did not even hear him, but went on kissing his hand, muttering incoherently.

Then as the thought struck her she feverishly tore open her blouse, clawed off the straps of her chemise.

"Look, Henri, look!" She was holding her breasts out to him with her two hands. "They're nice, aren't they? You used to say you liked them . . . Once you said they were lovely . . . You liked to touch them. Well, you can touch them, kiss them, do anything . . . Anything . . ."

Henri never forgot the hour that followed. Disheveled, tears streaming down her face she pleaded, lifted her skirt, tried to draw him to the couch. In broken sobs she offered to cook for him, pose, wash, mend his clothes, scrub the floor.

One hand over his eyes he remained hunched on his easel stool. Irrelevantly she brought to his mind what he had read of Madame Du Barry on the scaffold. She, too, had been blonde; she, too, had come from the slums; she, too, had knelt before the executioner, kissed his hands, bared her breasts to him, begged for mercy. *"Une minute, monsieur le bourreau! Encore une minute!"*

Suddenly she sprang to her feet. Now she was the scorpion about to strike.

"I hate you, see? I've always hated you, you and your ugly face and stumpy legs. A runt, that's what you are. A runt and a cripple. A goddamned cripple who can't even walk. I've hated you since I laid eyes on you. Even when I said I loved you I hated you inside. It made my flesh creep when you touched me. I'd never have come back if it hadn't been for Bébert. He forced me to do it . . ."

She thrust her grimacing face close to his.

"And another thing! I'm glad you're a cripple. Glad, d'you hear? Glad! Glad!"

Viciously she spat the words at him, breaking into fits of shrill laughter, loading each word with venom.

"And besides I ain't going! How d'you like that? No, I ain't going, and you know why? Because you owe me money. Yes, you do! Don't say you don't—you said you'd pay me a hundred francs every day and you only gave me seventy-five. You cheated me! . . ."

She spoke like a demented woman, with violence unsure of itself, a lack of good faith or logic that was typical of her. At first he was almost grateful for her vindictiveness. It made things easier. His resolution strengthened with each insult. Finally he mentioned Patou. One more word and Patou would come and pack her off to Saint-Lazare.

That brought her to her senses.

She crumpled on the couch, defeated, exhausted, whimpering like a child, fumblingly refastening her blouse.

"You can send my things to my sister's. I'll pick 'em up there."

He came to sit at her side, and took her hand. "Aren't you going back to Bébert?"

She shook her head, and for a moment her face was a

mask of unbearable pain. "I can't . . . He don't love me, he loves another girl, a redhead . . . It's only my money he wants . . ."

"It's hard to love someone who doesn't love you, isn't it?" he said in a low voice. "You and I know that. You'll see, after a while one gets used to being alone . . ." It wasn't true, one never got used to being alone . . . "Maybe some day you'll find someone who'll be kind to you . . ."

She was not listening, probably did not hear him. Mechanically, she rearranged her hair, wiped the tears with her wrist —a childish gesture that touched him. Then she rose, took the envelope he held out, did not thank him. Like an automaton, she walked out of the room, leaving the door open. For a moment he listened to her leaden footsteps down the stairs.

Suddenly, the studio was very quiet. Flies droned in a shaft of sunlight. The scent of her rice powder still lingered in the air. It would go away in two or three days . . .

He hobbled back to his easel, thumbed his palette and started to paint.

XV

Pere Cotelle's Atelier de Lithographie Artistique was a dilapidated shed in the rear of a brick-paved courtyard behind the Church of Notre Dame de la Croix, in the Ménilmontant district. It once had been a livery stable, and a subtle aroma of horse manure clung to the premises, mingling not unpleasantly with the pungent odors of printing ink, nitric acid, gum arabic, tobacco and coffee.

Henri introduced himself and explained the object of his visit. Père Cotelle listened with attention, his eyes on the thick square lithographic stone lying on the bed of his printing press, his black skullcap on the back of his head, fondling thoughtfully the sparse long hair that hung down from his chin and made him look alternately like a Chinese scholar or an old goat—Henri could not decide which.

"A poster, did you say? You have promised Monsieur Zidler a poster . . ."

"In color," specified Henri.

". . . a poster in color," echoed Père Cotelle with a nod. "And I gather from your explanations that you have never done any lithographic work before. Is that correct?"

"Correct."

"You don't even possess the most rudimentary elements of the craft?"

"That's right."

There followed a long silence during which Père Cotelle pulled at his wispy beard. Henri's eyes traveled over the stones scattered about the shed or stacked against the walls, the cans of printing ink, the chipped washbowl in the corner, the blue enamel coffee pot gurgling on the gas burner. There

was a table in front of the window. A large frosted-glass skylight spread above the flat-bed printing press. Outside, the rusty sign over the door squeaked in the playful September breeze. Somewhere a bird sang.

"And when, may I ask, do you propose to deliver this poster in color?" inquired Père Cotelle with an intimation of irony in his voice. For the first time he took his eyes from the stone on the press and focused them on Henri.

"As soon as possible. Zidler needs it badly. There won't be any Moulin if I don't get busy."

"I see."

During the pause that ensued Henri could swear he saw the chin whiskers growing longer from fretful pulling.

At last, Père Cotelle emerged from his meditation.

"Five years would be a reasonable estimate, I should say," he declared silkily.

"FIVE YEARS!"

"More probably six. You do not appear to realize that lithography is one of the most complex and delicate of all graphic processes. And when you speak of chromolithography or lithography in colors, the technique grows still more difficult. You might be interested to know for instance that 'The Capture of Jerusalem', a memorable chalk lithograph, required two years to produce and the combined talents of all the experts of Messrs. Day and Haghe's establishment in London."

He squinted at Henri.

"Your position is similar to that of a man entirely ignorant of musical composition, who would undertake to write a symphony. I must tell you these things before you plunge headlong into this venture. If you still persist, and are willing to learn and work hard, I shall be delighted to teach you."

"Good. When do we start?"

"Immediately, if you like. Hang up your coat and hat and slip on this apron. We may as well begin by saying that the word 'lithography' comes from two Greek words, 'lithos' and 'graphein', meaning to write on stone. It was invented in the eighteenth century by a Bavarian printer Alois Senefelder. A genius, monsieur! Now the first thing to remember when you start drawing on stone . . ."

Thus it began.

September went; then October. Along the boulevards the autumn winds tore the last yellow leaves from the chestnuts and sent them twirling into the gutters. But in the *Atelier de Lithographie Artistique* all was peaceful. Work went on while rain drummed on the skylight. Every morning Henri

arrived, put on his blue apron, and spent the day hunched over a stone, learning the technique of the lithographic chalk and the possibilities of the medium. Before long, he had cases of cognac delivered to the shed and discovered that Père Cotelle was not averse to an occasional drink "to combat the dampness of the season."

"You know, it's astonishing," the old printer would declare, hovering over Henri, "but you seem to possess an innate flair for lithography. Are you sure you never studied it before?"

Soon Henri was indulging in experiments, exploring new techniques, wandering far afield from the conventional methods. Père Cotelle watched him with a mixture of wonder and alarm.

"Mais non, mais non, mais non! You cannot do this."

"Why not?"

"Because it has never been done before. No lithographer has ever done such a thing."

One morning Henri brought a toothbrush, dipped it in lithographic ink and proceeded to run his fingertip over the bristles, spattering the stone with a myriad of little dots.

"Mon Dieu, what are you doing?" wailed Père Cotelle, rushing to the table.

"I'm trying a new way to stipple the stone."

"With a toothbrush! *Mais non, mais non, mais non!* It is impossible. No lithographer has ever done *crachis* with a toothbrush."

Henri grinned at him over his shoulder.

"It seems to work. Want to try?"

Gingerly the old craftsman took the brush, leaned over the stone and ran his finger over the bristles.

"It does seem to work, doesn't it?" he muttered in wonder. "Now why has nobody ever thought of that before? You are a born lithograher, Monsieur Toulouse. Are you sure you've never studied lithography?"

One October afternoon, as Henri was stippling a stone, his friend Maurice burst into the shed, panting with excitement.

"Guess what happened?" he cried from the doorway. "Théo Van Gogh has had a stroke and been taken to Holland! Monsieur Boussod wants me to take full charge of the gallery."

Thereafter Henri saw Maurice every day, sometimes twice a day. At night when he left the shed he never failed to drive by the gallery, where he found his friend in his shirtsleeves, making inventories of stacks of paintings and mountains of engravings, auditing the books, putting in order the firm's affairs that had been disrupted by Théo's illness. They dined

together, confided in each other and drew strength and happiness from each other's presence.

In the *atelier* things were happening at vertiginous speed.

"I must hurry," Henri said when Père Cotelle advised moderation. "Zidler is getting desperate."

By now he had become an authentic lithographer with ink-stained fingertips and chalk smears on his cheeks. Already he had mastered the technique of drawing on stone, probed the mysteries of shading and stippling, and was presently sailing through the intricacies of chromolithography.

Père Cotelle still left his printing press to peer over his shoulder, pull at his straggly beard and mutter his *"mais non, mais non, mais non!"* But a subtle transformation had taken place in their relationship. He had followed his pupil's progress with a feeling of wonder, witnessed his breathtaking feats of draughtsmanship, watched his unerring sureness of hand for which no technical difficulties seemed to exist. It made him uneasy. This hard-drinking, dwarfish cripple was indeed a most extraordinary young man. Could he by any chance be a genius?

Shortly after Christmas, Henri informed Père Cotelle he would be absent for a few days.

"I feel ready to tackle that poster now."

He spent the following week in his studio with La Goulue and Valentin. During those days he did not go out, did not see anyone but his two models, hardly slept. He ate at home, munched absently whatever Madame Loubet brought him, most of the time forgot to eat altogether.

Night and day he remained at his drawing table in a fever of creation, interrupting himself only to light a cigarette, or refill his glass with cognac. The floor became littered with butts and preliminary drawings of the poster, each one simpler, more daring, more forceful than the previous one, until at last he attained perfection of line and the optical impact he had been striving for.

When he returned to the shed he handed Père Cotelle the original water color. The old lithographer took one look at Valentin's necrotic silhouette and La Goulue's vast expanse of lingerie and felt his beard turn rigid and his few hairs rise up on his head.

"You can't print that!"

"Why not?"

"First, because there have never been such colors in lithography . . ."

"We'll make them."

"Second, because if this poster goes on the streets we'll all go to jail. You for doing it, me for helping you, Zidler for showing it, and Charles Lévy for printing it."

"Good. Let's get to work."

First, came the infinitely difficult process of drawing in reverse each "state" required by the complex original. This was followed by painstaking shading with chalks of various granulation, stippling and "filling" with lithographic ink the parts to be printed in black. The task consumed days of unrelenting work done in an atmosphere of foreboding and amidst prophecies of disaster.

At last the stones were ready for etching. This was Père Cotelle's part, and he performed it with a maximum of showmanship. He held his breath, tugged at his beard, invoked the heavenly help of Alois Senefelder, the inventor of lithography.

"One false move and all is lost!" He removed his skullcap and scratched his head. Gingerly he let a few drops of nitric acid fall into a solution of gum arabic. "Not enough acid and the solution won't bite. Too much and the fine lines will break. Of course I expect two or three stones will have to be done over . . ."

The etching went well and the printing of the trial proofs began. Père Cotelle was at his wit's end.

"There is no chartreuse ink, Monsieur . . . And what kind of green is that? It looks green but it isn't. It's blue, yellow, pink, gray—anything but green. How do you expect me to print such colors?"

"Let's blend the inks. Here, let me try . . ."

Finally, one evening Henri hobbled into the Moulin Rouge and made his laborious way to the bar.

"Bonsoir, Monsieur Toulouse," cried Sarah the moment she spied him. "We haven't seen you for a long time. My, what's happened to your face? You have all the colors of the rainbow on your cheeks."

He stood before her, panting, one hand clutching the ledge of the bar.

"A cognac, Sarah," he said between gasps.

She filled a long-stemmed glass and leaned forward to give it to him.

"You see, you're all out of breath . . . And you shouldn't drink so fast. It burns your stomach."

He levered himself onto one of the high stools.

"Tell Zidler he can send Lévy to fetch the stones from Père Cotelle's. Everything is ready to start printing the poster."

She looked at him through her large, soft eyes.

"I knew you'd do it some time, Monsieur Toulouse. I knew you'd keep your word."

While Henri's poster was being printed the Société des Artistes Indépendants was organizing its spring Salon. Henri duly attended the meetings of the *Comité Exécutif* which took place in the back room of a Montmartre café.

One evening the committee was already in session when he entered the smoke-filled room and went to sit next to Seurat. The president, Monsieur Dubois-Pillet, was angrily rapping his spoon against his absinthe glass and shouting for order.

"Silence, messieurs, silence! Remember we are in session. Our bylaws forbid private conversations during the meetings. Please, messieurs, I beg of you . . ."

The committee members went on exchanging pleasantries across the room, borrowing matches, lighting their pipes, ordering drinks. With a helpless shrug, Monsieur Dubois-Pillet rested his spoon on the table, settled back on the leather banquette and engaged in a private conversation of his own with the neighbor on his left.

"It's been going on like this for an hour," remarked Seurat, as Henri unbuttoned his overcoat and removed his derby. "You haven't missed anything." Philosophically he added, "They'll quiet down eventually."

"A double cognac," Henri called to a passing waiter.

He had just finished dinner and felt in a mellow, digestive mood.

"How are the dots?" he asked, turning to his friend.

"Still sweating on my 'Circus'." The placid young man rubbed his bearded cheek in a gesture of patient resignation. "The composition is terribly difficult, and that inside lighting is even trickier than sunshine. In comparison my 'Grande Jatte' was child's play. If you have a moment after the meeting I'd like to show it to you."

Unexpectedly the president resumed his spoon-rapping. This time cajolery was discarded. Anger mottled his liverish complexion.

"*Nom de Dieu*, are you going to shut up?" he yelped, flashing angry eyes under knit brows. "Are you or aren't you going to shut up? I'm going to start fining everybody!"

A semblance of order descended upon the room.

"That's better," he snorted, still glaring at the members.

He turned to a stocky man in a shabby suit who was looking at him with the air of a doleful and agitated walrus.

"And you, Rousseau, you can go on with whatever you were saying. But for God's sake don't make another speech."

Henri Rousseau struggled to his feet.

"Monsieur le Président," he began with a bow in the direction of the chairman, "messieurs, and dear colleagues. One hundred years ago, on that glorious fourteenth of July . . ."

"Come to the point. What's your complaint this time? We can't stay here all night."

Rousseau gave him a hurt look.

"There were many complaints last year about the hanging of pictures. They weren't hung straight. They were placed without regard for their chromatic value. How can we impress the critics if our pictures aren't hung straight? Take my paintings, for instance, my beautiful paintings . . ."

"That's enough," cut in the president. "You've talked enough."

"But I haven't finished!"

"Yes. You have. I take the floor from you. Sit down."

Seurat stirred himself out of his quietude. "Eh, Rousseau, why don't you take charge of the hanging? I'll be glad to resign in your favor."

The suggestion brought forth a storm of protest.

"No, no, sit down, Rousseau," shouted the president. "You're always on your feet." He banged his fist on the table. "Silence, messieurs! Our treasurer, Monsieur Pipinette, is going to give us his financial report."

An uneasy hush fell over the room, as a mournful-looking man rose and pulled a small black notebook from his coat pocket.

"I regret to inform the committee—" he adjusted a gold pince-nez on his nose and squinted at the members over the rims "—that our treasury is empty. There is so little in the box there's no use talking about it. And it won't get any better until some people start paying dues."

He sat down amidst a strained silence.

Finances were a touchy subject. To relieve the embarrassment the president launched into a flowery address in which he thanked Monsieur Pipinette for his devotion to the Société and his illuminating report. Yes, artists were somewhat hazy in money matters. Why, come to think of it, he himself had been neglectful on that score! The matter had

purely and simply slipped his mind. The treasurer's tactful reminder was all that was needed. Soon the treasury would be overflowing.

Hastily he turned to Henri.

"Monsieur de Toulouse-Lautrec, who is in charge of the catalogue, will now have the attention of the committee and tell us the result of his negotations with the printer."

There was very little to tell, Henri informed the members. Negotiations had broken down, the printer insisting on being paid for last year's catalogue before tackling the new one. Perhaps it might be advisable to search for a less mercenary printer?

Again the president came to the rescue. "Money-mad. All business people are money-mad," he ranted. "They don't appreciate the honor of printing the Société's catalogue. It might not be amiss to act on Monsieur de Toulouse-Lautrec's suggestion and make inquiries—preferably in some distant suburb—for a less avaricious, less cynical printer."

Henri Rousseau stood up.

"Sit down, Rousseau!" thundered the president.

"But Monsieur le Président, I . . ."

"No, no, no! I won't listen. You talk all the time and never say anything."

After that the meeting was all business. In rapid succession minutes were read and approved, resolutions taken, motions offered, seconded, voted upon. It was unanimously approved to dedicate an entire room of the exhibition to Vincent Van Gogh's work as a memorial tribute to the Dutch painter and his brother.

The meeting was coming to an end, and the president had already put on his derby when a member submitted the motion to appoint a Jury of Admission to the Society's annual exhibition.

During the following hour not only the meeting but the Société des Artistes Indépendants itself came very near to breaking up. The perennial question "Jury or no Jury"— often argued in private—had never been brought up officially. Should the Salon des Indépendants have its Jury of Admission, like the official, academic Salon? Should it turn dignified, bar its doors to the daubers, the pranksters, the amateurs, the brush-waving lunatics?

"I second the motion," flung Henri Rousseau, leaping to his feet. "Only a Jury of Admission composed of the distinguished members of this committee can weed out those naive,

those amateurish pictures that heap ridicule on our show and mar its artistic dignity."

The proposed measure found a surprisingly large support. One after another members rose to express their approval. "It's true . . . Our Salon is a farce, a circus . . . People come to our show only to laugh . . . Now if we were allowed to select the pictures exhibited . . ."

Behind their sanctimonious protests, they betrayed their long-repressed frustrations, their revolutionists' hunger for hierarchy and official recognition. Oh, to be judges! To hold power over other people, to be the élite, the mandarins, the aristocrats of something, even if only of the Société des Artistes Indépendants!

"I am against this motion," Henri shouted, rapping his cane on the marble-topped table.

"Me, too," echoed Seurat from behind a cloud of smoke.

This double declaration shocked the committee into a momentary silence.

"It's true," Henri went on, "people laugh at our paintings, but what does it matter? People have laughed at Rembrandt's 'Nightwatch', and Manet's 'Olympia'. Laughter is the first resort of fools. It is easier to laugh than to try to understand. It's true we've shown some pretty terrible daubs in our Salon, but we've also shown some very great paintings that otherwise would never have had a chance to be seen. Besides, who the devil are we to decide what's good and what's bad in art? Artists have been notoriously wrong in their appraisal of their fellow artists. Michelangelo belittled Leonardo. David jeered at Watteau, Ingres at Delacroix. The Impressionists were ashamed of Cézanne, and now Cézanne thinks no one but he can paint! Let's remain what we are. Let's give everybody a chance. Time will decide those among us who are great artists and those who aren't. If you must have a Jury, let Time be our Jury."

The motion was defeated by a narrow margin. Hastily, the president adjourned the meeting.

"Let's get out of here," he said, "before some other damn fool comes out with another motion."

It was past midnight when Henri accompanied Seurat to his studio to look at his friend's painting.

On a February afternoon Henri sat perched on a stool in one of the rooms of the Pavillon de la Ville de Paris helping Seurat hang Vincent's pictures for the forthcoming Salon

des Indépendants. That is, he was reading the numbers from a catalogue open on his knees while the husky young pointillist hammered nails in the wall, inserted screws in the backs of the frames and did most of the work.

"What's the number of this one?" asked Seurat, his mouth full of nails.

"Twenty-eight. 'Cypresses'. A little more to the left, Georges."

Seurat straightened the canvas. "All right?"

Henri squinted behind his thick lenses. "Perfect. Come and look at it."

Seurat trudged over to Henri, lit his pipe and with a grunt sat down on the floor.

For a moment they studied Vincent's canvas.

Seurat shook his head and let out a sigh. "I'll be damned if I know how he did it. Optically it's all wrong, yet the thing glitters."

"Don't they look like tongues of green fire?" said Henri, examining Vincent's tumultuous cypresses. "To think he could turn out a thing like that in a few hours! Did you know he painted almost fifty canvases in the eight weeks he spent at Auvers. And he wanted to be a pointillist! Poor Vincent!"

"Fifty canvases in eight weeks!" repeated Seurat incredulously.

He broke into a violent fit of coughing. His face turned scarlet, and it was a moment before he could catch his breath.

"You'd better watch that cough, *mon vieux*," said Henri, looking at him. "There's a lot of sickness about."

"I must've caught cold last night in the studio. The stove went out and I didn't bother to light it again."

He cleared his throat, dabbed his mouth with his handkerchief.

"By the way, have you heard Gauguin is leaving for Tahiti next month?"

"Is he?" asked Henri, lighting a cigarette. "It's about time. He's been talking about his damn coconut palms and his naked girls for the last ten years. But you'll see, he'll be back. Like a few years ago when he went to Martinique, remember? He was going to stay there all his life, but he found it got a little warm there in summer. He didn't like being a laborer on the Panama Canal either."

"They're giving him a farewell dinner."

"I'm sure he'll have a brass band at the station. He can't do anything simply, that man."

Seurat glanced up at him from the corner of his eye.

"You don't like him very much, do you?" He grinned.

"I don't like what he did to Vincent in Arles. Imagine asking Vincent to call him 'Master'! And I don't like his posturing, his carved sabots and his embroidered jersey. He has talent, but I don't think he is half the artist Vincent was. Have you seen his 'Jacob Struggling with the Angel'? Looks as if the Angel were taking Jacob's pulse. And his 'Yellow Christ'? Somehow all these religious *Bretonneries* don't strike me as sincere. I just don't believe in financiers who turn primitive. Rousseau may be a simpleton and a bore, but I believe he's sincere. And incidentally, some of his jungle paintings are remarkable—I think. Have you seen them? If you want we'll go to his studio some day. They're really worth looking at. But Gauguin—I don't know. I always feel the man's trying to startle you, show you how clever he is. His naiveté is put on. At least that's how I feel. And if there's something I hate it is pseudo-naiveté."

"Maybe he hasn't found himself yet," ventured Seurat generously.

"Perhaps," shrugged Henri. "Maybe he will in Tahiti. Anyway, let's get back to work . . . Number twenty-nine. 'Sunflowers'."

As Seurat was about to rise he bent over, racked by another spasm of coughing, even more violent than the first.

"My throat hurts like the devil," he said, when at last he was able to talk. "I don't know what's the matter. I've never felt like this before."

"You'd better go home. We can finish the hanging tomorrow. Come on, I'll drop you on the way. It's getting late and you know how your mother worries."

Seurat did not come to the Pavillon the next day. Henri drove to Boulevard Magenta and learned that his friend was in bed with a high fever.

"He's asleep now," whispered Madame Seurat, a finger to her lips. "It's the first time he's been able to. The doctor says he'll be all right in a few days, though."

On March 10, the Salon des Artistes Indépendants opened, and the stately rooms of the Pavillon rang with the laughter of the crowds.

Henri Rousseau, in frock coat and shiny hobnailed shoes, stood guard before his paintings and engaged in conversation with anyone who happened to glance at them. "Allow me to introduce myself." A bow from the waist. "Henri Rousseau, former sergeant and customs officer. I am the creator of these remarkable pictures. Look at that tree! It has great orna-

mental majesty, don't you think? It also looks like a sponge. You can buy it for twenty-five francs." In a lower voice. "Let's make it twenty-two! . . . Twenty! . . . A bargain. No? Eighteen? No?"

Vincent's paintings passed almost unnoticed, but crowds gathered in guffawing groups in front of Seurat's work. Those vaporous canvases of glittering seas and peaceful landscapes were voted the most ludicrous pictures of the show. The term "confetti painting" was coined by a wag and became an instant success.

But the artist was spared the jibes and sarcasms. Drenched with sweat, his face purple from suffocation, he was gasping for air and struggling to live.

Every day Henri drove to Boulevard Magenta and as he received the news from Madame Seurat he could hear the grating wheeze of the dying man. One morning she opened the door, looked at Henri through blurry eyes, unable to speak. Then she cupped her hands over her face and shook with sobs. Finally she slid her fingers down her tear-stained cheeks.

"You can see him now," she said brokenly. "He died an hour ago."

Coming so shortly after Vincent's suicide, Seurat's death made a deep impression on Henri. Both had been young, in full command of their talents—and both now were dead . . .

A few days after the funeral, as Henri was seated in front of his easel, listening to the drone of Madame Loubet's voice, Zidler burst into the studio, bristling with excitement.

"I've just come from Lévy's. They've finished your poster. It's going to be plastered all over Paris during the night. It'll be on the streets tomorrow morning!"

XVI

"Have you seen it?"

"Have you seen it?"

"Have you seen it?"

In the morning it was a murmur; by nightfall a swelling chorus.

"Seen what?"

"That poster, of course! That girl doing the cancan . . ."

"It's an outrage!"

"It's a work of art!"

"A *cochonnerie!*"

"A masterpiece!"

It was sudden, absurd, irresistible, but there it was. Paris was thrilled! Paris was shocked! Paris was in a dither over that poster! It was everywhere: you couldn't avoid or forget it. It leapt at you from every wall, every kiosk, every *pissotière*. Crowds gathered before it, exchanging bawdy remarks, obstructing the traffic. Gendarmes pleaded, threatened, thrashed their arms in the air. *"Nom de Dieu,* haven't you ever seen a hooplala showing her *derrière* before? Allons, keep moving! Keep moving, if you please!"

People craned their necks and squinted their eyes to read the signature. And there it was in the left-hand corner: "LAUTREC."

"Lautrec!"

"Lautrec!"

"Lautrec!"

The name popped out of innumerable mouths on the terraces of cafés, in offices, clubs, barbershops, in the workrooms of *maisons de couture,* in fashionable Champs-Elysées dining

273

rooms and in *gargotes* where *cochers* lapped their soup while keeping an eye on their cabs.

The newspapers were full of it. Some declared the poster a satanic creation, demanded its immediate removal from the streets. Others pronounced it the first poster ever made that was also a great work of art. Civic leaders and moralists warned that the innocence of Parisian *jeunes filles* was being endangered and ladies could no longer walk in the streets without blushing.

On the other hand a number of artists and critics rose in spontaneous defense of the poster. "A highly moral work of art . . . A Hogarthian satire of morals in this *fin de siècle* . . . The graphic epitaph of a dying civilization . . ." The Moulin Rouge poster was a *tour de force*. Valentin's silhouette, for instance, was drawn as Holbein himself might have drawn it. This saturnine, top-hatted skeleton was a creation worthy of the master of the "Dance of Death." With this poster, lithography was freeing itself from the printing of bottle labels and cigar bands and was taking rank among the graphic arts. Monsieur de Toulouse-Lautrec had brought art to the street!

The most stupefied man in Paris was Henri. He felt like one who throws a pebble into a ravine and finds he has started an avalanche.

"I don't understand it. I don't understand what all this furore's about," he confided to Maurice.

"Well, your poster is rather shocking, you must admit."

"Damn it, that's what a poster should be. I only wanted to help Zidler get people in his damn Moulin. Not start a revolution!"

"Eat your dinner and don't get so excited. What does your mother think about it?"

"I don't know. She's never mentioned it to me. I'm not even sure she has seen it. Meanwhile the damn thing is wrecking my life."

"How's that?"

"I can't work any more. I don't know where people get my address, but they come to the studio in droves. Everybody wants a poster—manufacturers of corsets, perfume, beauty creams. Theatre managers, actresses, God knows what."

"What do you tell them?"

"To go to the Devil. Every morning Madame Loubet brings me a stack of invitations from people I've never heard of."

"What do you do with them?"

"Give them back to her to light the stove. What do you expect me to do with them?"

"It might not be a bad idea to open a few. You might even accept some of them and meet a few decent people for a change, instead of the riffraff you associate with. Incidentally, are you planning to stay in Montmartre the rest of your life?"

"Certainly."

"Aren't you tired of going to the Moulin night after night? Why don't you mix with successful, cultured people, instead of a bunch of Montmartre failures? I could introduce you to the Natansons. Madame Natanson is one of the loveliest and most intelligent women in Paris. She's been asking me to bring you . . ."

"I don't want to go anywhere. I'm perfectly happy at the Moulin. Everyone knows me and everyone is nice to me. Oh, by the way, there's a new girl who dances there I'd like you to meet. Her name is Jane Avril . . ."

For several years Henri's relations with his father had been strained. At his mother's insistence he had continued to pay his father formal and infrequent calls, during which they both endeavored to conceal their respective uneasiness.

One morning, not long after the appearance of the poster, his father burst into the studio.

"How dare you!" The count was livid with anger. "How dare you sign our name to that revolting dance-hall poster! If you were not a cripple, I'd whip you for that!"

Henri's face turned gray. He had heard of his father's rages, and they could be frightening indeed. For a few seconds he cringed in fear of the gold-knobbed cane the count was shaking in his fist. Then, suddenly he was no longer afraid, but angry, choking with a parricidal anger against this foppish boulevardier who was talking of whipping him. By the beard of Saint Joseph, he too was a Toulouse-Lautrec, and cripple or not, he wasn't going to allow anyone to speak to him like that!

He looked up.

"I don't think this visit serves any constructive purpose," he began with icy calm. Behind the thick lenses his eyes were level, unafraid. "I am sorry you do not like my work. I am sorry I cannot go riding with you on the Champs Elysées. I know how distressing my deformity is to you and I can only assure you it is just as distressing to me. I did not ask to be born and I am sorry to be your only son and the last of our

House. I know you do not approve of me and I am not sure that I approve of you. I am not afraid of you, Papa. I used to worship you, but I don't any longer. Maman and I needed your love, your companionship, your understanding. We needed them desperately, and you have failed us both. And so, if you don't mind, let's put an end to this scene and stay out of each other's way in the future. As for my work, I shall sign it as I like, for it is *my* work and it is *my* name, and not even *you* can change that."

"Work!" sneered the count. "Do you call this work?" He waved at the canvases on the walls. "Pornographic trash! A pretext to drink and loaf in brothels and dance halls!"

"Yes, I call it work!" Henri flung back. "But how would *you* know? How would you recognize what is and what isn't work? *You've* never worked. Our kind never did. Work is menial, good enough for bourgeois and villeins. We are the *grands seigneurs,* lords of the sword! We are above work. The world still owes us a respect for which we no longer give anything in return. We are so noble, so blue-blooded, so inbred, so steeped in pride and prejudice that we've become useless, and all that's left to us is to butcher defenseless beasts, or strut about on horseback, and, if we are lucky, die gallantly on some battlefield. We cloak ourselves in the glory of our name as if it were some remarkable achievement just to be born.

"The truth is that our world died with Versailles and Marie Antoinette, and perhaps we should have died with it. As it is we are the fossils of an age that is gone, as obsolete as the dinosaur and about as important. You say I associate with prostitutes. Of course I do. And I am grateful to them for associating with me. What other kind of woman would? You say I drink. Yes, I do! A little more every day. Why? Because when I drink I forget my ugliness, my loneliness, the constant pain in my legs. How would you like to be in my place? How would you like to drag yourself as I do? Do you think you'd like it? Of course, I drink. You would, too, if you were as I am. We all have our escape. Maman has prayer; you have your falcons and your horses. And I—I have cognac! What would you have me do? Spend my life on a chaise-longue? I tried. I couldn't stand it. Neither could you."

He stopped and looked at his father.

The count stood before him immobile as a statue. His eyes had lost their harshness and angry glitter. He looked very old, very proud and very lonely. For a moment the silk-lapeled frockcoat seemed to fade, and in its place were the gold

helmet, the coat of mail and oblong shield of Raymond IV, Comte de Toulouse. Behind him waved the Crusader's banners and crested gonfalons. Armor and swords sparkled in the sun, and the neighing of horses mingled with the blare of trumpets . . .

The vision faded. Once again his father was the Parisian boulevardier in white spats and ascot tie. For an instant Henri felt very close to this broken, erratic feudal lord who was born five centuries too late, in a world that no longer had a place for him. He would have liked to take his hand, tell him he understood him, his grief, his morbid pride, his futile worship of the past. He would have liked to say that, cripple or not, he, too, belonged to their vanishing caste; that he, too, was a Toulouse-Lautrec. But what was the use? Nothing could be changed . . .

"Henri, this is the end." His father's voice was husky, distant. "We won't see each other again. Do what you want, live as you please, but don't ever call on me for help, for I shall not give it to you."

"You didn't give it to me before," said Henri bitterly. "I won't expect it from you in the future."

The count tipped his hat, as if taking leave of a stranger, and stiffly walked out of the room.

Suddenly Henri felt cold. He limped to the table and poured himself a drink.

The poster had been out several months, and still Henri remained in Montmartre.

"Aren't you getting tired of that damn Moulin?" asked Maurice again and again. "Aren't you getting sick of the same place night after night, the same people, the same everlasting drivel about dealers and critics? You probably are the most successful artist in Paris and yet you insist on living among failures. You surround yourself with a crowd of braggarts and hangers-on when you could mix with the most charming, cultured and famous people in Paris?"

"A lot of dull snobs who would only stare at my legs . . ."

"Your legs! Always your legs! You think people can't see anything but your legs. You're wrong, Henri, I've told you a thousand times! For instance, you've heard me speak of the Natansons, haven't you? They're about the most delightful people you could ever hope to meet. For months Missia Natanson has been asking me to bring you to her house. She's an excellent pianist and very interested in art. She has a superb collection . . ."

"Women aren't interested in art," Henri shrugged scornfully. "Society women least of all. When they collect pictures, it's only an excuse to collect artists. They don't understand art. It's a pose with them, a pretext to chatter about it! Besides, what's wrong with the Moulin? I like it. I like the noise, the lights, the crush and clatter. I like to chat with Sarah and the cancan girls. Zidler can't do enough to show me his appreciation. He sends champagne to my table, won't even let me pay for my drinks . . ."

"After what you've done for him, he can afford it."

"Oh, stop your pestering! You keep your Natansons, and I'll keep my Moulin."

Yet despite his emphatic protestations, Henri was beginning to weary of Montmartre. He did not entertain many illusions about most of the people who rushed to his table the moment he entered the café. But he was getting tired of their bombast, their everlasting recriminations. The cancan girls, too, had changed. Gone was the impish *gaminerie* of the old L'Ely days. In three years the Moulin had turned them into self-conscious professionals and predatory *cocottes*. Skyrocketed to fame by the poster, La Goulue wore with obnoxious arrogance her crown of queen of the cancan. She had come to believe it was she alone who drew the crowds that nightly filled the dance hall. Her impudence knew no bounds. Once during a performance of the cancan she had yelled to the Prince of Wales, *"Alors,* Wales, you buy the champagne tonight?"* To Henri she had ceased to embody the plebeian gaiety of Montmartre. Pictorially she no longer interested him.

But it took a sequence of dramatic events to overcome his morbid sensitiveness and push him, so to speak, out of the district he had sworn never to leave.

One evening, one of the cancan girls died on the dance floor while doing the grand split, and the episode affected him more than he cared to admit. A few days later his good friend, Berthe, arrived in tears at his studio and told him a man had killed one of the girls. Le Perroquet had been closed by the police. For three days she stayed in Henri's quarters until she found a "position" in a *maison* on rue d'Amboise. The other girls scattered throughout Paris. Henri was forced to rearrange his sexual habits. Now he had to drive long distances to find what until then had been so conveniently close.

Barely had he recovered from these shocks when Jane Avril informed him she had secured a minor engagement at the Folies Bergère.

The last blow fell a month later.

That evening Zidler came to sit at his table, chewing his usual unlit cigar and rubbing his hands.

"Well, it's done! Signed and everything. I just sold the Moulin, Monsieur Toulouse. Remember how I used to say I was going to make a million? Well, I made it! But don't think I'm just going to sit back and count my money. Not me! I'm going to open another place. On the Champs Elysées. I'll call it 'Le Jardin de Paris.' And I'm taking Sarah with me . . ."

Henri felt as he had on that distant September afternoon when his mother had told him he must go to school. His world was crumbling about him. Without Sarah, without Zidler, the Moulin wouldn't be the same. What was he going to do? He had done many paintings of the Moulin, and said about all he wanted to say. From now on he would only be repeating himself. Perhaps Maurice was right. Perhaps he should go out, meet other people . . .

That evening he watched the cancan but made no sketches. After the show he stopped at the bar to say good-bye to Sarah; then to Gaston, his favorite waiter. On his way out he shook hands with Trémolada. For a minute he stood before his circus painting hanging in the lobby.

Then he went out.

As the landau started rolling away, he leaned out of the window. The red glittering vanes were turning in the night, just as Zidler had said they would. Because he was in a sentimental mood he fancied they were turning for him, only for him, whirling their blazing farewell.

"Good-bye, Moulin!" He whispered the words and made a small gesture of the hand as if taking leave of an old friend. "Good-bye, Moulin!"

Still lower, he added, "Good-bye, Montmartre!"

A few days later Maurice introduced him to the Natansons. At the door a liveried footman received their hats and gloves and helped them out of their capes. The two young men crossed the hall and paused on the wide stairs that led to the drawing room. While catching his breath Henri had a glimpse of an enormous room, rather dim despite a profusion of silk-shaded lamps, logs burning in a marble fireplace, a grand piano standing in a corner like a harp's coffin, tufted velvet furniture, scattered groups of bejeweled ladies in evening gowns, and beared men in glistening shirtfronts, sipping sherry and making polite conversation. White-gloved footmen moved about with trays.

At once Henri recognized Missia Natanson, not because she was the most beautiful woman there, but because instinctively he felt that this sumptuous room must belong to her.

She excused herself, picked up the train of her rose taffeta gown, and smiling, one hand outstretched, rustled toward them.

"Monsieur Joyant, how nice of you to come and bring your friend."

Then she turned to Henri.

"Monsieur de Toulouse-Lautrec, at last, at long last!" she said in her low, Slavic voice. "You may not be aware of it, monsieur, but for months I've been plotting and conniving to get you here. But now that you are here, I'm going to monopolize you. You won't mind, will you?"

And she hit him full in the face with her smile, her irresistible smile . . .

MYRIAME

MADAME

XVII

How long — how long did it take a fool to open his eyes? See that it was all make-believe, all a cruel farce? . . .

"About five years." He spoke the words aloud, with a low chuckle. "That's what it's taken me."

For a while he abandoned himself to the gentle swaying of the fiacre. Around him the Avenue de l'Opéra throbbed with the clatter of late afternoon traffic. A blonde, flashily dressed actress daintily waved to him from her landau. Absently, he tipped his silk hat, brushed cigarette ashes from the fur lapel of his overcoat, and leaned forward.

"*Cocher*, forget about going to Weber's. Please drive to the Joyant Gallery, 9, rue Forest."

Yes, it had taken him five long years to realize that it was nothing but a big joke. Five years, quite a long time . . . But, damn it all, it had all seemed so real at first—as if the whole world had conspired to make him forget that he was a cripple. Missia, for example. She didn't have to smile at him like that.

It was the smile she used to get what she wanted—for she was much too intelligent to rely on her intelligence—the smile that had made her salon one of the most famous in Paris, lured away from rival hostesses such hardened and sought-after celebrites as Zola, Clemenceau, Anatole France . . . Imagine what it had done to a poor dwarf of a cripple! It hit him in the solar plexus, capsized his heart, swept away whatever little sense he'd ever had and launched him on a five-year dream!

And she looked so damned beautiful that night! When beauty, taste and money get together—and she had all three—they make a formidable combination. She was all elegance, all poise and graciousness, the triumphant assertion of

283

what money can do when it has something to work on. Wealth doesn't become everybody, but it became her. At a glance you knew that the most expensive coiffeur had done her hair; that *femmes de chambre* had fluttered about her while she dressed, seen that every hook was hooked, every clasp clasped; that her rose taffeta dress came straight from Worth's or Paquin's and must have cost a mountain of money.

And he, being twenty-seven at the time and being that sort of man with that sort of mind, had become instantly aware that underneath the gown was a hidden loveliness of the sheerest, foamiest lingerie money could buy, a riot of Alençon lace; and underneath the lingerie, the lush peach-smooth body of a blonde in full bloom . . .

Now in retrospect he realized that she shouldn't have smiled at him like that. It was cruel. It was extravagant—like firing a cannon at a rabbit. A polite ordinary smile would have been enough. And the people he met that evening would have been kinder if they hadn't been so nice to him. They shouldn"t have praised his poster as they did. They should have said, "*Mon Dieu,* look at him, isn't he a fright! Look at that face, look at those legs!" It would have been kinder. Instead they had flattered him, made him feel welcome—worse, made him feel famous . . .

He could remember everything about that evening. Who was there, what the ladies wore, what people said, what he said, even what he thought. He remembered the green and gold dining room which had the frigid awesomeness of a vault in the Banque de France, but which by the time the roast pheasant had been served managed to look friendly, almost intimate. Sarah Bernhardt, sitting between Claude Dubussy and Oscar Wilde, wore a white moiré gown and had freckles on her shoulders. Anatole France was having a ceremonious debate with the bishop—for there was a bishop there that evening, one of those *prélats mondains* who become cardinals. A debate with smiles, little bows, deprecating gestures—a duel with sewing needles . . . Clemenceau was telling his pretty neighbor about the Civil War in America: "Lee was a better general, but he had only enthusiasm, madame; Grant had guns . . ." He even remembered being intrigued by Madame de Gortzikoff's enormous solitaire and wondering how much it weighed and how much it cost . . . Thinking that successful people—and everyone at the table was successful—were as a whole more interesting than failures and much less bitter . . . That intelligent men needed the attention of beautiful women to give their best . . . That many people

had wit but few had it at the right time, and that most really great *mots* were born at night in smart circles . . . Thinking that women *did* look better in couturiers' creations than in homemade dresses . . . That extremely wealthy women—if they were human-looking at all—had a fascination of their own, and that money had a subtle but very sexual appeal, which was perhaps why every midinette tried to look like a banker's daughter . . .

Above all he remembered Missia. Missia telling him about Poland, where she was born, her brother Cipa, how much she liked music and ballet, how much she admired his poster and how pleased she would be—here the famous smile went into action—if he would contribute a few drawings to *La Revue Blanche,* a magazine her husband had launched to amuse her . . . "I am glad you came, Henri—you don't mind if I call you Henri, do you? You will come again, won't you? Often, very often . . ."

It was then he had made his great discovery. Why, he belonged with these charming successful people! He, too, was charming, successful! A cripple—who was a cripple? He was Lautrec, that "young and daring artist"! He was famous! Famous! Paris was open to him! He would go everywhere, see everything, meet everybody . . . He could go anywhere he pleased, he was admitted, sought-after, famous! . . .

He had thrown himself on Paris. He had gone everywhere. He couldn't see enough, sketch enough, hear enough, go to enough places in one night. Since he worked during the day, he had to live at night. In order to live at night, he went without sleep, and in order to go without sleep, he drank . . .

Life became an endless climbing in and out of fiacres. "Pst, pst, *cocher!* Chez Weber's . . . Le Café Anglais! . . . The Irish-American Bar, Rue Royale! . . . Pst, pst, *cocher!* Chez Maxim's! . . . *Cocher,* L'Eldorado! . . . L'Alhambra! . . . Les Ambassadeurs! . . . Le Casino de Paris! . . . Pst, pst, *cocher!* Les Folies-Bergère. No, not the entrance, the stage door—and hurry! *Cocher,* 21 rue de la Boétie. Ask the concierge if Madame Sarah Bernhardt is at home . . . *Cocher,* to the Palais de Glace! . . . *Cocher,* to the Vélodrome! . . . *Cocher,* chez Madame de Gortzikoff, 16, rue Montaigne . . . Madame la Duchesse de Clermont-Tonnerre . . . Madame la Princesse de Caraman-Chimay . . . Pst, pst, *cocher!* Chez Larue's! . . . Chez Voisin's! . . . La Tour d'Argent! . . .

Curiously, he remembered very little of those five frantic, sleepless years: only a handful of insignificant, disconnected vignettes that for some reason had stuck to his mind, like

the confetti you find under the collar of your coat two months after a masquerade. Weber's at six o'clock, with the Tziganies in their red dolmans leaning over their fiddles, and Charles, the headwaiter, strolling majestically among the tables . . . The bar at Maxim's. Gérard, the monocled head-chasseur in his blue and red uniform . . . Ralph, the half-Cherokee, half-Chinese bartender, who used to call him "Monsieur le Vicomte-Marquis" . . .

Bars, bars, bars . . . Girls—blondes, brunettes, redheads. Round-hipped in their hourglass gowns, their hard red-lipped smiles pasted on their pretty faces . . . Young women with old hearts—the phosphorescent bats of Parisian nights . . . Actresses, hundreds of them. Polaire Réjane with her carriage drawn by white mules, Sarah and her satin-lined coffin at the foot of her bed, Eve Lavallière, Anna Held, May Milton, Yvette Guilbert, Jeanne Grenier, Marcelle Lender . . . Loie Fuller after her Fire Dance, mopping her face, telling him about her little town in the state of Illinois . . . May Belfort in a nightgown, a cat in her arms, singing, "I've got a little black cat" . . . Jeanne Derval entering Maxim's at two o'clock in the morning with her Briard bitch harnessed in a jeweled chastity belt . . . Jane Avril wolfing down a Welsh rabbit at the Café Riche after the show, saying, "Henri, this time it's different. He's so sweet, so tender, so intelligent and—so vigorous . . ." Theatre dressing rooms. Blue ones, pink ones, green ones with lingerie flung over the furniture or dangling from screens, smeared towels crumpled between make-up jars . . .

That was the sort of thing he remembered. The Folies girls stampeding to the wings after a number, stumbling on their long trains, swearing under their breaths . . . Debussy gobbling chocolate eclairs and talking about his adventures in Russia . . . Zimmerman training at five o'clock in the morning in the immense and empty Vélodrome . . . Driving to Père Cotelle's at six in the morning, tying on a blue apron over his evening clothes and tackling a fresh stone . . . Maurice shaking his head, "Work or play, Henri, but for God's sake don't try to do both at the same time . . ." Madame Loubet pleading with him to go to bed . . . More dinners at Missia's . . . Week-ends at her country house . . . Returning to Paris in a tallyho after the Longchamps races . . . The magnificent dining room at Madame de Gortzikoff's with the footmen dressed in Cossack uniforms . . . An evening with the Prince of Wales at Le Jardin de Paris . . .

What else? Tanguy dying of cancer at the Hôpital de la

Pitié, looking through sunken eyes, glassy with pain, trying to speak . . . Lunching with Maurice at the Dreyfuses' a few months before the scandal . . . La Goulue and Aicha facing each other at midnight on the bridge over the Montmartre Cemetery, springing at each other, kicking, clawing, biting. And a few days later, La Goulue—vanquished, black-eyed, her face scratched—coming to the studio and asking him to paint the curtains of her booth at the Foire de Trône.*

"Tante" Armandine's death . . . Two months later, journeying with Maman to Celeyran for Grandpère's funeral. The big house, once so full of laughter, now so quiet and soulless . . . Some houses die with their masters . . . What else? London . . . Amsterdam . . . London again, this time with Maurice. Sketching Whistler in his Chelsea studio, dining with him at the Criterion . . . Oscar Wilde, slumped on a chair, staring at the carpet, waiting for his arrest . . . The cruise to Lisbon . . . The pretty passenger aboard who was going to join her husband at Dakar . . . Madrid—the streets crowded at two o'clock in the morning . . . Toledo and the magnificent El Grecos . . . Finding an ex-Perroquet girl in a Barcelona brothel . . .

Then back to Paris. More music-halls, more bars, more, "Pst, pst, *cocher!*"

At a Natanson party he had tended bar in a mess jacket, a Union Jack as a waistcoat. He had invented a cocktail, "The Earthquake," and become proud of his talents as a bartender. He had given dinners where he served monkey meat to his guests, placed gold fish in the water carafes . . . Stupid things like that. And because he felt lonely and bitter he drove himself harder and harder, drank more and more, made himself conspicuous with his pink gloves, blood-red shirt and green jacket cut from a bolt of billard-table cloth.

Well, that was about all . . . Not much to show for five years. Entire weeks, entire months had left no imprint at all. Long before we die we begin dying to ourselves . . .

And now? Things were about the same. He had sold his carriage and Shetland ponies. He no longer went about dressed like a music-hall comic, but only because he was too tired to play the clown. He still haunted the backstages of theatres and *cafés-concerts.* But mostly out of habit, because he didn't

* These curtains were sold by La Goulue, cut up by an ignorant art-dealer and disappeared for many years. In 1929, after a painstaking search the Louvre managed to recover all the missing fragments which were carefully restored to their original state.

know what else to do. He still shuttled from one place to another, slept in fiacres. And he was still alone. He knew now that no woman would ever love him, that all the beautiful smiles were addressed not to him but to his fame as an artist. He was now only thirty-two, but he looked forty-five. His health was breaking down; he couldn't work half as hard as he used to. His hand shook when he took a drink, so that he had to steady his wrist with his other hand. Liquor didn't help his legs any more, and they hurt like the devil sometimes.

How long would it last? He didn't know, didn't really care . . .

The fiacre turned into a deserted side street and stopped in front of an unpretentious art shop over which hung a gold-lettered sign, "Galerie Joyant." Henri climbed down, pushed open the single-paneled glass door and plodded through the two dim and empty exhibition rooms. As he neared the office he could see Maurice working at his desk. The beam from the desk lamp fell on his serious face, stressed the blondness of his hair and mustache, deepened the frown of concentration between his brows. Dear Maurice, how hard he had worked these last years to open this little art shop! How serious and earnest he looked in his frockcoat!

Maurice glanced up from his desk. "*Bonsoir*, Henri—oh, *mon Dieu*, you've been drinking again!"

"I only had two apéritifs—well, let's say three—and a quick one on the way. I'm not drunk."

"No, you're not drunk, but your eyes are bloodshot and you have that certain look . . ."

"Mind if I sit down?" He eased himself into the capacious leather chair.

"Here," Maurice disgruntledly held out the paper, "read what they say about the exhibition while I finish my letter."

"On my way here," Henri said, taking the newspaper, "I went over the past five years and reached the conclusion I am a supernumerary man, like Saint Joseph . . ."

"Shut up. Let me write this letter."

". . . I've misspent my youth. And it's all your fault! Don't forget it was you who took me to Missia's that night . . ."

"I only wanted you to meet some decent people . . . For God's sake let me finish this letter! I'll talk to you in a moment," he added ominously.

Henri rustled the newspaper. "Listen to this! 'The first one-man show of this young and daring artist which is to open tomorrow afternoon at the Galerie Joyant promises

to be . . .' Et cetera, et cetera . . . Those art critics should change their epithets once in a while. When I'm ninety they'll still call me that 'young and daring artist'."

"Ninety!" Maurice signed his letter and slipped it into an envelope. "At the rate you're going you'll be lucky if you reach forty."

"Raphael didn't, neither did Correggio, nor Watteau . . . Now, out with it! I can see you have a sermon all ready, and nothing is worse than a bottled-up sermon. Go ahead. What is it this time?"

Maurice leaned back in his chair, clasped his hands behind his head and considered his friend. "Sometimes I wonder whether you sit up at night and search for new ways to wreck your career. For instance: what kind of reputation do you think it gives you to go to the Opera Ball with that notorious madame and introduce her as your aunt?"

"Oh, that! First, Madame Potieron isn't notorious. She's discretion itself. Second, she looked very respectable that evening. Third, she had never seen an Opera Ball and was dying to see one. Besides, she could have been my aunt."

"But she wasn't, and everybody knew it. They also knew you spend weeks at a time in her brothel. Everybody was talking about it."

"Were they? Well, let them, by all means. Don't you know calumny is the soul of conversation and most people wouldn't have anything to say if they couldn't tattle behind your back? Why should you worry if I don't? You know perfectly well, Maurice, that if it were not for La Fleur Blanche I'd be dead long ago. God knows, it's the only place where I can rest and where people leave me alone, and I can work in peace. All right, I spend a few weeks now and then in a brothel. Whose business is it, and what harm do I do? Berthe, my old friend from Le Perroquet, is *sous-maîtresse* there. The girls come to my room while I paint, and the food is excellent. You can't imagine the things you see when you live in a brothel!"

"I think I can," grinned Maurice.

"No, you can't! And stop being dirty-minded like all sanctimonious people. I meant the subjects, the poses, the expressions —things that have never been painted before."

"Do you know what a critic called you? 'The Velasquez of the Whores'."

"I didn't know, but I take it as a compliment. Now look, Maurice, stop being so tight-lipped and Christian for one minute and be reasonable. Morally speaking there is no differ-

ence whether you paint a nude in your studio or in a brothel, is there? But from the artistic point of view the difference is enormous. How can I make you understand? It's the difference between a panther in a jungle and a panther in a taxidermist's. One is free, natural, beautiful; the other is a stuffed thing, lifeless and grotesque. On a model stand a nude is a woman with no clothes on. When you are through painting her you have an aphrodisiac in oils, a dirty postcard that will pass as art. In a brothel a nude becomes un-self-conscious; she moves freely; she walks, stands, sits, stretches out as Eve must have done in the Garden of Eden. You discover that a woman is not the walking coathanger you see in the streets. She is a smooth-skinned, extremely pliant biped, able to assume the most varied positions. Have you ever watched a woman's stomach when she laughs? I have. One day Rolande was telling the story of a night she spent with a client who insisted on dressing her as a nun. She was telling the story very well, with appropriate gestures and pantomime. It wasn't sacrilegious in the least, it was just extremely funny, and the girls were laughing their heads off. They were sprawled on my bed, some on their backs, some on their stomachs. I could watch their reactions through the flapping of their navels, the vibrations of their rumps. Their whole bodies were laughing. Even their toes were arching and wiggling with laughter. Another time I remember watching the tightening of muscles in a woman's thighs, the breathlessness that froze her face when Docteur Bouchon told her she had syphilis. It was the most poignant thing I've ever seen . . . But you are a dealer, you wouldn't understand."

"All right, I wouldn't understand. Then if you think brothels are so wonderful why do you hang your brothel pictures in the basement instead of exhibiting them with the rest? To spare the public's feelings?" he added with veiled irony.

"Not in the least, but rather to avoid their prurient curiosity. I want to show them only to a few people who I think are intelligent enough to understand them. Besides, it might bring unpleasant publicity to La Fleur Blanche, get Madame Potieron in trouble. After all, she isn't supposed to run a boarding house for artists. I don't want to repeat the mistake I made with my Moulin poster: attract so many people there that in the end the place becomes impossible and I have to leave. I like it just as it is. By the way, is everything ready downstairs? The bar, the liquor? How much cognac have they brought?"

"Enough to float a battleship. I only hope you and your

friends won't make too much noise, and people won't start
wondering what's going on in the basement."

"Don't worry, we'll be quiet. They'll come and go by
the back door. Missia is coming. At least, that's what she wrote
me. Jane Avril also told me she'd be here. But you know
these actresses, you never can rely on them—unless they
want something. Altogether I don't expect more than twenty,
twenty-five people. Oh, I forgot to tell you, I invited Degas.
But he said he wouldn't come to an exhibition for anything
in the world. He hates the smell of humans. I'm disappointed,
for I'd looked forward so much to showing him my brothel
pictures. He'd understand them. I'd hoped he'd bring Whistler
with him."

"What shall I say if someone asks where you are? Camondo,
for instance. He's the greatest art collector in France. He might
want to speak to you."

"Tell him I'm sick. Tell him I'm dead. That's it! Tell him
I'm dead! He'll surely buy something if he thinks I'm dead.
A painter is worth ten times more dead than alive."

"And what if he is with the King of Serbia? Camondo told
me he might come with him; he's helping him with his art
collection. If the king comes, and asks for you, will you come
up from your basement?"

"Why? Tell him to come down if he wants to see me."

"Henri, you're a snob!"

"Make up your mind." Henri smiled. "One moment you
tell me I lower myself by associating with brothel women
and taking Madame Potieron to an Opera Ball. Next I'm a
snob, because I won't rush upstairs to meet your Balkan king.
Why should I? I've met him anyway. He is very nice and all
that, but I don't see why I should climb all those stairs, just
to see him."

"All right, all right!" Maurice nodded wearily. "Anyway,
that's not what I wanted to talk to you about. What the hell
did you mean by playing such a trick on Monsieur Durand-
Ruel?"

Henri burst out with laughter. "Oh, he told you?"

"Yes, he told me! And he wasn't laughing either!"

"What would you have me do?" said Henri still chuckling.
"He wanted to come to my studio and look at my pictures.
I told him to come and see them. You should've seen his face
when he entered La Fleur Blanche and the girls started working
on him. 'But, mesdemoiselles, I am here on business . . . I
am a married man!' "

"Do you realize Durand-Ruel is the biggest dealer in Paris and what he could do for you?"

"What could he do?"

"Don't try to be naive. You know damn well what he could do for you. Artists go on their knees when they speak to him and you invite him to a brothel! For God's sake, Henri, don't you care about anything?"

"Very little. I'm sorry, however, about the Durand-Ruel incident. I hope it won't hurt your business to be known as my friend. You know I wouldn't do anything to hurt you. I just wanted the girls to have a little fun. They have so little. Now tell me about the show. Do you expect a big crowd? Do you still think you'll make a few sales? Would you like me to paint you a few flowers? People always buy flowers."

"Don't worry, we'll make sales. People are beginning to realize you can do other things besides posters. I hope Camondo comes. If he buys, you're made, Henri. He only buys the best—Manet, Degas, Renoir. And not just scraps but *toiles maîtresses*. He hates to hand out the money but he will pay very high for an important canvas. They say he plans to leave his collection to the Louvre . . . What's the matter? You aren't even listening. Aren't you excited about your exhibition?"

"Of course I am," Henri said listlessly. "Terribly excited."

"You're a liar. You don't give a damn about the exhibition or Camondo or anything. Don't think I don't know why you're having this show."

"You are my friend, aren't you? *A la vie et à la mort!*— remember? Since you won't let me help you financially with the shop, the least I can do is let you show my pictures. I only wish they were more commercial and you could make some money. Now, how about dinner?"

Maurice hesitated.

"I see," said Henri with a rueful smile. "You're taking Renée to dinner and want to be alone with her. I'd feel just the same if I were in your place."

He struggled to his feet and stood before the desk.

"I'm glad you found a girl at last, *mon vieux*. Such a pretty one too! And so much in love it's positively indecent. If you decide to get married don't forget I want to be godfather to your first baby. Well, good night, Maurice. See you tomorrow."

At dinner that evening Maurice and his sweetheart spoke about Henri.

"Can't anyone do anything for him?" she asked.

"I'm afraid not." Pensively he tapped the ash from his cigarette. "He's cracking up, dying of loneliness. I know Henri pretty well. No one ever had such a thirst for living and he has never lived. Some people can't live without love and he is one of them. Until a year or so ago he still hoped. Now he doesn't any more. The desire to live has left him. What can you do when a man feels like that?"

The opening of Henri's dual exhibition took place the following afternoon. Shortly after four o'clock the first carriages arrived. The critics came a little later, trying to look unobtrusive but doing their best not to pass unnoticed. Their umbrellas hooked on their arms, they strolled before the pictures like generals reviewing troops, stopped now and then to study a canvas, stepped backwards, tilted their heads and jotted notes in their catalogues. By five-thirty the small gallery was crowded. People glanced at the paintings, searched about for familiar faces. Gentlemen craned their necks between ladies' hats to catch glimpses of the pictures. Maurice, in pin-striped trousers and cutaway, flitted from one group to another, just long enough to bow, say a few words and convey the regrets of the artist who had been taken suddenly ill.

Later that afternoon Count Isaac Camondo and a martial-looking gentleman in a fur-lined overcoat made their entrance and at once the room buzzed with whispers. "The tall one, that's King Milan of Serbia . . . You know the one who abdicated a few years ago . . ."

"I rather like this picture," remarked Camondo, stopping in front of a painting of a woman dressed as a clown, fastening her corset. "But where's the signature? I don't see the signature." He ran his bulging myopic eyes over the painting. "I don't buy anything that's not signed. All the paintings in my collection are signed."

"How wise of you, Monsieur le Comte!" smiled Maurice, who was standing by. "The signature is here in the right-hand corner. The date, too. I need not point out the superlative excellence of this work, the sureness of composition, the perfect chromatic . . ."

"How much is it?"

"Only six thousand francs."

The art lover winced. "Six thousand francs! Look here, Lautrec is still a very young man . . ."

"So was Raphael, Monsieur le Comte. Of course there

are other less expensive items in the exhibition. But this happens
to be a *toile maîtresse*."

"Just the same—six thousand francs! Why, three years
ago I bought a Degas for that!"

"And today you could sell it for twice that amount. Your
collection, monsieur, is a monument to your business acumen,
as well as to your love of art."

Count Camondo breathed heavily and re-examined the
picture. "Are you sure it's a *toile maîtresse*? I hope you're
right . . ."

It was after seven o'clock when the last guest left the gallery.
Maurice hurried down the rickety stairs that led to the base-
ment. Henri, glass in hand, was escorting Jane Avril to the
door. "All right, darling, I'll meet you at Le Riche after
the show. But if you're thinking of wheedling me to do your
poster, the answer is 'No'! I don't do posters any more. It's
too much work."

The actress blew him a kiss and hurried away.

"Well, Maurice, how did it go upstairs?" Henri raised his
glass. "Any sales? You look happy. Did Camondo come?"

"Happy! I should say I'm happy. Not only did Camondo
come, but he bought Cha-U-Kao. Six thousand! The king
was with him, and he, too, bought a painting!* You're made,
mon vieux! Not as a poster artist this time, as a painter.
Already I'm planning a London show for you. Some time
next year. And then New York. Ah, New York, that's where
the money is!"

He was interrupted by the jingle of the doorbell upstairs.

"Now who the devil is that? Some woman who's forgotten
her gloves, I'll wager."

He rushed upstairs, hastily turning up the gas jets on the
way and opened the door for two top-hatted gentlemen he
recognized at once.

"Monsieur Degas! Monsieur Whistler! What an honor!
BUT I'm afraid everybody's gone."

"That's why we came," snapped Degas entering the gallery.
"Where's Lautrec?"

"Downstairs. I'll fetch him at once."

When Henri emerged from the basement, Degas and Whis-

* The painting purchased by Count Camondo was painted on
cardboard and is today in the Louvre Museum. The one purchased
by King Milan of Serbia was painted on canvas. It, too, was a
portrait of Cha-U-Kao, and is listed in the Joyant catalogue as
being in the king's collection. Since then it has changed hands
several times.

tler were standing before a large canvas of the Moulin Rouge—two women and three men seated around a table.*

"What do you mean by painting that woman's face green?" Degas barked from a distance. "Of course I know why you did it, and you were right, but wait and see what the critics say! Oh-la-la! . . ." He bent forward and pushed his nose close to the canvas. "I'm almost blind. Can't see much, but that woman's hair is superb."

"Very much the color of hair of my 'Girl in White'," remarked Whistler, imbedding his monocle in his socket. "I particularly admire the way you concealed all traces of effort. Remember our conversation last year in London? *Il faut cacher l'effort!* Now young man, don't ever forget . . ."

"Now, Jimmy," cut in Degas, "don't start one of your lectures. You aren't in London." He scratched his short grizzled beard. "Well, Lautrec, show me your other pictures . . ."

For more than an hour he studied the paintings downstairs, making his usual ill-tempered remarks as he went along.

About to leave, he turned abruptly to Henri. "How old are you, Lautrec?"

"Thirty-two, Monsieur Degas."

"Thirty-two! Exactly thirty-two years younger than I am! I wish I had known at your age what you seem to know. And I wish I had the courage to spend a few weeks in that brothel of yours. What a revelation!"

His eyes clouded and an odd gentleness softened his voice.

"You belong, Lautrec, you belong. You are one of the sixty-odd people in the history of art who had something to say and said it."

He spun on his heels, fumbled with his woolen scarf and, followed by Whistler, stepped out into the night.

"How about having dinner together?" asked Henri, as Maurice lowered the gasoliers for the second time.

"I can't. Not tonight. I want to send a note to the critics about King Milan buying one of your pictures. That, *mon vieux,* is *real* publicity!"

After a lovely dinner Henri dropped in at the Folies Bergère and from the wings watched the finale of the first act, something called *"L'Amour à Venise."* A papier-mâché gondola rocked under a cardboard Rialto bridge, and a couple dueted their everlasting love while showgirls in Venetian tricorns, loups and little else, streamed down from the bridge, paraded minc-

* This painting, "Au Moulin Rouge," is today in the Chicago Art Institute.

ingly in front of the footlights, hands on hips, bleating away, *"C'est l'amoooooooour véni-tien! C'est l'amoooooooour véni-tien!"* The orchestra swelled to a final crescendo and the curtain came down in a thunder of applause. Instantly the stage became a scene of utmost confusion. The moonlight was switched off. The gondola stopped rocking and the lovers clambered off without as much as a word to each other. The show girls removed their loups and rushed to the wings, babbling among themselves. *"Merde,* these high heels are killing me! . . . Did you see him, the poodle-faced one in the first row? He's taking me to Maxim's after the show . . ."

On leaving the Folies Bergère, Henri decided he needed a drink and stopped at a neighborhood bistro patronized by the theatre personnel. Actors came there between numbers for a café-calvados and a quick cigarette. Now and then a chorus girl bundled in a man's overcoat rushed in, pantingly ordered a canteen of hot coffee and dashed back to the dressing room.

Henri was enjoying his second cognac when he remembered an appointment he had made with Polaire the previous week. He reached L'Eldorado just in time to see the *diseuse* standing in the middle of the stage, her feet planted far apart, her chin thrust out, singing her last encore from the corner of her mouth.

"I thought you'd forgotten," she cried as she breezed into her dressing room. She sat down and began removing her make-up. "How do you want me to pose? It's for *Le Rire,* did you say? Good. An actress can always use publicity. What are you doing this evening? How about joining us at Maxim's later on?"

It was after midnight when he finished his sketch and left the music hall.

"Look," he said to the *cocher.* "I have to be at the Café Riche in less than five minutes. Think you can make it?"

After midnight the Café Riche was a favorite rendezvous among show people. They came, many with their stage make-up still on, to gobble their *soupe à l'oignon,* eat their scrambled eggs or Welsh rabbits, meet their agents, friends or sweethearts. The place had a backstage atmosphere of confusion and informality. Actors and actresses addressed one another from their tables in the familiar "thou" of the profession, shouted comments about the evening's performance, talked with their mouths full. Business was transacted between sandwiches, gulps of beer, amidst the clatter of crockery, the strains

of popular tunes and the steady hum of the evening traffic outside. Newspaper reporters and gossip writers eavesdropped, took furtive notes on their cuffs. Nobody put on airs at "Le Riche." Even established *vedettes*, with their names on marquees, forgot their newly acquired manners and acted refreshingly like the *grisettes* and modest *cocottes* they had been a few years before.

"I'm starved!" exclaimed Jane Avril. She tossed her fur cape on the back of the chair and began pulling off her gloves. "I don't know what you're going to have, but I'm going to have *soupe à l'oignon*—zut!" She snapped her fingers. "I can't eat onions. I'm spending the night with—well, I'll have *soupe au fromage* instead, scrambled eggs and coffee. And you?" She rolled up her veil and peered at Henri across the table. "What will you have?"

He gave her order to the waiter. "And just bring me a brandy," he said, unbuttoning his fur-lined coat.

"Wait!" With her hand she stopped the *garçon*. "Henri, you must eat something! No wonder you're all skin and bones; you don't eat anything." She turned to the waiter. "Bring him some scrambled eggs."

"And a double brandy," Henri flung over his shoulder. "Now tell me why you want a poster. I told you I don't make posters any more."

He held out his cigarette case and fumblingly struck a match.

She noticed the trembling of his hands. "Henri, you've got to stop drinking." Her thin, pretty face was creased with concern. "You can't go on like this. What are you trying to do? You don't eat anything and you drink, drink, drink!"

"Oh, my God, you, too! I can't even sit down and enjoy myself for ten minutes without having someone hurl a sermon at me. Now look here, young lady, I love you very much, you are very pretty and we've been friends for many years, but if you mention my drinking again I'm going to knock your pearly little teeth out! Let's go back to the poster. You don't need a new one. The one you use is perfectly good."

"No, it isn't."

Her palm against her cheek she looked at him through clouded eyes. Nobody could get him away from liquor. There was no use talking to him.

"I'm going to London this spring. I open at the Palace in May and I want something that'll make the English sit up and take notice. Please, darling! You've done posters for everybody, and you've never done a thing for me."

"Only about a dozen portraits and I don't know how many drawings," he grinned.

"What good is a portrait to me? What I need is a poster. Please, Henri. This London engagement means everything to me. If I'm a success my manager thinks he can get me a New York booking next year. Besides, your posters bring good luck. Take Yvette Guilbert, for instance. Do you think she'd be where she is today if you hadn't done her poster? And Loie Fuller? And May Milton? And that little Irish slut, May Belfort? All she does is walk on the stage in a nightshirt with á cat in her arms and yap, 'I've got a little black cat! I've got a little black cat!' What're you laughing at?"

"Nothing," he chuckled. "I was just thinking the world would be a very silent place if women stopped catting on one another. Now," he continued, as the waiter set the tureen on the table, "forget about May Belfort and eat your soup while it's hot."

With eyes narrowed in an affectionate twinkle he watched her ladle the potage onto her plate.

"Traveled quite a long way in the past few years, haven't you, Jane? Think of it! Only five or six years ago you were dancing at the Moulin. And now, at twenty-nine, you're a full-fledged star."

Quickly she glanced up from her plate. "I am not twenty-nine, I'm twenty-five."

"Twenty-five? How can you be? You told me you were born in '68."

"I don't care. I'm twenty-five." With a disarming smile she added, "I've been twenty-five for the last four years, and I intend to stay there for a while."

They were old friends and they fell into easy talk, reminiscing about the Moulin, the Folies, the Casino de Paris and other music halls where Jane had worked at one time or other on her zigzagging way to stardom. They ate leisurely, stopped now and then to wave, shout a few remarks to acquaintances at nearby tables.

"Last week I went to Montmartre with some friends." She waited until the waiter had set the plates of scrambled eggs on the table. "The place has changed so much I almost didn't—eat your eggs, Henri, even if you aren't hungry—I almost didn't recognize it. Nothing but tourists and foreigners."

"I know. If it weren't for Madame Loubet I think I'd move away. But we've both been there so long . . ."

"Here's that little tramp," whispered Jane Arvil, waving a friendly hand at May Belfort, who was entering the café

escorted by an opulent-looking gentleman. "She is with her bank account."

Henri did not turn his head, but gazed reflectively at his plate. Yes, Montmartre had changed. It had become hard and cosmopolitan. It had become the night spot not only of Paris, but of the world; a sort of Pittsburgh of commercialized vice where saloon and brothel keepers from the four corners of the earth came to select their wares. "L'Ely" was closed and so were most of the old places. In their stead a swarm of night bars had sprung up all over: dimly lit dives for perverts of both sexes, cocaine and morphine haunts . . .

"What are you thinking about?" she asked. "Eat your eggs."

Her voice brought him out of his reverie.

"You know, Jane," he said as if musing aloud, "if I had to do it all over again, I don't think I'd do my Moulin poster. It helped Zidler, but it's done me a lot of harm. I remember . . ."

"Where's Georges?" she fretted, glancing impatiently at the clock. "He said he'd meet me after the show."

"Georges? Who's Georges? What's become of Albert?"

"Albert! Don't talk to me about that man! He used to say he loved me and all the time he was running around with that little . . ."

He listened, a smile in his sad brown eyes. Yes, she was in love again. How did she do it? How did she manage to be in love every three months with a different man, and always with complete sincerity? She was not mercenary; with her, love was a diversion, an adventure—never a business. Her tastes ran to arts and belles-lettres and she was forever discovering some poet, or sculptor, or novelist, or composer, who was understanding, clever, faithful, ardent and invariably poor.

". . . But Georges is different. He's a writer. Nothing published yet, but wait, one of these days he's going to make a name for himself. You'll see!"

The pleasure of speaking about her new lover incandesced her face. The faint wrinkles at the corners of her eyes had vanished. She *did* look twenty-five . . .

"Oh, Henri, this time it's real! The others didn't count. I thought I loved them, but I didn't. Georges is so different. His mind is so keen and penetrating, and he is so strong, so—vigorous."

"I thought we'd come to that," he smiled. "You know, Jane, I've known you a long time and I think you are the nicest girl I've ever met, but I've never been able to decide

whether you are the most gullible woman on earth or a nymphomaniac."

"But I tell you I love him. I love him with all my heart. I'm even thinking of marrying him."

"Eh, be careful! From what I've seen, marriage is a dull meal with the dessert at the beginning. Be careful, Jane. Don't do something you might regret. And promise not to do anything without telling me first."

"I promise."

She lit a cigarette, took a few deep draughts and smoked in silence for a while. "Henri," she said with sudden tenderness, "why do you drink so much? Why do you kill yourself with that damn cognac?"

"Please, Jane!" For once there was no flippancy in his voice. "I know I drink too much, but there's nothing you or anyone else can do about it. I can't stop. I wish I could, but I can't."

Thoughtfully she nibbled her lower lip, scanning his ugly, straggly-bearded face, made still uglier by the pallor of his cheeks and the vivid brightness of his bloated lips. "You are lonely, aren't you?" she went on, and even in the midst of the hubbub he could hear the ring of compassion in her voice. "Don't say you aren't, because you are. You are so damn lonely it even shows on your face. I wish I . . ."

Her eyes widened and assumed a staring fixity. Her small red lips slackened and arched in an inaudible gasp.

"Myriame!" she exclaimed under her breath. "Myriame! . . . Why didn't I think of her before?"

"What are you mumbling about?"

"Oh, nothing! I just thought of something."

It was after two o'clock when he took his leave from Jane Avril and her new sweetheart and hobbled out of the Café Riche.

"*Cocher*, to Maxim's." He tipped the young *chasseur* who had fetched the carriage. "Take your time."

As the fiacre started rolling down the boulevard, now quiet and almost deserted, he spread the blanket over his knees, slipped his hands into the pockets of his overcoat and settled back into the corner. Thank God, it wasn't cold tonight . . . It could get devilishly cold at times in these fiacres around three or three-thirty in the morning . . . Well, here he was on his way again. This time to Maxim's. And after Maxim's to the Irish-American Bar, or Chez Achille or some other place . . . How many thousand miles had he driven like this at all

hours of the night in the last five years? . . . Perhaps he purely and simply was restless—one of those people who couldn't stay in the same place? Like Gauguin . . .

Gauguin—that was another memory of these last five years . . . Gauguin rigged up in a pale blue redingote, yellow waistcoat and white gloves, strutting along the boulevards, twirling that carved stick of his with the pearl in its knob . . . An uncle had left him thirteen thousand francs, and this time, oh, this time he was going to take Paris by storm with his Tahiti paintings, his afternoon teas in his studio and his Polynesian bric-a-brac. But he hadn't, and that was another memory . . . Meeting him two years later at two o'clock in the morning in the Left Bank bistro. No gloves, no collar, no tie. Slumped in front of an absinthe glass. He was to leave again in a few days for his yellow beaches and naked girls, but this time there were to be no banquets, no speeches. He was penniless, almost fifty, beaten. All he had got for his thirteen thousand francs was mockery, disease, a broken ankle and enough memories to poison the rest of his life. Poor Gauguin. He, too, had wanted what he couldn't have . . . What was he doing now? . . .

"Eh, m'sieu, here we are. Maxim's. Can't you hear the music?"

Henri raised his eyes to the blazing windows on the first floor. Yes, they were playing a waltz . . . Dear old Rigo and his Tziganies! Dear old Maxim's with its grand dukes incognito, its mournful *noceurs,* sitting between their bottles of champagne and their *cocottes de luxe.* He really didn't feel like going up, did he? Polaire wouldn't mind. As a matter of fact, she wouldn't care a bit whether he came or not . . . How about going to Ralph's? . . . Or the Irish-American Bar? . . . Later, perhaps . . . The night was mild, why not drive on a little longer?

"Drive on, *cocher.*"

"Where to, m'sieu? Any place in particular?"

"Anywhere. Along the quays—anywhere . . ."

Again he felt the gentle rocking of the fiacre and the soft fingers of the misty night against his face.

For a while they rolled along the quays. Now and then he caught a glimpse of the Seine shimmering under the arches of a bridge. They passed a small, deserted square, mysterious and romantic like a Spanish plaza with its arched passage and plashing fountain. Could this lunar desolation, this concert of silence be Paris, the gay Paris of the guidebooks? Now and then he spied a moving silhouette behind a lighted window,

or the curled shadow of a derelict asleep on a bench, feet bundled in newspapers. Once he heard the strolling footsteps of two gendarmes ambling leisurely along, their voices echoing in the silence of the street.

"Mind if I light a pipe, m'sieu?" said the *cocher* over his shoulder. "Gets kind of lonely up here, driving nowhere like this."

"Go ahead. I think I'll have a cigarette. Care for one?"

"No, thanks, m'sieu. I'm a pipe smoker myself. Been one as long as I can remember." He dropped the reins in his lap and searched through his pockets. "A pipe's like a woman, you might say. You get used to her. She keeps you warm and makes you feel good. And she don't talk back."

These remarks filled the cabby with an uncontrollable glee. He burst into a wheezy, choking spasm of laughter, and Henri noted *en passant* how similar were mirth and grief in their reflexes.

"If you want to know what I think—" still laughing, the man struck a match and went on talking while teething on his pipe "—women are like sponges. You've got to wet them once in a while or they go bad on you."

Puffing large clouds of smoke he flapped the reins, clucked his tongue and for sheer joy cracked his whip. The horse shuddered and lunged into a jerky trot.

Henri tossed his cigarette away, closed his eyes and without effort imagined himself at Arcachon, lying on the deck of his boat, face to the sun, listening to the joyous lapping of waves against the hull.

Arcachon! . . . His summers at Arcachon—they were his happiest memories . . . The bay glistening in the morning sun, the bay glassy and rose-hued at sunset, the bay in the moonlight . . .

In a few months it would be summer again . . . Meanwhile there was the winter to be lived through . . . Thank God, the exhibition was off to a good start . . . But he wouldn't see much of Maurice the next few weeks . . . Maurice was getting to be quite a busy man—and then there was Renée. Sweethearts took precedence over friends. Only fair—but inconvenient when you were the friend. After the holidays, there would be Jane's poster to be done. A chore, but he owed it to her . . . Meanwhile what was he going to do with himself for the next few weeks? . . . How about going to La Fleur Blanche? Madame Loubet wouldn't mind. She'd know where he was. You couldn't hide much from her . . . She was almost as bad as Maman . . .

He opened his eyes. It was still dark, but the inkiness of a moment ago had thinned to a slaty gray. From the middle of the Seine rose the spiked silhouette of Notre Dame.

"*Cocher,* La Fleur Blanche, rue des Moulins."

Rue des Moulins was such a short, insignificant street that most of the Paris maps omitted it altogether. Nothing had ever happened on rue des Moulins: no sensational *crime d'amour* had ever disturbed its quietude; no historical massacre had stained its cobblestones with blood. Napoleon, who had lodged about everywhere at one time or other in his career, had never lived there.

The graystone houses still bore the traces of eighteenth-century elegance in their wrought-iron balconies and doric columns, and concealed a maze of modest apartments in which lived obscure and parsimonious families. One of these houses in particular stood out by the quality of its adornments and its air of aristocratic distinction. It had been the folly of a Regency financier who had built it for a winsome milkmaid and used it as a haven from the strain of business and the attentions of a devoted but ugly wife.

After the financier's death a kindly fate had watched over the gracious house and spared it the humiliations that had befallen its neighbors. It had not been quartered into bourgeois apartments, and had remained what it had been intended to be: *une maison d'amour.* But since the days of follies were past, the dainty mansion with its sculptured escutcheon, its dimpled cherubs, its marble staircase and bedroom mirrors had become a brothel.

During the Second Empire La Fleur Blanche had known a brief period of prosperity. Its proximity to the Tuileries had made it a favorite rendezvous among the dignitaries of the Imperial Court. On its plush divans saucy-breasted lorettes had cuddled against resplendent uniforms and toyed with the gold braid of the General Staff. It had all come to an abrupt end with Sedan. No more frivolous chamberlains, no more amorous aides-de-camp. The stern and virtuous *républicains* who had seized power had frowned upon this nest of Imperial venery. There had been talk of revoking the precious license, despite the madame's shrill protests that her girls slept with the portrait of Monsieur Thiers under their pillows and were ready, eager in fact, to render the *républicains* the same first-class favors they had rendered—reluctantly and against their convictions—to the *cochons de bonapartistes*.

At last a few officials had decided to investigate the truth of these statements and get to the bottom of the matter. They

had come; they had investigated. Singly and unofficially they had returned, investigated still further. There had been no more talk of revoking the license.

When Henri entered La Fleur Blanche that night, he peered into the salon just long enough to wave at the girls who were variously engaged and exchange a few words with Berthe who sat decorously at the counter, between two piles of neatly folded towels.

He told her his intention to spend a few weeks in the house; she heartily approved.

"You look simply awful," she remarked, resting her knitting and inspecting him with disapproving eyes. "You look as if you were dead."

She interrupted herself to hold out two freshly laundered towels to Adrienne and receive the ten francs in small change the patron counted on the desk.

"All this running around is no good for you," she went on, when Adrienne and her *miché* had disappeared. "D'you want me to send up one of the girls?"

"Thanks, Berthe. Not tonight. I think I'll sleep and go to work early tomorrow."

He climbed the spiral marble stairway to Madame Potieron's office for a friendly chat. He found her hunched over her ledger with Tutu, her papillon dog, asleep on her lap.

She had been crying and smears of hastily wiped tears still glistened on her saggy cheeks.

"*Bonsoir,* Monsieur Toulouse," she said, giving him a tremulous smile. "Going to stay a while or just paying a visit?"

Madame Potieron was one of Nature's mistakes. Her ugliness was complete, unimprovable, unredeemed by any visible feature, her loving heart being lost in a mountain of crumbling flesh and her keen business brain hidden behind a face that irresistibly reminded one of a sow's. The girlish ribbons she pinned on her hair in the hope of attracting her husband's attentions merely succeeded in making her look like a frivolous sow.*

Henri was perhaps her only friend, and the only person who would listen to the troubles of this lonely and superlatively unattractive woman.

"He is a good man, my Alexandre," she said, concluding the recital of her conjugal disappointments. "He's faithful and gentle, but when it comes to—you understand what I mean,

* Lautrec's portrait of the madame, her husband and the lapdog is today in the Albi Museum.

Monsieur Toulouse—he just can't rise up to it. I just don't appeal to him, I guess," she ended with a heart-rending sigh.

After comforting Madame Potieron as best he could, Henri went up to his room and got into bed. The sheets felt cool. The night breeze billowed the window curtains. For a while he listened to the muffled sound of voices and the squeak of bedsprings from neighboring rooms. Then he fell asleep.

He awoke much later than he had expected and was surprised to find Elsa in his bed.

"I don't like to sleep alone," she explained, "and Lucie has an all-night *miché*. So I thought I'd come and sleep with you."

Elsa-the-Viennese had once been a very beautiful girl, and still was at times. Toward men she felt such a profound indifference that she complied without difficulty with their most esoteric requests.*

This morning she lolled in bed, smoked cigarettes and watched Henri work. In his brown bathrobe he reminded her of a monk, she said. As he was bending down to pick up the bottle of cognac at his feet, she remarked liquor was not good.

"It will kill you one of these days," she said, calmly buffing her nails.

He agreed that it probably would, but since one had to die anyway the cause of one's death was a rather academic question. She went on to talk about Vienna, the beauty of its parks, the charm of its beer gardens, the happy disposition of its people. With the same phlegmatic detachment she spoke of her family and mentioned in passing that her uncle had raped her when she was twelve. There was neither recrimination nor reproof in her voice. When Henri glanced at her she was busy scratching her foot.

"It's going to rain," she predicted. "When my corn aches it always rains."

For a while she elaborated on the extraordinary accuracy of her corn as a hygrometer. Then by some obscure association of thoughts she came to speak of the women she had loved and the men who had loved her.

"I remember one," she said, once more buffing her nails. "He was a captain of uhlans. I liked him a lot. He used to dress me in a uhlan uniform—everything but the trousers—and make me drill in front of him. He was very strict. If I made a mistake he'd get very angry. Ach, *mein Gott*, how angry he'd get! To punish me, he'd degrade me. First he'd snatch off

* Lautrec's portrait of Elsa-the-Viennese is in the Albi Museum.

my busby and jump on it. Then he'd rip the gold braid from my dolman . . . Last time I heard of him they'd locked him up."

She finally departed, repeating her prediction about the coming change in the weather.

Early in the afternoon the other girls began to straggle, one by one, into Henri's room. They came in, wrapped in loose peignoirs, puffy-eyed, their hair undone. With great yawns of boredom they miauled their *"Bonjour,* Henri," examined his painting, and stood for a moment by the window looking down in the street in the hope of witnessing some exciting occurrence. But nothing ever happened on rue des Moulins, and with a moan of ennui they flopped, curled up or sprawled on the bed.

Cléo pulled out a pack of cards and proceeded to read her future.

"I'm going to get a letter!" she exclaimed. "Now, who do you think . . ."

She was interrupted by Rolande, a long-legged brunette with the eyes and neighing laugh of a restless mare.

"You know, Henri," she remarked, tossing back a strand of hair, "you look just like a monk in that bathrobe."

"Funny," he grinned back, "that's exactly what Elsa said this morning." He set his palette aside and leaned down to lift the bottle of cognac at his feet. "Perhaps I should have become one."

"Do they wear trousers under their gowns," asked Yvonne, known as "Trompette" because of the brassy timbre of her voice, "or just nothing?"

They pooled their ignorance and reverently exchanged views on monastic orders.

While cleaning her nails, Liane happened to wonder aloud whether one could pray sitting or whether one must kneel to pray efficaciously. For some reason this question capsized their moods, and the conversation degenerated into a quarrel of extraordinary virulence. In a few seconds they were shrilling at one another, hissing irrelevant and cruel truths, glaring, ready to come to blows.

Elsa, brought back by the noise, ventured the opinion that perhaps God didn't care much one way or another.

This remark incensed Yvonne who was the "kneeling" champion. She flew a stream of invectives at Elsa, her inversion, her mother, her country.

"Anyway the Austrians, they're almost Germans, ain't they?" She spat the words, flashing pulverizing glances. "And the

Germans, d'you know what I'd do to them? I'd do *that* to them!"
An offensive gesture corked the sentence.

"But," remonstrated Elsa phlegmatically, "I only said that
God . . ."

"What d'you know about God?" With a wave of her hand
Yvonne put an immense distance between them. "Your God,
He can't even speak French! And besides, let me tell you . . ."

From his easel Henri watched the senseless quarrel between
these nuns of sin, made neurotic by the absence of sunlight
in their lives, the frictions of communal existence and the
endless repetition of the act of love without love. He noted
their jutting chins and heaving bosoms, their angry lips stretched
over their teeth. In the Corinthian or Roman brothels courte-
sans must have brawled like that . . .

And quickly, in unerring strokes, he sketched them.

In the midst of the altercation the door was flung open and
Marcelle rushed in with the news that through an error on
the laundryman's part, La Fleur Blanche had been delivered
the towels of another *maison*.*

"You can bet I won't use them," she scorned. "I might
catch something. I'll use my handkerchiefs."

Instantly the debate was forgotten and the laundry incident
was discussed with interest by everyone but Cléo, who had
returned to her cards.

"My aunt's the only one who'd want to write to me," she
mused, bewilderment on her face. Absently she pushed back
her breast which had slipped out of her negligee. "Though
she hasn't written to me in ten years."

With a petulant snort she rustled the cards and invited
Trompette and Elsa to a three-hand game of piquet. Her
invitation was accepted, and the three women fell into an
absorbed silence.

Later that afternoon Marcelle came in and, after a brief
circular nod, went into a rapid half-voiced conversation with
Rolande, who was her best friend.

". . . So I told him, 'Now look here, a girl's got to keep
her self-respect.' Then he started telling me there was seven
orifices—that's what he called 'em—in a woman's body—you
could see he must be some kind of professor and very educated
by the way he talked—and that was the worst one to keep
my self-respect in. So I told him . . ."

She was still talking at great speed when Berthe peered

* Lautrec's painting of the laundryman hangs today in the Albi
Museum.

into the room to announce it was almost five o'clock and dinner was ready.

Henri rested his palette, wiped his brushes. Then he poured himself another drink, carefully washed his hands and followed the girls into the dining room.

As usual the food was excellent. Alexandre Potieron was the cook, not so much for economy but as a means to fill his leisure. He was a man broken in spirit, and cooking had become for him the outlet of his unemployed energies, as well as a consolation. Whenever one of the girls complimented him, a wan smile would float over his hairless face and a brief light come to his opaque jaundiced eyes.

During his sojourn at La Fleur Blanche Henri worked, drank cognac, made love and followed the schedule of the *maison*. The girls had grown so used to his presence they did not notice him any longer. With total unconcern they dressed, undressed, bathed, douched, washed, combed and curled their hair in front of him, and unconsciously opened to him the secret and ancient world of prostitution, hardly changed since Babylonian days.

As one may experience a profound spiritual stirring and discover the elations of mysticism in a monastery, at La Fleur Blanche he probed the somber ultimate depths of human sexuality. He listened to the girls' chatter and quarrels, watched their effusions and inverted caresses.* He received confidences of staggering naiveté and others of breath-taking depravity. He stumbled upon new caves and abysses of turpitude as well as unexpected havens of innocence in the unbounded landscape of the human soul.

He penetrated into the topsy-turvy labyrinth of their ethics. He understood and comforted Adrienne when she burst one morning into his room and, shedding bitter tears, told him she had enjoyed a *miché's* caresses.

"Yes, I did! Yes, I did!" she sobbed, in a fury of self-indictment. "I am a bitch, a tart, a nothing-at-all! I'm *déshonorée!* Now what shall I tell my *chouchou* next week when he asks me if I've been faithful to him?"

He heard Madame Potieron at dinner severely rap her spoon on the table and rebuff any salacious talk with a stern, "Please, *mesdemoiselles*, remember where you are!" He even attended the dreaded Monday medical *visite* and recorded the girls' trembling apprehension as they queued at the door

* "The Kiss," one of Lautrec's greatest studies of Lesbianism, hangs today in the Louvre.

of the examination room, and in unsurpassable mastery captured the ludicrous pathos and utter abjection of the scene, as he had in previous years seized the agonies of hospital amphitheatres and the rowdy gaiety of Moulin Rouge and L'Elysée-Montmartre.*

The evening before he left he played dominoes with Alexandre Potieron after dinner.

"I'll be sorry to see you go, Monsieur Toulouse," sighed the madame's husband.

They were alone in the dining room. The light from the ceiling lamp gave the scene the intimacy of a Dutch interior painting.

"I don't really want to go," said Henri. "But I've promised to do a poster for a friend of mine."

Alexandre's slablike face mirrored a wistful envy. "You at least can get out whenever you want! It's been nice having you here, a member of the family you might say. You get tired of all these females around. They're all over the place, like cockroaches." He refilled Henri's glass. "What do you say we go and have a drink with the *popotes*."

The *popotes* were engrossed in a game of cards when Henri and his companion entered the Café de la Patrie that evening.

They were three staid middle-aged brothel-keepers of the neighborhood who met there every night for a few moments of relaxation and an exchange of professional news. Like Potieron, they still displayed some vestiges of a certain beefy handsomeness. But age, the sedentary life they led and the cares of business had left their marks on them. They had pouches under their eyes, furrows of worry on their brows. In their late forties or early fifties they no longer resembled the dashing pimps they had once been. They stroked their mustaches thoughtfully, rubbed their chins with the air of men of affairs and responsibilities. With their derbies, stickpins and watch chains they looked like respectable, prosperous shopkeepers—and not very happy.

"We'll be through in a minute," said Marius, owner of a *maison* on rue Montesquieu.

Courteously he waved Henri and Alexandre to the two vacant chairs at the table.

They played in silence for a while. Then they slammed their cards in rapid succession, and the game was over.

* "La Visite," one of Lautrec's few brothel paintings owned privately, is today in the Chester Dale collection.

Henri congratulated him. "You've won again, Marius. You're a lucky man."

"That's where you're wrong, Monsieur Toulouse." There was much dissatisfaction in Marius' voice. "You know the proverb, 'Lucky at cards, unlucky in . . . ' Well, in business, that's me."

He wet a pencil stub on his tongue, jotted down some figures on a scrap of paper.

"You, Philibert, you owe me two francs and fifty centimes. And you, Antoine, one franc and five sous."

Carefully the losers counted the money out of black leather purses.

"A moment ago you said I was lucky," said Marius, turning to Henri while slipping the change in his waistcoat pocket. "As a matter of fact, you're looking at about the most unlucky man in the world. We had *la visite* today. And what happens to me? Two casualties! Two of my best pigeons! Now I've got to start looking for replacements. There's no end of trouble in this business. The profession isn't what it used to be. Take my word for it."

"It's the girls," declared Philibert without hesitation. "They've changed. In the old days they were obedient, respectful, hard-working, anxious to give your *maison* a good name. Delicate feelings, too. When Victor Hugo died, in '85, I remember my pigeons were so broken up they put bows of mourning crêpe here and there—" he made the appropriate gestures "—and that night they refused to do any *spécialités.*"

"And they loved *la Patrie,*" confirmed Antoine. "On the fourteenth of July they wore tricolor garters and little blue, white and red rosettes on their you-know-what-I-mean to show their patriotism. Today? Today they're all socialists!"

"That's not all," added Marius. "In the old days a girl was a *jeune fille* or a tart. You knew where you stood. Today every midinette does the business as a sideline. In my street there's a girl under every lamppost. It's all this amateur whoring that hurts the profession. Another thing. The police inspectors used to take their graft in trade, and perhaps one or two bottles of wine. Now they want money! This sort of thing cuts the profits. Would you believe it, Monsieur Toulouse, there was a time when a man with a small *maison*—let's say, six pigeons— could make five or six thousand a year and sleep quietly? At fifty-five he could retire. Today he's lucky if he makes a bare living."

He twirled his mustache despondently.

"My friends here will tell you I am what you might call

a self-made man. Built my business from scratch. Just my
wife and my sister-in-law. They took care of the *michés*,
I did the brainwork. We worked hard and saved our money,
and finally we had enough to buy a little five-franc *maison*
on rue Sainte Anne. For eight years, monsieur, we worked
and we worked. I must say this for my wife. She's got less
brains than a flea, but she's a glutton for work. 'Just one more,
chéri,' she'd tell me when I pleaded with her to rest a bit. 'Let
me take just one more. It'll pay for a bidet.' You see, she loved
me and wanted me to be a success. Believe me, Monsieur
Toulouse, the love of a good woman is a wonderful thing . . .''

XVIII

With a disapproving shake of her jowls, Madame Loubet emptied a scuttle of coal into the stove.

"If you'd let me know you were coming back," she complained, "I would have had the place nice and warm for you."

"Please, don't look so grumpy, Madame Loubet. How could I let you know? I was in the country visiting an old aunt of mine."

The same scene took place on each return from his sudden mysterious trips. She knew where he went, having coaxed the information out of Maurice, and had long ceased to object. Anything, anything was better than his roaming the streets at night . . . But her ill-humor permitted her to conceal her delight at having him back in the house, and afforded her the opportunity to show him she was not deceived by his fabrications.

"They don't even have a post office where she lives—deep, deep in the woods," he went on, ignoring her snorts, and inventing with increasing zest as he went along. "She was sick all the time I was there. I spent every minute at her bedside."

From the couch he gave her a broad grin she pretended not to see.

"But those three weeks in the country did me a world of good, didn't they? Don't I look better?"

She flung him a frowning glance over her shoulder.

"At least you don't look as pasty as you did—that's one thing. And I hope you got a little sleep while you were in the country —with your poor sick aunt," she added with massive sarcasm. "Just the same I wish you'd let me know you were coming back."

He watched her fiddle with the stove and said coaxingly,

"Didn't you miss me a little, just a little? Please, leave that stove alone and come sit near me."

She took a few grudging steps.

"Sit down here," he tugged at her sleeve, "next to me."

With a protesting rumble she eased herself down at his side on the edge of the couch.

"A lot of people came while you were away. There's a pile of mail for you downstairs."

"Oh, let it wait!" He shrugged and pulled a tiny box from his pocket. "See what I brought you from the country."

"Now, Monsieur Toulouse, you shouldn't . . ."

It happened every time, and each time it confused her strategy of stern reproachfulness.

"You shouldn't!" she repeated with a last reproving look.

Her face wreathed into a weepy smile as she unwrapped the box and her eyes fell on the cameo brooch.

"You just shouldn't . . ." she said a third time very weakly. Her voice broke and she started the familiar search through her numerous pockets.

"Here, take mine," he said with a gentle smile, offering his handkerchief. "But what kind of homecoming is this? I return from the country, bring you a nice brooch, and you burst into tears!"

She wept, gulped, sniveled, blew her nose, dabbed her eyes with the relish of people whose hearts have long been on the brink of tears, and who find in weeping the only solace to their grief. Forgetting the brooch she gazed at him with muted despair. It broke your heart to see a nice young man like him wreck his health with that miserable cognac, prowl all night, God knew where, come home in the morning more than half drunk and so tired he often hadn't the strength to take off his clothes . . . Last summer he had promised to catch up on his sleep at Arcachon, and instead he had gone gallivanting to foreign countries. She had received a silver bracelet from Lisbon, an embroidered shawl from Madrid, a silver box from a place called Toledo. Just suppose something had happened to him . . . But did he care? You could see in his eyes he didn't care about anything any more, not even living . . . Things couldn't go on much longer this way. If *le bon Dieu* was going to do that miracle, He'd better hurry or soon it'd be too late . . .

"Please, don't cry, Madame Loubet," he said in a low, tender voice. "I know what you're thinking and it makes it worse. Please, don't!"

He patted her free hand and held it a few seconds in his own. Then with a great show of efficiency he rose from the couch and limped to his easel.

"Mademoiselle Avril is coming in about an hour. But please, stay with me until she comes and tell me the news."

Everybody was sick in the street . . . It was that disgusting Paris weather that was full of vapors and malicious little beasts, so small that you couldn't even see them . . . The hooplala on the second floor had slipped away the day after New Year without paying her rent. That's what you got for having people like that in a house! Things were about the same though as they were before he'd left for the country . . .

"To see your poor sick old aunt," she said with a pallid smile of recovery.

While speaking she had settled into her familiar armchair, elbowed the pillow at her back and adjusted her steel-rimmed spectacles. Now she opened the paper, glided hurriedly over the headlines, turned the page and let out a cry that made Henri glance at her over his shoulder.

"What's the matter, Madame Loubet? Are you ill?"

"A murder, Monsieur Toulouse! There's been a murder in our street!"

"Where?"

"I don't know yet."

Breathlessly she began to read:

ENIGMA OF BLOOD AND
PASSION IN MONTMARTRE

Hôtel de la Lune, a squalid hostelry on rue Caulaincourt, has been the scene of one of the most fiendish murders in the annals of the Montmartre district.

According to information given out by Le Laboratoire de Criminologie Scientifique the crime was perpetrated several days ago. For the benefit of our readers, Monsieur Pipiton specialist in *crimes passionnels* has kindly taken time from his pressing duties to reconstruct step by step this ghoulish affair.

"Quelle horreur!" gasped Madame Loubet.

Monsieur Pipiton's reconstruction of the crime was razor-edged in its deduction, logical in its emotional motivation and rich in horrifying detail. As Bouche-de-Sang was handing over the night's meager receipts, the pimp had berated her

for her laziness, her lack of élan. The woman had retorted she was too ill to have any élan. In fact she had expressed a strong wish to retire from business. This aspiration had been unfavorably received. A heated altercation had followed in the course of which, Caillette, always a violent man, had grasped the unfortunate creature by the throat and strangled her. Up to now no trace of the man had been found, but the Parisian gendarmes were in possession of important clues and an arrest could be expected momentarily.

"I hope they catch him and chop his head off," bristled Madame Loubet, removing her spectacles.

She was about to elaborate when there was a knock on the door and Jane Avril froufroued into the studio.

"What's going on? The street is full of gendarmes. I thought they weren't going to let my carriage go through."

While Henri explained the cause of the unusual animation, Madame Loubet excused herself.

"I'll trot down to the Hôtel de la Lune and see what I can find out," she said.

One hour later the actress stepped down from the model stand. "Would you mind if we didn't work any more today? I must go and try on a dress at Paquin's. Why don't you come with me? Please," she urged, "put on your hat and coat and come with me."

As they were bouncing along rue Lafayette, his attention was caught by a magnificent basket of white roses displayed in a florist's window.

"Mind stopping for a moment?" he said. "I'd like to send these to my mother."

He came out of the shop shortly after and climbed back into the carriage.

"Here, these are for you. You used to like violets in the old days. Remember? But perhaps you've become too chichi for violets now you are a star?"

She buried her face in the bouquet and inhaled the flowers' perfume.

"Henri, you are sweet," she said, raising her head and looking at him with tender eyes. "Always thinking of people."

He was still protesting he couldn't understand why she wanted to drag him to Paquin's when their carriage pulled up in front of the famous *maison de couture*. A uniformed doorman swung the entrance door open. They were led to a small, circular, thickly carpeted and profusely mirrored room.

"Would you please ask Mademoiselle Hayem to come if

she is not busy at the moment?" Jane asked a bowing and
goateed gentleman in pin-striped trousers.

Henri had taken his place on a sofa, grumbling under his
breath, when a striking brunette in a simple black dress glided
in. She was rather tall and moved with an easy grace that
reminded him of Marie Charlet. Her dark, glossy hair, parted
in the middle and coiled in a bun at the nape of her neck,
accentuated the ivory pallor of her oval face. But her most
arresting feature was her eyes. They were not quite black—
coffee-brown, he judged—lustrous and set wide apart, and
their sharpness belied the sensuous curve of her mouth.

"*Bonjour,* Jane." She offered the greeting with unexpected
familiarity.

"Myriame, this is Monsieur de Toulouse-Lautrec."

The mannequin turned to Henri. "I went to your exhibition,
monsieur," she smiled, and he noticed she had perfect teeth,
"but I didn't get much of a chance to look at your pictures.
There was such a crowd."

Their gazes met and he saw in her eyes neither mockery
nor compassion, but rather a cool appraisal.

"I'm terribly sorry. I wish I had known."

What difference would it have made? She probably was
accompanied by some rich *monsieur*. All mannequins had
lovers . . .

But already Myriame was turning back to the actress.
"Would you like to try on your dress?"

To Henri's surprise, Jane let out a gasp. "*Mon Dieu,* I
almost forgot! I have an urgent appointment. I'll come back
tomorrow."

The two women exchanged a swift nod of understanding.

"Well, what do you think of her?" Jane asked Henri as
they were driving through Place Vendôme.

"How does she happen to call you Jane?"

"I'll tell you that later. First tell me what you think of
her?"

"I don't think anything. She is a very beautiful girl. What
difference does it make what I think of her?"

"She liked you."

"How do you know?"

"She told me."

"She didn't do anything of the kind. All she said . . ."

"She didn't say so in so many words, but I know her."

He looked up at her, a smiling frown on his face. "What
is it? What's going on in that pretty little head of yours this
time?"

"Well, I took you to Paquin's because I wanted you two to meet. You see I spoke to her about you. I told her not only who you are, but the kind of life you lead—the good and the bad."

"Why on earth did you do that?"

"Because I think you two could be good friends. She admires you."

"How do you know?"

"Because I know Myriame, and success is the thing she admires most in the world and you've achieved it. Now I must warn you, Henri, Myriame is a strange girl. At one time we lived together and I wanted her to go on the stage. I introduced her to Brasseur and he thought she was wonderful. He went to work on her, told her all he could do for her. And do you know what she did? Yawned in his face! Yes, she's a strange girl, and in many ways I don't understand her. I don't really know much about her. She is Jewish, and I think an orphan. She is extremely ambitious and knows what she wants. Love doesn't fit in with her plans. She doesn't want to fall in love with some nice and penniless young man. She is after a mansion on the avenue du Bois and all that goes with it. And unless I'm very much mistaken she'll get it some day. For the moment she is biding her time and waiting for the right man to come along. She can afford to wait, she's only twenty-one."

"What has all that do do with me?"

"I told you. I thought you two might become good friends. Friends, Henri. Remember that. Just friends, that's all!"

"And with me she'd feel safe," he said acidly. "No danger of falling in love, is that it?"

"We-l-l . . . Yes, in a way. She wants companionship, Henri, not love. You may not believe it, but there are girls who enjoy a man's friendship without necessarily wanting to go to bed with him."

"You mean she's willing to be my friend? Have dinner, go to the theatre with me—things like that?"

"Yes. Of course you'll have to make her like you enough to want to go on with it. But she is willing to give it a try. Another thing. Don't expect it to last forever. One of these days some man is going to turn up and give her the things she wants, and when he does . . . But in the meantime, for six months or maybe a year you can enjoy the company of a wonderful girl. Well, Henri, that's the story. Take it or leave it. And if you have any sense you'll take it. Next week,

if you like, we'll get together at Le Riche after the show and you'll have a chance to know her."

He recognized her as soon as he entered the Café Riche that evening. Again she was dressed in black. She sat with Jane and Georges, her elbow on the table, one hand arched against her cheek, gazing about her, obviously waiting for him and looking very bored, he thought. His misgivings about Jane's well-meaning efforts assailed him once more.

"Oh, here you are!" cried Jane from a distance with obvious relief. "What kept you so long? I was beginning to think you weren't coming!"

He bowed to Myriame, shook hands with Georges and apologized for his delay. While he was ordering a Welsh rabbit, Jane drew on her meager resources as an actress to establish an atmosphere of conviviality around the table.

"Georges," she prompted, "tell Myriame and Henri about your novel. I know they'll be terribly interested."

"With pleasure," acquiesced the young writer. "It is a study of jealousy in the Dostoievsky manner . . ."

His pleasure was short-lived, for Jane took the floor, proceeded to describe the plot of the novel. This she did with her natural zest, a wealth of irrelevant details, omissions, personal comments and editorial changes, which brought forth numerous complaints, timid at first, then snappish, then choleric and unrestrained, from the injured author. Soon the lovers forgot their guests and were blissfully snapping at each other.

While the argument went on Myriame turned to Henri.

"Are you working on any new posters, monsieur?"

"Yes, mademoiselle. I am doing one for Jane."

"Are they very difficult to make?"

Obviously she was making conversation, but it was gracious of her to appear interested. "Some are and some aren't, mademoiselle. It all depends on whether you are interested in lithography or not. If you are, then you don't mind difficulties and a poster is fascinating work. If you aren't, it's just a long and deadly boring process."

"Which one of your posters gave you the most trouble?"

He could not refrain from smiling at the obviousness of the inquiry.

"My first one, mademoiselle," he replied in a tone of quizzical politeness. "A poster I did several years ago for the Moulin Rouge."

"Oh, I remember. The cancan poster! I remember stopping to look at it on my way to work. Of course I couldn't judge

its artistic merits, but I thought it was very effective. And that's what a poster should be, shouldn't it?"

His hands clasped under his chin, he watched her as she spoke, unable to decide whether her interest was genuine or well-simulated. Jane had been right: there was something curiously seductive about her. He liked her unaffectedness, her casual reference to her working-girl status, the directness of her gaze. Of course, it might all be clever acting on the part of a twenty-one-year-old girl who had dismissed love from her life and decided on a career as a *grande cocotte*. She was different—and truly beautiful. On close scrutiny her beauty seemed to deepen. There was about her a ripeness just attained, warm, luscious, faintly oriental.

"When I arrived at the store where I worked then," she continued, "everybody was talking about it. During lunch hour the girls argued about it. It was the first time I heard your name."

"I'm afraid it mustn't have been in a very complimentary way. Opinions were quite divided about that poster. A great many people thought it indecent. I honestly don't think it was, but . . ."

"But it made you famous!" She smiled, a gleam of admiration in her eyes.

"I don't know about that," he grinned with a deprecatory gesture, "but I know it brought me so much trouble I almost wished I'd never done it."

"Did it take you long to do?"

"Several months. Of course at the time I knew nothing about lithography."

"I'd like to know about lithography."

The oddity of the remark and the eagerness of her tone rekindled his suspicions. She was acting . . . All this talk about the Moulin poster was nothing but invention and pretense . . . Perhaps to please Jane who was anxiously glancing at her now and then, or to appear cultured and art-minded . . . She probably hadn't been to his exhibition either . . .

"You don't believe me, do you?" she said noticing the ironical narrowing of his lids. "I can see it."

"On the contrary, mademoiselle," he protested with a smile of frank skepticism. "I believe you wholeheartedly. Perhaps you are also interested in Etruscan pottery or esoteric metaphysics. Permit me to congratulate you. You have a lifetime of fascinating study before you."

She lowered her eyes and did not reply. When she finally spoke, her voice was no longer eager and young, but hurt

and yet unprotesting—the voice of a person who has grown used to disappointments.

"I am sorry you don't believe me, for it happens to be the truth. But I realize it must have sounded ridiculous and insincere for a shopgirl to say she wanted to learn about lithography. Yet, I really meant it. I've alway been curious about things."

"But why?" he asked, no longer sarcastic but in genuine surprise. "How could you possibly be interested in a thing like lithography?"

She looked at him. "I don't know why. I told you, I like to learn about things." She sensed he was sorry and was suing for peace. A cautious smile returned to her lips. "I've always been like this. When I used to live with Jane she made jokes about it. I am naturally curious, I suppose."

"You know what they say about curiosity?"

"Yes." Her smile spread over her face. "They say it killed the cat, but I don't believe it. I read somewhere that curiosity is the beginning of wisdom. I don't know if that's true, but I'd still like to learn about lithography and I still wish you'd tell me about it."

"But it will bore you to tears," he weakly persisted.

"No, it won't. Why don't you try and see? Go ahead. You'll soon know whether I'm bored or not."

"I know. You'll yawn in my face."

She laughed. "Oh, Jane told you about Brasseur! *Mon Dieu,* I wonder what else she told you about me."

She leaned toward him and lowered her voice.

"Between you and me I don't think Jane approves of me."

"Because you like to learn about things?"

He told her about lithography: the history of the craft, the evolution of the various techniques. Occasionally he drew a quick diagram on the tablecloth. On and on he talked, slowly abandoning himself to the pleasure of monopolizing the attention of this strange and beautiful girl.

"How about going to Maxim's?" broke in Jane, who had made peace with her lover.

It was getting late. People were leaving; others were beckoning to the *garçon* and sending *chasseurs* to fetch carriages. Outside the snow was muting the sound of traffic.

"If you don't mind, I think I'll go home." Myriame hooked her short fur-trimmed cape and began buttoning her gloves. "Don't forget, I have to be at the shop by nine in the morning."

"May I see you home, mademoiselle?"

They hardly spoke during the drive. Now that they were alone he couldn't think of anything to say. For an instant he had a glimpse of her face as the fleeting beam of a street lamp illuminated the inside of the carriage. Her eyes turned away from him, gazing calmly out of the window. Silence became her . . . Or perhaps she had forgotten he was there, as Marie used to do . . .

The absurdity of Jane's scheme returned to him with fresh insistence. How could a girl like her possibly be interested in him? Well, her good deed was done. She was on her way home now, and hadn't even suggested that they should meet again. In a few minutes she would hold out her hand and say, *"Bonsoir, monsieur. It's been a delightful evening."* Then she would vanish, and he would never see her again . . .

The landau halted in front of a house on rue des Petits Champs. It was a modest three-story building, sooty with age, with a watchmaker's shop on the ground floor.

He wondered how she could manage to live in the neighborhood of rue de la Paix on a mannequin's salary.

"Of course," she said, as though reading his thoughts, "I don't really have an apartment. Just a back room over the courtyard. But it has a fireplace and there's a kitchen—not very big, but big enough for me. I'd ask you upstairs but I'm afraid it's rather late. I enjoyed our evening very much, monsieur."

"The pleasure was all mine, mademoiselle," he said formally. "May I hope to see you again?"

"Would you care to meet me tomorrow?"

Her directness took him aback.

"Tomorrow?"

"Yes. We could have dinner together if you like. I finish work at six."

In the dim light of the carriage he could only see the blurred whiteness of her veiled face and the red smear of her mouth. Thoughts whirled in his head. Could she—could she mean it? Perhaps she was only trying to live up to her promise to Jane.

"Are you sure you want to?" This time there was gentleness in his voice. "I don't mean just meeting you again, I mean the whole thing. Jane told me about asking you to go out with me. You don't really have to do it, you know. I'd understand."

He felt the quick pressure of her gloved fingers on his hand.

"Tomorrow. Half past six. Corner of Place Vendôme."

Two weeks later Henri was waiting for Myriame at their

usual rendezvous at the corner of Place Vendôme and rue de la Paix, gazing through the carriage window at the stream of traffic and the shadowy silhouette of the Colonne rising like a gigantic candle in the early winter dusk.

He glanced at his watch.

Half an hour to wait . . . He didn't mind. Waiting could be such a pleasure when you knew you weren't waiting in vain . . . That in thirty minutes she would appear in Paquin's service entrance and hurry toward him, smiling, a hand to her hat, her slim figure trimmed to the wind . . .

Myriame. Softly he rolled the name on his tongue. Myriame . . . In two weeks she had brought him such happiness as he did not know existed. She had transformed his whole life. He was drinking less, much less. Who wanted to drink when he was happy? He no longer haunted music-halls and bars, no longer roamed the streets until dawn. He slept; he worked. Maman was happy again—at least less unhappy. Maurice was busy making plans for a London show. As for Madame Loubet, she went about praising *le bon Dieu*. The fact that His miracle had assumed the shape of a beautiful girl made no difference; a miracle was a miracle whatever its shape.

Ten minutes . . .

He began watching Paquin's service entrance. First came the midinettes, salesgirls, *petites mains*, apprentices—all the nameless, faceless atoms of the Parisian *haute couture*. They poured out of the dingy hallway, like schoolgirls, in noisy, laughing groups, scanned the sidewalk for a glimpse of their *amoureux*, rushed to them, raised themselves on their toes to kiss them, took their arms and vanished into the crowd. Next, the older employees: the seamstresses, the blockers, the fitters, the cutters, the finishers. No one waited for them. They hustled out unobtrusively, bundled in ill-fitting coats, scurried down the street to the nearest bus or horse cars on their way to their distant suburban homes and meager suppers. Then came the male employees: receptionists, cashiers, bookkeepers, shipping clerks. They walked out in derbies, mufflers and over-coats, trying to look like important men of affairs; they shook hands as if leaving on a six-month journey and scattered in various directions.

Finally the mannequins appeared, recognizable by their elegance and mincing walk. They paused in the doorway, glanced about, chic and haughty, while buttoning their gloves or fluffing their boas; then they sauntered across the sidewalk, ducked into waiting carriages, helped by men's gloved hands.

Then he saw her.

She did not pause, as the others had done, but hurried directly to the landau.

"*Bonsoir*, Henri," she cried gaily, taking her place at his side. "Been waiting long?"

"Only a few minutes, but I'm glad you weren't late. They're giving the *Précieuses Ridicules* at the Comédie Française and I bought tickets. I thought you might enjoy a show tonight."

"I'd love to go. I've never been to the Comédie Française."

He thrust his head out of the window. "Voisin's."

They dined with youthful appeties, chatted and laughed a great deal, not so much at what they said, but because they felt happy, and laughter came easily to their lips. As usual they argued incessantly. Since the very first day of their relationship they had adopted extreme and opposite views on nearly everything, mostly for the sake of conversation.

That evening Henri opened the discussion by remarking that, as a royalist, he objected to the Colonne Vendôme.

"The impudence of that Corsican adventurer! Putting his own statue on top of that column, like a wick on top of a candle! You know, Myriame, nations are as baffling as individuals. They tolerate good governments but they fall in love only with dictators. The worse—the better."

He saw the protest in her eyes.

"You don't believe it? All right, look around. Napoleon ruined France, bled her white, slaughtered more men than all the kings put together, yet all Paris is a shrine to him! The Arc de Triomphe, the Invalides, that confounded Colonne Vendôme, the Obelisk. Why, you can't take a step without bumping into that man. As a royalist, I resent it."

"Now, Henri, you don't really mean you are a royalist, do you?"

"Of course, I am! What else could I be! What a question! Like asking a cardinal if he is for the Pope."

"I don't believe it," she flung over the rim of her glass. "How can you? How can you defend those depraved old kings?"

"First, they weren't old. Louis the Fifteenth was king at five . . ."

"All right. Those young and depraved kings, then."

"I object. I respectfully submit that kings weren't any more depraved than plumbers, cashiers, artists or church deacons. As a matter of fact, some of them—the worst, unfortunately—were actually virtuous. At least one of them, Louis IX, is officially listed as a saint."

She flashed him a challenging look and for a moment busied herself with her food.

"And those nobles, those aristocrats!" she cried, returning to the charge. "Were they virtuous also? No, they weren't! They were rude and insolent and full of their own importance."

He made a sweeping, dramatic gesture. "I'll have you know, my dear Myriame, that servants are rude, not *grands seigneurs.* You will notice it's usually the butler who is snobbish and insolent, not the master of the house. At the château we had a major-domo, 'Old Thomas', who was the greatest snob I've ever known."

He glanced at his watch.

"And now, my dear young *sans-culotte,* please hurry or we'll never make the first act."

That day they saw Molière's *Précieuses Ridicules;* the next he took her to a Dilhau musicale, where she charmed everyone —including Degas—by her grace, her beauty and her sincere appreciation of music. The following evening they went to La Renaissance. After the performance Henri led her backstage and introduced her to Sarah Bernhardt.

But the next evening they spent in her room by the fire; he, on the sofa, nursing a brandy; she, on the floor, gazing at the flames, her arms hugging her knees.

It was a howling February night with rainy gusts of wind that flailed the windowpanes, but here in the room it was quiet and warm. He leaned back contentedly against the cushions, watching her face reddened in the fireglow. How she loved a fire! . . . The moment she entered the room, her first thought was to light one. All evening she tended it, toyed with it, sat as close to it as she dared, abandoning herself to its warmth with a feline sensuous pleasure.

Neither had spoken for a while. It was one of the most precious features of their companionship, this mutual enjoyment of silence.

"Happy?" he asked softly.

"Purring."

"I've always suspected you were half cat."

Although she hadn't turned her head, he could see the smile lingering on her lips. Again the silence closed around them, broken only by the wailing of the storm outside and the crackling sound of the burning logs.

Idly he fondled his beard and ran his eyes over the room. It was small, low-ceilinged and sparsely furnished. A green carpet covered most of the floor. The book shelf and the engravings on the walls gave it a faintly bookish atmosphere. It had the intimacy of much-lived-in places, and he liked it because it was exactly the sort of room he imagined

she would have; and because it was part of her, like her coffee-brown eyes, the tiny beauty spot on her left cheek, her habit of sitting on the floor, the way her lips parted when she listened to music.

"Henri," she said unexpectedly, "tell me about Dreyfus. At the shop the girls talk about it all the time. I don't know if he is guilty or not, but I'd like to know what it's all about. First of all, who is he?"

"He is an Alsatian. He was born in Mulhouse, like my friend Maurice. He entered the Army, became an artillery captain, and one day, four years ago, was suddenly arrested, tried, condemned, degraded and shipped to Devil's Island, where he is now rotting for a crime he did not commit."

"How do you know he didn't commit it? Everybody says he did."

"Which is almost good enough a reason to be sure that he didn't," he smiled, "but there are other reasons."

Leisurely he told her about the tragic affair: the experts' confusion about Dreyfus' handwriting, the secrecy that had surrounded the trial, the forgery of evidence, the perjury of witnesses.

"No, Myriame," he concluded, draining his glass and reaching for his cane, "he is not guilty. And there are a few honest men left in France who are fighting to redress a great wrong. I hope they succeed. I'm afraid it won't be easy, though."

When he left that evening, she picked up the lamp from the table and walked by his side down the narrow outer hall.

"Not a very exciting evening, was it," she said as they reached the stairway, "just sitting by the fire?"

"I couldn't imagine a nicer one. About the nicest I've ever had. I really am a dreadfully domestic man at heart, you know . . . Shall I see you tomorrow?"

After an imperceptible hesitation he added, "Aren't you getting tired of my taking all your time? Are you still willing . . ."

"Shhh! Tomorrow. At the same place," she said quickly.

The look in her eyes fell upon him like a caress. He would have liked to take her hand, hold it in his own for a long time. Instead he said, almost inaudibly, "Thank you, Myriame."

She held the lamp high above her head when he started descending the stairs. Pity clouded her eyes and she repressed a sigh as she watched him slowly, awkwardly navigate his way down.

At the foot of the stairs he paused to catch his breath and

rest his legs. For an instant he looked up at the pure oval of her face bathed in the yellow light.

He waved happily. *"Bonsoir,* Myriame."

When two weeks later she suggested they go to the Louvre on Sunday afternoon he protested stubbornly.

"The Louvre! That old graveyard! Who wants to go to the Louvre?"

"I do."

"Don't you know that only tourists go to the Louvre? Tourists and art students. I assure you there's nothing on earth as depressing as those rooms full of statues, mummies, sarcophagi, broken slabs of marble. It's like the warehouse of some enormous cemetery. Those miles-long galleries with their thousands of paintings . . ."

"But, Henri, I like paintings. I like to look at them. I'd like you to tell me about them, explain to me what makes a great painting."

"Impossible! Like asking to explain what makes a beautiful woman. It isn't true that great art is simple; it is devilishly complex. After all, why shouldn't it be? Life isn't simple. The human mind isn't simple. The human heart certainly isn't. Great music isn't simple. It may sound simple, but it really isn't. Mathematics isn't simple."

"One more reason for you to take me to the Louvre next Sunday and begin my education," she said with a teasing smile in her silky oriental eyes. "If art is as difficult as all that, we may be at it for years! Already I can see us, when we're both in our dotage, going every Sunday to the Louvre to look at Mona Lisa."

"Don't talk to me about that smirking Florentine bourgeoise!"

"I thought she looked very nice, but if you disapprove of her . . ."

The meekness of her tone did not conceal her tranquil assurance as to the outcome of this debate. Her smile had a quiet certitude of victory that did not escape him.

"I said 'no Louvre', and that's final," he declared with a gesture of irrevocability. "And don't think you can wheedle me, bind me to your will, twist me around your little finger with that smile of yours."

"Why, Henri," she protested with a great show of wronged innocence, "I wasn't smiling at you."

"Then you were smiling at someone else, and that's worse."

He wagged a wise finger at her. "I know that kind of smile.

Missia has one like it. So, you see, there's no use wasting your smiles on me."

She looked so lovely, sitting like this on the floor, shimmers of fireglow in her hair and on one side of her face, her slender legs folded under her serge skirt, that for a few seconds he gazed at her, forgetting the train of his thoughts. "When I say 'no Louvre', it's no Louvre—and no argument."

The following Sunday they went to the Louvre, and regularly every Sunday afternoon thereafter.

To his surprise these visits proved for him a new and delightful experience. He enjoyed watching her eyes widen at the sight of some world-famous canvas, answering her questions, pointing out technical details. As they strolled through the echoing galleries, he was enchanted by the eager curiosity of her alert and perceptive mind. Unconsciously he found himself talking about art, explaining why Rembrandt was greater than Peter de Hooch and Fragonard greater than Nattier, analyzing canvases, pointing out what was genius and what was mere cleverness.

One Sunday they were standing in front of Venus de Milo, white and remote in the paleness of that March afternoon.

"She is beautiful, isn't she?" he whispered. "We know nothing about her, except that a Greek peasant found her in a cave and sold her to the French Government for six thousand francs. The only bargain our government ever made, except of course those wonderful canvases Napoleon stole from Italy. You know," he went on after a pause, "she is so beautiful we forget how very, very old she is. Do you realize she is older than Paris, older than Caesar, older than Christ? Sometimes I wish Saint Paul had never gone to Athens."

For a while they talked in murmurs, slowly walking around the towering statue, looking at her from all angles.

"We should be going," he said. "It's getting late. We've seen the Egyptian bas-reliefs, the Greek caryatids, and the Phoenician marbles. That should satisfy your cultural instincts for another week."

"But, Henri, you promised to show me Filippo Lippi's 'Madonna'. Remember?"

"Oh, my God, you never forget anything, do you? We'll have to hurry then; they're about to close."

They climbed the wide marble stairs to the first floor, crossed the Salon Carré and entered the Salle des Sept Mètres. The room was deserted.

"We'll only have time for the Lippi." Pantingly he hastened

toward the picture of a blonde, exquisitely featured Madonna gazing down at the Child on her knees. "We can look at the others next Sunday, if you want."

They stood side by side in reverent silence before the picture.

"This, Myriame, is great painting," he said at last. "Do you notice how the light seems to come from beneath the skin, as if it were illuminated from within? That's because Lippi under painted with ocher. It's an artifical device, but very effective. It creates a sort of inner radiance. Now every student uses it, but in Lippi's time it was a novelty. Isn't she ethereal and angelic-looking?" A twinkle came to his eyes. "To look at her you'd never think she is probably frying in hell right this minute. Lippi, too, for that matter. They were a naughty pair, those two . . ."

He was interrupted by a uniformed guard who popped his head into the room. "We're closing in a few minutes, *mesdames et messieurs.*"

He flung the words in a breathless haste, darted an appreciative glance at Myriame, a puzzled one at Henri, shrugged, and dashed off.

"Art owes a tremendous debt to sin," Henri elaborated as he and Myriame retraced their steps. "By an odd coincidence very few virtuous women were ever painted by very great artists. Remind me to tell you the romance of Filippo Lippi and his pretty nun one of these days."

"When we get home—while I make tea."

The following Sunday they did not go to the Louvre, but to the Salon des Indépendants which had opened during the week. Henri introduced several members of the *Comité Exécutif* to Myriame and was pleased by their unabashed admiration. Then they began walking through the various exhibition rooms, glancing rapidly at the innumerable paintings as they went along.

"Now you understand why artists starve to death," he remarked as they meandered round a gallery solidly walled with pictures. "Art is the most abundant and least necessary commodity of all. Only fools or geniuses or people who, like me, have no other choice, can deliberately choose art as a career."

They spied Henri Rousseau standing guard before his painting. In his shiny brogues and patched redingote, the former sergeant and customs-house officer cut an impressive figure.

"Myriame, this is my old friend, Monsieur Rousseau. If you ever plan to learn the violin or write a difficult love letter, he is your man. Incidentally, he is an excellent artist."

Henri Rosseau bowed from the waist, mumbled something through his drooping mustache and taking Myriame by the arm led her to a large painting entitled "La Carmagnole." On the frame he had tacked an inscription that read, "O Liberty! Forever be the guide of those who by their labor wish to contribute to the glory and grandeur of France."

On the way back to rue des Petits Champs, Henri made Myriame laugh with his account of the ludicrous séances of the *Comité Exécutif*. Gradually he came to speak about Seurat and Vincent.

"I wish I'd known you then. You would have liked them . . . Both were great artists, though different as night and day. I think you would have liked Vincent especially. It was difficult not to like him, although he was a strange man. But then he was a democrat like you, and you'd both have agreed on the depraved old kings and impudent aristocrats. He probably would have fallen in love with you. He was such a fool, poor Vincent, he couldn't get it into his head that some people can never have love."

"What became of him?"

"He killed himself . . ."

And so the weeks passed. Every evening Henri waited for Myriame at Place Vendôme. They went to the theatre and the Opera, to concerts and to the circus. He took her to the Vélodrome d'Hiver and she was thrilled when he introduced her to the great Zimmerman. One day he asked if she had ever attended a *séance cinématographique*.

"Mon Dieu, what's that?"

"I don't exactly know. Something like a magic lantern show, I understand, but the images change so fast people seem to move."

They attended the *séance cinématographique* at the Salon Indien, a basement on boulevard des Capucines. It was an unforgettable, hair-raising experience, with locomotives charging from the screen, horses galloping right into the room, and people shrieking in terror, rushing out of their seats, fainting.

Occasionally they had dinner with Maurice and Renée and spent pleasant evenings together, chatting or playing cards. On Sunday mornings she often surprised him by coming to the studio, watching him paint, curled up on the couch, book in hand. She and Madame Loubet had become fast friends and they held long whispered conversations behind his back.

By degrees their friendship blossomed into intimacy.

He told her about himself, the loneliness of the past years.

He even told her about Denise, and one rainy evening about Marie Charlet.

Gradually she returned his confidences, mentioned episodes of her childhood.

"You know why I'm always wanting to learn things? Because I didn't have a chance when I was little. I never finished school. My parents were too poor, and when Papa died I became an apprentice in a dressmaking shop. One franc a day. I was thirteen . . ."

Pity swept over him as he imagined her as a *petite main* in a crowded, unventilated room, hunched ten hours a day over a long table, sewing, pricking her fingers. At thirteen . . . How cruel poverty could be!

"You don't know, Henri, what it is to be poor, really poor. It does things to you. Some day I'll tell you."

She did not say more that day, but a month later she told him about her father.

"He was a jewelry designer. When he was young he came to Paris from a little town in Poland . . ."

A blond, soft-spoken man, phthisic, naive and devout, he had taken her to the Synagogue on rue de Nazareth, filled her childhood with the poetry of the Talmud and the wailing despair of Hebraic chants. He had died after a lingering illness that had consumed the family's piteous savings and left mother and child penniless. The following years had been an unbroken nightmare of privations and toil. After the day in the sweatshop she had spent evenings huddled by the kitchen stove, helping her mother sew buttons on gloves. Suppers of warmed-over potatoes, crusts of stale bread softened in tepid water. And always the specter of the landlord. No Sundays, no picnics on the bank of the Seine, no rides on the carousel, no hide-and-seek games with other children. Yet somehow she had survived. The scrawny somber-eyed *gamine* had become a woman. Beaux had begun to wait for her at closing time, to escort her home.

"Then one day I met André, and fell in love with him. He was a foreman in an optical instruments factory. He was kind, quiet. We had the same tastes, the same religion, the same hopes. We were very much in love. So much that when my mother died he asked me to marry him—I almost did." Her voice trailed off in the silence of the room and she gazed at the fire.

"Why? Why didn't you marry him?"

"Because he was poor." The trenchant finality of her voice startled him. "He was intelligent, hard-working, kind and hand-

some—but he was poor. My father also was intelligent and hard-working and I saw the sort of life he gave my mother. And I watched him die. I heard him cough and cough and cough all night, because we couldn't buy medicine. And each time I heard him through the wall I pushed my face in my pillow and swore I'd never be poor again, swore I'd do anything not to be poor any more. That's why I left André. Without a word, without a note. I knew that if I saw him I might weaken. And so I ran away. I've never seen him again," she said very low.

Then it was May, and once more the miracle of spring with its magic of old stones seen through the new foliage was over Paris. The boulevards bloomed with sailor hats and bright parasols. In the Parc Monceau the puppet show reopened and a new generation of children watched the furious bouts between Guignol and *le Diable*. Lovers kissed in doorways.

Jane Avril, accompanied by her lover, her maid, her business manager, two poodles and twenty-six trunks, left for London in a confusion of misplaced luggage, last-minute telegrams and *bon-voyage* gifts befitting the departure of a music-hall star.

Before the train pulled out the actress managed to steal a few minutes alone with Henri in her compartment.

"You look like a new man," she said, fanning herself with her gloves. "How are things between you and Myriame?"

"Wonderful. She is all you said she was and much more. I'll never be able to repay you for what you did. You can have as many posters as you wish."

The intensity of his tone made her give him a suspicious glance. "You aren't falling in love, are you?"

"Of course not. What do you think I am—a fool?"

"Remember, Henri. Friendship—nothing else!"

That evening he took Myriame to a Brahms festival organized as a tribute to the composer who had died recently in Vienna. They played the C minor Symphony and Myriame listened with her eyes closed, her hands folded in her lap, to its thunderous waves of sound. Watching her from the corner of his eye he etched her image in his mind, her face rapt with the enjoyment of music, her lips parted as for a kiss, the lean curve of her throat. It was a perfect moment to be treasured, lived again and again when she was gone.

During the last moment of the symphony she laced her fingers through his.

"Thank you, Henri," she whispered. "I'll never hear that symphony again without thinking of you."

In the landau she again placed her hand over his. "You've been very good to me."

Slowly their palms touched and their fingers intertwined in obscure, almost unaware sensuality.

When they entered the room she tossed her cape on a chair and crouched down to light the fire.

"I wish I could do that for you," he said from the sofa. She did not reply, and to ease the awkward moment he went on in an airy tone of voice. "I wonder what you do in summer when it's too hot for a fire."

"Grumble all the time and wait for the fall to come. I hate summer anyway. Paris is dreadful in summer."

"Not at all! Paris is delightful in summer. You'll see. I'll take you to the fairs. We shall eat caramels and visit every booth. We'll go to see my old friend La Goulue at the Foire de Trône. We'll take the *bateau-mouche* down the Seine and we'll lunch in little places where they play the accordion. We'll drive to Saint Cloud, to Versailles and to . . ."

"Aren't you going to Arcachon this summer?" she asked, surprised. "Jane told me you had a villa and a boat there."

"No, not this summer," he said quickly. "I'm too busy."

"Do you know, Henri," she said after a pause, "I've never been out of Paris, never seen the sea?"

"Arcachon isn't exactly by the sea, but around a bay. The loveliest bay in the world, I think. There is a winter town that spreads through the pine forest, and a summer town near the beach. That's where my villa is, Villa Denise. It has a terrace that opens right on the bay. You have no idea how pretty it is in the morning when I come down for breakfast: the sun, the white sails of the yachts, the children playing on the beach. After breakfast I go out for a sail and a swim with Laurentin. That Laurentin, he's a *numéro!* When he was young he was a sailor and roamed about the world. Now he has become a fisherman, but only in the winter. In summer he and his wife, Mariette, hire themselves out as a household couple. He taught me how to man a boat, and two years ago I took part in the local regattas. You may not know it, but I am an authentic yachtsman with several trophies to my credit. And those morning swims!"

He realized that he had been carried away by his enthusiasm and shrugged deprecatingly. "Don't believe what I say. Arcachon is just a humdrum little beach town like dozens of others. And I won't go there this year. I can't leave Paris. I've promised to illustrate Clemenceau's book and haven't even started work on it. By the way, I think you might be

interested in it. It's a collection of Jewish short stories. He gave me the galleys to read. I'll bring them to you if you like."

She acquiesced with a nod, jumped up and smoothed her skirt. "I'm going to make coffee. Would you like some?"

She disappeared in the tiny kitchen, and for a while he listened to the grating of the coffee grinder. How little it took to be happy. A fire, coffee, a girl . . . A girl like her. How soft and warm her hand had been in the landau . . .

"You looked beautiful tonight," he called to her from the sofa.

She peered out of the kitchen. "Thank you, monsieur. About time you paid me a compliment."

"You don't need any compliment from me or anyone else. You know perfectly well you are a very pretty girl. Much too pretty, as a matter of fact. Besides, you can never tell a woman something nice about herself she doesn't already know."

"She likes to hear it just the same," she laughed back, above the sound of the coffee grinder. "But if you saw me in the morning you'd be horrified."

"I'm sure I would be," he replied in the same chaffing tone. "But somehow tonight you managed to look very beautiful. Men were ogling you at the concert and I could tell what they were thinking."

"Could you?" Again he heard her rippling laughter. "What were they thinking?"

"How horrible you must look in the morning!"

"You're horrid. I hate you!" She peered out of the kitchen door and put out her tongue. "Jane was right. She said you were . . ."

"Never mind what she said," he laughed. "There, you see? When you take women at their word and agree with them, they hate you, call you names and put their tongues out at you. Flattery, that's what they want. Flattery, and still more flattery. Nevertheless the fact remains that you were a distracting influence at the concert. Women like you are a public menace and shouldn't be allowed to go about loose."

"But I wasn't loose. I was with you."

In the past they had sometimes indulged in this kind of banter, but tonight he was aware of an undercurrent of tenderness, a new, faintly libertine, intimacy.

"Here, have a brandy." She set a bottle of cognac and a glass on the side table. "Not that you deserve it, but because I am a sweet, forgiving, generous and kind-hearted girl."

"I was about to say those very words," he teased, "but I feared to offend your natural modesty. I am happy to see

that we share the same opinion." He hunched his shoulders
in mock terror as she opened her mouth to protest. "All right,
all right, I apologize. You are none of these things. Now don't
you think it might be a good idea to let me pay for the liquor
I drink. I'm quietly ruining you in cognac."

"No. And if you say another word . . ."

"But, Myriame, you won't let me buy you presents. You
won't let me pay for liquor. Please!"

"No."

"You're stubborn as a mule. Come on, Myriame, try to . . ."

"No. Another word and I take the bottle away."

She walked back to the kitchen, only to reappear almost
immediately carrying two cups of coffee. "Drink it while it's
hot."

She curled up on the floor close to the fire, her slender legs
folded under her black velvet skirt.

For a while neither of them spoke.

How desirable she looked tonight! The months had not
lessened the wonder of her presence, the thrill of her loveliness.
All his life he had dreamed of a girl like her. It was she he
had hoped to find during those past frantic, wasted years.
And she had been here all the time in this little room! How
many times he had driven through this street, never suspecting
she lived in one of these old houses! If only he had met her
then! Oh, the regret of things that could have been . . .

"Why are you staring at me?" she asked, without turning
her eyes from the fire.

"How do you know I was looking at you? Besides being
a sweet, forgiving, generous and kind-hearted girl, as you said,
do you have eyes in the back of your head? I suppose you
also knew what I was thinking."

"What were you thinking?"

"If you must know, I was wondering whether you were
really here or whether I was making you up. I'm very good
at make-believe. I can see things that never were there, and
hear things that never were said. Sometimes I awake at
night thinking you don't exist and we've never met. Oh,
Myriame, I'm so glad we met! So glad and so grateful."

"Grateful—for what?"

"For your being alive, being here close to me, letting me
sit with you, letting me be your friend."

She did not move. Her motionlessness was one of suspense.
She laid her cup in her lap, searching the fire with her eyes.
Her face was remote, shuttered in thought.

"Henri, are you in love with me?" The chaffing tone of a moment ago was gone.

He felt himself gulp and the glass of brandy tremble in his hand. She was going to leave him . . . She had been strange all evening. Too nice . . . She was going to tell him the rich man she had been waiting for had come . . . Or she had guessed he had fallen in love . . . He had betrayed himself with that stupid remark about awakening in the night and thinking about her.

"In love with you? What makes you say that? Of course not."

Every cell in his brain was alert. This time he must lie well, lie superlatively well . . . He must, he must convince her or she would leave him . . .

"We are good friends. I enjoy being with you. But love—no, Myriame. No, thank you! I've learned my lesson the hard way, but I've learned it, I assure you."

"Are you sure?"

"Sure? Of course I'm sure."

Instinct told him to place his hope in flippant brazenness, try to confuse her by questions, ironies, a pretense of amusement. If he defended himself he was lost.

"What is this? A self-searching game? You women are so vain you can't imagine a man may enjoy your company without losing his heart and plunging head over heels in love. Sorry to disappoint you, but friendship is all I want. I'm growing old, I guess. I have no wish for the turmoil of love. I yearn for the calm waters of friendship."

Slowly he was gaining confidence, taken in by the sound of his words, almost believing them.

"How would you like it if I suddenly turned to you and said, 'Myriame, are you in love with me?' Well, let's not speak any more about it. And now, my poor jilted *amoureuse*, let me drink my coffee in peace."

"All right," she said, "I believe you. But—but you want me, don't you?"

"Ha-ha, that's different! Love is a marshy sort of thing, an emotional quagmire. But lechery is a normal, pleasant gentlemanly feeling. Of course I want you, my dear Myriame, as I would want any young beautiful woman. After all, you are not exactly horrible-looking—except in the morning, of course —and I am not yet ninety years old. Wouldn't it be rather unflattering to us both if I remained entirely unaware of your obvious assets? But don't worry, I'm not going to bind and

gag you so that I can appease my carnal hunger on you. There are places in Paris where that kind of hunger is adequately satisfied."

"I know," she smiled. "Jane told me."

"My God, that woman should be shot! Well, since you know, this should put your mind at ease and reassure you I shan't unexpectedly throw myself upon you and after a fierce battle force you to my will—if that's what has been worrying you."

He was winning; he was convincing her. He relaxed his defense.

"No, Myriame," he said with a gentle smile, "I only want to be your friend. I don't hope, don't want anything from you, but the enchantment of your friendship. I know that some day you will go away, and I am ready, but until then let me continue to be your friend."

She scanned his face with intense, probing eyes. "I am glad to hear that, Henri. I, too, want to be your friend. I, too, am grateful to you. More than you know, more than you imagine. Jane has told you what I want from life. You know I don't love you, and I don't want you to love me, for you'd be hurt, and I don't want you to be hurt. I want to give you nothing but happiness."

"Thank you, Myriame," he said huskily, "and now that everything is settled, I think I'd better go home. Tomorrow is Sunday, and it looks as if it is going to be a nice day. How would you like to drive to Versailles?" He set his empty glass on the table and reached for his cane.

Before he could rise she had sprung to his side, her lips close to his.

"You don't have to go, Henri."

XIX

Even before he opened his eyes he knew it was a perfect summer morning, that the room was filled with sunshine and that over the bay the sky stretched tight and blue. Through the open window came the twitter of children playing on the beach and the lulling murmur of the surf. The faint stirring in the air told him that the eleven-o'clock breeze was about to rise, and soon the sailboats would be gliding out of the harbor.

He did not open his eyes but lay motionless in the bed, listening to her calm breathing, seeping in the warmth of her nude body stretched out in tired sleep at his side. This was the heavenly hour that came once in every life. Pellucid, iridescent, heartbreaking in its intensity of joy. It had come to him at last on this summer morning, and he was living it, each precious second of it—now . . .

No one could possibly be happier than he had been these last weeks. She had given herself to him. Not from pity, not with condescension, but willingly, joyously, in a pagan gesture of redress. She had wanted to make up for Denise, Marie, the years of loneliness, his ugliness, the pain in his legs—to balance the injustice of life with the spontaneous gift of herself.

Often in the past he had wondered how it would feel to make love to a beautiful, intelligent and sensitive girl. Now he knew. It was the highest rapture on earth, the thing for which Adam had been wise to lose Paradise . . .

She had been avid and wanton, for sex is nothing if not avid and wanton. She had denied him nothing, for she had wanted him to taste at least once in his life the full ecstasy of love, and she was the kind of girl who gave all or nothing. In the firelit penumbra of her room in Paris, and here in the

sapphire-blue dimness of the summer nights, she had let him use and abuse her body, take all he wanted of her.

For once he had blessed his carnal voraciousness, blessed the humble whores who had taught him the anatomy of pleasure and the craftsmanship of love. And he had given her pleasure —of that he was sure. He had felt her shuddering flesh, the arching of her spine under his hands. Looks did not count in the performance of love. Nor brains, nor fame, nor social graces . . . When you reach certain levels of sexuality, pierced through the conventions and proprieties, nothing counted any more but plain animal lust and sexual endurance. In the enveloping darkness they had ceased to be a beautiful girl and an ugly man, but two faceless shadows locked in their passionate frenzy and their desire to give each other pleasure.

He would never forget her, but neither would she forget him. She would remember the ugly dwarf who had loved her so fiercely and well. She would remember him when she listened to Brahms' First, when she went to the Louvre, drove past Voisin's or the Colonne Vendôme. Somewhere in her mind, in her heart, in her sex, he would go on living, being part of her, even after they were separated. For they would separate. Affairs such as theirs did not last long. Life did not tolerate them. Something happened to break them.

She did not love him—of that he was also certain. She never would. She had given him her body, not her heart. If he were younger, more foolish he might have hoped, as he had hoped at Malromé. But not now, at thirty-three and his beard turning gray . . . One thing you learned as you went on was a certain resignation, the wisdom of renunciation, the surrender to the inevitable. You stopped wishing for the moon.

As for himself, he was in love, desperately in love—and very sorry about it. He wished he had been able to keep his feelings in check, but he hadn't. But this was his problem, and he would have to handle it. He had lied to her and would pay for it. When the time came to say good-bye, he would have the courage, the decency to bow out, spare her the ludicrous spectacle of the tearful, imploring lover.

Meanwhile the future was a long way off. She was here, at his side. They still had three weeks ahead of them. Three weeks of swimming, sailing, lunching on the sun-splashed terrace. Three weeks of summer nights . . .

He opened his eyes, cautiously raised himself on one elbow, drinking her loveliness in long thirsty draughts, telling his love in inaudible whispers. He suppressed his impulse to caress

her exposed breasts, kiss the smooth expanse of her throat. An instinct held him back. Their love was of the night . . .

Stealthily he slipped out of bed, dressed and went down. In the hallway Laurentin was waiting for him, dressed in his morning livery, trying hard to look like the busy servant.

"Bonjour, Monsieur le comte." He held his feather duster in mid-air and gave Henri a flash of his tessellated smile. "A nice day, perfect for a sail," he remarked with a wistful sigh.

Since the arrival of the young Madame, things weren't as they used to be. Less drinking, fewer man-to-man talks, less early-morning fishing. Monsieur le comte had other things on his mind than fishing these days, and frankly you couldn't blame him. Something extra-special, she was, this young lady he had brought down with him from Paris. Nice and friendly, and not one of those noses-up-in-the-air, like so many of them . . . Just the same, females did upset things.

"The breeze's just in," he went on casually, while dusting the banister. "A pity to let it go to waste."

"Go and get the boat ready then." Henri grinned. "I'll be on the terrace."

He sat down and lit a cigarette.

The white-sailed boats were crisscrossing the bay, knifing the glittering water. On the beach children dug industriously while their mothers, in peignoirs, knit or read yellow-backed novels under large umbrellas. Gentlemen in boaters and striped bathing suits peacocked about before braving the surf.

Mariette appeared, a broad smile on her round face. "Nice day, *hein,* monsieur le comte?" she beamed setting the tray on the table. "Arcachon's wonderful in summer—in winter, too," she added loyally.

They exchanged a few remarks in low tones, so that their voices would not wake the young Madame asleep in the room upstairs. Then Laurentin pushed his grinning coolie face between two balusters of the railing. He no longer wore his butler's uniform, but was dressed in a decrepit straw hat, an open shirt and a pair of faded blue trousers, rolled up at the knees. Naturally he was barefooted.

"She's ready, m'sieu. Any time you want."

A moment later they were sailing through the bay. Henri, stretched out on the deck, was enjoying the gentle prickling of the sun on his face, while Laurentin, a hand on the tiller, his tattooed hair-felted chest bared to the breeze, was making conversation.

"You know, Monsieur le comte, the very chic couple that's

moved across the road? They aren't married, those two. But they might as well be, the way she cuckolds him . . . And that lady, you know the one who lives at the Villa Mon Plaisir, well—judging by her lingerie . . ."

"Now what do you know about her lingerie?" laughed Henri, sitting up. "Laurentin, you are worse than an old woman. What do you do while I'm paying you to take care of the house? Spend your time peeping through keyholes?"

"I got eyes, Monsieur le comte. And the help likes to talk."

The old fisherman pulled a bottle of cognac from under the seat.

"How about a little drink before your swim, as you used to?"

"No, thanks, but you can have one. You'll have it anyway behind my back," he grinned.

They reached a lonely cove, gleaming in its semi-circle of sand dunes and maritime pines. Henri removed his pince-nez, dipped his toes in the water; then with a propelling motion of his arms, pushed himself overboard. He reappeared a few seconds later at the stern, his hair glued to his forehead, panting, puffing, his small body wriggling joyously in the green transparency. He waved at Laurentin, dived again, turned a complete somersault and started swimming away from the boat.

"Don't go too far," warned Laurentin, taking a second gulp of Henri's cognac.

Henri swung around, splashed and capered for a while. At last he swam back to the boat, grasped the fisherman's knotty hand and hoisted himself aboard.

As they neared the shore he could see Myriame, dressed in white, standing at the end of the wharf, waving to him. As he waved back, the mood of a moment ago was upon him again, and this time his happiness rose in prayer to his lips. "Thank you, God, for letting me know such happiness! . . . I do not hate You any more. I shall never hate You again . . . When she is gone, don't let me live too long . . . But now, please, make time go slow—very slow . . ."

They went sailing and they went fishing. They sprawled on the deck, their eyes closed, their faces to the sun, their hands touching. They laughed easily and said the foolish nonsensical things people say when they are happy. They lunched and dined on the terrace; drove through the pine forests of the "winter town," dawdled at the terraces of little waterfront cafés, gobbling the famous Arcachon oysters and washing them down with Bordeaux *blanc*. They browsed through gift shops and

sent Madame Loubet a china statue of Saint Francis standing in a giant oyster shell on which was inscribed "Souvenir d'Arcachon." Again night cloaked in darkness the rapture of their embraces; again dawn found their bodies in sleep, their pleasure spent.

Toward the latter part of August Maurice and Renée joined them for a few days. After dinner the two girls talked fashions while Maurice unfolded his future plans.

"Everything's ready for your London show. Monsieur Marchand, Goupil's manager in London, has put you on his spring schedule. Two weeks in May. Then the next year—New York! Oh, there's a certain Herr Moraw who has a gallery in Dresden, and he too would like to show your work. A sales guarantee, and he pays the shipping. I tell you Henri, in five years you'll fetch prices as high as Degas."

After their friends' departure, Henri and Myriame resumed their lazy routine. They took a few last drives, lingered on the terrace in the evenings. But Myriame's vacation was almost over, and over them hung the melancholy of things about to end.

On the eve of their return to Paris, they were sitting side by side watching the sun go down in a cloudless sky. A few late bathers were struggling out of the surf, rubbing the salt from their eyes. The breeze had died down.

She reached out and took his hand. "It's been the happiest summer of my life. We've had four heavenly weeks and I'll never forget them."

He dared not speak, afraid to betray himself. The future had become a haunting terror, Paris a thousand-armed rival waiting to lure her from him.

She turned to him. "You've made me very, very happy, Henri. I want you to know that."

"I, too, have been happy," he murmured, gazing down at her hand. "That's why I hate to see it come to an end."

"But it won't come to an end. It'll be the same in Paris."

He shook his head, "No, it won't. In Paris I'll see you in cabs, in restaurants. A few hours in the evenings. On Sundays perhaps . . ."

"But, Henri, that's what we had last winter, and you said you were happy." Her eyes rested on him with tender reproachfulness. "Remember what you said about being contented with what we had and not wanting more?"

"I meant we shouldn't want the impossible. But this would be so simple."

"What?"

"Spend the autumn here, return to Paris after Christmas." The words escaped him, tricked out by the languor of the moment, the touch of her hand. He felt her fingers stiffen. "Forgive me. I did not mean . . ."

"You are in love with me, aren't you?" This time it was no longer a question, but a statement. "I've felt it for some time, but I wasn't quite sure."

He nodded, suddenly tired of pretense, like those criminals who unexpectedly give themselves up out of sheer weariness.

"Yes, Myriame, I am in love with you. Practically since our first rendezvous. I was in love with you when I was swearing I only wanted friendship. I lied well that night, didn't I? I lied simply because I couldn't endure the thought of losing you. And I've lied ever since. But I hoped you wouldn't know or see it, and I had promised myself I would never tell you. But now, since you know, won't you let me take care of you?"

He raised his face and looked entreatingly at her.

"I know you don't love me, and I don't expect you to. But you do like me, don't you? Won't you give me the same chance you would give any other man? Jane told me the things you want from life. I can give them to you. Please, Myriame, please . . ."

The words trailed on his lips as he felt her withdraw her hand.

"I'm sorry this had to happen. Terribly sorry." Her voice was low and sad. "No, I am not angry at you for lying to me. I understand. I would do the same. I am only very sorry, because it spoils something that gave us a great deal of happiness, and we both could use a little happiness. Neither of us has had too much of it."

She went on after a pause, "You say you don't expect me to love you. You are wrong, Henri. Anyone who loves hopes to be loved. You do. Don't say no. You still believe that if you are kind enough, generous enough, patient enough I shall fall in love with you. Remember when you said you'd learned your lesson? I believed you then, but now I know you'll never learn it. Never. You will go through life unresigned, always hoping some girl will love you, and always being disappointed and hurt. Hurt, darling, as I am hurting you now. You see, in a way, you and I are in the same situation. We both want what we can't have; we both want love and neither of us can have it. I, because I've renounced it; you because you are crippled and ugly."

The words hit him with a crushing violence. In her mouth

they assumed a new, hopeless finality. Suddenly the sky was gray, the air cold, the bay leaden.

She saw the blood drain from his face, yet she went on slowly, deliberately. "Yes, Henri, you are crippled and ugly. You spend your life trying to forget it, trying to make people forget it, but it's useless. No girl can possibly love you as you want to be loved. If it were possible I would, for I've tried. But I don't and I never will!"

He opened his mouth to interrupt.

"No, not now," she said with a tired gesture. "And you know why I don't love you, why I never loved you? Because I still love André, the man I told you about, the one who wanted to marry me. If you gave me the most beautiful mansion on the avenue du Bois, if you gave me clothes, furs, jewels, I still wouldn't love you. On the contrary I might like you less, I might stop liking you altogether. You'd no longer be the best friend I ever had; you'd become a rich young man who can pay for what he gets. I would stop seeing you and only see your money. And because of your money I might learn to hate you. I want all those things, but I could take them only from someone I didn't like—not from you, Henri. You don't believe it, but it's true.

"I certainly wouldn't give you any more than I've already given you, and I'd probably give you less. I could easily become cruel. It's so easy to be cruel to one who loves. He is without defense. There is a good deal of bitterness in me and I can be cruel to others as I can be hard to myself. I would hurt you, Henri—and I don't want to hurt you. I like you as much as one can without loving, and I want to go on liking you. Money would only poison our relationship, turn something beautiful into something ugly."

She gazed at her hands for a while.

"And now what should we do? Stop seeing each other, I suppose. That's what I promised myself if you ever fell in love with me."

She turned to him with a wan smile. In the deepening twilight her eyes were two pools of darkness.

"But you see, I too am weak. I like you so much, you have become so dear to me I hate not to see you again. We were so happy last winter. Remember the Louvre, our evenings by the fire, the *séance cinématographique* where I almost fainted? It can still be like that. But you must never, never speak of love again. It's up to you, Henri. Please, try."

The sun had vanished behind the dunes. Slowly two sailboats

glided back to their moorings. Already the stillness of night hung over the bay.

They returned to Paris.

As he had feared, life wedged itself between them. After the constant intimacy of Arcachon, he found it hard to see her only a few moments in the evening. Instead of the Myriame in diaphanous white or lying half-nude on the deck of his boat, he rediscovered the chic mannequin, hatted and gloved, her face remote behind the filigree of her veil. Because she had to rise early and needed sleep they had little time for lovemaking: sex which had been the leisurely delight of their summer nights became a hurried fortuitous incident that left them both unsatisfied. But he kept his word, never spoke of his love. Again he drove to Place Vendôme every afternoon, waited for her amidst the bustle of evening traffic. They returned to Voisin's and Larue's, laughed and argued over their crèpes-suzette; they went to concerts, heard *Carmen* and *Manon* at the Opéra Comique, attended another *séance cinématographique*. And they sat by the fire in her little room on rue des Petits Champs . . .

He tried hard to be the jocular friend of the previous winter, but a subtle change had taken place in their relationship. Uneasiness lurked beneath their gaiety. There were sudden holes of silence, hastily covered by embarrassed smiles and spurts of talk. Their friendship, so natural a few months ago, turned into artful deceit.

Now he resented the crowds about them, no longer derived any pleasure at being seen in public with her. Terror swept over him whenever he caught some handsome man eyeing her. He almost resented her beauty, her elegance. Because he feared she might meet someone who would attract her, he avoided taking her to the Natansons' or introducing her to his fashionable friends. At least at the theatre people couldn't speak to her . . .

As his fear that she might leave him increased he grew more possessive. If she was late, he fancied her modeling décolleté gowns for some lecherous millionaire, and when she arrived he asked her the reasons for her delay. Even when they sat by the fire he suspected her thoughts. She sensed his jealousy and was hurt. More than once he found her eyes, knowing and desolate, resting on him.

Unhappy love is a disease that follows the pattern of physical illness. It grows and gets worse, or it improves and disappears; it does not remain static. As the weeks passed, Henri's one-sided

love began to poison their moments together, take the joy out of her presence. He cursed himself for having fallen in love, savagely berated himself for hurting her. Yet, once with her, he repeated the very things he had sworn never to do again.

He discovered that jealousy, like desire, is impervious to reason, and that the heart can be as much an autocrat as the flesh. The thought of her going away left him no peace. With a shudder he would awake at night imagining she had gone away. He would drive to rue des Petits Champs in the morning just to get a glimpse of her as she left the house on her way to work.

In anger at himself he started drinking again. Not too much, however, in fear that she might use his drinking as an excuse for leaving him. As in the days of Marie Charlet, time ceased to flow when he was not with her. The days seemed interminable. He reappeared in Montmartre cafés, where he found his former companions engaged in their everlasting denunciations of *l'Académie* and the blindness of an unappreciative public. Again he killed time by taking long aimless drives through Paris or dropping in unexpectedly on friends. He spent a rainy afternoon with Debussy at work on his opera; he visited Gauzi and learned that his old *atelier* friend was about to be married.

"Une femme parfaite, mon cher! A beauty. Extraordinarily sensitive. A tremendous temperament. And between you and me, an elegant little dowry . . ."

He journeyed to Plaisance, where Henri Rousseau showed him his canvases, played the violin and read him a long speech he planned to deliver at the next meeting of the *Comité Exécutif*. Once more he ferreted out old Desboutins in his basement and found the etcher nervously pacing the floor in a tattered bathrobe, his gray-maned head shrouded in clouds of tobacco smoke and vapors of nitric acid.

"Ha, *mon cher* Lautrec! What a pleasure, what a delightful surprise! Have a seat. You wouldn't happen to have fifty francs, would you? I'm expecting some important sales, but that goddamned landlord . . ."

He derived small comfort from these visits. If anything, they increased his feeling of loneliness. All these people were wrapped up in their own affairs. They had their own troubles and weren't interested in his. Why force himself upon them? He had no real friend but Maurice, and Maurice was busy. Anyway what would *he* tell him? That he was dying of jealousy, terrified at the thought of Myriame's leaving him, that he was losing her through his own stupidity?

Thus autumn drew to a close. October ended in a wretchedness of sodden clouds and dripping eaves.

Henri one morning awoke to find a small bouquet on his bedstand and a card from Madame Loubet wishing him a happy birthday.

A moment later she burst into his room, all aflutter with excitement.

"Happy birthday, Monsieur Toulouse! Guess what? They've caught him!"

"Caught whom?" he asked, sitting up with a yawn.

"Caillette! That monster who strangled that girl last winter."

"About time. It's almost a year since he killed her."

"They caught him in Marseilles. Think of it, monsieur, in Marseilles. Thousands and thousands of kilometers from here."

"Not thousands, Madame Loubet," he smiled. "About eight hundred."

"And you know how they caught him?" she proceeded, unperturbed. "He tried to sell one of her rings to a jeweler and he called the police."

While eating his breakfast Henri learned the details of Caillette's capture. The man had fought "like a wolf." He had climbed on a roof, hurled bricks at the gendarmes. But in the end he had been cornered, overpowered, handcuffed.

"Now they're bringing him back to Paris for the trial. And if they don't chop his head off, then there's no justice."

As was his habit on his birthday, he lunched with his mother. As usual he received Joseph and Annette's congratulations, as well as those of the cook and parlormaid. He did his best to join in the somewhat forced joviality of birthdays and appear delighted at having accomplished the feat of being thirty-four.

It had started raining and Myriame was late when he drove to Place Vendôme. He lit a cigarette, took a few nervous puffs. The lunch with his mother had increased his moodiness, his self-displeasure. Poor Maman! What a cross he was to her! She sensed something was wrong. She was afraid. Well, so was he, for that matter . . . Afraid of Myriame's leaving him, afraid of his drinking, afraid of the future . . . Where would he be on his next birthday? By then Myriame would have left him. It was only because she was a wonderful girl that she had not left him already, told him to go to the devil, he and his suspicions, his questions, his jealousy . . .

Through the rain-blurred window he watched the last em-

ployees leave the service entrance. Why didn't she come? What was keeping her? Probably some old roué pretending to choose a dress for his wife . . . Making propositions to her . . . Perhaps she was smiling at him, slipping his card in the bodice of her dress? And what if she did? What business was it of his? What rights had he over her? Was it her fault if she didn't love him? Hadn't she given him more than any girl ever had? But, no! That wasn't enough! He must also have what she couldn't give. The tinsel of love, the words, the looks, the sighs, the age-old drivelings of lovers in public parks! And if he must be such a fool and fall in love, couldn't he at least have kept it to himself? But, no! He must blurt it all out, like a love-sick schoolboy. And he, thirty-four! That morning at Arcachon, that morning of the "heavenly hour" he had sworn he would spare her the ludicrous sight of the clinging, distracted lover. Why was he harassing her? Why? Goddamn it, why was he doing that to her? Because he loved her. That's all. Because he loved her . . .

When you loved, you stopped being fair, you stopped even being intelligent. You thought with your heart instead of using your brain and you became a cruel, selfish idiot. The heart was a muscle to pump blood, not to think with . . .

"Sorry to be late, Henri."

He hadn't seen her come, and for a moment or two he blinked unseeingly at her.

"Oh, it's you!" he sighed at last with incredible relief. "I was wondering . . ."

"I'm so sorry, especially today, on your birthday. But I couldn't help it. Just before closing time I had one of those customers who don't know what they want and can't make up their minds. I must have shown her every dress in the shop, and in the end she bought a pair of gloves! Ouff, I'm tired!" She smiled at him behind her veil and took his hand. "And you, what did you do today?"

They had dinner at La Tour d'Argent, and he insisted on ordering champagne. They worked hard at being gay, and with the help of champagne they almost succeeded.

"We must celebrate," he said, as they were finishing their demitasses. "Where would you like to go, darling?"

"Home, if you don't mind. Let's go home and sit by the fire. I've had a beastly day and I am very tired. Besides—" she forced a weary smile "—I have a little surprise for you."

The surprise turned out to be a de-luxe edition of *L'Anthologie de l'Estampe Japonaise,* bound in morocco with

his crest stamped on the cover. As always when he was deeply moved, words refused to come. He gulped, ran his fingers over the book and looked at her through moist eyes.

"You—you shouldn't . . ." he managed to say at last.

"I didn't know what to give you," she said, nestling to him on the sofa. "You have everything. Finally I remembered what you'd said about Japanese prints and how much you liked them. I found this. Do you like it, darling?"

"You shouldn't have done it," he scolded tenderly. "It must have cost a fortune. Why didn't you give me a few handkerchiefs?"

"I wanted to give you something you'd always keep."

"I shall. Always."

They had spoken in murmurs, their cheeks almost touching.

After a while he turned and whispered in her ear, "Thank you for being so patient with me . . . Love is a sickness . . . It will pass . . ."

"Do you think so, darling?" Her eyes were heavy with sadness and doubt. "Do you?"

That evening was one of their last joys, although he did his best, reasoned and tried to be firm with himself, pleasant and casual with her. But he was no stoic and no actor. His grief hung over his face like a mask, cried to her from his enormous eyes.

"Why do we go on, darling?" she cried one evening. "We're only hurting each other."

He protested so vehemently, promised so imploringly to mend his ways that she agreed to go on meeting him, giving him whatever bitter pleasure he derived from her presence. And again he tried, harder than ever. Too hard. She found the spectacle of his forced gaiety more pitiful than that of his anguish.

Despite their efforts the breach between them continued to widen. Their moments together became fraught with unspoken reproaches and guarded glances. At dinner he watched every move she made, every look she gave. At the theatre he refused to go out to the foyer during the intermissions. Again he asked questions. Once more she pleaded with him that they stop seeing each other. Once more he begged; once more she forgave.

Finally he realized her patience was coming to an end. They no longer could spend an evening alone without some painful scene. He saw that if he wanted to hold her a little longer he must share her—and probably lose her.

He began introducing her to his society friends. Together

they attended several *soirées mondaines*. He took her to the Natansons' and Missia welcomed this beautiful and reticent girl who knew how to dress, when to talk and when to be silent. Their mutual liking bridged the social abyss between them; they understood each other and became friends.

One night Henri was escorting Myriame to one of Missia's dinner parties. She sat in the corner of the landau, the sable cape he had given her for Christmas unfastened and revealing the décolletage of her black moiré gown. He thought she had never looked so beautiful as she did now, gazing pensively through the window; and he wanted to tell her so, as he had done the night of the Brahms Festival. Then she had welcomed his compliment. They had jested; she had made faces and put out her tongue at him. They had been happy then. But now all naturalness had ebbed out of their friendship. He did not dare say what he thought, for he only thought things he must not say.

"Do you think Monsieur Clemenceau and Monsieur Zola will be there tonight?" she asked as they passed the Arc de Triomphe.

"Most probably, for they both like good food, besides being half in love with Missia. Unless, of course, they are detained by that damned Dreyfus affair. I told you they were both up to their necks in it, trying to prove he's innocent."

Impulsively she laid her hand on his, a thing she had not done for a long time. "I want you to know how grateful I am for giving me a chance to meet all these famous people."

"If you ask me, the chance is theirs," he smiled in an attempt at the old gallantry. "Famous men walk the streets, but beautiful women are rare."

She acknowledged the compliment with a look. "I certainly hope that Dreyfus affair ends soon. If he's innocent . . ."

"Don't say 'if'. He is innocent. Anyone in good faith can see that."

"I hope so. Anyway I wish it'd end soon one way or another." She hesitated. "Things are getting rather difficult at the shop. I don't know how long they are to keep me. Yesterday one of our best customers asked me point-blank if I were Jewish, and when I told her I was, she called the manager and said she wouldn't patronize the store any more. You'd think it was I who'd sold those plans to the Germans!"

Her words filled him with mixed feelings. Perhaps if she lost her position she would let him help her . . . On the other hand, she might accept more readily some other man's proposition . . .

"I am sure the firm won't let you go on account of some stupid old woman. Even if they did you wouldn't have any trouble finding another position."

"I am not sure. Other firms wouldn't like losing customers on my account either. Anyway I certainly hope this Dreyfus thing comes to an end, once and for all . . ."

Nothing had changed: the marble-floored hallways, the bowing white-gloved footmen, the drawing room with the portrait of Missia in a cloud of pink tulle over the fireplace, the ladies in trailing gowns and the men in evening clothes making conversation . . . Yet everything *was* changed. The air had a density of omen, an oppressiveness of disaster in suspense. The men looked grave and spoke in low tones; the women seemed to have lost their coquetry. The shadow of the Dreyfus affair hovered over the house.

As they paused on the marble steps that led into the drawing room Henri and Myriame could hear Zola reading in subdued yet booming tones from the sheaf of papers he held in his hand. When the last *"J'accuse"* had dissolved into breathless silence, Henri recognized Clemenceau's familiar chuckle. "When this letter is published, my dear Missia, you're going to lose two very faithful dinner guests. You will have to send us our portions of roast pheasant in prison."

Missia Natanson hastened toward the newcomers. "Forgive me. Monsieur Zola was reading an article he has just written and which is going to be published in *L'Aurore*."

A moment later they filed into the dining room.

"And now," said Missia, with a sweeping glance around the table, "I beg of you! Not a word about Dreyfus during dinner. My chef is threatening to give notice. He says he's wasting his talents and nobody appreciates his *cuisine* any more. Let's talk art, music, scandal if you wish, but not a word of politics!" Then turning to Anatole France, who was unfolding his napkin, "What have you been doing lately, *mon cher*, now that you are a member of our illustrious Académie Française?"

The academician let out a sigh. "Writing, my dear Missia, nothing but writing. At my age work is the only pleasure left, and believe me, it is the dullest of pleasures."

As by enchantment the joviality of Missia's dinners returned. Men furbished their wit; the women remembered their laughter. Henri toyed with his food, small-talked with his neighbors, listened to the conversations in progress around the table.

"A woman, *cher monsieur,* can be a wonderful wife or

a wonderful mistress, but it is asking too much of her to be both to the same man . . ."

"Never loan books, my dear Missia. Why, I built my library with books that had been loaned to me . . ."

"Have you seen those new contraptions they call automobiles? . . ."

"Of course Jesus forgave the adulterous woman! He wasn't her husband! . . ."

"Did you notice that collectors of modern art always get academicians to paint their portraits?"

Covertly Henri watched Myriame across the table. She was listening to Jules Dupré, an aggressive bull-necked man who had amassed one of the largest fortunes in France. He hoped she would look at him, but she kept her eyes lowered, a faint, enigmatic smile on her lips. Thank God, she looked bored . . .

Instead it was Jules Dupré himself who caught his eye and leaned forward to him.

"I was telling Mademoiselle Hayem about a certain Caillette, a Montmartre pimp who murdered one of his girls a while ago. We're about to publish a serial about him, as soon as the trial is over and he's executed. Have you heard of him?"

"Heard of him! My concierge has been talking about him for about a year. I understand he's been caught at last and brought back to Paris."

Dupré nodded. "It's just the kind of story our readers love, and I've assigned one of my men to embroider the facts and write me a serial. We should start publishing in about three months. You wouldn't be interested in making a poster for it, would you?"

"I—don't think so," said Henri, taken by surprise. "I don't do many posters nowadays. Besides, in a few months I'm supposed to go to London for my show."

Myriame was smiling at him across the table and he thought he detected a hint of encouragement in her eyes.

"And yet—wait! Perhaps I can manage it. A man walking to the guillotine should make a great subject for a poster . . ."

He was in high spirits as they drove back to rue des Petits Champs.

"Yes, it should make a striking poster, don't you think? They say Da Vinci used to attend executions and sketch the faces of the condemned men. Not that I am a Da Vinci . . . The most formidable expression of terror ever caught by an artist

is in Michelangelo's "Last Judgment" in the Sistina. It is of a man who learns he's been condemned to hell. You only see half of his face, but it positively freezes your blood. By the way, why did you nod at me?"

"I didn't. I smiled because I hoped you'd make that poster. You should make a very beautiful thing of it. Perhaps you'll let me watch when you print the first proof. Do you think Père Cotelle would object?"

"Of course not. He will pull his beard, scratch his head, make you feel he's doing the most difficult thing in the world, but he will be delighted. Incidentally, how did you like Dupré?"

"Not very much. He's clever, but crude and terribly conceited. He likes to flaunt his wealth about. He must have told me a dozen times about his racing stable and his yacht in Monte Carlo."

When the carriage halted in front of her house, she drew her cape around her shoulders and kissed him good night. "I enjoyed my evening," she said. "I'd ask you to come up, but it is very late."

"I understand," he nodded, trying to conceal his disappointment. "Tomorrow then?"

"No—not tomorrow, Henri, if you don't mind. We've been out almost every night this week and I'd like to catch up on my sleep. Let's make it the day after tomorrow. You don't mind, do you?"

"Of course, I do," he smiled. "I mind very much, but I understand." Two days without seeing her, an eternity . . . "Good night, darling. Friday, the usual place."

He watched her cross the snow-covered sidewalk, her skirt swirling about her ankles. At the door she turned to wave. Then there was only the night, black and empty.

During the following weeks he saw less of her. Occasionally she offered some excuse and declined to meet him at their usual rendezvous. Nevertheless he drove to Place Vendôme, watched Paquin's entrance from afar, hoping and dreading at the same time to see her meet someone. But she never met anyone and walked directly home. Yet when he was with her he could not hide his suspicions, asked questions, sought to trap her into conflicting statements.

Finally she could not stand it any longer.

"We can't, we simply can't go on like this!" she cried one evening, pressing her palms against her temples. "I wouldn't let any other man do what you are doing to me!"

"Because you feel sorry for me, is that it? You pity me because I am a cripple. Say it! Say it!"

"Stop it! Stop it, Henri, for Heaven's sake! You don't know what you're saying. You've spoiled everything between us. I am sorry I ever met you. Yes, I am! I don't want to see you any more!"

Her words brought him back to his senses. His face turned ashen.

"Please, Myriame, please, don't send me away! I couldn't live without you. You're all I have. I'll never ask questions again, I'll never doubt you again. But please, don't send me away!"

Hopelessly she looked into his tormented eyes. She saw the trembling of his swollen lips, his pitiful legs.

"All right," she moaned. "All right. Let's try once more."

However, they had a few happy moments together. They returned to the Louvre, looked again at Venus de Milo. At last he told her the story of Filippo Lippi and his Madonna.

"Her name was Lucrezia Buti. She was Florentine, young, blonde—and a nun. He was past middle age and a wandering friar. He saw her when he was painting a mural in the chapel of her convent and begged the Mother Superior to let her pose for him. During the sittings they fell in love, and when the mural was finished they fled together. And, as we say in the French fairy tales, they had many children and then they were married and lived happily ever after."

One day he said to her. "You know the Clemenceau book? I've finally started work on it. As I told you, it's a collection of Jewish short stories. I wonder if you'd show me the Temple district. I've never been there and I'd like to make a few sketches."

To Henri the drive through the Jewish district was like a journey in a foreign, mysterious world imbedded in the heart of Paris. Here signs were written in Hebrew and people spoke a tongue he did not understand . . . Myriame showed him the tenement where she had grown up in want and loneliness. She told him anecdotes about the places and the people she had known: the baker where she had bought the unleavened bread for the Passover, the synagogue on rue de Nazareth, the municipal pawnshop where she had pawned her mother's earrings to buy medicine. Along the way they heard violin music drifting from black holes in slimy culs-de-sac. They caught glimpses of Rembrandtesque interiors, junkshops, secondhand basement-stores where stooped-shouldered old men in skullcaps and caftans crouched in the shadows, dreaming vacantly of some Promised Land. They lunched in a little restaurant that reeked of onions and fried grease . . . At

dessert she told him Jewish stories and for the first time in weeks they laughed freely again.

"Why couldn't it always be like this?" she said as they were driving home. "It could be so nice."

Another Sunday he took her to Versailles. It was a playful day with sudden gusts of wind that moulded her skirt against her thighs and threatened to blow her new boater away. They visited the King's apartments, the Galerie des Glaces, the Chapel, wandered through stately and mournful rooms. Finally they grew tired of gilt and *rocaille* and went out into the garden. They sat down on a stone bench and listened to the birds.

"You see that window?" he said, pointing his rubber-tipped cane. "That's la Pompadour's window. She was sitting by it when she died. As you know she couldn't lie down."

He told her the story of the great courtesan and how she had died in her *bergère*, mouched, rouged and powdered, looking at the same landscape they were looking at now.

"What a handsome way to die!" he finished.

On a bleak March dawn, Henri witnessed Caillette's execution. He sketched the murderer, his head shaven, his face distorted with fear, as he crossed the cobbled yard of the Roquette Prison and shambled to the guillotine. He saw the flash of steel, the spurt of blood, the absolving gesture of the priest. One hour later he was hunched over a stone in Père Cotelle's shed.

In a few days the poster was ready, and Myriame came to see the printing of the first completed proof. With joyous excitement she watched the old artisan ink his rolls, grumble prophecies of disaster, pull back his skullcap, set the stones and finally heave on the wheel of his flat-bed press.

"It's beautiful," she cried, holding the poster at arm's length. "It's horrible, but beautiful. Henri, you *are* a great artist."

A few minutes later Jules Dupré arrived, apologized for his delay and showered compliments on Henri. "Your best yet! When you return from London you'll see it on every wall."

Toward the end of April Henri took Myriame to Eragny to spend the day with Camille Pissarro. They left Paris by an early morning train, changed later to a clanking, puffing *train de campagne* which stopped every few minutes for no apparent reason and trumpeted its passage through sleepy villages with joyous, frivolous squeals. Pissarro was waiting for them at the station, looking more than ever like some Biblical shepherd in his long flowing cape, his brogues and round

hat. They lunched *en famille* under a budding chestnut tree, the children doing the service. At dessert the old artist lit his huge curved pipe and between puffs recalled the early days of Impressionism, the evenings at the Café Guerbois with Manet, Degas, Zola, Cézanne, Renoir, Whistler; the heated discussions about open-air and blue shadows; the long years of poverty. But there was no bitterness in the old painter's filmy eyes.

"All that was long ago, long before you were born," he said, grinning at Henri across the table, his face half-hidden behind smoke, like some benign Olympian. "I used to think I should have stayed home, on Saint Thomas Island. Oh, by the way, I got a letter from Gauguin. He's in the Marquesas now, living in a hut, in great pain and dying of loneliness. Poor Paul! He's one of those people who can't adjust themselves to life. Vincent was like that. They find peace only in death."

They strolled through the small weedy garden, peered into the master's studio nestled in a clump of old trees. As he was driving his guests back to the station in his modest buggy, he suddenly turned to Henri. "If you see Degas, give him my regards. We don't see each other any more since that miserable Dreyfus affair . . . A pity, isn't it, to see an old friendship break on a thing like that! He thinks all Jews are German agents. You can't reason with him. Poor Edgar, he isn't very happy. His eyes are failing him, like mine. He is lonely and has only his bitterness for company. And bitterness is poor company."

As his departure for London approached, Henri grew increasingly moody and restless. A vague apprehension gripped him at the prospect of leaving Myriame alone in Paris. Three days before he was scheduled to leave he bluntly told Maurice he would not go.

Maurice gulped at the news. "Not go?" Panic, then anger fleeted across his face. "NOT GO?" he roared this time. "Are you out of your mind?"

"They have my paintings, haven't they? That's what they want, isn't it? They certainly don't want to look at me. Then why should I go?"

"Why should you go?" Maurice's blue eyes sparkled exasperation. "I'll tell you why you should go. Because I been working more than a year on that show. Because your arrival has been announced in the press. Because interviews have been promised. Because a dinner in your honor has

been planned. Because Mr. Marchand needs your advice to hang your pictures. And finally, because the Prince of Wales . . ."

"Oh, yes, damn it! I forgot he was opening my show. Very gracious of him."

"Gracious. Listen to him! Good God, what's the matter with you, Henri? You don't seem to realize the honor the prince's doing you!"

"Honor?" It was Henri's turn to flush with anger. "Now, look here, Maurice. As a friendly gesture I appreciate the prince's visit, but if we're talking about honor, I'd like to know who's honoring whom? By the beard of Saint Joseph, Maurice, do you know who I am? I am Comte de Toulouse! A Toulouse was leading the Crusades and a cousin of mine was king of England when the Saxe-Coburgs were only Thuringian peasants!"

It took the combined powers of Maurice, Missia and Myriame to convince him he should go.

"All right," he agreed grudgingly. "But only a week—not a day more."

Myriame accompanied him to the station, sat with him in his compartment before the train's departure.

"Only a week," he murmured, filling his eyes with her loveliness. "You will write, won't you? Remember the address. 'Claridge, Grovesnor Square.' Should you need me, darling, should you need me for any reason, any reason whatsoever, telegraph me. I'll come immediately."

They remained silent for a moment, listening in their minds to the ticking away of the last seconds.

"When I return, things will be different, you'll see . . ."

She did not move, did not seem to hear what he said, but merely stared at him with blurred intensity, as if trying to speak to him with her eyes.

"Soon it'll be summer," he said, pressing her hand. "We'll go back to the Arcachon. Remember the bay, the terrace, our little room . . . We were very happy, weren't we?"

Tears rolled unnoticed down her cheeks. "Yes, very happy. I'll never forget it."

The locomotive let out a piercing whistle. A clanking shudder rippled through the length of the train.

"Good-bye, Henri . . ." She kissed him on the lips. "Good-bye, darling . . . Don't forget me."

As the train started to move, he thrust his head and shoulders out of the window, waved his handkerchief.

"Only a week!" he shouted at the receding white blur that was her face.

Then he could see her no more, but he stood at the window, his hair ruffled by the wind, still waving, staring at nothing.

Goupil's was a strictly de-luxe establishment, and no nonsense about it. The poor and the meek might get into Heaven, but they just didn't get into Goupil's. At one glance its formidable doorman could estimate the bank account of any approaching visitor and accordingly his manner turned obsequious or stonily forbidding. Inside all was silence and refinement. The mercantile bustle of Regent Street was shut off by thick velvet portieres, and the crude daylight had to filter through lead-glassed Tudor windows before being allowed to rest on the gallery's bituminous, gilt-framed paintings. There was about the place an air of rarefied and inflexible ennui, an atmosphere of heavenly boredom as if "Art" dwelt within its velvet-draped walls, yawning itself into eternity. In the cathedral-like dimness business was transacted in ritual whispers and the high-collared clerks in cutaways and pin-striped trousers delivered their sales talks with the gestures of altar acolytes.

As for Mr. Spencer Dawson Marchand, the director, he was well-nigh invisible to the mortal eye, except in rare moments of crucial emergency when the sale of some dark and glossy canvas hung in the balance. Then, and only then, did he emerge from his office, pink-cheeked and deadly, his shiny pate exuding bonhomie and superior knowledge. With the refinements of a *grande amoureuse* he enlaced the hesitant client, massaged his ego, caressed his vanity, numbed his brain with such expressions as "the polyphony of pictorial tones, the cryptic synthesis of chromatic values." The unequal conflict came to its inevitable end in the privacy of the directorial office, to which the painting had been deftly moved. There, in the fragrance of fine sherry and Havana cigars the perplexed art-lover finally saw the light: now he understood the artist's innermost intentions, discovered unseen beauties in the canvas he was about to acquire, savored in anticipation the envy of his friends and finally signed the check. Goupil's had made another sale.

Mr. Marchand was in his most effusive mood this morning when Henri shuffled through the portieres of his office.

"I trust you enjoyed a good rest after the wearisome Channel crossing, monsieur? If I may say so, you did look rather tired when you arrived yesterday. Is your hotel satisfactory? Good.

Now we can get to work. I've just received the bill of lading, and your canvases will be delivered this afternoon. I cannot tell you how great is my excitement at the prospect of examining them."

"You haven't seen them?" asked Henri with surprise. "Any of them?"

"No, I regret to say, I haven't. I know you specialize in scenes of the Parisian night life, but I dare say a touch of realism won't be out of place, especially since it comes from France . . . Hahaha! You don't mind my little joke, do you? You know, Paree, gay Paree and that sort of thing . . . I was in Paris in '89 for the Exposition and able to judge for myself of the amenities of your delightful city. As I was saying, I've felt for a long time that our gallery ought to take an interest in contemporary art. A firm as important as Goupil's cannot remain static and must show a catholic interest in all the various expressions of artistic endeavor, don't you think?"

"By all means," approved Henri absently.

"When I read the accounts of your successful show at the Galerie Joyant last year and learned that His Majesty the King of Serbia and such a discriminating collector as Comte Camondo had purchased canvases, I knew Goupil's was the firm to introduce your work in London. I immediately opened a correspondence with Monsieur Joyant and I must say it's been a most satisfactory experience. The short biographical notice he sent me about you has been widely reproduced in the press and created an unusual amount of interest among the art-loving public. All London will be here Thursday—I mean all the London that counts. Of course, when an aide-de-camp came to inform me that His Royal Highness would graciously consent to inagurate your exhibition—an unprecedented honor, monsieur—I knew I had secured a priceless attraction for our firm. And now, monsieur, if you wish we can go over the list of the various engagements that have been scheduled for you during your brief sojourn . . ."

For Henri the following days were spent in a breathless whirl of activity. He liked London, the stateliness of its monuments, the orderliness of its crowds. It was nice seeing Piccadilly again, Trafalgar Square and the Nelson Monument—so much like the Colonne Vendôme—with its pedestal of supercilious lions; driving in hansoms; seeing the white-gloved bobbies in their funny helmets, looking like toys grown up to life size; being entertained by Conder, Rothenstein and other British artists he had met at various times in Paris.

But his pleasure was spoiled by the absence of news from

Myriame. He had been disappointed at not finding a telegram
from her on his arrival, but had argued with himself that she
was a sensible girl who sent telegrams only when she had urgent
things to say. Obviously she had nothing urgent to tell him . . .
The two following days had brought no mail, and his impatience
had turned to anguish. Why, why wasn't she writing? Why
hadn't she thanked him for the flowers he had had delivered
to her after his departure? Was she too busy to write? Was
she ill?

His anxiety hung over him like a spell. Journalists had to
repeat their questions during interviews and received absent-
minded, almost incoherent answers. Their after-lunch speeches
at the Chelsea Club were a confused drone in his ears. Why,
oh, why didn't she write?

For a moment Marchand's panic at the extreme realism
of his paintings had held a hope of escape.

"You're absolutely right," he had concurred with enthusiasm.
"They are too sordid, too brutal. They just don't fit in a place
like this. They will arouse a storm of unfavorable publicity.
Besides, I doubt whether you'll make a single sale. Why don't
we call the whole thing off? I'll be glad to refund all expenses."

His hopes had crumpled when the art dealer had shaken
his head. "Too late, monsieur. His Royal Highness is coming.
The critics are coming. The invitations have been mailed.
It is too late! All we can do—as we Britishers say—is to keep
a stiff upper lip and carry on."

On the opening day Henri's nerves had reached the breaking
point. Two more telegrams to Myriame had remained unan-
swered; a telegram to Maurice had brought no reply. This
time there could be no doubt. Something was wrong, terribly
wrong. Why had he come to this damn country? Why had he
ever left Paris? He had spent the previous night alone in his
hotel room, drinking whiskey, torturing himself with these
questions, conjuring images that made him rake his fingers
through his hair or bury his face in the crook of his arm.
Myriame, modeling décolleté gowns for some libidinous pluto-
crat; Myriame, dining at Voisin's with some handsome and
wealthy admirer; Myriame, ill, bedridden in her little room,
unable to contact him; Myriame, victim of an accident, lying
on a stretcher, rushed in an ambulance to a hospital, dying
in a ward.

He was sick with anxiety and burning with fever when he
arrived at the gallery that afternoon. He did not notice the
flower baskets, the clerks in their cutaways. Pushing himself
with his cane, he shuffled through the velvet portieres of the

exhibition room. It was empty, stifling with the perfume of gladioli, curiously still in the atmosphere of almost unbearable expectation that weighed over the gallery.

Yes, something was wrong and he should have remained in Paris . . . He slumped on the green plush sofa. Well, tomorrow he would know what was going on. There was a train for Dover at six this evening, and, by God, he'd be on it! He'd just have time to rush to his hotel, take off this idiotic cutaway and drive to the station. Tomorrow he would be in Paris . . . Never, never again would he go through such agony! If he went to New York next year he would take Myriame along. Never, never, never would he let her out of his sight! . . . Why hadn't she written? It wasn't like her—a girl who had gone to endless trouble to locate that *Anthologie de l'Estampe Japonaise* for his birthday . . . How sad she'd looked those last few minutes in the train compartment! How sad, and how lovely! God, how hot it was in this room.

He raised his eyes, gritty from lack of sleep, ran a finger around his collar. No air, no ventilation . . . These damn galleries were always overheated, even Maurice's . . . Observing he had not removed his top hat, he took it off and laid it cautiously, crown down, on the carpet. Then he glanced at his watch. Almost an hour to wait! Well, tomorrow he would be waiting, but then it would be a happy wait at their usual rendezvous. Myriame!

As his mind brought him the image of Myriame emerging from Paquin's employees' entrance and rushing toward the landau, he stretched out on the sofa. Now she was waving to him, smiling at him through the carriage window, her face aglow with pleasure. And she was telling him how much she'd missed him, and she couldn't understand why he hadn't received her telegrams, her long letters . . . But it didn't matter now that he was back, for, while he was away in London, she had discovered she loved him—yes, she loved him . . .

What had begun as a thought continued as a dream. A smile on his lips, his hands crossed over his chest, he slept, dreaming away the longings of his heart.

"Monsieur! Sir! I say, this is outrageous! I'd been warned he was a drunk. I should've had him watched! By Jove, these blasted Frenchmen . . ."

At first Henri was only conscious of the rocking of his body and a booming noise in his ears. Then he felt the pressure of a hand on his shoulder. Someone was shouting at him ex-

citedly. Through half-opened lids he had a swimming image of a crowd surrounding him and Marchand bending over him, a new Marchand, grimacing, purple-faced with rage. He blinked, struggled to a sitting position, rubbed his eyes.

"I must've fallen asleep," he mumbled groggily. Then, with a start, *"Mon dieu, le prince!"*

"His Highness has come and gone!" sputtered Marchand. "Come and gone, d'you hear?"

Henri stared at him. "Why didn't you wake me?"

"Why? Because His Highness gave orders to let you sleep."

A broad, vacant smile widened Henri's lips. Nice man, the prince . . . Very considerate of him . . .

Still grinning, he studied the crowd around him, let out a sudden gasp. *"Mon train! Mon train! . . . Quelle heure est-il?* What time is it?" he repeated fumbling for his watch.

"Five o'clock," said someone.

"Cinq heurs! O mon Dieu! . . ."

Now he was wide awake, snatching his top hat from the ground, reaching for his cane, pushing himself off the sofa.

At the door he turned around, bowed to the crowd. *"Mes excuses, mesdames et messieurs, mais j'ai un train à prendre* . . . A train to catch . . . *Vous comprenez, n'est-ce pas? C'est très important* . . . Very important . . . My respects, ladies and gentlemen . . . My regrets to His Highness . . ."

A last circular bow and he was gone. The velvet portieres shuddered an instant, then hung still.

The train was speeding through the Paris suburbs. Already he could distinguish the familiar silhouette of the Eiffel Tower. Knuckles against his cheek, he watched the telegraph posts flash across the window of his compartment. He had tried to count them to occupy his mind, but had lost track. Another half hour and he'd be in Paris! He would have time to go home and wash before driving to Place Vendôme.

Suddenly, without warning, a thought exploded in his brain, and the shock was so great that for a moment he gazed, wide-eyed and open-mouthed at his reflection in the window. Fool, unspeakable fool, why hadn't he thought of it sooner? But, of course, this was the solution! This was what he should have done that day at Arcachon instead of insulting her with offers of money! He should have proposed to her! He had been so obsessed with the dread of losing her, he hadn't thought that marriage was the surest way of never losing her . . . Perhaps that's what she had expected and why she had looked so hurt when he had spoken of money. She was right, a

thousand times right. Money would only debase their relation-
ship. It wasn't money he should have offered, it was his name!
Please, God, don't let it be too late!

Tonight in her little room he would make amends.
"Myriame," he would say, "please come and sit close to
me." For a moment they would gaze, hand in hand, at the fire.
Then, gravely, tenderly, he would say, "Myriame . . ."
How well she would bear his great and ancient name! Myriame,
Comtesse de Toulouse-Lautrec . . . She would take her place
among the exotic-named princesses who had married other
Toulouse-Lautrecs. Sibille, Princess of Chypre . . . Richilde,
Princess of Provence . . . Elvire, Princess of Castile . . .

The train clattered through the approaches of the station,
came at last to a shuddering stop. Already he was climbing
down to the quay, elbowing his way through the crowd.
Halfway to the door he realized he had left his valise in his
compartment, but did not turn back.

"Twenty-one, rue Caulaincourt," he cried to the *cocher*.
"And a five-franc tip if you hurry."

It was good to be back. The whiskered gendarmes, the
women's springy gait, the flower merchants, the striped awnings
of cafés . . . He noticed his Caillette poster on the walls,
but was too preoccupied to give it more than a fleeting thought.

"Wait," he said, when the landau reached the house. "I'll
be back in a few minutes."

Madame Loubet was not in her lodge, and her absence
dampened his spirits for a moment. Neither was she in his
studio, as he had hoped. It would have been nice to see her.
Instead the room was plunged in dimness, the stove unlit.
In the huge window the sunset gashed the sky red.

He had washed, changed clothes and was about to leave
when he heard Madame Loubet's clumping footsteps.

The door opened.

"Those steps!" she panted, "They're getting steeper every
year. Sorry I missed you, Monsieur Toulouse. I went to church
to . . ."

"What is it, Madame Loubet?" he asked sharply.

He knew something was wrong. He knew it by her face.
He was rooted to the floor, but felt himself tremble from head
to foot, as Marie had trembled that day . . .

"What is it?" he repeated.

For the first time she looked at him. Her eyes were wide,
dry and mortally sad.

"Better sit down, Monsieur Toulouse."

That's what he had said to Marie that day . . . He could

not speak but stared at her, his gaze unfocused, as she pulled
an envelope from her apron. The trembling of his body made
his teeth chatter. Dying must feel like this . . .

"The mademoiselle brought it the day you left . . ."

He tore open the envelope, raised the letter close to his
shortsighted eyes.

> "I am leaving tonight with Monsieur Dupré.
> It is better this way, *chéri* . . ."

THE CURTAIN

FALLS

XX

"Absinthe! Nom de Dieu, Victor, bring me another absinthe! And be quick about it!"

"Excuse me, Dodo," Victor said to the man standing at the counter. "You know how these drunks are . . ."

Aloud he said, turning toward Henri's table, "Now, Monsieur Toulouse, don't you think you've had enough?"

"You miserable lout, bring me another absinthe or I'll break everything in this . . ."

His roar ended in an unintelligible slur. His head sagged, rolled down on one side and with a sickening thud bumped against the marble-topped table.

"Perhaps he's hurt himself?" said Dodo with concern.

"Drunks never hurt themselves. And this one least of all. He should be dead with all the bumps and stumbles he's taken."

He glanced over his shoulder at Henri's prostrated form.

"Look! He's sleeping now."

With a clucking sigh, he shrugged and wiped a glass.

"For a year I've told him to take his trade somewhere else. But, no, he keeps on coming back. He's got troubles. Now, everybody's got troubles, isn't that a fact? When he sleeps like that it's not so bad, but it's when he awakes! Sometimes he wants to fight. Now just take a look at him. If you blew on him, he'd fall flat on his face. But he don't care. Sometimes he reads the same letter over and over again and cries like a baby. You'd think he'd know by now what's in that letter, but, no, he keeps on reading it."

"Some girl probably," ventured Dodo, removing his damaged derby to scratch his head. "Nothing like a girl to get you in trouble."

"Isn't that a fact!" agreed Victor. "Then sometimes he sings.

That's the worst of all. You'd never guess the voice he's got, that little man. You can hear him down the street. And can I do anything about it? Not a damn thing! Why? Because he's a friend of Patou's. You know—the *rouquin*. And Patou told me the same as he told all the bistros in the district, 'If anything happens to him, I'll put the screws on you.' Now, nobody in his right mind likes having difficulties with the vice-squad chief, does he?"

"Nobody," concurred Dodo, who was now picking his nose.

"I tell you life is no end of trouble," moaned Victor in self-pity.

"Everybody's got troubles," confirmed Dodo, exploring the other nostril.

"Yes, but not like me! And of all my troubles—" he pointed an eloquent thumb at Henri "—he's the worst."

"Absinthe! Absinthe! Where's my absinthe?"

Henri had suddenly awakened and was rapping his cane on the table.

"See what I mean?" sighed Victor.

He walked to the end of the counter in the direction of Henri. "You know I only get in trouble with Patou . . ."

"Patou! He's a big fat pig, that's what he is. Bring me an absinthe, I tell you. No! Come here. I want to speak to you. COME HERE!" he thundered.

Reluctantly the man shambled to the table.

"What is it?"

Henri examined him with intense interest.

"Now, Victor, you and I are old friends, aren't we? You're a man of worldly wisdom and deep insight. Don't say 'no'! I can see it on your handsome face, your witty mouth, your sparkling eyes. Now, Victor, between us, what d'you think of women?"

"Personally, in my opinion and if you want to know what I think, women are nothing but trouble. Take my wife, for instance. She snores, whistles and talks in her sleep. Sleeping with her is like trying to sleep with the whole goddamned Opéra Comique."

"That's terrible! Have you tried tying a pillow on her face?" sympathized Henri with the effusive solicitude of drunkards. "A friend of mine did and it cured his wife. She not only stopped snoring, but she stopped breathing altogether. Now go back and get another absinthe and then we'll have a real talk . . ."

As he spoke the ache from his blow reverberated in his

head in rippling circles of groggy painfulness. For a few seconds he stared at Victor, with swiveling eyeballs as if trying to follow his whirling image. Then once again his head slumped to one side and lurched forward on the cushion of his sleeve. Without warning he felt his gorge rise. A spinning blackness engulfed him and he let out a low gurgling croak. He was going to vomit . . . Already he could taste the bitterness of bile. He remained humped, not daring to move, trying to hold his breath. Then the pressure in his throat lessened somewhat and he began to breathe more freely. With a grunt of relief he raised his head, groped for his pince-nez. Phew—that was better! Indigestion, no doubt . . . But he hadn't eaten since breakfast . . . Hunger, then! That was it. He was hungry. Still he didn't feel hungry, but perhaps . . . His body stiffened. Bile was surging into his mouth with the force of champagne gushing out of an uncorked bottle.

Blindly he felt for his cane. One hand over his mouth he staggered to the latrine. As he pushed open the door the stench of the place stopped him short. For a moment he reeled on the threshold, his eyes closed; then he lurched forward, bent over and retched. The pounding in his ears seemed to burst his skull. His knees buckled. With his free hand he clutched at the wall and held himself up by the sheer pressure of his fingertips.

The spasm subsided, only to return a few seconds later with renewed violence. The ground rocked and the walls converged upon him. His shoulders heaved, his gullet blocked and through it came a sibilant rattle. A rivulet of spittle and bile drooled from his mouth. The nausea abated unexpectedly and his lungs clamored for air. Weakly he ran the back of his hand over his mouth. Sweat trickled down his cheeks and lost itself in his beard. For a few seconds he remained like this, swaying, waiting for the retching to start again. It did not, and with extreme caution he pulled out his handkerchief, wiped his mouth, ran it down the sides of his face, brushed some filaments of saliva from the lapel of his coat.

He hobbled back to his table, tried to raise his hand, but was unable to lift his arm. He slumped across the table, and all turned black. Time ceased to exist—time and pain and memories.

For a long while he floated in oblivion, total and vapid as death itself.

Then out of this nothingness came a voice, clear yet incredibly distant.

"Monsieur Toulouse! Wake up, Monsieur Toulouse!"

He did not move. The warmth of his hand felt pleasant against his cheek.

"Come on, Monsieur Toulouse, wake up! WAKE UP!"

The voice was becoming louder, disagreeably so. Someone was shaking his shoulder. He forced open his lids but could see only the tip of his nose squashed against his knuckles and the tiny black hairs on the backs of his fingers.

"Come on, be sensible, Monsieur Toulouse. Time to go home."

He raised his face, recognized Patou in his derby and black overcoat.

"Oooooo—it's you!" He grinned foolishly.

"Yes, it's me." The detective held out a cup of black coffee. "Now you drink this, Monsieur Toulouse. Everything's all right."

"What—are—you—?"

He wanted to say "What are you doing here?" but the words died on his tongue. His lids closed, and with the irresistibleness of a toppling tree, his head slumped back on his arm.

Nothingness closed in once more; but this time ringed with a fringe of subconscious alertness, as though a part of him remained awake. He was aware of a jumble of whispering voices, followed by the weird sensation of being lifted bodily under the armpits and carried off. Then there was the cold dampness of dawn bathing his face, sluicing through his sleeves; the gentle oscillation of a fiacre against a rhythmic background of hoofbeats, "Clip clop, clip clop, clip clop"—like giant raindrops falling in a tin basin.

He awoke in midafternoon with a headache, a foul taste in his mouth and a vague feeling of guilt. Something had happened, but what? He nuzzled his face into the pillow, tried to recapture the oblivion of sleep. But the machinery of consciousness was now at work and sleep would not come.

All right, what *had* happened? His hands clasped behind his head he interrogated the ceiling, endeavoring to reconstruct the previous night's events. He had left the studio late in the afternoon, walked down rue Caulaincourt and . . .

"Oh, my God, I forgot again!" he gasped with irritation at his absentmindedness.

It was the third time he'd forgotten an appointment with Maurice. Maurice, of all people! This was getting serious. He was rapidly losing all his friends. Missia had been furious last time. And flowers and apologies hadn't helped . . . Hostesses didn't like empty chairs at their tables. Like a broken

front tooth . . . That's what liquor did to you. Made you forget. Gave you splitting headaches, too. And the only thing for headaches was a swig of cognac . . .

He walked to the table, grabbed the bottle and poured himself a drink. Alcohol cleansed the furriness of his mouth, burnt his raw inflamed throat and made his eyes water. But his headache was better. Another drink and he would be all right.

He was about to drain the glass when there was a knock on the door. The shock jarred his nerves.

"Come in for heaven's sake!" he bellowed. "Come in!"

Maurice stood on the threshold, unsmiling, looking at him.

"Well, what's the matter?" Henri barked at him. "Never seen a man have a little drink before?" His shame at being caught like this, bottle and glass in hand, his hair tousled, his clothes rumpled, spurred his anger. "Are you coming in, or aren't you?"

He wanted to rush to him, take his hand, beg forgiveness, but a perverse resentment flared in him at his friend's neatness, his handsomeness and gravity. Maurice, too, looked down upon him because he drank a little too much. Like Madame Loubet. like everybody in this goddamned sanctimonious world . . .

"I suppose you want to know why I didn't come last night. I have a perfectly legitimate excuse. Perfectly legitimate. Something unexpected . . ." It was farcical, sickening, this lying and shouting at Maurice—Maurice, the blood brother, the friend of always . . . Why didn't he shout back? Why didn't he get angry? "I suppose you came to snoop, find out what time I came home. *Nom de Dieu,* say something! Don't just stand and gape!"

He tossed down the drink, thumped the glass on the table, walked back to the couch in short, jerky strides and stretched out.

"I didn't come to discuss last night." Maurice closed the door noiselessly and crossed the studio. "I came—I see I shouldn't have come at all. I'm sorry."

"Well, now you're here, what do you want?"

"There's a lady who'd like to have her portrait painted. Three thousand . . ."

"What would I do with three thousand francs? Buy more cognac? Besides, I'm too busy. Lots of work . . . I have great plans . . ."

"I see," said Maurice quietly. "Well, I won't disturb you any more." There was heavy silence. "Good-bye, Henri."

When the door was closed, Henri covered his face with his hands. "He's gone," he muttered brokenly, as if he had learned of the sudden death of his friend. "How could I, how could I speak to him like that?" Oh, liquor! Abruptly the episode of the Apollo Bar returned with haunting clarity: the foul latrine, the retching, the drunken stupor, the drive home. God, to what depths he had fallen! He, Henri, Comte de Toulouse! His father had been right. He *was* headed for an early and miserable end. Oh, liquor!

He remained hunched on the couch, his face in his hands. Perhaps . . . Perhaps it wasn't too late? Some people did stop drinking. But even as these thoughts raced through his mind he was aware of a growing desire for another drink. Just one—the last! Saliva flooded his mouth in reflex to the thought. No, he mustn't stay here, with all these bottles around. He must go. But where? There were bistros everywhere. Maman's. He'd be safe there near her. He'd be able to resist.

With trembling hands he laced his shoes.

"I must resist . . . I must resist . . ." He was still repeating the words to himself through clenched teeth when he rang the bell of his mother's apartment. The drive had been a torture. All those cafés, those bars where you could have one drink, two drinks, three drinks, just for the asking. But he had resisted. He had battled every minute, every second of the way. And there had been regiments of minutes, armies of seconds. Now at last he was safe.

"I'm glad you came, Henri," said his mother from her wing chair as he burst into her sitting room. "I haven't seen you for a long time, and I want your advice. But first you must eat something."

She turned to Joseph, who had opened the door. "Bring another cup and some biscuits for Monsieur Henri, please."

As soon as they were alone Henri kissed her, letting his lips linger on her cheek as though he wanted to absorb some of her tranquil strength. "Oh, Maman," he whispered in her ear, "it's so good to be here. I've missed you so!"

She slipped her arm around him and held him close. "I, too, have missed you." She felt the feverishness of his skin, the trembling of his body. Poor Riri! He was ill, he was in pain, he was in trouble and he had come to her. Soon he would reach the end of his senseless journey, his journey into despair and he would come back—this time to stay. "You must be tired. Take off your hat and sit down on the footstool as you used to."

The door opened and Annette breezed in, her winged coif

bobbing with excitement. She set down the cup and platter, seized Henri's hand, kissed it repeatedly and with a last toothless smile trotted away.

"Eat, Henri," his mother said.

Greedily he stuffed a biscuit into his mouth. Mothers were amazing creatures! How had she guessed he was starving? How nice it was to be here!

"And drink this while it's hot," she said, pouring tea in his cup.

In a flash memories of Myriame returned. That's what she had said that night, the night of the Brahms Festival . . .

The next hour passed swiftly. He had drunk two cups of tea, eaten all the biscuits, and now he felt drowsy in the warmth of the fire, safe in his mother's nearness, listening to her with a smile as she pretended to need his advice about what to do with Annette.

"She's getting quite old and very deaf. She scolds the cook and the parlormaid in patois which they don't understand, and talks to Joseph, who is sixty-eight, as though he were a youngster, and only ten days in service . . ."

Then it bore upon him again.

It started with a tenseness of all his muscles. A stringent imperiousness of thirst that parched his throat and knotted his nerves. All at once the room was full of swirling bottles. His mother's voice grew faint and loud in turn. "I must resist . . . I must resist," he told himself in panic. As in the days of the *attaques* he closed his eyes and instinctively groped for his mother's hand. Then unbeknown to himself, his lips moved, formed the words.

"Maman, I need a drink."

She caught the mortal urgency of his voice. Without a word she left her chair, hurried out of the room, returning almost immediately with a bottle of cognac.

"Here, Henri, drink," she said, pouring the liquor into his empty cup.

He grasped the cup with his two hands and drank so avidly that some of the liquor spilled upon his coat. Instantly he felt better.

"Forgive me, Maman." With his handkerchief he blotted up the cognac, dabbed his mouth. Then he raised his head and looked into her eyes. "Now, you know."

"I've known for a long time."

"But what you don't know," he broke in, his voice ringing with shame, "is how much I drink. I've always tried to deceive you, so you wouldn't smell liquor on my breath. In the

beginning I was proud. I thought I could drink like a gentle-man. Liquor helped the pain in my legs and gave me some-thing to boast about. It made up for other things. At least I thought so. But now liquor doesn't help my legs any more, and I get drunk. Drunk, Maman, abjectly drunk. Yesterday I was sick in a bistro, and they had to carry me home. Half the time I don't know where I am or how I got there. I don't work any more. I forget appointments. I've lost most of my friends. Before coming here I quarreled with Maurice . . . Please, Maman, help me! Take me away with you. Anywhere —some place where they have doctors. I read that alcoholism can be cured. I want to be cured. I'll do anything, anything. Let's go to Barèges. No, not to Barèges—Evian! Let's go to Evian! Remember Evian? We went there once. We'll go sailing on the lake . . ."

She watched him with undeceived eyes as he spoke. His eagerness was pathetic. How could one be so perceptive, yet so blind? A part of him had never grown. Always he would have illusions about his legs, about himself, about life.

"Evian would be perfect. When would you like to leave?" she asked, forcing herself to share his fervor. Perhaps he was right. Perhaps doctors might help him, in spite of himself. "Could you be ready by tomorrow?"

"Of course I can!" His vehemence brought a fey smile to her lips. "I can be ready in two hours! I only have to say good-bye to Maurice and Madame Loubet. Do you know whether the train leaves in the morning or the afternoon?"

"I think I have a timetable in my room. No, don't get up. You wouldn't know where to look for it. I don't exactly know where it is myself. I'll be back in a minute."

Alone he continued to spur his enthusiasm. Evian. Yes, they would have a wonderful time there . . . They would sail together, take long drives together. The countryside was beautiful. They . . .

Something inside him started to laugh—a soundless, wooden laughter that chilled him, a mirthless guffaw that spread to his whole body. You fool, you really think you can give up liquor like that, do you? Just say "Maman, take me to Evian" and all's well! Sailing with Maman—how touching! And what will you do when you crave a drink, and your throat is parched and your tongue swells in your mouth so you can't even swallow your own saliva? What then? And at night when you need a woman and there is no Fleur Blanche? What will you do then? Go sailing? On the beautiful lake? And since you can't

sail all the time, there will be long hours in a chaise-longue on the hotel's veranda, the contemplation of the majestic Alps . . . Fool, don't you see it's Malromé all over again in a different setting? You couldn't stand it when you were a youngster and you think you can stand it now that you are an adult —and an alcoholic. Go! Go back to your Montmartre and your bistros. Go before you do something to disgrace your mother and break her heart once more. Hurry! Hurry before it's too late. Get up and run! Run before Maman returns, before you're trapped.

He picked up his cane; walked out of the room. Then, like a thief, holding his breath, he scanned the hallway, hurried through it, stealthily unlatched the entrance door, and fled.

Madame Loubet stirred in her bed and opened her eyes with a start. It was he, all right! He was coming home—or rather he was being brought home again. And of course, he was drunk. He was always drunk.

She propped herself on one elbow and strained her ears. He was shouting at somebody. She recognized his voice as it rose from the street mixed with the hoofbeats and the crunch of wheels on the cobbles. He was shouting, yelling like a madman, awakening the whole neighborhood. He, who used to be so polite, so soft-spoken! What had he been up to this time? What had he done now? God only knew in what condition he would be! Perhaps with a bloody nose, or a bump on the head! Probably with his collar torn, his tie dangling over his coat, and no hat. He must have lost a dozen derbies in the last six months! How he reached home at all . . .

She flung back the covers, lighted the lamp and opened the window. The icy February night made her shiver in her nightgown, but she leaned out, listening, gripping the windowsill with her two hands. It was he, all right.

She winced, shook her head despairingly and started to dress.

If it weren't for Monsieur Patou he'd never come home . . . He'd sleep on a bench, in a doorway. Anywhere, like a tramp. He wouldn't care! Since he had got that letter he'd been like one out of his mind. He didn't care about anything, didn't even comb his beard or clean his nails any more. His suits were torn and spotted, and it was all she could do to make him change his clothes. He—he, who used to be a regular dandy! And he looked so ill and so old she almost didn't recognize him sometimes. His face, white as the moon and eyes that were twice

their right size . . . Things couldn't go on like this much longer. Something awful was going to happen one of these days.

She finished tying her petticoat around her waist, squirmed into her skirt and again paddled to the window. The fiacre had reached the top of the hill and she could distinguish Henri, disheveled and brandishing his cane. His shouts boomed in the silence of the streets.

"You're nothing but *un cochon de rouquin,* d'you hear? *Un sale cochon de rouquin!* That's what you are, Patou. Always nosing in other people's business. Why don't you stop pestering me? I am a citizen. Have you a warrant for my arrest? They'll send you to Devil's Island for this!"

His voice fell into a drunkenly, slurry whine.

"Look here, Patou, you and I are old friends. I'll never forget the good advice you gave me about Marie. Can't you see I don't want to go home? It's full of cockroaches. Let's go somewhere, just you and I, and have a drink, eh? Talk the whole thing over? No?" Again his voice rose to a strident bellow. "Then you're nothing but a pig, a revolting gendarme, a *cochon de rouquin!*"

From the window Madame Loubet watched him grapple with the detective, try to jump out of the moving fiacre. It made you cry! Hastily she shuffled to the kitchen, poured hot coffee into a cup. Then, knotting her red woolen shawl around her shoulders, she hurried into the street.

She helped Henri out of the carriage, held him by the arm while Patou paid the *cocher.* Together they half-dragged, half-carried him up the four flights of stairs, stretched him out on the couch and began to undress him. He protested, pushed them away, thrashed his arms about, but they succeeded in slipping his nightshirt over his head, removing his pince-nez and tucking him into bed. Gradually his screams abated to a driveling monotone, an incoherent blubber and finally an inaudible twitching of the lips.

He fell asleep. But they did not dare leave him, and sat down near the couch, talking in whispers.

"He didn't give us much trouble this time," she remarked, watching him with troubled eyes.

"No, he didn't." In the soft light Patou's angular face had assumed a ruminative pensiveness. "He didn't vomit like yesterday."

He went on nibbling the fringe of his mustache, gazing down at his clasped hands.

"But if you think he's getting any better, you're mistaken,

Madame Loubet. He isn't. He's getting worse. I know you're fond of him and I'm fond of him, too. He did the portrait of my little Eulalie, and I feel sorry for him. But things can't go on like this much longer. He's never sober; he wants to fight everybody; he gives me more trouble than a dozen hooplalas. Last week he wanted to fight a pimp because he was beating his girl! Lucky my man arrived in time!

"And he does the damnedest things! Know what he did tonight? He sneaked out of Montmartre—not far, just to La Villette, thinking I'd never find him there. He went to a bistro where they don't know him and ordered every brand of liquor in the place—whisky, rum, brandy, vermouth, absinthe, calvados—mixed the whole damn mess and drank it! Enough to kill a horse. And as a matter of fact that's exactly what I think he's trying to do—kill himself."

Madame Loubet pressed her lips together and lowered her eyes while Patou went on, like a man anxious to say his piece and get it over with. "No use fooling ourselves, Madame Loubet. I've seen plenty of drunks, but this one isn't a drunk; he's a lunatic. I mean it. He's crazy! He's mad!"

Mad! The work knifed through Madame Loubet. She kept her eyes down to hide her tears. Mad! Could the *petit monsieur* really be mad? Frankly you didn't know what to think! Watching him do some of the things he'd done in the past few months—things that even Patou didn't know about—you couldn't help wondering if he hadn't lost his mind! The time he had poured kerosene all over the studio to kill those cockroaches. A thing that could have put the whole house on fire! And the time he had all those buckets of sand carried upstairs because he wanted to make his studio look like a beach. And he, pleased as they come! "See, Madame Loubet, now it looks like Arcachon." And that horrible toad! God knew where he had found it. A whole month he'd kept it in his room, spending all his time trying to catch flies for the poor creature. How he'd loved that toad! "We're alike, he and I. You see, Madame Loubet, he's very ugly. Nobody loves him. That's why I must be good to him." And that confounded rowing machine which was going to make his legs grow! How could an intelligent man believe such foolishness, but he did! "It's guaranteed, Madame Loubet, absolutely guaranteed!" And push on those oars, push and pull and push and pull, day and night! Dressed in nothing but his underdrawers and a jersey, panting like a locomotive, sweat pouring down his face. Push and pull! "It's guaranteed, Madame Loubet! Absolutely guaranteed!" It made you cry! But the worst of all was when

he was quiet, stretched on his couch, staring, just staring at the ceiling and you could see he was thinking about that girl! Even when he was drunk he talked to himself about her . . .

She noticed that Patou was looking at her, and she raised her tear-wet face to him. For a moment the only sound was Henri's breathing.

"I know it hurts you to hear me speak like this," said the detective, "and I assure you I don't like it myself. I know that Monsieur le Préfet de Police has given orders to watch over him, and I have every man in my squad on the lookout for him. But he's getting out of hand. He's begun sneaking out of Montmartre. God knows what he'll do tomorrow. You must tell his mother, before something serious happens. If you don't, I will. But coming from you it'll be easier for her. Being a woman and all that, you'll know better what to say."

Her chin sank on her fichu and a sob heaved her shoulders.

"Don't take it so hard," he said patting her hand. "It's for his own good."

"They'll put him away in an asylum with a lot of crazy people."

"Asylum? Oh, no! Not an asylum, Madame Loubet, a *maison de santé!*" he protested hastily. "People like him don't go to asylums. In a *maison de santé* they have every comfort, every convenience. It'll only be for two or three weeks . . ."

Her face brightened a little, and she looked at him, begging silently for reassurance.

"And they'll cure him," he added.

"They will? You mean he won't drink any more?"

"Not a drop. Those doctors, they know! In a few weeks he'll be just like he used to."

She turned this in her mind. "They won't hurt him—beat him if he does anything wrong?" she asked tremulously.

Patou waved such notions aside. "Not in a *maison de santé,* Madame Loubet! They'll treat him just like you and me, except they'll know what to do. They'll give him things to make him go to sleep. And they'll keep him away from the bottle."

"And they'll cure him?"

"In no time. They do wonderful things in those places."

This seemed to convince her, yet she did not capitulate. "I'll see how he is tomorrow and then, if he isn't any better . . ."

"All right, you do that, but don't wait too long. Well, I think I should be going."

"I have some coffee on the stove. We'll have a cup before you go. Then I'll come back and see how he is." She struggled to her feet, bent down over Henri and tenderly pulled the

blanket up to his neck. "He sleeps nice," she whispered over her shoulder.

They filed out of the room as silently as they could and began climbing down the stairs.

They had reached the third floor when they heard a piercing, demented shriek. Almost immediately the door of the studio was flung open and Henri in his nightshirt staggered to the landing, eyes dilated with fright.

"Madame Loubet! Madame Loubet! Where are you? They're back, the cockroaches! Millions of them!"

He did not wear his pince-nez and was groping shortsightedly for the banister.

"Millions of them, Madame Loubet! Where are you Mada-a-a-a-!"

His heel caught in the hem of his shirt. With horror they saw him teeter, clutch frantically at the wall, and still screaming, plunge forward.

Then they heard only the dull thump of his body rolling down the stairs.

XXI

Doctor Selamaigne's maison de sante was located in the aristocratic suburb of Auteuil and did not look in the least like an asylum for the insane. It consisted of a magnificent eighteenth-century mansion that had belonged to Marie Antoinette's friend Princesse de Lamballe, whose crest still adorned its elegant and forbidding gate. With its stately garden, its well-tended flower beds, and its air of wistful quietude it looked exactly like some sumptuous and melancholy country estate. And that's exactly what it was, contended Doctor Selamaigne. A country estate, a retreat, a hermitage for wealthy patients suffering from nervous or mental disorders.

To Henri it was a loathsome, terrifying place. In the three weeks he had been "sojourning" there, he had come to hate its immaculate corridors, its grinning physicians and white-clad male nurses, its mysterious rooms and their closed doors from behind which escaped weird, unearthly sounds. After dark it became a house of nightmares, a castle of eerie silences broken by blood-curdling howls, a graveyard without the peace of death.

On this March afternoon he was hating it with every cell in his brain while pretending to gaze out at the sky through the heavily barred window of his suite. If only he could shout for help! But that brute of a guardian who sat there, chewing his toothpick and reading the paper would merely say, "Go ahead! Shout all you want. Nobody can hear you." And that was the terrifying thing about it. When you were here, nobody could hear you, nobody wanted to hear you. You were dead, you were *fou!* When would they see, those unctuous, addle-brained specialists, that he wasn't crazy? A drunk, yes. But not a *fou!*

"Say something?" His guardian was peering at him over his newspaper.

"N-no. It must have been the woman across the corridor."

He realized he had been muttering to himself. That was bad. People weren't supposed to talk to themselves. But, damn it, another month in this place and he'd be carrying on full conversations with himself, questions and answers. Three months and he'd be swearing he was Napoleon or the Holy Ghost . . .

"I was wondering if anyone had come to see me today."

"I wouldn't know. Anyway you aren't allowed visitors."

No use getting angry, telling that grown-up foetus that he was perfectly sane and could receive all the visitors he wished. Neither Doctor Selamaigne nor his assistants could be made to see it. Not later than last week he had still tried, only to get that same bland look and the same indulgent, maddening smile. "But of course you're sane! Perfectly sane. Anyway, this is not an asylum; it's a hermitage. All you need is a rest—a good, long rest . . ."

They all thought he was crazy; you could read it in their eyes. They had investigated. How doctors loved to investigate! They were worse than lawyers; they could make everything look black. They had wormed out of poor Madame Loubet the story of his rowing machine, the kerosene episode, and the sand on the floor. They had even found out about the time he had disguised himself as a beggar and created a scandal at the door of Durand-Ruel's. About La Fleur Blanche, the red cockroaches, that business of falling asleep while the prince was opening the show. They had learned about the billiard-green jacket, the red shirt, the pink gloves, the kangaroo dinner—everything. They had nosed out everything, like pigs rooting for truffles. And on paper it all had looked bad. Put into Latin words it had looked terrible.

Through the bars of his window he contemplated the sky. He wasn't used to those bars yet, but neither was he used to being watched every minute, ordered about, handed things to swallow, going to bed at nine, being sober—though he was beginning to get used to being sober now. But those first few days, those first few nights—no words could describe them! Strapped in bed, unable to move, dying for a drink . . . And the pain of his broken clavicle. He had called, shouted and screamed and ranted, but a lot of people screamed in this house . . . Now he did not scream any more and as a reward they didn't strap him any more. He was no longer

considered a *fou dangereux*: he had graduated—he was a *fou tranquille!* The question was: how long were they going to consider him a *fou tranquille* and keep him in this place?

Despairingly he ran his hand over his forehead.

"Headache?" asked his guardian.

"No, no," Henri jerked down his hand. "I'm all right. I feel fine." He turned away from the window. "Nice day, isn't it?"

"Ugh."

"Do you think we could take a walk in the garden?"

The man examined him suspiciously. "Don't know. I guess it'll be all right, though. But no funny business—*hein?*"

That's how people talked to you when you were a *fou*. Everything you said was interpreted, suspected. Did you run your hand over your head? You had a headache and therefore you were a *fou* . . . Did you suggest taking a walk in the garden? You were planning to climb a tree or make a dash for the gate . . . You yawned, you were *fou*. You talked, you were *fou*. You didn't talk, you were *fou* . . .

"I only thought a little fresh air might do me good," he said meekly. "But, of course, if you think I shouldn't . . ."

"I guess it's all right." The guard rose from his rocker. "But only ten minutes."

Early spring smiled in the beds of daffodils; lilacs were about to bloom. Flowers—silent and faithful friends of the unhappy, the sick, the dead . . . Other inmates, also escorted by their attendants, strolled aimlessly or sat on benches. A white-haired distinguished-looking lady smiled at Henri, then put out her tongue at him. A garden of lost souls . . . Vincent had been right. It wasn't the seclusion; it was the proximity of mad people . . .

"Could I take this?" he asked, bending down to pick up a woodcock feather.

"What d'you want that for?"

Why, eat it of course! Slash my throat with it! That's what he would have replied three weeks ago, but now he knew better. This half-witted brute would rush to the office, repeat their conversation, and Doctor Selamaigne would shake his head and click his tongue . . .

"I thought I might try to draw with it," he said, "if I could have some ink and paper. I used to do drawings—before I came here."

The man frowned, searched his face, but let him keep the feather.

That evening Henri made his first circus drawing. For the

first time the hours passed swiftly. At his side his guardian watched him warily; then by degrees with something approaching interest . . .

"I can see you've been to the circus a lot," he remarked almost amiably. "Me, too, I like to go to the circus. On my day off I often go to the Cirque d'Hiver. I like the trapeze artists."

"They are my favorites also. Did you ever see the Morellis?"

"They are good. But nothing like the Zuppinis!" argued the guardian, coming to life. "The Zuppinis, they could make three somersaults—not just two like the Morellis. And no net . . ."

Henri made him talk, flattered him and gave him the drawing.

A few days later Henri was summoned to the office, where he found Doctor Selamaigne, flanked by his two assistants, beaming at him from behind a huge desk.

"We are delighted, simply delighted!" prefaced the physician, stroking his beard. "I've always contended you merely needed a good rest and I was right. Your appetite has improved. Your amnesia seems better and the distressing symptoms so evident at the time of your arrival have almost entirely disappeared. We've examined with the greatest interest the little sketches you have been making. Please feel free to use our library for whatever other illustrations you wish to copy."

"Copy? But I didn't . . ."

"It will help you regain your memory. What did you say? You didn't copy those sketches?"

"Of course not. I did them from memory."

"Impossible! In your condition—"

"My condition!" Unwisely Henri shouted the words at him. "Can't you see I haven't lost my memory? I was an alcoholic, that I'll admit, but I haven't lost my memory. Ask me anything. What do you want? Dates? Ask me, ask me anything . . ."

"Our files show . . ."

"Damn you and your files! Are you deaf, are you blind? I tell you I haven't lost my memory and I am no more crazy than you are and certainly more reasonable! For God's sake, why don't you submit me to a test? I tell you I am sane. Please believe me. Sane, do you hear? Sane, sane! Sane!!!"

With sickening helplessness he realized he was not convincing them. The doctors' faces were frozen masks of disbelief. Only a madman shouted he was sane.

"But of course you are sane." Doctor Selamaigne gave him his most syrupy smile. "Sane as can be. You merely need a little more rest, that's all. A few months . . ."

"MONTHS?" Henri screamed. "Months in this madhouse! Now I know you want me to go crazy! You don't want me to get out of this place! You want me to rot here the rest of my life! I tell you I am sane! Ask me, ask me anything . . . Let me draw for you . . . Let me prove to you . . ."

He was still shouting when the two burly guards dragged him out of the office.

Back in his room he flung himself down on the bed, beating the pillow with his fists, sobbing, yelling for his mother. "Maman! Maman!"

The next day he was calm. Unresigned, but calm. Only Papa could get him out of here. He would see he wasn't crazy. He wouldn't be impressed by those asses of doctors, their files and their talk about amnesia and distressing symptoms.

That afternoon he wrote his father, bribed the guardian to mail the letter and confidently waited the count's thunderous arrival.

Days passed. One week—two—three. His father did not come.

Henri sank into a defeated torpor, spending his days by the barred window, rocking endlessly in his chair. He was trapped, he would never get out . . .

Oddly the alienists interpreted his brooding lethargy as an improvement. His mother was allowed to visit him.

"You understand, don't you, Henri?" she murmured, when they were left alone. "I had no other choice. If I hadn't brought you here the authorities would have placed you in a state institution."

He nodded without raising his eyes. "Yes, Maman. I understand."

He wanted to cling to her, beg her to take him away, tell her he was sane, but it would merely add to her distress. How much would his word weigh against that of three distinguished scientists? Besides, she had seen the files . . . And then perhaps he *was* crazy and didn't know it? After all, how did you know you were not crazy?

"I am very grateful," he went on, staring at the carpet. "You did it for my own good, like everything else. And I only brought you pain in return. Please, forgive me, Maman."

She took him in her arms, ran her fingers through his hair, as she had done at the château when he was a child. "Be brave, Riri. Be brave . . ."

They strolled in the garden, sat down on a bench under a budding tree. In a toneless voice he answered her questions. Yes, his collarbone had healed. It didn't hurt any more . . .

Yes, it was a miracle he hadn't broken his legs that night . . .
The doctors were very solicitous and kind . . . Oh, yes, he
was extremely comfortable, and allowed to read . . . No,
he wasn't lonely.

"They let me draw again. It passes the time."

"Try to be patient. You've had a nervous shock. Give
yourself time to regain your strength. I'll come to see you as
often as the doctors allow."

At the gate she leaned to kiss him and whispered, "Pray,
my child, if you can. Prayer will bring you peace."

From behind the gate he watched her climb into the carriage.
Joseph was not on the front seat.

"She didn't want him to see me," he thought desolately,
as he hobbled back to the house.

It was Maurice who came to his rescue.

When Henri saw him standing in the doorway of his room
he broke into hysterical sobs.

"YOU! How did you . . . How did they let you . . .
How . . ."

"Yes," grinned Maurice, closing the door behind him, "it's
easier to have breakfast with the Queen of England than get
inside this damn house. From what that secretary told me
downstairs I expected to find you in a strait-jacket in a padded
cell, but you have no idea how persuasive a fifty-franc note
can be to an underpaid secretary. Well, here I am. You don't
look crazy to me. Sit down on that chair and let's talk. We
don't have much time. Tell me everything. The papers are full
of the most fantastic stories. How did it really happen? I didn't
want to ask your mother. As for Madame Loubet, she is in
a daze and I couldn't get much sense out of her. She cried all
the time I was with her. You had an attack of delirium tremens,
ran out on the landing and fell down the stairs—is that it?"

In a torrent of words Henri told him all he remembered, de-
scribed his terror of the house, the screams of the women
across the hall, the doctors' refusal to admit his sanity.

"Look!" he cried, going to the table and snatching a sheaf
of drawings. "Look! At first they said I copied them. Even when
they found out I hadn't copied them—couldn't have copied
them—they still insisted I was crazy. Oh, Maurice, how am
I going to make these fools see I'm not crazy? Please, help
me. You are my last hope. I wrote my father. He didn't
answer."

Maurice examined the drawings one by one. Finally he
looked up at his friend, a wide grin of relief on his face. "If
a crazy man did these drawings then I'm crazy too! Those

damn newspapers had got me confused and I had a few doubts when I came here. You have done some rather crazy things, you know, at one time or another. But you are not *fou,* and I'm going to get you out of here. Now, listen to me. I have an idea, but I don't know if it will work. If it doesn't I'll try something else. Meanwhile stay here and be as good as an angel and keep on drawing. You'll hear from me in a few days. Can I take these with me?"

"Naturally, take anything you want."

As he was about to leave, Maurice put his hand in his pocket. "Here's some mail I picked up when I went to see Madame Loubet. Good-bye, Henri, and don't give up. Remember, *'A la vie et à la mort.'* I'll get you out of here if I have to blow up the place!"

One of the letters bore the heading of the Ministry of Beaux-Arts. In the stiff formality of official communications it informed him that his name had been placed on the next promotion list of the Legion of Honor to be submitted for the signature of Monsieur le Président de la République. Would he, at his earliest convenience, notify this department of his acceptance, since otherwise the decoration could not be awarded. This high distinction was to be conferred upon him in recognition of his outstanding artistic achievements and the services he had rendered the cause of French art and culture.

At thirty-five, when most artists were still unrecognized and starving in their garrets, he was being offered the Legion of Honor! Strange, this persistence of success in his life . . . Fame was the only woman who had tirelessly thrown herself at him . . . Should he accept? Of course not. Especially after the scandal of his confinement. Legion of Honor bestowed upon a mad artist! The papers would like that. No, he had had enough publicity. The best and the worst. He no longer wanted to see his name in print. Maman wouldn't care one way or another. She was beyond happiness. Papa? Papa would rumble something about this imbecilic government that pinned decorations on daubers of pornographic trash. But Myriame would have been thrilled. She admired success.

Suddenly he saw her in his mind, crouching by the fire. It was a quiet winter evening and the darkness pressed against the windowpanes. Out of a long silence he remarked, "Oh, by the way, darling, they gave me the Legion of Honor." And she was turning to him, a little breathless, her eyes wide with pride . . .

He bent down and took his head in his hands. Would he never stop thinking about her?

"Bad news?" asked the guardian, entering with the dinner tray.

"No—no." He straightened up. "Nothing important."

Slowly he tore up the letter and tossed the pieces into the waste basket.

Maurice returned a week later, accompanied by Monsieur Arsène Alexandre, art critic of *Le Figaro*.

"You see I did as you said, Maurice," Henri smiled, rising from the table to greet them. "I've been working."

"May I look at your drawings?" inquired the critic, adjusting a gold pince-nez on his nose. For a while he remained silent. "And entirely from memory, did you say?" He removed his pince-nez and tapped it in his palm. "No notes, no preliminary sketches from life?"

Henri shook his head. "How could I? All my notes are at my studio."

"It's unbelievable! As a matter of fact, I can't recall any similar feat of pictorial memory in the entire history of art. If you are crazy, I can only say I wish there were more crazy artists."

They went into the garden. Henri, knowing he was under scrutiny, refrained from any facetious remarks and kept his answers dull—eminently sane. By the end of the afternoon the critic was convinced.

Doctor Selamaigne read Alexandre's article at breakfast and enjoyed neither. Here was an eminent art critic who, having spent an afternoon with a supposedly lunatic artist, had found him in possession of all his faculties and at the very summit of his artistic talent.

The physician had regained his composure and was his benign self again when Henri was ushered into his office.

"I always said a little rest was all you needed," he began with a fatherly grin, crossing his hands over his paunch, "and now the facts have proven me right. Once again our little hermitage has performed a miraculous cure. Well, how does it feel to be cured? Completely cured?"

"Very good," said Henri, on his best behavior.

"Of course it does!" cooed the alienist, growing more expansive by the minute. "You had a narrow escape, but I consider your case about closed. Another great victory for medical science! How would you like to be allowed to receive visitors? To paint and sketch all you want? Even take a few drives—accompanied, of course. It would be wonderful,

wouldn't it? Well, that's exactly what you're going to do for the next two weeks . . ."

Henri did not try to argue that he wanted to leave at once. As a matter of fact, now that he was assured of his liberty, he was not so anxious to leave. What would he do when he was released? The old life again, the "Pst, pst, *cocher*," the music halls . . . Of course he would never touch another drink in his life, never set foot in another café again . . . Life would be quite dull . . .

The sitting room of his suite was converted into a studio. An easel was procured. Maurice—always Maurice—sent in paints and canvases. Now that the news of his recovery had been made public, a colorful procession of visitors made the pilgrimage to Auteuil. Madame Loubet was the first to arrive, looking stylishly dowdy in her black alpaca dress and sporting the cameo brooch he had given her. Missia Natanson and a few of his society friends sipped tea in the unusual and sophisticated setting of a barred-window drawing room. From La Fleur Blanche came Monsieur and Madame Potieron and Berthe, all looking frightfully respectable in decorous black. The *Comité Exécutif* of the Société des Artists Indépendants sent a delegation headed by Henri Rousseau. Old Desboutins presented himself at the gate and haughtily demanded to be led to Monsieur le Comte de Toulouse-Lautrec, an "intimate friend of mine." As usual his battered felt rested on the back of his head, his pipe dangled on his chest, and he was shod in slippers. As he was holding out a grimy calling card to the gatekeeper a bottle of cognac slipped out of his cape and crashed to the ground. Despite his protestations that he couldn't understand how such a thing had happened he was promptly ejected. From his window, Henri caught a glimpse of the old etcher, gesticulating wildly with one hand while holding his hat with the other, hopping about in his trailing cape between two beefy attendants.

Jane Avril came accompanied by a tall young man with a passionate horse-face and a shock of black hair.

"This is Christophe," she said. "He's a composer."

After a few polite remarks Christophe announced he would wait in the garden.

"Isn't he wonderful?" she said, lighting a cigarette. "A great musician. Nothing published yet, but he is at work on an opera. I shudder when I think I almost married Georges. What did I ever see in him? Commonplace and without any talent. That novel of his was a mess. Well, it was just an infatuation, I suppose. But Christophe—ah, Christophe, that's different."

He watched her in smiling wonder. "Darling, you've found the secret of eternal youth."

They talked for a while, carefully avoiding mention of Myriame. But they both felt her presence between them.

"I am so sorry it turned out this way," Jane sighed, as she slipped back her gloves. "I meant well, I assure you. I only wanted you to . . ."

"Don't be sorry," he said gently. "You gave me the only happiness I've ever known."

A few days before his release Henri received a visit from his mother.

"And now, Henri," she said, looking at him with pain-heavy eyes, "have you made any plans? What are you going to do?"

"I—I don't exactly know," he evaded, averting his eyes. As always he was taken aback by her directness. "Return to Montmartre, I guess. It seems about the only thing for me to do. I want to go back to work and make a portrait of Maurice. Do you know I've never done his portrait? Odd, isn't it? He never asked me to, but I think it would please him."

"Then you should, by all means. Maurice is a fine person."

"Don't think I don't know it. No one knows it better than I do. I'll never be able to repay him for what he's done."

"But you haven't told me your plans."

"I told you. Go back to Montmartre . . . After that, I don't know. I haven't made any plans. Somehow my plans never seem to work out right. Maurice's been talking about a show in New York next year. Perhaps I could persuade him to go there with me. It would be exciting to visit the United States."

"But meanwhile what will you do?"

"What do you mean? I'll work, of course. I have several things I want to finish. In June I thought I might go to Dieppe or Trouville. I don't want to go to Arcachon again. I'm tired of that place."

He read her thoughts in her pale, knowing face. "Oh, I see . . . You're worried about my drinking, aren't you? You can set your mind at ease, Maman. I'll never touch another drink. Never, I give you my word."

"I know you mean it, Henri, I know you do," she said slowly. Her eyes rested on his, loving but undeceived. "For some things you have a tremendous will power, but for others you haven't. And you easily delude yourself, although you can be extremely keen about others. You see, in many ways I know you better than you know yourself, and I know how lonely and heartsick about that girl you are. Your loneliness will prompt you to

seek diversion. Gradually you will return to your old kind of life. Temptation will come, and you won't be able to resist it. Once again you will turn to liquor for escape. And then?"

He kept his eyes lowered and did not reply.

"Then," she continued in her quiet voice, "you will soon drink to excess, because that also is in your nature. Before long you will be exactly where you were when you came here. Is your life to be a constant shuttling between Montmartre and this place? I've given the matter a great deal of thought. I wouldn't have a moment's rest if I knew you were alone in Montmartre, and I've asked Monsieur Viaud, an old friend of the family, to come to Paris and stay with you. Paul is a bachelor, a kindly and cultured gentleman. You will find him a pleasant and understanding companion."

He looked up slowly. "A keeper?"

"Yes, Riri . . . A keeper."

For more than a year Henri did not touch a drink and savored the delicate raptures of contrition. Like an often-deserted but always-forgiving mistress, Virtue welcomed him back and clasped him to her chaste bosom. Passionately he returned the embrace. For months he wallowed in righteousness. With the usual violence of his nature, he set out to be the reformed sinner, lamenting his past excesses, exulting over the thrills of playing lotto with Paul Viaud and Madame Loubet, the benefits of regular living and the bliss of a good conscience.

"When you stop to think of the millions of men and women who wreck their health with liquor, the ruined families, the innocent children victimized by a heredity of alcoholism, I say there should be a crusade—a world-wide crusade against alcoholism . . ."

His conversion was total, all-inclusive. Even the vulgar demands of the flesh came in for their just deserts. If at times their insistence forced him to visit La Fleur Blanche he did so only after obtaining Paul Viaud's permission, with many expressions of regrets, and the air of someone who must excuse himself to appease an urgent and unmentionable need.

In this exalted state of mind he painted portraits of Maurice, as well as several other portraits of men. Dark, uncertain works, reminiscent of his *atelier* studies. He also painted Renée, the pretty modiste, and the sight of her delicate profile, her mane of blond hair aflame in the lamplight stirred his dying genius to produce one of his last masterpieces. No more nudes, no more brothel girls, no more actresses. Virtue had him now in her grasp and was gradually strangling him.

Stern and pompous art critics who had shied at the "revolting brutality" of his art killed the fattened calf to welcome the Prodigal Son into the folds of dignified portraiture. Now that he was acknowledged as a great artist, dealers remembered the pictures he had given them in his careless youth. Framed in impressive mouldings they began to grace the windows of fashionable art galleries. Forgeries, many brazenly signed, saw the light and were sold as the work of the thirty-six-year-old master.*

When, occasionally and always accompanied by Viaud, he stopped at the terrace of a café for an innocuous lemonade or a demitasse, art students paused in their debates to nudge one another and ogle the gray-bearded cripple, as once he had stared at Degas. Some, the most daring, came to his table and he delivered homilies on art, industriousness and clean living with the false bonhomie and reticence peculiar to celebrities.

Like most righteous people he began to believe the compliments that were showered upon him and take himself seriously. He discarded the undignified cardboard and turned to wood panels for his painting. Now that he was exhausted he was turning his eyes toward posterity. Briefly he toyed with etchings, executed nine dry points.

Fame, his faithful and never discouraged *amoureuse*, knocked at his door again. He was offered the Legion of Honor a second time and seriously considered accepting it. Monsieur le Président de la République appointed him chairman of the poster committee of the Grande Exposition that was to inaugurate the magic twentieth century. With proper gravity he examined hundreds of posters and made appropriate remarks. A legend was forming around him. Still living, he was entering into glory.

The nineteenth century expired in the weeping darkness of a drizzly night. That evening, while the Moulin Rouge rang with the howls of cardboard trumpets and the frantic gaiety of New Year's revelry, Henri drove to Boulevard Malesherbes and visited his mother. At dinner he was effusive in his protests of eternal vigilance and was somewhat hurt by her scant responsiveness.

Wearily she smiled at him from across the table. Her hair was white, her lips pale.

* Forgeries of Lautrec's paintings, drawings and even posters were so common that Maurice Joyant made a list of them in his catalogue of the artist's work.

"She should look happier," he thought, "but then perhaps she can't look happy any more."

As coffee was being served, he remarked, "Maman, don't you think we could dispense with Paul's services now? He is very nice, and I enjoy playing lotto and going to the zoo with him. And you were absolutely right to insist on him when I left Auteuil . . . I was weak then and could have easily slipped back into my old habits. But now I've regained my will power and there's really no need of him any longer."

"Perhaps . . ." Her voice trailed with weariness. "We'll speak about it in a few months."

"But, Maman, I assure you . . ."

"Paul needs the money," she lied quickly, to end the argument.

"Oh, well, then . . ."

XXII

"Please, Victor!"

Through the vitreous grayness of the empty bistro the voice wafted in a beseeching whine.

"Please give me another absinthe. Just a little one . . ."

The whine became imploring.

"Please, Victor . . . Don't you see I need it?" His ashen face creased into a piteous grimace. "I'll give you twenty francs . . . A hundred francs . . . Five hundred francs . . ."

"Oh, God, these drunks!" moaned Victor.

Grumbling under his breath he took a bottle from the shelf at his back and shuffled to the table.

"Here." He poured some green syrup and a little water into the empty glass. "And for Christ's sake, leave me alone. This is the last drink I'll give you. I mean it, Monsieur Toulouse. The last . . ."

Henri took an avid gulp. The liquor sent a spiral of giddiness through his brain. The floor undulated. The marble top of the table floated before his eyes. Eerie whistles rang in his ears.

For an instant he swayed on his chair, trying to steady himself with his free hand, holding his breath, blocking his gullet to check the flow of bile into his mouth. Was he going to be sick again?

Gradually equilibrium returned. The table solidified again; the floor stopped rocking. Only his brain went on swaying, but then that swayed almost all the time now.

Cautiously he set the glass back. For no reason his attention veered to the rivulets of rain zigzagging down the plate-glass window. He squinted his inflamed eyes at the dreary street outside.

It really did rain too much in Paris. Madame Loubet was right; Paris weather was disgusting. His whole life seemed to have been spent against a background of gurgling drain pipes and dripping eaves.

Poor old Viaud! He must be soaking wet, wandering about in this rain, peering into every Montmartre bistro. He wasn't cut out to be a drunk's bodyguard. Didn't he know a drunk was a liar and a cheat when he craved his drink? Maman should have hired one of the asylum guards.

Well, Viaud would go and tell Patou and in ten minutes that devil would pick him up. Once again he would bundle him in a fiacre and take him home. Viaud and Madame Loubet would give him coffee, undress him and put him to bed. To-morrow he would sneak out again on some pretext or other, and it would be the same thing once more.

And the day after that . . . And the day after that . . .

The memories had done it. In the end they had worn him down, made him break his word. One day he had felt he could not endure one minute longer remembering Myriame. Her body arched in pleasure, her mouth open in a kiss, her rigid nipples . . . Couldn't endure knowing that she was gone, that perhaps at this moment she was being loved by another man . . . Perhaps enjoying his caresses . . .

That day he had given Viaud the slip for the first time and got drunk. Not drunk—sick. For that was the supreme irony. You lied, broke Maman's heart, drank to forget, only to discover you couldn't drink any more! Two absinthes, and—the latrine! Stomach rolling, eyes swimming, mouth full of bile, the walls collapsing on you . . .

Well, it had been going on like this for about four months. The memories were still there, and you went on living . . . Ashamed, in constant pain . . .

"Could I have 'em, m'sieu?"

With a start he turned around.

A crone in rags was looking at him through bleary eyes. Her gray hair hung in damp wisps on either side of her face. A wet, black-fringed shawl draped her bosom.

"Have what?" He blinked at her in a daze.

"Your cigarette stubs, m'sieu," she pointed to the ashtray. "Can I have 'em? I sell 'em."

There was something hopelessly final about her, as though she had reached the end of everything and could go no lower. Oddly it gave her an air of tranquil detachment, a certain abject dignity. Nothing could hurt her any more.

"Of course. Take all you want."

He pushed the ashtray toward her and fumbled through his pockets.

"Here, take these, too," he said, emptying his gold cigarette case into her cupped hands. "Perhaps you'd like something to drink? Please, sit down. What would you like?"

"Could I have some rum?"

She sat down, unfastened her shawl and brushed back a strand of gray hair with unexpected grace.

"You're an *artiste-peintre, hein?*" she asked with a crinkle of her rheumy eyes.

"Yes. I am, or rather I was. How did you guess?"

"Artists are easy to spot. I used to know lots of artists."

She waited till the patron had set the drink in front of her.

"*A votre santé, m'sieu.*"

"*A votre santé, madame,*" Henri said, lifting his glass in courtesy.

He watched her slosh the liquor in her mouth between her cheeks, then gulp it down with a quick toss of her head.

She rested the glass on the table, wiped her lips with her wrist and softly giggled to herself. " 'Madame' . . . Madame, he called me!"

Still chuckling she put her elbow on the table and looked at Henri with curiosity. "Like you, he was," she said. "Polite, even in bed. A real gentleman. Maybe you've heard of him? Manet."

"Manet? Edouard Manet?" Then in a flash he recognized her. "You are Olympia!"

"Yes, that's what he called me. I don't know why. My name's Victorine, but he said, 'No, to me you're Olympia.' Maybe you've seen the picture he did?"

"Seen it?" He grinned at her ignorance. "Everybody's seen it! Everybody! It's one of the most famous paintings in the world!"

"He fussed enough with it! You should have seen him in his studio looking me up and down. And me with nothing on lying on the sofa. First he put a big yellow pillow under me. Then he stuck a flower in my hair. But you could see he still didn't like it. Then he ran out of the room and came back with a little black ribbon. 'That'll do it!' he laughed. 'That's just what it needs.' You know how artists are. Half the time you don't know what they mean. Well, he tied the little ribbon around my neck and then he was happy. 'Don't move,' he said. And then he started the picture."

Olympia! This shapeless tattered derelict! Oh, the horror of it, the indescribable horror of this crumbling decay of

all living things! This dissolution of all youth and beauty. Art indeed was greater than life. Only Art stopped Time.

She pushed back her chair.

"I got to go now. I still got to collect my stubs or I won't eat. They used to give me four francs for one kilo, now they give me only three and a half. Things get worse and worse. Well, that's life, I guess. Thanks for the drink, m'sieur."

He thrust a note into her hand. "Take this. And don't thank me. Please don't."

She looked at the money without greed, even without surprise.

"He was like you, Generous . . ."

She turned, gathered her shawl around her shoulders and shambled out of the bistro.

Alone, he finished his absinthe. Again he heard the undulating whistles in his ears, felt the contractions of his stomach and the twitching of his nerves. For a moment pain distorted his face.

In front of him the glass stood empty, iridescent, in a materialization of inanimate sarcasm.

"Things weep," he thought, "but they laugh too!"

This glass, this chalice of evil, was laughing at him. Because it had finished with him . . . He couldn't drink any more. And there were other victims to snare, other fools to delude into dreamy and deadly escape.

"You are poison, absinthe," he mumbled aloud. "You are poison, and I spit on you!"

He gathered some saliva on his tongue, spat at the glass and with a backhand sweep sent it crashing to the floor.

Outside it was getting dark and it had stopped raining.

He stood a moment on the sidewalk, not knowing why he had left or where he wanted to go. His eyes traveled up and down the street undecidedly. To get a fiacre he would have to go to rue des Martyrs. Good. The walk would take a little time, give him something to do for a few minutes. Once in the carriage he would decide what to do next, where to spend the evening.

Keeping his eyes on the ground he started walking, pushing hard on his cane, pausing every few steps for breath. He rounded the corner. With surprise he found himself in rue Clauzel. Across the pavement Tanguy's shop, its blue façade, washed by the rain, stood vacant and dark.

He crossed the street, pressed his face against the window. The counter where Madame Tanguy had wrapped the tubes

of paint was still there, gathering dust. On the walls, where Cézannes and Van Goghs had hung, pale squares made a phantom exhibition. How quiet it all was—and how dead! Tanguy holding the Japanese print between his fingers. "An Utamaro, monsieur . . . An Utamaro triptych . . ." Madame Tanguy bending over her *ragoût à l'oignon* . . . Vincent, tilting his chair in the courtyard, pulling on his pipe . . . They all were dead, and when everyone was dead, it was the living who became the ghosts . . . What was he doing here in the approaching night, looking at nothing?

He turned up his overcoat collar, resumed his painful walk. He reached rue des Martyrs as it was starting to drizzle again. Of course, no fiacre. Life was a study in disappointments, great and small . . .

He shivered and went on.

It was drizzling steadily when he arrived at Place Pigalle. Rain drummed on the crown of his derby and now and then a drop slithered icily down the nape of his neck.

He spied a landau at the curb.

"Free?"

"Oui, m'sieu." The *cocher* touched a grimy finger to his hat. "Nice weather for frogs, *hein?* Where to, m'sieu?"

Henri slumped on the seat, shook his dripping derby.

"Where to?" repeated the cabby, gathering the reins.

"I hear you! *Nom de Dieu,* give me time to think! Can't you see I'm soaked to the bone?"

Where to? That's what it was—where to? Where did he want to go, where could he go? His mind was a blank. What he should do was go home and change clothes. As a matter of fact, he shouldn't have given a nice old man like Paul the slip. Was he still searching for him in this rain? That's what happened when you were a drunk. You went ahead, regardless of consequences. Then you were sorry. You spent your life being sorry. For what you did. For what you did not. For a Maman. For Madame Loubet. For Viaud. For yourself. Oh, to hell with it!

"Drive to the Moulin," he cried at random.

"The Moulin? But, m'sieu, it's not open at this hour."

"Sorry. Drive to L'Ely then."

"Now I know you're a stranger around here. Why, L'Ely's been closed for years, m'sieu."

"Of course! I was thinking of something else. Drive to the Gare du Nord," he flung haphazardly.

He took out his cigarette case. Luckily there was still one cigarette left. He struck a match, took a few puffs, blew the

smoke in long curved tusks from his nostrils. Good God, for a moment he thought he'd never get the damn thing lighted! His hands shook worse than before the asylum. The joggling of the landau. Joggling! Would he ever run out of alibis? He was worse than a lawyer. Oh, all right, all right, his hands shook. What of it?

For a while he smoked quietly, his eyes closed, listening to the wooden sound of the hoofbeats on the wet pavement. And after the Gare du Nord where would he go? To La Nouvelle? Yes. To La Nouvelle. It was a long time since he had been there. It would be nice to see the old place again . . .

He opened the window and thrust his head out.

"I've changed my mind. Please, drive back to Place Pigalle. La Nouvelle Athènes."

When the landau stopped in front of the café he did not want to go in. Why go in? Elderly bourgeois reading the newspapers; noisy black-fingernailed art students; middle-aged bohemians in corduroy, sipping absinthe, brooding over money, staring at their failure . . . And ghosts. Rachou, Fanny, Julie, Vincent, himself . . . Leonardo . . . "I spit in your eyes . . . *Merde alors!* . . ." All gone . . . The air was full of dead words.

"Well, here you are!" The *cocher* leaned impatiently on his seat. "That's where you want to go, isn't it?"

He did not hear him. No, he didn't want to go there. He didn't want to go anywhere. He didn't know what he wanted. He hadn't wanted anything since—since that letter. He still had it in his wallet.

Well, well, if he didn't want to go to La Nouvelle, how about Drouant's and a good dinner? He hadn't eaten anything for hours. But he wasn't hungry. His stomach hurt. Well, for heaven's sake, where then?

"Please, *cocher,* drive back to the Gare du Nord," he said apologetically. "And go slowly, if you please."

The cabby shrugged and with a jerk the carriage drew away from the curb.

Then, how about dropping in at the Natansons'? He hadn't seen Missia in months. "How nice, Henri," she would say. "Where have you been hiding yourself?" But it wouldn't be like the old days. Prison and asylum were two things you never quite lived down. In spite of themselves people expected you to start drooling, or rolling on the floor, or pocketing the silverware . . . Wilde had found that out. His real punishment had begun after his release from prison. How cruel and unforgiving this Christian world could be! Poor Oscar, he was dead

at last. He wouldn't have to drag his bloated self from dive to dive and cadge drinks any more. He had looked very noble, almost regal in his cheap coffin, his rosary around his neck, a medal of Saint Francis on his chest. No scarab ring, no green carnation.

No, he didn't want to go to the Natansons'. All right, where, then? He had to go somewhere. He couldn't go on driving in this upholstered box forever. What about Le Moulin? No. The Folies? L'Eldorado? "Le Riche"? Maxim's? The circus, perhaps . . . That was nice. The acrobats, the bareback riders in their tutus, the trained elephants. No, he had had enough of them. He had seen them too often, sketched them too many times. Even the clowns didn't amuse him any more.

How about going to the theatre? A nice stall, a good show. Sarah was giving *L'Aiglon* at La Renaissance . . . And sit all evening with Myriame's ghost? He wouldn't hear a word of the play. He would see her, try to take her hand, speak to her, create another scandal . . . He would remember the way she had looked that evening when they had gone to *Phèdre*. At Voisin's, he would remember the way she had said, "How can you defend those depraved old kings?" At the Comédie Française, in concert halls, even the *cinématographe* he would see her. She was everywhere in Paris. She was Paris.

La Fleur Blanche! That was it. La Fleur Blanche! Nobody watched him there . . . Alexandre Potieron, the *popotes,* the poor whores . . . But, no, he couldn't go there either. He couldn't look at their doughy buttocks, their flabby breasts, their tired mouths. They brought back the memory of Myriame's caressing lips, her lean flanks, the way she pressed her cheeks in the pillow and turned her head in her moment of rapture.

And so that too was finished.

Fine! He didn't want to go to La Fleur Blanche. He didn't want to go to the Natansons', the circus, the theatre. Well, then where did he want to go? How was he going to spend this evening? And tomorrow's evening? And next week's evening? And next month's? And next year's? How? How?

"HOW?" he shouted to himself.

His face twisted in a sudden orgasm of pain. The cigarette slipped from his fingers. With a stifled cry he flung himself forward and bent double on the seat as if he had been shot in the abdomen. For a few seconds he writhed and groaned through clenched teeth, his nails dug into his palms.

Gradually his contortions subsided, but he remained slumped

in the same position, inert, almost lifeless, except for the ludicrous oscillation of his legs.

"Maman!"

The word bubbled in a broken sob to his lips.

"Maman!" he repeated, as if the mere sound of her name brought him comfort.

From the pit of his abjection and fright he was calling to her. For he was going to die . . . He knew it, as surely as the man who saw the first plague spots on his hands. This spasm was not the first. Soon others would come more and more frequently, be more and more painful. His body was disintegrating under the years of abuse. It was like a hand around your throat, this certitude that soon you would be dead, wouldn't have eyes to see with any more, nostrils to breathe with, that your heart would have stopped pumping and that you would be lying underground, deep underground, so that your stench wouldn't offend the living.

It did something strange, this knowing you were going to die. It made you feel and think as if already you were dead, out of the society of the living. Suddenly you were looking at things in a new way. Things that a moment ago had seemed important didn't seem important any more. You forgot most of the people you ever knew, as they had already begun to forget you.

But on the other hand, some other things became clear—imperative.

First, you mustn't die in Montmartre. Mustn't collapse in a street gutter, a bistro, a fiacre. A Toulouse-Lautrec did not die in Montmartre.

Second, you must make amends. No, not to life. Life gave no quarter and expected no amends. But to the few people who had been kind to you—when you were alive. Maurice, Madame Loubet, Patou, Berthe . . .

He would take care of that tomorrow. He would apologize to them for the trouble he had caused them, thank them for what they had done. There was no more time for deeds. Only words—and money . . . Not Maurice or Patou, of course, although both could use it. But money had such a bad reputation, people easily misinterpreted it. All their lives they thought of nothing else, slaved for it and when it was given to them they resented it . . .

But Berthe would understand it was not a payment, an insult, the wiping out of a debt. Madame Loubet also would understand. She was an old woman and wise in many ways. She knew that the rich, like the poor, could only give what

they had. A few thousands in an envelope absently left in her lodge would give her her last years in her beloved Chambéry. She would look upon it as a gesture—like the cameo brooch, the Saint Francis pottery from Arcachon, all the little presents he'd given her through the years. A humble gesture of gratitude. The humblest because it cost so little. The last he still could make. Perhaps she would believe it was one of her *bon Dieu's* miracles . . .

Then, this done, he could try to make amends to Maman. If only he could live a little while longer, give her a few months of total, undivided love, he would go content . . . If only he could tell her, show her how sorry, how very sorry he was for the pain he had caused her during those long Calvary years when she was waiting for him! He couldn't undo the past, couldn't repair his mistakes. But at least he could beg her pardon, offer her his bruised, battered, unwanted heart.

XXIII

Malrome was in darkness except for a light in Henri's room on the second floor.

"I think he'll sleep tonight."

The old doctor felt Henri's pulse while looking at the countess.

"Now that he is paralyzed, he doesn't suffer much any more. That's one good thing."

Gently he set back the fleshless hand on the coverlet, walked away from the bed.

"I wish you'd go to your room, Madame la Comtesse. You need sleep—and you're going to need your strength."

At the door he turned to bow and read the question in her eyes.

"It's hard to say," he muttered with a helpless shrug. "Two days, perhaps three. Perhaps less. He's young. At thirty-seven the body puts up a fight. He'll be all right tonight though. I'll be back in the morning."

He looked at her through eyes that had remained kind.

"Try to sleep," he urged in a compassionate murmur.

Downstairs Joseph was waiting for him.

"How is he tonight, *Monsieur le Docteur?*" he asked, helping the physician with his macintosh.

"About the same. I don't know how he survived that stroke. But it can't last much longer, I'm afraid. Any news from the father?"

Joseph shook his head.

The old country doctor began descending the perron stairs to his waiting buggy.

"If he's going to come at all, he'd better come soon."

With a groan of fatigue he lifted his corpulent self into the frail vehicle.

"See if you can get the countess to sleep," he said, gathering the reins. *"Bonsoir, Joseph."*

Joseph watched the carriage disappear down the gravel driveway. He heard the squeak of the gate being opened and the faint echo of *bonsoirs* exchanged in the darkness.

Then all was silence—or rather the thousand hushed sounds that made the silence of the moonlit night.

Tiredly he started up the stairs.

The countess did not hear him enter the room. She was standing by the side of the four-posted bed, looking down at her child, engraving once more in her eyes the image of his poor, emaciated face. The shaggy graying beard concealed the deep hollows in his cheeks. The nostrils had already a waxy deathly pallor. Around the sunken eyes lines of pain told the agony of the last weeks. On the coverlet one hand lay, bony and lifeless, the skin stretched tightly over the knuckles like a thin, transparent rubber glove.

He had come back, given her the desperate tribute of his love in amends for his faults. In a last outburst of his passionate nature he had compressed a lifetime of adoration in these last few months. Every glance, every smile had told her his contrition, his pleading regrets.

And now he was about to go. Oh, why didn't Alphonse come? He couldn't, couldn't let his child die like this, without a word, a kiss . . . "Two days, perhaps three, perhaps less," the doctor had said . . . It was better that way. He had suffered enough. If pain cleansed, he was as pure as a flame. And he had made his peace with God. Death would be more merciful to him than life had been.

How small and helpless he looked in that great bed! As small as in the days of the *attaques*. Had he ever been anything but a child, for all his cynicism—a hungry-hearted child who wanted the love he could not have? Whatever he had done, he had hurt no one but himself . . .

"Madame la Comtesse . . ."

She turned to see Joseph standing behind her. He too had been looking at Henri, and his eyes were moist.

"The doctor said you should take some rest . . ."

For an instant they looked at each other, united in their grief.

"You are right, Joseph."

"I'll stay with him, and if anything happens . . ."

Impulsively she grasped his hand.

"Thank you, Joseph." In her whisper was the gratitude for a lifetime of inarticulate devotion. "Thank you for everything."

Dawn had not yet come when Henri opened his eyes.

In the window the sky was still violet, but you could feel the night was almost over. The stars were beginning to fade. In the old days it was the time when he said, "Let's go home, *cocher* 21, rue Caulaincourt. And stop at the first open bistro on the way . . ." It was the time when the night waiters and the last streetwalkers straggled home and the first pushcarts rattled over the cobbles on their way to Les Halles. Perhaps Marie was pushing one of those carts now? Perhaps she was sleeping on a bench? A lot could happen in eleven years. Perhaps she was dead? Grief killed in the end, but it killed slowly.

How still the house was! The lamp was burning on the bedstand. Joseph was dozing in the chair. Poor Joseph, how old and worn he looked with his stubbly chin sunk on his chest, his bony hands clasped on his lap! At his age he shouldn't be spending a night on a chair. He should have let Maman engage a night nurse as she wanted to. But no, it was his way of showing his devotion—as if you could doubt it—this spending a wretched night on a chair. Maman was so tired she could hardly stand up. It seemed impossible that so much fatigue and sadness could be written on a human face.

That was perhaps the hardest part about dying, this pain you brought to those you loved just by being ill, by not getting better. If at least you could explain to them it was all right, you were not afraid of dying any more, you were anxious to die—but that also would hurt them.

It would have been wonderful to die during that stroke two weeks ago. Joseph wouldn't be dozing on that chair; Maman wouldn't be so tired. Death relaxed. It was hope that exhausted. After death the sadness remained—in Maman's case it would never go away—but the tension disappeared. The living returned to their tasks, their worries, their regrets, their food, their laughter. The dead went on being whatever it was to be dead.

Well, it couldn't last much longer. Soon he would take himself off and stop plaguing everybody. Perhaps today . . . Even his foolish heart must have realized by now the uselessness of going on. There was only the agony to go through now, and all would be over. They said it started when you began

to rattle . . . You entered life crying and you went out rattling . . . Most humiliating! But then what humiliation illness was!

Anyhow, nothing mattered much any more. Even vanity went in the end. And he wasn't afraid of death any more. Familiarity, even with death, did not necessarily breed contempt—merely familiarity. You wished death would get on with it . . . He was ready to go.

He had made peace with God. First of all to make Maman happy—she had prayed so much for that. But also, when you were about to die you understood a lot of things you didn't understand before. You wanted peace and hope, more than you wanted truth. Reason could become very tiresome. It depoetized everything. It missed the point, explained none of the really important things. And it certainly didn't help you when you were racked with pain and were going to die. To rationalize was a little bit like standing on your toes. It was all right when you were young and full of vigor, but when you were tired and about to die you longed for the wide warm bed of faith. You needed a hand to help you across.

And so one evening after dinner, a week before the stroke, when Maman had retired, he and Abbé Soulac had walked out to the terrace. He had said, "Monsieur l'Abbé, will you please listen to my confession." It had been a balmy summer night, with the poplars soaring like fountains in the moonlight. And there, amidst the calls of crickets, he had confessed his wayward and lonely life. The Moulin, the bistros, the brothels —everything. Oddly, it all had sounded incredibly trivial—and not very sinful . . .

He slipped into a shallow pool of sleep. When he awoke, dawn had come and the sky was turning rose. Night had gone, taking her stars with her.

Somewhere a rooster crowed, and Joseph stirred on his chair, rubbed his eyes and looked at Henri, who was smiling at him.

"*Bonjour*, Joseph. Have a good sleep?"

"I'm afraid I dozed off, Monsieur Henri. I didn't mean to, but . . ."

"You're tired. I know. Everybody's tired in this house. Go down to the kitchen and have a cup of coffee. It'll do you good."

"In a little while. The cook isn't up yet. It's still very early. Have you been awake long, Monsieur Henri?"

"Only a few minutes. Prop me up, will you, Joseph, and hand me my glasses."

Gently the old coachman lifted him to a sitting position and held out the pince-nez.

"I can manage. I can still use one hand."

"Would you like me to close the window, Monsieur Henri?"

Henri chuckled softly. "You haven't changed a bit. Remember when you used to wake me to go to Fontanes and I pretended to snore? Come here," he whispered. "Sit here on the edge of the bed. I want to talk to you."

"Please, Monsieur Henri, don't. The doctor says . . ."

"Sshh! I want to speak to you while I still can. Lean over so you can hear me." A light of affection came into his sunken eyes as he scanned the leathery, tired face.

"First, I want to thank you for what you've done . . . Sshh! Don't interrupt me. You've been like a father to me. Naturally you know you'll be taken care of all your life, but I'd like to give you something and the only things I could think of were my watch and my cigarette case. I know you don't smoke, but keep them in memory of me, will you?"

His eyes closed, and his voice hushed to a labored whisper.

"Now, listen to me," he went on, opening his eyes with a desperate effort. "When I am gone I don't want Maman to be alone for long. You must find some excuse to come into the drawing room even if she doesn't ring for you. Pretend you've come to stir the fire or see if the window curtains are drawn. And don't go around with a long face, saying 'Yes, Madame la Comtesse . . . No, Madame la Comtesse.' Think of something else to say, something cheerful. Try to look happy. Tell her how the horses are getting along and try to get her to go out for drives when the weather is fine."

Again his eyes closed and for a moment his breath came in sibilant gasps.

"Please, Monsieur Henri," entreated Joseph.

"Another thing. She loves flowers, especially white roses. Make arrangements with Auguste so that there'll always be flowers about the house. Always . . . Now go downstairs. The cook must be up."

He saw Joseph's hesitation and a wan smile played about his lips.

"Don't worry. I won't die while you're away."

That day Henri felt a little better. Doctor Mouré came in the morning, smiled, went through the perfunctory ritual of taking his pulse, like the conscientious old country doctor he was. At noon, Henri managed to swallow a few spoonfuls of broth. Annette came, stood a moment by his bed, smiling down at him through her lashless eyes. She kissed his hand,

muttered endearments in Provençal; then, with a sob, fluttered out of the room. The parlormaid also paid him a short visit, and so did the cook. Auguste, the gardener, thrust his head through the embrasure of the door, gave Henri a long look and vanished. In the afternoon Abbé Soulac sat at his bedside in silence, his hands resting in the lap of his patched cassock. When he left, he made the sign of the Cross over the bed.

Then, time closed in again, empty, interminable. Through the half-shuttered window, sunlight latticed the floor. And once again they were alone, Maman and he.

"Maman, what day is it?"

"Sunday, *mon petit*. September the eighth."

"I'm sorry you missed Mass on my account . . ."

She pressed a finger to her lips. "Sshh! Don't talk, Riri."

"All right, Maman."

It was Barèges all over again. Barèges, Nice, Lamalou, Amélie-les-Bains. The bedstand cluttered with useless medicine, the vapid smell of illness in the air. It was his childhood revisited. Paris, Montmartre, the studio, "La Nouvelle," the *Comité Exécutif,* Le Riche, la rue des Petits Champs, the Natansons', even Arcachon . . . It all seemed so very far, so unreal. Perhaps it had all been a dream, a long, long dream, from which he had just awakened, gray-bearded and half-paralyzed. And Maman still at his bedside, but grown old during the dream . . .

"Are you comfortable, *chéri?*"

This time it was she who had spoken, and her eyes were smiling at him in the way he knew so well. Oh, the tenderness of her voice!

"Yes, Maman."

A pause.

He watched her knit. Maman and her everlasting knitting. At the Château she had done needlework. She had been sewing the day he had done her portrait and she had told him he must go to school . . . She used her knitting like a fan to hide her thoughts, the desolation in her eyes . . . What became of the things she was forever making? Those little socks, those shawls, those baby blankets? She probably gave them to some orphanage. Some foundling would sleep under that pink blanket she was knitting now . . .

"Maman?"

"Yes, *chéri?*"

"What became of Denise? Did she ever marry?"

"Yes. She married a Navy officer. They have three children now."

"You know, Maman, I didn't mean to . . ."

Again she raised a finger to her lips. She knew he wanted to say he was sorry for what he had done, for the pain he had brought her.

For a while he tried to recall the days he had spent with Denise, the drives in the blue victoria, the portrait, but he found he could barely remember her face. He could only remember that her hair was auburn like Maman's. In time even memories died.

It was strange lying here, waiting for death's good pleasure, with your mind lucid, without pain, except that numbness in the right side of your body—that part of you that was already dead. It was like descending stairs. Already most of the world ceased to exist. For instance, you knew you'd never see again the poplars in the garden, the rambler roses on the terrace, the clouds loafing in the sky.

Most of Malromé was already gone. He would never lie in his chaise-longue again. He would never need his clothes again, never lean on his little rubber-tipped cane he had cursed so often. Poor little cane, what would become of it? Perhaps some crippled child would inherit it? He would never squeeze another tube of paint, never touch another brush. The dead did not paint . . .

Perhaps in Heaven—that's what was so wonderful about faith, it let you dream—perhaps in Heaven there was a Montmartre, a heavenly Butte. Why not? They said there were many mansions; perhaps there were also many districts. This celestial Montmartre would be at the outer fringe of Heaven, a sort of suburb, a sort of third-class Heaven, where God sent people He didn't know what to do with and didn't have the heart to send to hell. Artists, like Vincent, Henri Rousseau, Desboutins, the members of the *Comité Exécutif* . . . People like Agostina, Julie, Père la Pudeur, la grosse Maria. Models, midinettes, lorettes . . . People like Gaston, Trémolada, Tanguy, Père Cotelle, Sarah, and even poor La Goulue . . . The poor whores who had been kind to him; Berthe, who had said, "My God, it's Henri!" People like Monsieur and Madame Potieron, and the wife of Marius, the *popote*, who worked hard because she wanted him to be a success. And even Marie, because like Mary Magdalen, she had loved, loved desperately, and God couldn't possibly send anyone to hell for loving too much . . . If there was such a Heaven that's where he would go.

"Maman!"

"Don't talk, *mon petit*."

"Maman, I love you."

"I know." Again her eyes smiled. "I love you, too, very much."

"That's what you said at the château, the day you scolded me about Monseigneur the Archbishop."

"Please, don't talk."

"Just a little bit . . . It doesn't hurt me to talk . . . You know that book *L'Anthologie de l'Estampe Japonaise*? Please take good care of it. Also about my paintings . . . You have seen a few of them, but believe me, they are not dirty. They are true and truth is sometimes very ugly . . . Let Maurice handle everything. He knows, he understands . . ."

Hundreds of paintings! Myriads of drawings, watercolors, sanguines, lithographs, charcoals, pen and inks . . . Whatever they would think of him, if they thought of him at all, they could never say he had been a loafer . . . It only showed how much you could accomplish when you had time to kill. Weeks, months, years of it . . .

"Maman!"

He saw the finger go up to her lips. As in the days of his childhood, he coaxed, "Just a little more . . . Let me talk a little more. Then I'll be quiet. Were you always good when you were a little girl?"

She rested her knitting on her lap. "Not always. I did foolish little things. All children do. Now, go to sleep, *mon petit*."

He closed his eyes, and suddenly he was back at Arcachon and Myriame was standing at the end of the wharf of the villa waving to him. Hundreds of times she had been waving like this in his mind. And this time it was more real than ever. He could feel the buoyancy of the bay under the boat, feel the heat of that summer morning beneath the breeze. But for the first time there was no grief, no longing, no regret. His heart had found peace at last.

There was a light knock on the door.

"A telegram, Madame la Comtesse," Joseph whispered.

"What is it?" asked Henri from the bed. "A telegram? From Papa?"

He watched her feverishly tear open the envelope, the flush of hope leave her face.

"No, Henri. It is from Maurice. Shall I read it to you?"

She pulled her chair to the bed, so that their faces were very close. She began reading,

"Government just accepted Camondo collection for Louvre. You are in, Henri . . ."

"The Louvre?" he gasped. "Did he say 'the Louvre'?"

Suddenly she was crying overtly, bending over him, kissing his cheeks.

"Oh, my darling, I wish I had understood . . . I didn't know . . . I'm so happy for you . . . So happy . . ."

"Are you proud, Maman?"

"Yes, Riri. I am proud, very proud . . ."

"The Louvre, that's even better than the Salon, isn't it? Oh, Maman, if you knew how much I wanted to show you my Icarus! But that makes up for it, doesn't it? The Louvre, the . . ."

His voice broke, changed to a throaty gurgle. His lips were still moving, but he could no longer speak.

Now it was almost daybreak—and still Papa hadn't come. Joseph was standing by the window, his head bowed. Annette was kneeling by the bed, weeping softly, mumbling to herself, clasping her rosary in front of her sucked-in mouth. And Maman was there, leaning over him, whispering to him, dabbing the sweat off his face, as in the old days . . .

"Not yet, *mon petit* . . . Not yet . . . Soon he'll be here . . . Be brave, Riri . . . Be brave . . ."

So, that's what dying was. This wheezy pumping of your lungs that came out in a panting rattle, this desperate alertness of the brain trapped in a drowning body . . . Once on the Channel he had experienced the same sensation of rising and falling. Suddenly the deck rose under your feet as if the ship were trying to wrench herself free from the sea and take flight. And you felt yourself soaring up, up, up, as on a swing. For a few seconds the boat remained suspended on the crest of the wave, throbbing from bow to stern, its propeller out of water, flaying the spume. Then with an exhausted, defeated rattle, it nosed downward again.

Dying was like that. Air sluiced into your lungs and you rose. When it went out you felt yourself sinking.

"Oh, Papa, hurry, hurry! . . ." A little more breathing . . . Just a little more breathing. "Wait, Death, wait a little while! I haven't lived very long, have I?"

Through the laboring of his lungs he heard the morning Angelus, the crowing of a rooster . . . Another day was being born—a fine September day, warm and sunny, a little sad, already autumnal.

His eyes closed, and his brain spun. For a moment he ceased breathing and felt himself fall into a dark bottomless shaft. Then once again his heart fluttered. Air whistled in through

his strangling gullet. In his chest the lungs avidly sucked and swelled again.

"Courage, my child . . . Please, Riri, please . . . Soon . . . Soon . . ."

His mother's voice came to him in a fluctuating murmur.

A little more breathing for Maman . . . A little more air for Maman . . . "Wait, Death, wait!"

There was a noise outside.

He saw his mother's face freeze in an agony of expectancy. Then there was the familiar squeak of the gate, followed by a crescendo of galloping hoofbeats.

Papa! He was here at last . . .

How like him to arrive on horseback! He must have left the express at Bordeaux and instead of waiting for the train to Saint-André-du-Bois, he had hired—or bought, or stolen—a horse and ridden all night, galloping along moonlit roads like some legendary knight, crossing fields, hurdling fences, trusting to an animal's instinct and his own superb horsemanship. It was the sort of thing Papa would do to reach the bedside of his dying son—the last of his House!

From downstairs rose an excited babble and the count's imperious voice.

"Am I in time?"

Almost at the same moment the bedroom door was flung open and the count strode toward the bed, disheveled, his boots splashed with mud, his crop in his hand. Still panting, he leaned down over his son, his face shattered with grief.

"Henri! . . . Henri, my boy . . ." The words tumbled from his lips in heaving sobs. "Forgive me . . . If you knew how much I've missed you . . ."

He kissed him on the forehead, and for a fleeting instant their gazes fused into mutual forgiveness.

Oh, if only Papa hadn't waited so long. If only he had resigned himself to a crippled child. Instead, they had spent their lives apart, both lonely, both trying to forget. And now it was too late.

Perhaps his death would bring Papa and Maman together. Both were old now, both alone. Perhaps in memory of him they would merge their solitude, join their common grief and end their days together.

The count straightened up, turned to his wife.

"You, too, Adèle, try to forgive me," he said with a new gentleness. Then, stepping back, he motioned her to the bed. "Go to him. He wants you."

Now there was only Maman. Her face was very close, her lips almost touching his. She was running her cool fingers through his hair as she had done when he was a child and wanted him to sleep.

"Go to sleep, *mon petit*."

Tears were trembling on her cheeks, yet she was smiling. No, not quite smiling, but she was happy. He could tell that. And proud. He hadn't failed her. Now he could stop struggling. She was no longer holding him back . . .

"Go to sleep, Riri . . ."

Already her face, her grave, tender face was receding in the distance, growing dim and shadowy, although the first light of morning was spreading through the room. This time darkness was rising from within. Maman . . . Maman . . . Adieu, Maman . . .

HISTORY AND BIOGRAPHY
Best-Sellers Of Enduring Importance Now In Inexpensive Paperback!

QUEEN VICTORIA by Elizabeth Longford V-1280 $1.25

An incomparable and unusually entertaining picture of its time. Seven months a national best-seller at $8.50. Illustrated.

DU BARRY by Stanley Loomis T-1254 75¢

"One of the finest biographies I have read in a long time" — Orville Prescott, The New York Times.

THE LIFE AND DEATH OF LOUIS XVI
by Saul K. Padover T-1078 75¢

The only biography of Louis XVI and a remarkable story of the French king and his wife, Marie Antoinette. Bibliography and index.

LINCOLN FOR THE AGES ed. by Ralph G. Newman N-1048 95¢

Seventy-eight outstanding writers and historians reveal the man and his Age.

THEY ALSO RAN by Irving Stone T-1014 75¢

The fascinating story of twenty "might have been's"—men who ran for the Presidency of the United States—and lost!

LAWRENCE OF ARABIA by Robert Payne R-838 50¢

An original biography of one of the most romantic and controversial figures in modern history.

THE NILE by Emil Ludwig T-833 75¢

The whole fabulous story of the Nile as it flows through 4,000 miles and 6,000 years of history.

THE PRIMEVAL FOREST by Albert Schweitzer R-856 50¢

The beloved winner of the Nobel Peace Prize writes about his thrilling years as physician to the people of the Congo.

JAPANESE INN by Oliver Statler N-695 95¢

This unusual best-seller is a panoramic, colorful picture of four centuries in the turbulent history of Japan. Lavishly illustrated.

NOTE: Pyramid pays postage on orders for four or more books. On orders for less than four books, add 10¢ per book to cover postage and handling.

——WHEREVER PAPERBACKS ARE SOLD OR USE THIS COUPON——

PYRAMID BOOKS
Dept. K-160, 444 Madison Avenue, New York, N.Y. 10022.
Please send the History and Biography titles circled below.
I enclose $_____

V-1280 T-1254 T-1078 N-1048 T-1014 R-838 T-833 R-856 N-695

Name_____

Street Address_____

City_____State_____Zip_____